LIFE OF JESUS

Happy Birthday Miss.
Nise self. Thank
you Jesus. for
your Blessing

LIFE OF JESUS

A GLORIOUS HISTORY OF HIS LIFE AND TEACHINGS

David John Meyers

PaRRagon

Bath · New York · Singapore · Hong Kong · Cologne · Delhi
Melbourne · Amsterdam · Johannesburg · Auckland · Shenzhen

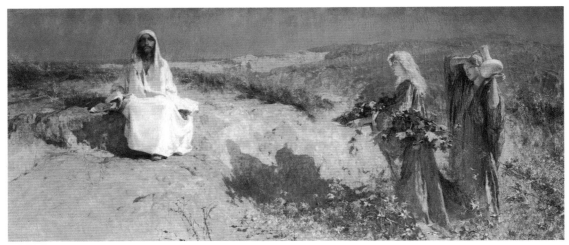

Christin the Desert, Domenico Morelli, 1826–1901

Moseley Road Inc.
President: Sean Moore
General Manager: Karen Prince

First published in 2005 by Moseley Road Inc.
123 Main Street, Irvington, New York 10533

This edition published by Parragon in 2011

Parragon
Queen Street House
4 Queen Street
Bath BA1 1HE, UK
www.parragon.com

ISBN: 978-1-4454-6691-0

Printed in China

CONTENTS

ILLUSTRATION LIST 8

INTRODUCTION 16

CHAPTER I
THE BIRTH OF JESUS 20

CHAPTER II
THE EARLY LIFE OF JESUS 34

CHAPTER III
THE MINISTRY OF JOHN THE BAPTIST 42

CHAPTER IV
THE TEMPTATION OF JESUS 50

CHAPTER V
JESUS' EARLY MINISTRY 54

CHAPTER VI
JESUS TEACHES THE CROWDS 80

CHAPTER VII
JESUS IN GALILEE 98

CHAPTER VIII
JESUS TEACHES IN PARABLES 124

CHAPTER IX
JESUS BEGINS THE JOURNEY 150

CHAPTER X
ON THE WAY TO JERUSALEM 166

CHAPTER XI
JESUS VISITS JERUSALEM 188

CHAPTER XII
JESUS' MINISTRY IN JUDEA 202

CHAPTER XIII
JESUS ENTERS JERUSALEM 218

CHAPTER XIV
JESUS PROPHESIES AND TEACHES 236

CHAPTER XV
THE PASSION AND DEATH OF JESUS 254

CHAPTER XVI
THE RISEN ONE 290

ILLUSTRATION LIST

FRONT COVER

Madonna and Child......................Front Cover
The Art Archive / Museo di Capodimonte, Naples /
Dagli Orti

Head of Christ.............................Front Cover
The Art Archive / Dagli Orti (A)

Crucifixion of Christ....................Front Cover
The Art Archive / Album/Joseph Martin

Christ Blessing.............................Front Cover
The Art Archive / Museo del Prado Madrid / Dagli Orti

The Resurrection of Lazarus...........Front Flap
The Art Archive / Musée Bonnat Bayonne France / Dagli
Orti (A)

Suffer the Little Children to.......... Back Cover
Come unto Me
The Art Archive / Queretaro Museum Mexico / Dagli
Orti

Last Supper Back Cover
The Art Archive / Museo del Prado Madrid / Dagli Orti
(A) .

Mary Magdalene Back Cover
Anoints Feet of Christ

The Art Archive / Museo Civico Padua / Dagli Orti (A)

INTRODUCTION

Christ in the Desert 2
The Art Archive / Galleria d'Arte Moderna Rome /
Dagli Orti (A) .

Mary Magdalene Anoints Feet of Christ 17
The Art Archive / Museo Civico Padua / Dagli Orti (A)

Suffer the Little Children to 19
Come unto Me
The Art Archive / Queretaro Museum Mexico /
Dagli Orti

I. THE BIRTH OF JESUS

The Departure for Egypt 20

Adoration of the Magi 21
The Art Archive / Museo del Prado Madrid /
Album/Joseph Martin

The Return from Egypt 21

The Nativity with Rabbits, Mark, and21
Saint John the Baptist
The Art Archive / Museo di Castelvecchio Verona /
Dagli Orti (A)

Adoration of the Magi................................21
The Art Archive / Museo del Prado Madrid /
Album/Joseph Martin

Adoration of the Magi 22
The Art Archive / Museo del Prado Madrid /
Album/Joseph Martin

The Christ ... 23

The Return from Egypt............................. 24

Retable of the Genealogy of Jesus25
The Art Archive / National Museum of Sculpture
Valladolid / Dagli Orti (A)

Adoration of the Magi................................27
The Art Archive / Museo del Prado Madrid /
Album/Joseph Martin

The Nativity, Adoration of the Magi, and
Presentation in Temple28
The Art Archive / Musée Royale des Beaux Arts
Antwerp / Dagli Orti (A)

The Adoration of the Shepherds.................30
The Art Archive / Musée du Louvre Paris / Dagli Orti
(A) .

The Visitation...31
The Art Archive / National Gallery Budapest / Dagli
Orti (A)

The Nativity with Rabbits,33
Mark, and Saint John the Baptist
The Art Archive / Museo di Castelvecchio Verona /
Dagli Orti (A)

II. THE EARLY LIFE OF JESUS

Jesus in the Midst of the Doctors...............34

Presentation of Jesus in the Temple.............35
The Art Archive / Scrovegni Chapel Padua / Dagli Orti (A)

Jesus at the Temple Among the Doctors......35
The Art Archive / Galleria Sabauda Turin / Dagli Orti

Christ's Presentation in the Temple.............35
The Art Archive / Museo del Prado Madrid / Dagli Orti

The Child Jesus..................................35

Saint Joseph and Jesus, with.......................36
Toledo in the Background
The Art Archive / Album/Joseph Martin

The Child Jesus..................................37

Presentation of Jesus in the Temple.............38
The Art Archive / Scrovegni Chapel Padua / Dagli Orti (A)

Christ's Presentation in the Temple.............39
The Art Archive / Museo del Prado Madrid / Dagli Orti

Jesus in the Midst of the Doctors...............40

Jesus at the Temple Among the Doctors......41
The Art Archive / Galleria Sabauda Turin / Dagli Orti

III. THE MINISTRY OF JOHN THE BAPTIST

John in the Wilderness..............................42

Saint John the Baptist Preaching..................43
The Art Archive / Castello di Aglie Turin Italy / Dagli Orti (A)

The Baptism of Jesus Christ by.................43
Saint John the Baptist
The Art Archive / Pinacoteca Civica Forli / Dagli Orti (A)

Saint John the Baptist.............................43
The Art Archive / Museo Civico Modena / Dagli Orti (A)

The Jews Asking Saint John the Baptist......43
If He Is the Christ
The Art Archive / Musée des Beaux Arts Rouen / Dagli Orti (A)

Saint John the Baptist.............................44
The Art Archive / Museo Civico Modena / Dagli Orti (A)

The Baptism of Christ by..........................45
John the Baptist
The Art Archive / Santa Corona church Vicenza / Dagli Orti (A)

Saint John the Baptist Preaching..................46
The Art Archive / Castello di Aglie Turin Italy / Dagli Orti (A)

The Baptism of Jesus Christ by.................48
Saint John the Baptist
The Art Archive / Pinacoteca Civica Forli / Dagli Orti (A)

The Jews Asking Saint John the Baptist......49
If He Is the Christ
The Art Archive / Musée des Beaux Arts Rouen / Dagli Orti (A)

IV. THE TEMPTATION OF CHRIST

The Temptation......................................50
Christ Tempted by the Devil......................51
The Art Archive / Biblioteca Capitolare Verona / Dagli Orti

Jesus' Temptation in the Desert..................51
The Art Archive / Château de Blois / Dagli Orti

Christ's Temptation in the Desert...............51
The Art Archive / Saint Sebastian Chapel Lanslevillard Savoy / Dagli Orti

Christ's Temptation in the Desert...............51
The Art Archive / Dagli Orti

Christ's Temptation in the Desert...............52
The Art Archive / Dagli Orti

V. JESUS' EARLY MINISTRY

The Calling of the Fishermen....................54
Jesus Instructing Nicodemus......................55
The Art Archive / Musée de Tournai / Dagli Orti

The Calling of Saint Matthew....................55
Christ Preaching....................................55
The Art Archive / Musée de Tournai / Dagli Orti

Healing of the Impotent Man at the Pool...55
Christ Preaching....................................56
The Art Archive / Musée de Tournai / Dagli Orti

The Marriage Feast at Cana.......................57
The Art Archive / Museo Correr Venice / Dagli Orti (A)

Christ's Entry into Jerusalem.....................58
The Art Archive / Biblioteca del Studio Teologico Accademico Bressanone / Dagli Orti

Nicodemus Seeks Jesus by Night59

Jesus Instructing Nicodemus......................60
The Art Archive / Musée de Tournai / Dagli Orti

Christ and the Samaritan Woman62
The Art Archive / Nicolas Sapieha

Christ Giving Word of God to64
Saint Peter and Paul
The Art Archive / Santa Costanza Rome / Dagli Orti
(A)

The Calling of the Fishermen65

The Calling of Saint Matthew67

Christ Teaching at the Synagogue...............69
The Art Archive / Klosterneuburg Monastery Austria /
Dagli Orti (A)

Meal at the House of Simon70
The Art Archive / Galleria Sabauda Turin / Dagli Orti

The Leper.......................................71

Healing of the Impotent Man at the Pool...72

The Calling of Saint Matthew73
The Art Archive / Contarelli Chapel San Luigi dei
Francesci / Album/Joseph Martin

Casting a Net74

Oriental Mode of Threshing.....................75

Jesus Preaches from a Ship77

The Man with the Withered Hand.............78

The Marriage Feast at Cana:......................79
Christ Walking on Water
The Art Archive / Armenian Museum Isfahan /
Dagli Orti

VI. JESUS TEACHES THE CROWDS

The Sermon on the Mount80

The Sermon on the Mount, Our Father81
The Art Archive / Galleria d'Arte Moderna Rome /
Dagli Orti (A)

Christ Blessing.................................81
The Art Archive / Museo del Prado Madrid / Dagli Orti

Christ's Sermon to the Women81
The Art Archive / Dagli Orti

The Prayer in Secret81

Christ Blessing82
The Art Archive / Museo del Prado Madrid / Dagli Orti

The Sermon on the Mount.......................83

The Sermon on the Mount, Our Father.....84
The Art Archive / Galleria d'Arte Moderna Rome /
Dagli Orti (A)

Christ's Sermon to the Women...................87
The Art Archive / Dagli Orti

Jewish Priest Offering Incense89

The Prayer in Secret.................................90

Oriental Mode of Threshing91

Eastern Method of Winnowing Grain........93

Goat-skin Bottles94

Women Gringing at a Mill97

VII. JESUS IN GALILEE

The Daughter of Jairus................................98
Raised From the Dead

Miracle of Jesus Christ99
Curing Man Born Blind
The Art Archive / San Angelo in Formis Capua Italy /
Dagli Orti (A)

The Centurion Kneeling Before Christ......99
The Art Archive / Cathedral Cremona / Dagli Orti

Jesus Christ Healing the Sick99
The Art Archive / Kariye Camii Istanbul / Dagli Orti
(A)

A Woman Healed By Touching99
the Garment of Jesus

Jesus Christ Healing the Sick100
The Art Archive / Kariye Camii Istanbul / Dagli Orti
(A)

Healing the Centurion's Servant................101

The Centurion Kneeling Before Christ102
The Art Archive / Cathedral Cremona / Dagli Orti

The Widow's Mite104
The Art Archive / San Apollinare Nuovo Ravenna /
Dagli Orti (A)

The Miraculous Draught of Fishes105

Miracle of the Curing of the....................107
Woman of Issue of Blood
The Art Archive / Museo Nazionale Romano Rome /
Dagli Orti (A)

A Woman Healed By Touching.................108
the Garment of Jesus

The Daughter of Jairus Raised..................109
From the Dead

Miracle of Jesus Christ Curing Man...........111
Born Blind
 The Art Archive / San Angelo in Formis Capua Italy /
 Dagli Orti (A)

Christ Heals the Blind Man from112
Jericho
 The Art Archive / San Apollinare Nuovo Ravenna /
 Dagli Orti (A)

Jesus and His Disciples on the...................113
Road to Caesarea

Christ Teaching the Apostles.....................114
 The Art Archive / Musée du Louvre Paris / Dagli Orti

The Apostles Preaching the Gospel...........117
to the Nations
 The Art Archive / Sucevita Monastery Moldavia
 Romania / Dagli Orti (A)

Triumphal Entry into Jerusalem................121

VIII. JESUS TEACHES IN PARABLES

The Miracle of the Loaves124

The Beheading of.....................................125
Saint John the Baptist
 The Art Archive / Roger Cabal Collection / Dagli Orti

The Syrophenician Woman125

The Miracle of the Loaves and Fishes,.......125
from Life of Jesus Christ
 The Art Archive / Goreme Cappadoccia Turkey /
 Dagli Orti (A)

The Multiplication of the...........................125
Loaves and the Fishes
 The Art Archive / San Apollinare Nuovo Ravenna /
 Dagli Orti (A)

Christ Raising Hand in Blessing126
 The Art Archive / San Spiridione church Trieste /
 Dagli Orti (A)

Parable of the Sower.................................127

Eastern Plowing and Sowing....................130

Wheat ..131

Mustard...132

Casting a Net...132

Christ Healing the Paralytic at the133
Pool of Bethesda

 The Art Archive / National Gallery London / John Webb

The Beheading of.....................................136
Saint John the Baptist
 The Art Archive / Roger Cabal Collection / Dagli Orti

The Miracle of the Loaves and Fishes,.......138
from Life of Jesus Christ
 The Art Archive / Goreme Cappadoccia Turkey /
 Dagli Orti (A)

The Multiplication of the..........................139
Loaves and the Fishes
 The Art Archive / San Apollinare Nuovo Ravenna /
 Dagli Orti (A)

Jesus Walks on the Water140

Jesus Walking on Water.............................142
 The Art Archive / Dagli Orti

The Syrophenician Woman145

Miracle of Feeding of Five Thousand146
 The Art Archive / Archbishops Palace Ravenna Italy /
 Dagli Orti (A)

The Miracle of the Loaves.........................147

Healing a Deaf-mute.................................149
 The Art Archive / Kariye Camii Istanbul / Dagli Orti
 (A)

IX. JESUS BEGINS THE JOURNEY

Healing of Two Blind Men150

Tribute Money ...151
 The Art Archive / Sta Maria del Carmine Florence /
 Dagli Orti (A)

The Transfiguration of Jesus Christ151
to the Apostles
 The Art Archive / Antalya Museum Turkey / Dagli Orti
 (A) .

I am the Vine, with Christ151
and the Apostles
 The Art Archive / Byzantine Museum Athens /
 Dagli Orti

Christ Predicts that Apostle Peter...............151
will Deny Him
 The Art Archive / San Apollinare Nuovo Ravenna /
 Dagli Orti (A)

Christ Predicts that Apostle Peter152
will Deny Him
 The Art Archive / San Apollinare Nuovo Ravenna /
 Dagli Orti (A)

Saint Peter..153
 The Art Archive / Basilica San Giusto Trieste /
 Dagli Orti

Jesus in Prayer ...154

I am the Vine, with Christ.........................155
and the Apostles
 The Art Archive / Byzantine Museum Athens /
 Dagli Orti

Saint Peter Preaching156
The Art Archive / Fine Art Museum Bilbao / Dagli Orti
(A)

The Transfiguration of Jesus Christ157
to the Apostles
The Art Archive / Antalya Museum Turkey /
Dagli Orti (A)

Transfiguration with Christ and................158
the Apostles
The Art Archive / Church of the Buckle / Dagli Orti (A)

Healing of Two Blind Men160

Tribute Money.................................163
The Art Archive / Sta Maria del Carmine Florence /
Dagli Orti (A)

Frankincense and Myrrh 165

X. ON THE WAY TO JERUSALEM

Healing of an Aged Woman.....................166

Providing for the Religious, Following
Christ's Teaching167
The Art Archive / Dagli Orti

The Good Samaritan.................................167
Helping Wounded Robbed Man
The Art Archive / Museo Tridentino Arte Sacra Trento /
Dagli Orti (A)

Giving Bread to the Poor,167
Following Christ's Teaching
The Art Archive / Dagli Orti

Jesus Rejected at Nazareth167

Entry of Christ into Jerusalem168
The Art Archive / Dagli Orti

Jesus Rejected at Nazareth169

Providing for the Religious,.....................170
Following Christ's Teaching
The Art Archive / Dagli Orti

Giving Bread to the Poor,171
Following Christ's Teaching
The Art Archive / Dagli Orti

Jesus and the Twelve Disciples...................173
The Art Archive / Suermondt Museum Aachen /
Dagli Orti (A)

The Good Samaritan Helping.................174
Wounded Robbed Man
The Art Archive / Museo Tridentino Arte Sacra Trento /
Dagli Orti (A)

The Good Samaritan.................................175
The Art Archive / Queretaro Museum Mexico /
Dagli Orti

Jesus at the House of Martha and Mary.....176

Healing of an Aged Woman.......................179

Healing of the Man with the Dropsy180

Silver Penny: Time of Caesar182

Dives and Lazarus184

Saint Radegund Curing187
Demolenus in His Dreams
The Art Archive / Bibliothèque Municipale Poitiers /
Dagli Orti

XI. JESUS VISITS JERUSALEM

Jesus Preaching in the Synagogue188

View of Jerusalem from189
Valley of Jehoshaphat
The Art Archive / Musée du Louvre Paris /
Dagli Orti (A)

Christ and the Adulterous Woman.............189
The Art Archive / Musée des Beaux Arts Rouen /
Dagli Orti (A)

Christ and the Adulterous Woman.............189
The Art Archive / Musée du Louvre Paris / Dagli Orti
(A)

"Behold the Lamb of God"189

View of Jerusalem from190
Valley of Jehoshaphat
The Art Archive / Musée du Louvre Paris / Dagli Orti
(A)

Jesus Talks with the Samaritan Woman191

Jesus Preaching in the Synagogue..............192

Christ and the Adulterous Woman.............194
The Art Archive / Musée du Louvre Paris / Dagli Orti
(A)

Christ and the Adulterous Woman.............195
The Art Archive / Musée des Beaux Arts Rouen /
Dagli Orti (A)

The Man Blind from His Birth197

"Behold the Lamb of God"198

"Peace Be to This House".........................199
The Good Shepherd201
The Art Archive / Musée des Beaux Arts Tours /
Dagli Orti

XII. JESUS' MINISTRY IN JUDEA

The Woman Taken in Adultery202

The Resurrection of Lazarus203
The Art Archive / Musée des Beaux Arts Rouen /
Dagli Orti (A)

Jesus Leads the Blind203

The Resurrection of Lazarus203
The Art Archive / Musée Bonnat Bayonne France /
Dagli Orti (A)

Christ Blessing the World203
The Art Archive / Galleria Sabauda Turin / Dagli Orti

Christ Blessing the World204
The Art Archive / Galleria Sabauda Turin / Dagli Orti

The Woman Taken in Adultery205

Jesus and the Child..................................206

The Rich Young Man..............................207

Cultivating the Vines209
The Art Archive / Museo del Bargello Florence /
Dagli Orti (A)

Wine Press in Oriental Vineyard210

The Resurrection of Lazarus211
The Art Archive / Musée des Beaux Arts Rouen /
Dagli Orti (A)

The Resurrection of Lazarus....................212
The Art Archive / Musée Bonnat Bayonne France /
Dagli Orti (A)

Lazarus Raised from the Dead..................213

The Scribes and Pharisees sit....................215
in Moses' Seat

Jesus Leads the Blind217

XIII. JESUS ENTERS JERUSALEM

Jesus Drives the Money-Changers.............218
from the Temple

Marriage Feast at Cana............................219
The Art Archive / Barber Institute Birmingham

Expulsion of Traders from Temple219
The Art Archive / National Gallery London /
Album/Joseph Martin

Triumphal Entry into Jerusalem219
The Art Archive / Scrovegni Chapel Padua / Dagli Orti
(A)

Return of the Prodigal Son.......................219

Triumphal Entry into Jerusalem220
The Art Archive / Scrovegni Chapel Padua / Dagli Orti
(A)

Entry of Christ into Jerusalem...................221
The Art Archive / Cathedral Treasury Aachen /
Dagli Orti (A)

Expulsion of Traders from Temple.............223
The Art Archive / National Gallery London /
Album/Joseph Martin

Jesus Drives the Money-Changers224
from the Temple

Jesus Drives the Money-Changers226
out of the Temple
The Art Archive

Return of the Prodigal Son228

Marriage Feast at Cana............................231
The Art Archive / Barber Institute Birmingham

The Pharisee and the Publican234

XIV. JESUS PROPHESIES AND TEACHES

Jesus Foretells the Destruction236
of the Temple

Christ Tempted by the Devil.....................237
The Art Archive / Biblioteca Capitolare Verona /
Dagli Orti

Last Judgement ...237
The Art Archive / Scrovegni Chapel Padua /
Dagli Orti (A)

Last Supper Detail of237
Apostles Peter, Judas, Jesus, and John
The Art Archive / Cenacolo Santa Apollonia Florence /
Dagli Orti (A)

Jesus Christ Entering Jerusalem.................237
The Art Archive / Antalya Museum Turkey /
Dagli Orti (A)

Jesus Christ Entering Jerusalem.................238
The Art Archive / Antalya Museum Turkey / Dagli Orti
(A)

Jesus Foretells the Destruction239
of the Temple

Christ Tempted by the Devil240
The Art Archive / Biblioteca Capitolare Verona /
Dagli Orti

Madonna and Child243
The Art Archive / Museo di Capodimonte, Naples /
Dagli Orti

Last Judgement ...244
The Art Archive / Scrovegni Chapel Padua /
Dagli Orti (A)

Wise Virgins246
The Art Archive / Museo de Artes de Catalunya
Barcelona / Album/Joseph Martin

Parable of Wise and Foolish Virgins247
The Art Archive / Accademia San Luca Rome / Dagli
Orti (A)

Head of Christ249
The Art Archive / Dagli Orti (A)

The Last Supper, Illuminated250
Capital Letter N
The Art Archive / Abbey of Novacella or Neustift /
Dagli Orti

Crucifixion of Christ251
The Art Archive / Album/Joseph Martin

Last Supper Detail of252
Apostles Peter, Judas, Jesus, and John
The Art Archive / Cenacolo Santa Apollonia Florence /
Dagli Orti (A)

XV. THE PASSION AND DEATH OF JESUS

The Crucifixion254
Christ Shown to the People255
by Pontius Pilate
The Art Archive / Museo del Prado Madrid /
Album/Joseph Martin

Last Supper ...255
The Art Archive / Museo del Prado Madrid /
Dagli Orti (A)

Christ in the Garden of Olives255
The Art Archive / Royal Chapel Granada Spain / Dagli
Orti (A)

The Blood of Christ255
The Art Archive / Galleria di Storia ed Arte Udine /
Dagli Orti (A)

The Dead Christ256
The Art Archive / Galleria Brera Milan / Dagli Orti (A)

Spanish Betrayal of Christ257
The Art Archive / Salzillo Museum Murcia / Joseph
Martin

Crucifixion of Jesus Christ with258
Charles IV
The Art Archive / Cathedral Treasury Aachen /
Dagli Orti (A)

Veiled Christ ...259
The Art Archive / Dagli Orti (A)

The Washing of the Feet with261
Blessing of Host
The Art Archive / Museo del Prado Madrid /
Album/Joseph Martin

Seizure of Christ: Soldiers........................262
Arrest Jesus in Garden of Gethsemane
The Art Archive / Museo del Prado Madrid /
Album/Joseph Martin

Jesus Washing Feet264
The Art Archive / San Angelo in Formis Capua Italy /
Dagli Orti (A)

Last Supper...267
The Art Archive / Museo del Prado Madrid /
Dagli Orti (A)

Christ in the Garden of Olives269
The Art Archive / Royal Chapel Granada Spain /
Dagli Orti (A)

Christ Shown to People by.......................273
Pontius Pilate
The Art Archive / Album/Joseph Martin

Christ before Caiphas274
The Art Archive

Betrayal by Saint Peter276
The Art Archive / Civiche Racc d'Arte Pavia Italy /
Dagli Orti (A)

Christ Shown to the People by.................279
Pontius Pilate
The Art Archive / Museo del Prado Madrid /
Album/Joseph Martin

Descent of Jesus Christ into Limbo280
The Art Archive / Brancacci Chapel Florence /
Dagli Orti (A)

The Blood of Christ................................282
The Art Archive / Galleria di Storia ed Arte Udine /
Dagli Orti (A)

Passion Cycle of Christ:...........................285
Agony in garden, Kiss of Judas,
Crucifixion
The Art Archive / Palatine Library Parma / Dagli Orti
(A)

Calvary..286
The Art Archive / Musée des Beaux Arts Tours /
Dagli Orti (A)

Dead Christ in Mary's Arms287
The Art Archive / Fine Art Museum Bilbao / Dagli Orti
(A)

Veiled Christ (1753, Marble)288
The Art Archive / Dagli Orti (A)

Dead Christ Supported289
by Two Angels

The Art Archive / Museo Correr Venice / Dagli Orti (A)

XVI. THE RISEN ONE

Peter Leaps from the Boat to290
Meet Jesus

Holy Sepulchre with291
Resurrection of Christ
 The Art Archive / Museo de Zaragoza (Saragossa) /
 Dagli Orti (A)

The Incredulity of Saint Thomas291
 The Art Archive / Museo di Castelvecchio Verona / Dagli
 Orti (A)

The Angel at Christ's Tomb291
 The Art Archive / Accademia San Luca Rome / Dagli
 Orti (A)

Jesus Appears to His Disciples....................291

Holy Sepulchre with292
Resurrection of Christ
 The Art Archive / Museo de Zaragoza (Saragossa) /
 Dagli Orti (A)

The Angel at Christ's Tomb294
 The Art Archive / Accademia San Luca Rome /
 Dagli Orti (A)

The Risen Jesus Appears to295
Mary Magdalene
 The Art Archive / Scrovegni Chapel Padua / Dagli Orti
 (A)

Risen Christ Appears to296
Mary Magdalene
 The Art Archive / Unterlinden Museum Colmar /
 Album/Joseph Martin

Peter Leaps from the Boat to297
Meet Jesus

Supper at Emmaus....................................298
 The Art Archive / Galleria Brera Milan / Album/Joseph
 Martin

The Incredulity of Saint Thomas300
 The Art Archive / Museo di Castelvecchio Verona /
 Dagli Orti (A)

The Disciples at Emmaus..........................301

Jesus Appears to His Disciples...................302

The Resurrection of Christ......................304
 The Art Archive / São Paulo Art Museum Brazil /
 Dagli Orti

★All black and white images that are not credited were reproduced from *Christ in Art*, by Edward Eggleston, D.D., published in 1875 by J.B. Ford & Company, New York.

INTRODUCTION

In our electronic culture, where yesterday's news is ancient history, it may come as a surprise that the first written accounts of the life of Jesus did not emerge until at least 60 A.D., some thirty years after his death. How could events that would change the history of humankind forever take so long to be recorded for future generations? Should not such "good news" have been almost immediately on its way to the uttermost ends of the earth?

The good news that burst forth from Jesus' empty tomb was announced with joy and urgency, along the infrastructure of first-century Palestine. There, most local news stories traveled by word-of-mouth, from one neighbor to another, as most people did not read, write, or have the space in their homes for libraries of parchment scrolls. Towns in Palestine and throughout the first-century Roman empire did have places for exchanging news and sharing revelations—places where Jews and interested Gentiles would gather to hear readings from the Law, the Prophets, and the Psalms, to pray, sing, and catch up on what was happening in one another's families. It was in these places—the village synagogues, and the temple in Jerusalem—where Jesus had done his preaching, where the good news was first proclaimed.

Unlike Moses, who, according to tradition, authored the first five books of the Hebrew Bible, nothing written by Jesus survives. Furthermore, the earliest disciples believed that Jesus' resurrection was the sign that the end of time was at hand, and that their Lord would be returning soon. The message of the Kingdom of God needed to take the fastest route possible—via missionaries traveling on foot from town to town, or to distant places by boat on the Mediterranean Sea. Those missionaries, like Paul of Tarsus, founded communities of believers in many places—communities who believed, as they still do, that Jesus was alive and present in their assemblies, speaking among them through preachers filled with his spirit and binding them together across cultural and socioeconomic barriers in the "breaking of bread." Given these realities, it is understandable that the first written Christian documents were letters addressed to specific communities to speak to particular problems and concerns.

It was not until 60–70 A.D., when the eyewitnesses to the risen Jesus (the twelve disciples, James, Paul, and the other first generation apostles) had died, that the first "Gospel," probably the Gospel of Mark, was written and circulated to other communities of believers. In the next twenty or thirty years, other gospels were written, documents that later tradition connected with Matthew and John, members of the twelve, and with Luke, a physician and traveling companion of Paul. These gospels recorded stories about Jesus that had been remembered and passed along orally, because they spoke to the concerns and challenges of the faith communities of the time. Along the way, the gospels grew into the form in which we read them in the New Testament.

No original copies of the four gospels exist. The oldest remaining manuscripts of the gospels, written in Greek, date back to the second and third centuries A.D. There are no known signature copies. The earliest written witness connecting the known names to the gospel document is a Bishop named Papias of Hieropolis (in Asia Minor), who is quoted by the Church historian Eusebius in his *Ecclesiastical History*. Papias shares an early second-century tradition about Mark and Matthew:

Mark, having become the interpreter of Peter, wrote down accurately, however, not in order, all that he recalled of what was either said or done by the Lord. For he had neither heard nor followed the Lord. . . . Now Matthew arranged in order the sayings in the

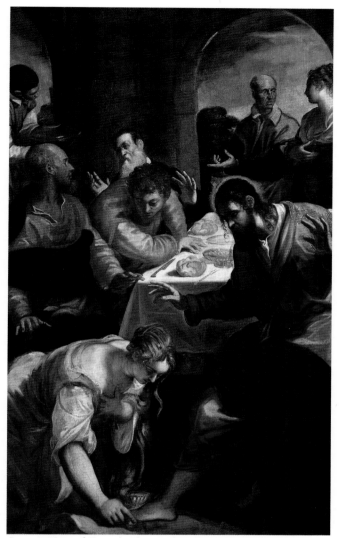

Supper in House of Simon the Pharisee where Woman Sinner Mary Magdalene Anoints Feet of Christ, by Jacopo Robusti Tintoretto, 1518-94

Hebrew language, and each one interpreted as he was able.

ECCLESIASTICAL
HISTORY 3.39.15–16

Irenaeus, the Bishop of Lyons (in Gaul), writing about 180 A.D., confirmed that the four gospels of our New Testament came to be widely accepted in the Church by the second half of the second century. He said the following about the origin of the four gospels:

So Matthew among the Hebrews issued a Writing of the gospel in their own tongue, while Peter and Paul were preaching the gospel at Rome and founding the Church. After their decease, Mark, the disciple and interpreter of Peter, also handed down to us in writing what Peter had preached. Then Luke, the follower of Paul, recorded in a book the gospel as it was preached

by him. Finally John, the disciple of the Lord, who had also lain on his breast, himself published the Gospel, while he was residing in Ephesus in Asia [Minor].

AGAINST HERESIES, BOOK 3.1

Almost all we know about Jesus and his ministry from the first century comes from the four gospels. However, there are a few mentions of Jesus in non-Christian writers of the first century. Perhaps the most important informant on the events and social life of first century Palestine is (Flavius) Josephus, a Jew, whose two works, *Antiquities* and *The Jewish War*, give us a fairly comprehensive source of information about politics, religion, and life in the century that Jesus walked around Galilee and Judea.

About this time arose Jesus, a wise man, if indeed it be lawful to call him a man. For he was a doer of wonderful deeds, and a teacher of men who gladly receive the truth. He drew to himself many, both of the Jews and of the Gentiles. He was the Christ; and when Pilate, on the indictment of the principal men among us, had condemned him to the cross, those who had loved him at the first did not cease to do so, for he appeared to them again alive on the third day, the divine prophets having foretold these and ten thousand other wonderful things about him. And even to this day the race of Christians, who are named from him, has not died out.

ANTIQUITIES 18:63–64

While all the manuscripts of Josephus contain this quote, the Christian writer Origen in the third century plainly states that Josephus did not believe Jesus to be the Christ. In the *Annals of Tacitus*, the Roman historian, he refers obliquely to Jesus while describing Emperor Nero's treatment of Christians:

Consequently, to get rid of the report [that the burning of Rome was at his order], Nero fastened the guilt and inflicted the most exquisite tortures on a class hated for their abominations, called Christians by the populace. Christus, from whom the name had its origin, suffered the extreme penalty during the reign of Tiberius at the hands of one of our procurators, Pontius Pilatus, and a most mischievous superstition thus checked for the moment, again broke out not only in Judaea, the first source of evil, but even in Rome, where all things hideous and shameful from every part of the world find their center and become popular.

ANNALS 15.44

All four gospels have many stories, sayings, and teachings in common, but the gospels of Mark, Matthew, and Luke share large blocks of the same material, sometimes in exactly the same words. Mark's gospel contains 661 verses; Matthew has 1,068; and Luke has 1,149. In total, 80 percent of Mark's verses are found in Matthew; 65 percent of Mark's verses are contained in Luke. Matthew and Luke also have between 220 and 235 verses of additional material in com-

mon. Since the order of the verses shared in common among all three gospels is similar, as well as the order of the material shared by Matthew and Luke, it is safe to say that they depend upon one another to a certain extent. While students of the Bible have several different opinions about this, the most likely scenario is that Mark is the first gospel to have been written; that Matthew and Luke had before them a written copy of Mark, to which they added a large body of material. Much of this material consists of sayings of Jesus, from a common written source called Q (for the German word Quelle, meaning "source"). Though no written manuscript of Q has been unearthed, the discovery of the Coptic Gospel of Thomas, a translation of what may be a second-century Greek document, attests to the existence of a written document containing sayings attributed to Jesus. Both Matthew and Luke also contain some material that is unique to each, but it is hard to determine whether that material originally came from written sources or from stories transmitted by word-of-mouth.

Each of the Gospels grew up in a community of disciples with its own unique makeup and challenges.

Mark's fast-moving gospel gets right to the point: "The beginning of the good news (gospel) of Jesus Christ, the son of God." Mark reveals Jesus' identity to the reader from the start; the characters come to discover it throughout the gospel. At his baptism Jesus hears a voice from heaven: "You are my beloved Son. . ." The demons know it, for as Jesus casts them out they scream: "You are the Son of God!" At the midpoint of the gospel, Peter begins to catch on to Jesus' identity as the Christ, the long-awaited son of David who would restore the Davidic kingdom to Israel. Jesus' true identity is finally revealed to the world at the foot of the cross by the Roman Centurion: "Truly this man was the Son of God!" Mark's inconclusive ending seems to suggest that if one wants to understand Jesus, the only way is to follow him through suffering to victory.

Matthew, by far the most widely beloved of the gospels, follows Mark's basic outline, but adds a large amount of new material, much of it in five great "sermons." Matthew, as Papias and Irenaeus allude, emphasizes the Jewish roots of Jesus, tracing his ancestry back to Abraham and David—both focal points of God's covenant with Israel. From the first chapter, Matthew's Jesus "fulfills the scriptures," retracing the steps of God's people. An underlying theme in the portrayal of Jesus' ministry is the inclusion of the Gentiles in the plan of God, as God promised Abraham in Genesis 12:3: "In thee shall all the families of earth be blessed." In the last verses of the gospel, Jesus sends his disciples to "all the nations" (i.e. "all the Gentiles").

If Matthew's story brings out the Jewish roots of Jesus and his teaching, Luke emphasizes the global nature of the good news that the Messiah had indeed come. Luke mentions in his prologue that it was written for a man named Theophilus ("friend of God," in Greek). Tracing Jesus' genealogy all the way back to Adam and to God, Luke picks up the universality of Jesus' story—and the salvation it brings. And yet, Luke emphasizes the faithfulness of God to God's covenant people, and their faithfulness to God. Luke sees the ministry of Jesus as the central point in a three-stage

history of salvation, in the life of Israel, in the life of Jesus, and (in Luke's second volume, the Acts of the Apostles) the life of the Church.

John's story is the gospel that sees things from above. John is divided into two parts: the Book of Signs and the Book of Glory. In the Book of Signs, Jesus' ministry is done for the world to see, made manifest in seven "signs," or acts of power. Through these acts he reveals his glory (the saving presence of God), and his disciples believe in him. The Book of Glory looks forward to the ultimate glory—as Jesus is lifted up from the earth (John 12:32) that he might draw all unto himself. Jesus reigns as king from the cross—bringing together the beloved disciple and his mother. His final word is a cry of victory, not abandonment: "It is finished!"

Taken as a whole, the four gospels provide a portal through which people of every walk of life, and every nationality may span the centuries and enter into the presence of Jesus. In their characters we see ourselves—for better or worse. Through them the living Lord continues to speak personally, powerfully, to those who would draw near to meet him.

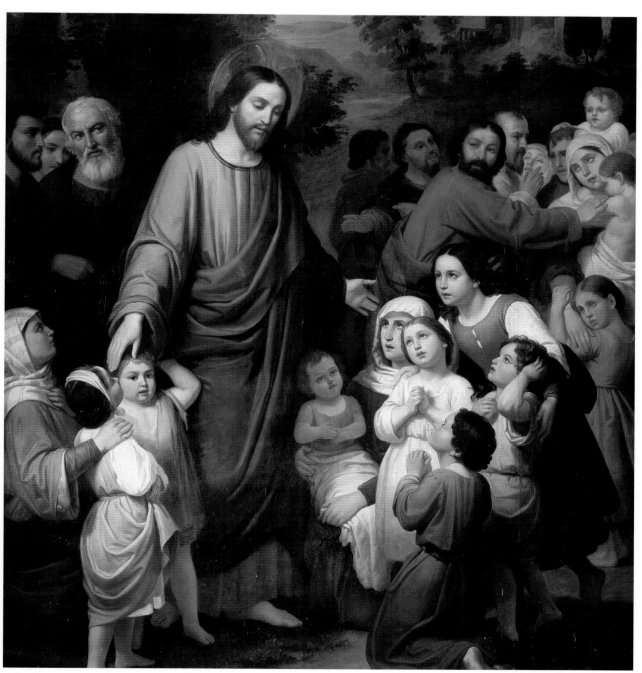

Suffer the Little Children to Come unto Me, 1854, by Juan Urruchi, 1828–92

LIFE of JESUS

The Birth of Jesus

The Birth of Jesus

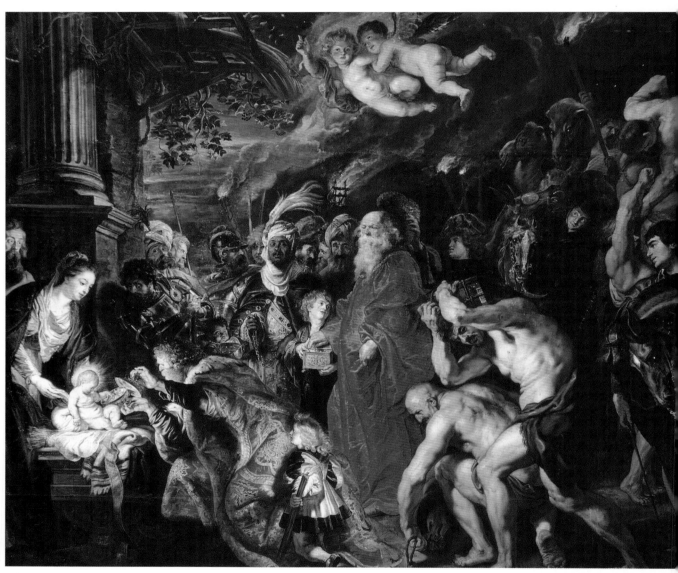

Adoration of the Magi, 1610, by Sir Peter Paul Rubens, 1577–1640

AFTER DISCOVERING THAT SHE IS PREGNANT, Mary and her new husband, Joseph, travel to Bethlehem for a census and to pay a tax. Finding nowhere to stay, they meet an innkeeper who offers them his stable. It is there in the modest stable, among the animals, that Mary gives birth to Jesus. The star of Bethlehem shines brightly in the sky, leading three wise men from the far east to the stable so that they may celebrate the birth of Christ.

JESUS' STORY: THE BEGINNINGS

Every story needs a beginning—a place at which the storyteller meets the reader(s) and reveals important clues about (1) why the story is worth hearing, (2) what the reader(s) can expect to learn by entering the story world, and—perhaps most important, (3) where the storyteller stands in relation to the story, i.e., does he view it from outside as an impartial observer, or from inside as one of its characters? Mark comes right to the point: "The beginning of the gospel of Jesus Christ, the Son of God." His story is "good news" (Old English "godspell") about Jesus, whom Mark calls Christ (in Greek "Anointed One," in Hebrew "Messiah") and Son of God. Matthew begins by tracing the "generation" (Greek "genesis") of Jesus back to David, Israel's most beloved king, and to Abraham, father of God's covenant people. In classical Greek style, Luke addresses his story to Theophilus ("God's friend" in Greek), "in order" about "those things which are most surely believed among us." With cosmic strokes John roots Jesus' story in the very creative energy of God, whose "Word" made all things—and "dwelt among us . . . full of grace and truth."

The Christ, by Bida, 1813–1895

MATTHEW 1:1

1 The book of the generation of Jesus Christ, the son of David, the son of Abraham.

MARK 1:1

1 The beginning of the gospel of Jesus Christ, the Son of God;

LUKE 1:1–4

1 Forasmuch as many have taken in hand to set forth in order a declaration of those things which are most surely believed among us,

2 Even as they delivered them unto us, which from the beginning were eyewitnesses, and ministers of the word;

3 It seemed good to me also, having had perfect understanding of all things from the very first, to write unto thee in order, most excellent Theophilus,

4 That thou mightest know the certainty of those things, wherein thou hast been instructed.

JOHN 1:1–18

1 In the beginning was the Word, and the Word was with God, and the Word was God.

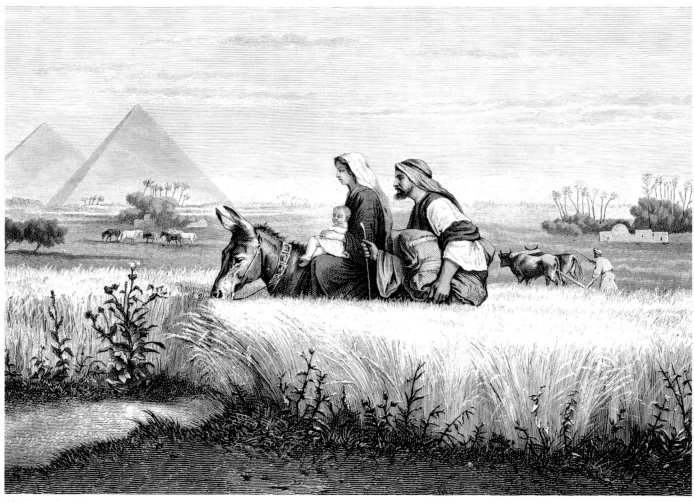

The Return from Egypt, by Alexander Bida, 1813–1895

the Word was with God, and the Word was God.

Which were born, not of blood, nor of the will of the flesh, nor of the will of man, but of God.

And the Word was made flesh, and dwelt among us, (and we beheld his glory, the glory as of the only begotten of the Father,) full of grace and truth.

—JOHN 1:13–14

2 The same was in the beginning with God.

3 All things were made by him; and without him was not any thing made that was made.

4 In him was life; and the life was the light of men.

5 And the light shineth in darkness; and the darkness comprehended it not.

6 There was a man sent from God, whose name was John.

8 He was not that Light, but was sent to bear witness of that Light.

9 That was the true Light, which lighteth every man that cometh into the world.

10 He was in the world, and the world was made by him, and the world knew him not.

11 He came unto his own, and his own received him not.

12 But as many as received him, to them gave he power to become the sons of God, even to them that believe on his name:

13 Which were born, not of blood, nor of the will of the flesh, nor of the will of man, but of God.

14 And the Word was made flesh, and dwelt among us, (and we beheld his glory, the glory as of the only begotten of the Father,) full of grace and truth.

15 John bare witness of him, and cried, saying, This was he of whom I spake, He that cometh after me is preferred before me: for he was before me.

16 And of his fulness have all we received, and grace for grace.

17 For the law was given by Moses, but grace and truth came by Jesus Christ.

18 No man hath seen God at any time; the only begotten Son, which is in the bosom of the Father, he hath declared him.

THE FAMILY TREE OF JESUS

Matthew details Jesus' ancestry, generation by generation, in three segments: from Abraham to David, from David until "they were carried away into Babylon," and from exile to the birth of Jesus. Each segment spans fourteen generations. David is a focal point—the letters in his Hebrew name, dwd, when read as numbers, total fourteen (4+6+4=14)—for to David was given the promise that his son would rule over God's people forever (II Samuel 7:16). The five women named in the listing are themselves non-Israelites or (in the case of David's wife) were previously married to non-Israelites—a reminder of God's promise to Abraham in Genesis 12:3: "in thee shall all the families of earth be blessed." Luke makes the same point in his version of Jesus' family tree which extends from Jesus, "being (as was supposed) the son of Joseph" back to Adam "which was the son of God."

Retable of the Genealogy of Jesus, 18th century, Studio of the Sierra Castiglia

tree which extends from Jesus, "being (as was supposed) the son of Joseph" back to Adam "which was the son of God."

MATTHEW 1:2–17

2 Abraham begat Isaac; and Isaac begat Jacob; and Jacob begat Judas and his brethren;

3 And Judas begat Phares and Zara of Thamar; and Phares begat Esrom; and Esrom begat Aram;

4 And Aram begat Aminadab; and Aminadab begat Naasson; and Naasson begat Salmon;

5 And Salmon begat Booz of Rachab; and Booz begat Obed of Ruth; and Obed begat Jesse;

6 And Jesse begat David the king; and David the king begat Solomon of her that had been the wife of Urias;

7 And Solomon begat Roboam; and Roboam begat Abia; and Abia begat Asa;

8 And Asa begat Josaphat; and Josaphat begat Joram; and Joram begat Ozias;

9 And Ozias begat Joatham; and Joatham begat Achaz; and Achaz begat Ezekias;

10 And Ezekias begat Manasses; and Manasses begat Amon; and Amon begat Josias;

11 And Josias begat Jechonias and his brethren, about the time they were carried away to Babylon:

12 And after they were brought to Babylon, Jechonias begat Salathiel; and Salathiel begat Zorobabel;

13 And Zorobabel begat Abiud; and Abiud begat Eliakim; and Eliakim begat Azor;

14 And Azor begat Sadoc; and Sadoc begat Achim; and Achim begat Eliud;

15 And Eliud begat Eleazar; and Eleazar begat Matthan; and Matthan begat Jacob;

16 And Jacob begat Joseph the husband of Mary, of whom was born Jesus, who is called Christ.

17 So all the generations from Abraham to David are fourteen generations; and from David until the carrying away into Babylon are fourteen generations; and from the carrying away into Babylon unto Christ are fourteen generations.

LUKE 3:23–38

23 And Jesus himself began to be about thirty years of age, being (as was supposed) the son of Joseph, which was the son of Heli,

24 Which was the son of Matthat, which was the son of Levi, which was the son of Melchi, which was the son of Janna, which was the son of Joseph,

25 Which was the son of Mattathias, which was the son of Amos, which was the son of Naum, which was the son of Esli, which was the son of Nagge,

26 Which was the son of Maath, which was the son of Mattathias, which was the son of Semei, which was the son of Joseph, which was the son of Juda,

27 Which was the son of Joanna, which was the son of Rhesa, which was the son of Zorobabel, which was the son of Salathiel, which was the son of Neri,

28 Which was the son of Melchi, which was the son of Addi, which was the son of Cosam, which was the son of

Elmodam, which was the son of Er,

29 Which was the son of Jose, which was the son of Eliezer, which was the son of Jorim, which was the son of Matthat, which was the son of Levi,

30 Which was the son of Simeon, which was the son of Juda, which was the son of Joseph, which was the son of Jonan, which was the son of Eliakim,

31 Which was the son of Melea, which was the son of Menan, which was the son of Mattatha, which was the son of Nathan, which was the son of David,

32 Which was the son of Jesse, which was the son of Obed, which was the son of Booz, which was the son of Salmon, which was the son of Naasson,

33 Which was the son of Aminadab, which was the son of Aram, which was the son of Esrom, which was the son of Phares, which was the son of Juda,

34 Which was the son of Jacob, which was the son of Isaac, which was the son of Abraham, which was the son of Thara, which was the son of Nachor,

35 Which was the son of Saruch, which was the son of Ragau, which was the son of Phalec, which was the son of Heber, which was the son of Sala,

36 Which was the son of Cainan, which was the son of Arphaxad, which was the son of Sem, which was the son of Noe, which was the son of Lamech,

37 Which was the son of Mathusala, which was the son of Enoch, which was the son of Jared, which was the son of Maleleel, which was the son of Cainan,

38 Which was the son of Enos, which

*And she shall bring
forth a son, and thou
shalt call his name
JESUS: for he shall
save his people from
their sins.*

—MATTHEW 1:21

THE ANNUNCIATION AND VISITATION

Both Matthew and Luke tell of Jesus' birth in Bethlehem, David's city, to Mary and Joseph, her husband-to-be. In both stories, angels take the lead delivering messages and orchestrating events—so that they take place in ways that fit the pattern of the prophetic scriptures. In Matthew, Joseph takes center stage: "a just man," who, when he finds that Mary was "with child," though he has not had marital relations with her, resolves "not to make her a publick example." And it is to him that the angel makes the annunciation of this child, his conception, the name he is to be called—Jesus (in Hebrew *Yehoshua*, "the Lord saves")—and the child's mission. In Luke, Mary is the "star": to her the angel appears and gives the instructions about the child's conception, naming, and destiny. Luke frames the events of Jesus' annunciation and birth with a parallel account of the annunciation, birth, naming, and destiny of John the Baptist, whose mother is Mary's kinswoman.

MATTHEW 1:18–25

18 Now the birth of Jesus Christ was on this wise: When as his mother Mary was espoused to Joseph, before they came together, she was found with child of the Holy Ghost.

19 Then Joseph her husband, being a just man, and not willing to make her a publick example, was minded to put her away privily.

20 But while he thought on these things, behold, the angel of the Lord appeared unto him in a dream, saying, Joseph, thou son of David, fear not to take unto thee Mary thy wife: for that which is conceived in her is of the Holy Ghost.

21 And she shall bring forth a son, and thou shalt call his name JESUS: for he shall save his people from their sins.

22 Now all this was done, that it might be fulfilled which was spoken of the Lord by the prophet, saying,

23 Behold, a virgin shall be with child, and shall bring forth a son, and they shall call his name Emmanuel, which being interpreted is, God with us.

24 Then Joseph being raised from sleep did as the angel of the Lord had bidden him, and took unto him his wife:

25 And knew her not till she had brought forth her firstborn son: and he called his name JESUS.

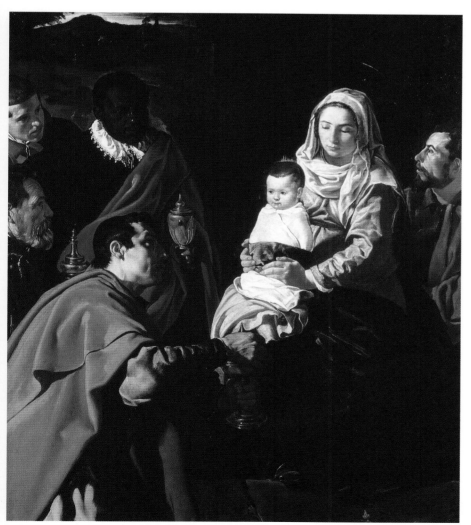

Adoration of the Magi, 1619, by Diego Velazquez, 1599–1660

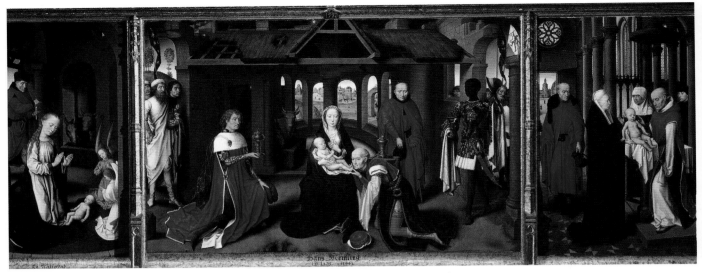

The Nativity, Adoration of the Magi and Presentation in Temple, by Hans Memling, 1425/40–94

21 And she shall bring forth a son, and thou shalt call his name JESUS: for he shall save his people from their sins.

22 Now all this was done, that it might be fulfilled which was spoken of the Lord by the prophet, saying,

23 Behold, a virgin shall be with child, and shall bring forth a son, and they shall call his name Emmanuel, which being interpreted is, God with us.

24 Then Joseph being raised from sleep did as the angel of the Lord had bidden him, and took unto him his wife:

25 And knew her not till she had brought forth her firstborn son: and he called his name JESUS.

LUKE 1:5–2:7

5 There was in the days of Herod, the king of Judaea, a certain priest named Zacharias, of the course of Abia: and his wife was of the daughters of Aaron, and her name was Elisabeth.

6 And they were both righteous before God, walking in all the commandments and ordinances of the Lord blameless.

7 And they had no child, because that Elisabeth was barren, and they both were now well stricken in years.

8 And it came to pass, that while he executed the priest's office before God in the order of his course,

9 According to the custom of the priest's office, his lot was to burn incense when he went into the temple of the Lord.

10 And the whole multitude of the people were praying without at the time of incense.

11 And there appeared unto him an angel of the Lord standing on the right side of the altar of incense.

12 And when Zacharias saw him, he was troubled, and fear fell upon him.

13 But the angel said unto him, Fear not, Zacharias: for thy prayer is heard; and thy wife Elisabeth shall bear thee a son, and thou shalt call his name John.

14 And thou shalt have joy and gladness; and many shall rejoice at his birth.

15 For he shall be great in the sight of the Lord, and shall drink neither wine nor strong drink; and he shall be filled with the Holy Ghost, even from his mother's womb.

16 And many of the children of Israel shall he turn to the Lord their God.

17 And he shall go before him in the spirit and power of Elias, to turn the hearts of the fathers to the children, and the disobedient to the wisdom of the just; to make ready a people prepared for the Lord.

18 And Zacharias said unto the angel, Whereby shall I know this? for I am an old man, and my wife well stricken in years.

19 And the angel answering said unto him, I am Gabriel, that stand in the presence of God; and am sent to speak unto thee, and to shew thee these glad tidings.

20 And, behold, thou shalt be dumb, and not able to speak, until the day that these things shall be performed, because thou believest not my words, which shall be fulfilled in their season.

21 And the people waited for Zacharias,

26 And in the sixth month the angel Gabriel was sent from God unto a city of Galilee, named Nazareth,

27 To a virgin espoused to a man whose name was Joseph, of the house of David; and the virgin's name was Mary.

28 And the angel came in unto her, and said, Hail, thou that art highly favoured, the Lord is with thee: blessed art thou among women.

29 And when she saw him, she was troubled at his saying, and cast in her mind what manner of salutation this should be.

30 And the angel said unto her, Fear not, Mary: for thou hast found favour with God.

31 And, behold, thou shalt conceive in thy womb, and bring forth a son, and shalt call his name JESUS.

32 He shall be great, and shall be called the Son of the Highest: and the Lord God shall give unto him the throne of his father David:

33 And he shall reign over the house of Jacob for ever; and of his kingdom there shall be no end.

34 Then said Mary unto the angel, How shall this be, seeing I know not a man?

35 And the angel answered and said unto her, The Holy Ghost shall come upon thee, and the power of the Highest shall overshadow thee: therefore also that holy thing which shall be born of thee shall be called the Son of God.

36 And, behold, thy cousin Elisabeth, she hath also conceived a son in her old age: and this is the sixth month with her, who was called barren.

37 For with God nothing shall be impossible.

38 And Mary said, Behold the hand-maid of the Lord; be it unto me according to thy word. And the angel departed from her.

39 And Mary arose in those days, and went into the hill country with haste, into a city of Juda;

40 And entered into the house of Zacharias, and saluted Elisabeth.

41 And it came to pass, that, when Elisabeth heard the salutation of Mary, the babe leaped in her womb; and Elisabeth was filled with the Holy Ghost:

42 And she spake out with a loud voice, and said, Blessed art thou among women, and blessed is the fruit of thy womb.

43 And whence is this to me, that the mother of my Lord should come to me?

44 For, lo, as soon as the voice of thy salutation sounded in mine ears, the babe leaped in my womb for joy.

45 And blessed is she that believed: for there shall be a performance of those things which were told her from the Lord.

46 And Mary said, My soul doth mag-nify the Lord,

47 And my spirit hath rejoiced in God my Saviour.

48 For he hath regarded the low estate of his handmaiden: for, behold, from henceforth all generations shall call me blessed.

49 For he that is mighty hath done to me great things; and holy is his name.

50 And his mercy is on them that fear him from generation to generation.

51 He hath shewed strength with his arm; he hath scattered the proud in the imagination of their hearts.

52 He hath put down the mighty from their seats, and exalted them of low degree.

53 He hath filled the hungry with good things; and the rich he hath sent empty away.

54 He hath holpen his servant Israel, in remembrance of his mercy;

55 As he spake to our fathers, to Abraham, and to his seed for ever.

56 And Mary abode with her about three months, and returned to her own house.

57 Now Elisabeth's full time came that she should be delivered; and she brought forth a son.

58 And her neighbours and her cousins heard how the Lord had shewed great mercy upon her; and they rejoiced with her.

59 And it came to pass, that on the eighth day they came to circumcise the child; and they called him Zacharias, after the name of his father.

60 And his mother answered and said, Not so; but he shall be called John.

61 And they said unto her, There is none of thy kindred that is called by this name.

62 And they made signs to his father, how he would have him called.

63 And he asked for a writing table, and wrote, saying, His name is John. And they marvelled all.

64 And his mouth was opened immedi-ately, and his tongue loosed, and he spake, and praised God.

59 And it came to pass, that on the eighth day they came to circumcise the child; and they called him Zacharias, after the name of his father.

60 And his mother answered and said, Not so; but he shall be called John.

61 And they said unto her, There is none of thy kindred that is called by this name.

62 And they made signs to his father, how he would have him called.

63 And he asked for a writing table, and wrote, saying, His name is John. And they marvelled all.

64 And his mouth was opened immediately, and his tongue loosed, and he spake, and praised God.

65 And fear came on all that dwelt round about them: and all these sayings were noised abroad throughout all the hill country of Judaea.

66 And all they that heard them laid them up in their hearts, saying, What manner of child shall this be! And the hand of the Lord was with him.

67 And his father Zacharias was filled with the Holy Ghost, and prophesied, saying,

And thou, child, shalt be called the prophet of the Highest: for thou shalt go before the face of the Lord to prepare his ways.

—LUKE 1:76

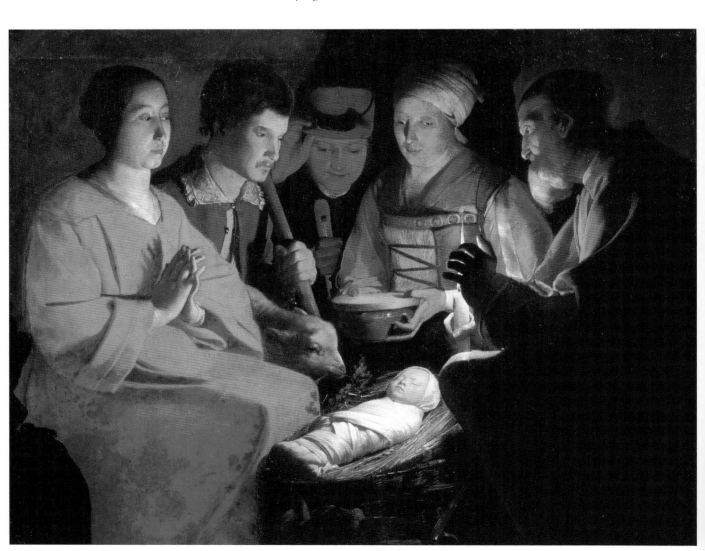

The Adoration of the Shepherds, by Georges de La Tour, 1593–1652

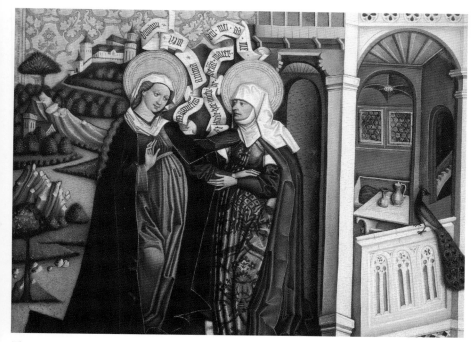

The Visitation, 1480, by the Hungarian School

74 That he would grant unto us, that we being delivered out of the hand of our enemies might serve him without fear,

75 In holiness and righteousness before him, all the days of our life.

76 And thou, child, shalt be called the prophet of the Highest: for thou shalt go before the face of the Lord to prepare his ways;

77 To give knowledge of salvation unto his people by the remission of their sins,

78 Through the tender mercy of our God; whereby the dayspring from on high hath visited us,

79 To give light to them that sit in darkness and in the shadow of death, to guide our feet into the way of peace.

80 And the child grew, and waxed strong in spirit, and was in the deserts till the day of his shewing unto Israel.

THE BIRTH OF JESUS

Luke—anticipating the worldwide destination of this story—mentions Augustus, the Roman emperor, famous for bringing the Pax Romana (the time of worldwide peace), and Cyrenius, the Governor of Syria whose census brought Joseph and Mary to Beth-lehem from Nazareth (and caused a rebellion among Syrians). From his birth Jesus is pictured, not as a revolutionary, but as the child of a peaceable, law abiding family. Like a Broadway musical, Luke's well beloved Christmas story frequently breaks into joyful singing—many of its songs continue to be sung in every language in the liturgies of the Christian community. Interestingly, John's story, whose cosmic prologue takes the place of a birth account, contains a piece where those who raise questions about Jesus note that he comes from Galilee: "Shall Christ come out of Galilee? Hath not the scripture said, that Christ cometh of the seed of David, and out Of the town of Bethlehem, where David was?" Both Luke (as mentioned

above) and Matthew (as the story continues) explain how Jesus of Nazareth came to be born in Bethlehem.

LUKE 2:1–7

1 And it came to pass in those days, that there went out a decree from Caesar Augustus, that all the world should be taxed.

2 (And this taxing was first made when Cyrenius was governor of Syria.)

3 And all went to be taxed, every one into his own city.

4 And Joseph also went up from Galilee, out of the city of Nazareth, into Judaea, unto the city of David, which is called Bethlehem; (because he was of the house and lineage of David:)

5 To be taxed with Mary his espoused wife, being great with child.

6 And so it was, that, while they were there, the days were accomplished that she should be delivered.

Now when Jesus was born in Bethlehem of Judaea in the days of Herod the king, behold, there came wise men from the east to Jerusalem.

—MATTHEW 2:1

Caesar Augustus, that all the world should be taxed.

2 (And this taxing was first made when Cyrenius was governor of Syria.)

3 And all went to be taxed, every one into his own city.

4 And Joseph also went up from Galilee, out of the city of Nazareth, into Judaea, unto the city of David, which is called Bethlehem; (because he was of the house and lineage of David:)

5 To be taxed with Mary his espoused wife, being great with child.

6 And so it was, that, while they were there, the days were accomplished that she should be delivered.

7 And she brought forth her firstborn son, and wrapped him in swaddling clothes, and laid him in a manger; because there was no room for them in the inn.

And she brought forth her firstborn son, and wrapped him in swaddling clothes, and laid him in a manger; because there was no room for them in the inn.

—LUKE 2:7

JOHN 7:41–42

41 Others said, This is the Christ. But some said, Shall Christ come out of Galilee?

42 Hath not the scripture said, That Christ cometh of the seed of David, and out of the town of Bethlehem, where David was?

THE ADORATION OF THE INFANT JESUS

The birth stories in Matthew and Luke are portraits that present—in miniature—the themes that interplay in the gospel stories that follow them. As in the gospels as a whole, there will be some people who come to see Jesus, receive him, bow down in adoration, and come to follow him, while others reject or even persecute him. In Matthew, the "wise men from the East" see his rising "star" and by it are led to Jerusalem—and from there to Bethlehem—to worship the one "born King of the Jews," and offer their treasures (as miniatures of the "nations" that will come bringing their wealth—including gold and frankincense in the prophecy of Isaiah 60: 1-6). In Luke it is the shepherds who hear the angels' songs of praise, the "good tidings of great joy" and follow their instructions to the stable, where—just as the angels said—they find the babe "wrapped in swaddling clothes, lying in a manger." Common to both stories is the reaction of those who seek and find the child: the wise men, who "rejoiced with exceeding great joy," and the shepherds, who "returned, glorifying and praising God for all the things they had heard and seen."

MATTHEW 2:1–12

1 Now when Jesus was born in Bethlehem of Judaea in the days of Herod the king, behold, there came wise men from the east to Jerusalem,

2 Saying, Where is he that is born King of the Jews? for we have seen his star in the east, and are come to worship him.

3 When Herod the king had heard these things, he was troubled, and all Jerusalem with him.

4 And when he had gathered all the chief priests and scribes of the people together, he demanded of them where Christ should be born.

5 And they said unto him, In Bethlehem of Judaea: for thus it is written by the prophet,

6 And thou Bethlehem, in the land of Juda, art not the least among the princes of Juda: for out of thee shall come a Governor, that shall rule my people Israel.

7 Then Herod, when he had privily called the wise men, inquired of them diligently what time the star appeared.

8 And he sent them to Bethlehem, and said, Go and search diligently for the young child; and when ye have found him, bring me word again, that I may come and worship him also.

9 When they had heard the king, they departed; and, lo, the star, which they saw in the east, went before them, till it came and stood over where the young child was.

10 When they saw the star, they rejoiced with exceeding great joy.

11 And when they were come into the house, they saw the young child with Mary his mother, and fell down, and worshipped him: and when they had opened their treasures, they presented unto him gifts; gold, and frankincense, and myrrh.

12 And being warned of God in a

12 And this shall be a sign unto you; Ye shall find the babe wrapped in swaddling clothes, lying in a manger.

13 And suddenly there was with the angel a multitude of the heavenly host praising God, and saying,

14 Glory to God in the highest, and on earth peace, good will toward men.

15 And it came to pass, as the angels were gone away from them into heaven, the shepherds said one to another, Let us now go even unto Bethlehem, and see this thing which is come to pass, which the Lord hath made known unto us.

16 And they came with haste, and found Mary, and Joseph, and the babe lying in a manger.

17 And when they had seen it, they made known abroad the saying which was told them concerning this child.

18 And all they that heard it wondered at those things which were told them by the shepherds.

19 But Mary kept all these things, and pondered them in her heart.

20 And the shepherds returned, glorifying and praising God for all the things that they had heard and seen, as it was told unto them.

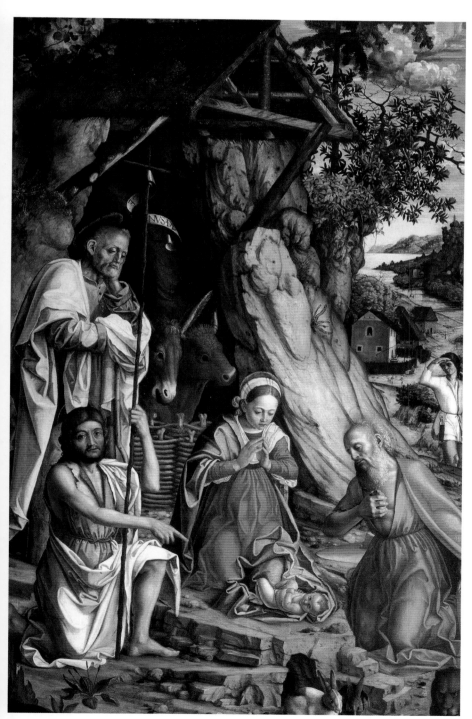

The Nativity with Rabbits, Mark and Saint John the Baptist, by Girolamo dai Libri, 1474–1555

For unto you is born this day in the city of David a Saviour, which is Christ the Lord.

And this shall be a sign unto you; Ye shall find the babe wrapped in swaddling clothes, lying in a manger.

—LUKE 2:11–12

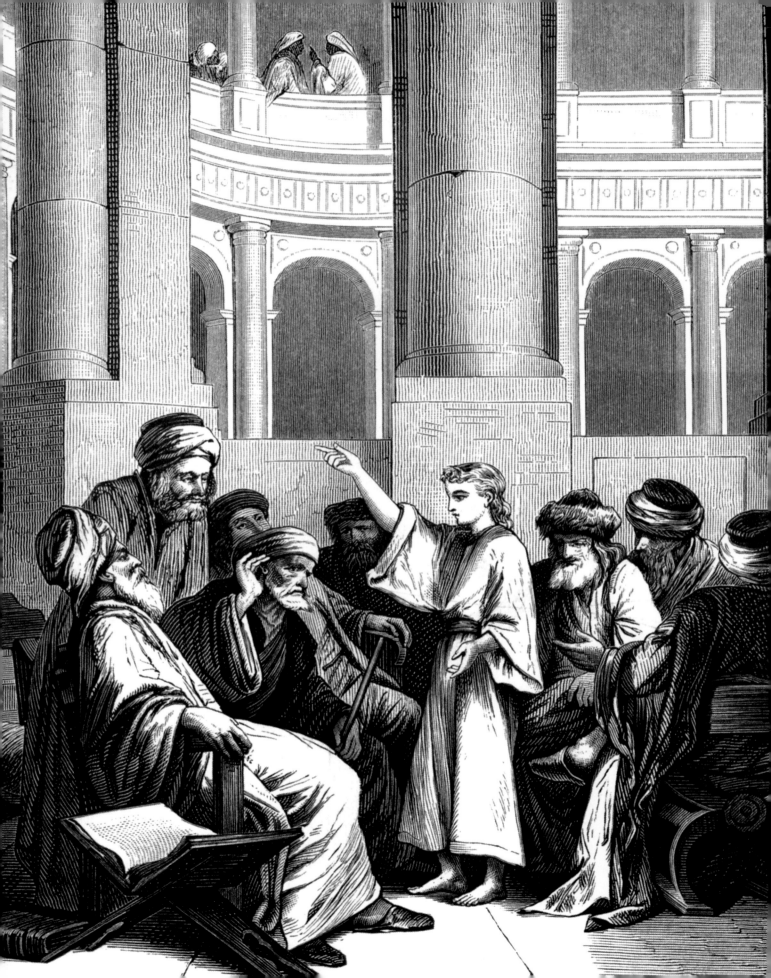

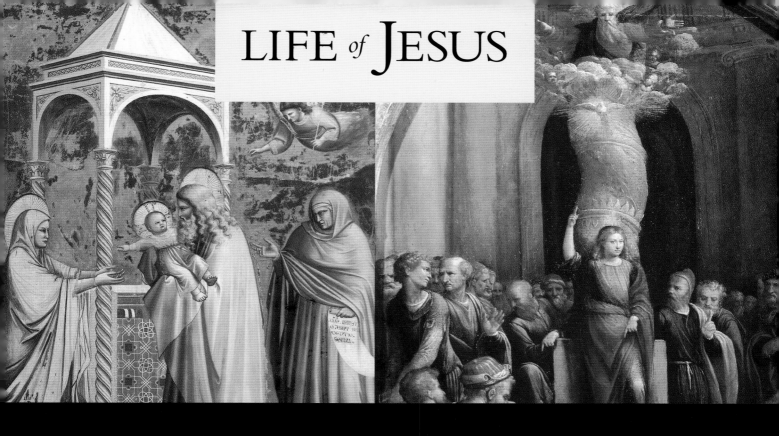

LIFE *of* JESUS

The Early Life of Jesus

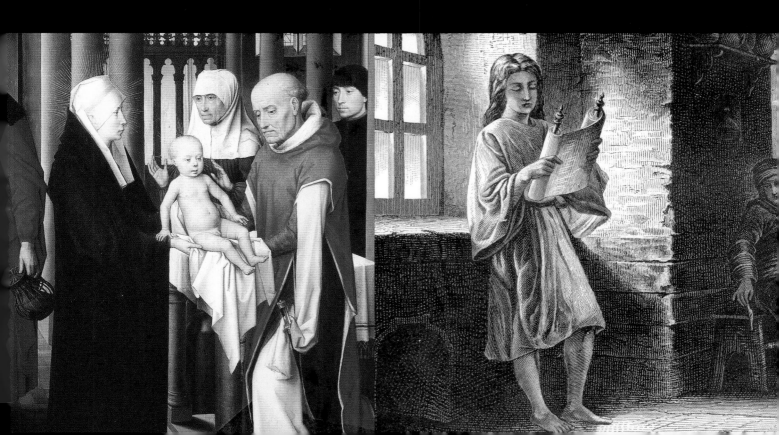

The Early Life of Jesus

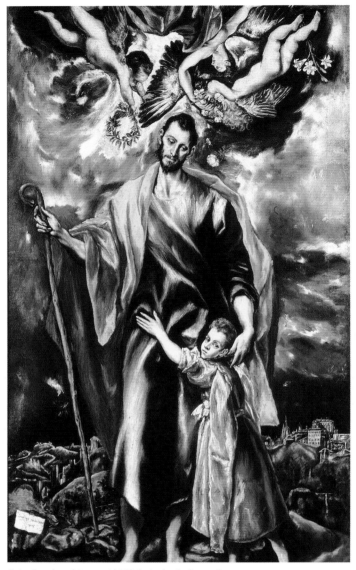

Saint Joseph and Jesus, with Toledo in the Background, 1597–99, El Greco, 1540-1614

THE FOUR CANONICAL GOSPELS (the ones the Church came to accept as authoritative for its teaching) have little to say about the time between Jesus' birth and the beginning of his public ministry at the age of thirty. Curiosity about the "lost years of Jesus" gave rise to many legends and, from the late second century onwards, written "gospels" that filled in the missing time with many interesting connections. These tales amplify the stories of Matthew and Luke, whose accounts remind us of the two reactions to Jesus which will recur throughout his ministry: acceptance and worship, or rejection and persecution.

THE ESCAPE INTO EGYPT AND RETURN

After the wise men depart, an angel appears once again to Joseph in a dream, warning him of King Herod's intention to destroy the child Jesus. Joseph takes the child and his mother and flees to Egypt by night, seeking refuge there. Matthew sees in this event the words of the prophet Hosea coming to a new fulfillment: "Out of Egypt have I called my son." The prophet looks backward to the time when God used another dreamer named Joseph to preserve his father Jacob and family, by bringing them to Egypt. Some time later another angry King sought to destroy the children of Israel—but one was spared—Moses, destined to be the one by whom God calls Israel, his son out of Egypt. Matthew sees notes the fulfillment of several prophetic words in the events that bring the family of Jesus back to Israel, and specifically back to Galilee. It seems once again that events men intended for evil, God used for good.

MATTHEW 2:13–23

13 And when they were departed, behold, the angel of the Lord appeareth to Joseph in a dream, saying, Arise, and take the young child and his mother, and flee into Egypt, and be thou there until I bring thee word: for Herod will seek the young child to destroy him.

14 When he arose, he took the young child and his mother by night, and departed into Egypt:

15 And was there until the death of Herod: that it might be fulfilled which was spoken of the Lord by the prophet, saying, Out of Egypt have I called my son.

The Child Jesus, by Alexander Bida, 1813–1895

And he came and dwelt in a city called Nazareth: that it might be fulfilled which was spoken by the prophets, He shall be called a Nazarene.

—MATTHEW 2:23

16 Then Herod, when he saw that he was mocked of the wise men, was exceeding wroth, and sent forth, and slew all the children that were in Bethlehem, and in all the coasts thereof, from two years old and under, according to the time which he had diligently enquired of the wise men.

17 Then was fulfilled that which was spoken by Jeremy the prophet, saying,

18 In Rama was there a voice heard, lamentation, and weeping, and great mourning, Rachel weeping for her children, and would not be comforted, because they are not.

19 But when Herod was dead, behold, an angel of the Lord appeareth in a dream to Joseph in Egypt,

20 Saying, Arise, and take the young child and his mother, and go into the land of Israel: for they are dead which sought the young child's life.

21 And he arose, and took the young child and his mother, and came into the land of Israel.

22 But when he heard that Archelaus did reign in Judaea in the room of his father Herod, he was afraid to go thither: notwithstanding, being warned of God in a dream, he turned aside into the parts of Galilee:

23 And he came and dwelt in a city called Nazareth: that it might be fulfilled which was spoken by the prophets, He shall be called a Nazarene.

THE PRESENTATION IN THE TEMPLE

As the shepherds take leave of Jesus and his parents, Luke shows us how Mary and Joseph fulfill the requirements of God's law and the instructions of the angel Gabriel. The child is circumcised on the eighth day and given the name Jesus. Their observance brings them to the Temple, on the day of Mary's purification, the fortieth day after Jesus' birth, where they present their first-born to the LORD, bringing the offering required of the poor, two turtledoves or young pigeons. While there, they are met by the aged Simeon and Anna, two who long have looked to see the redemption of God's people. Led to the Temple by the Spirit, Simeon takes the babe in his arms and sings yet another song of praise, "Lord, now lettest thou thy servant depart in peace" Simeon blesses them and speaks a prophecy to Mary, about her child's destiny—to be "a light to lighten the Gentiles and the glory of thy people Israel." Those who receive him will become a community spanning all nations, men and women of all ages. Yet, he will be a sign spoken against: "Yea, a sword shall pierce through thine own soul also."

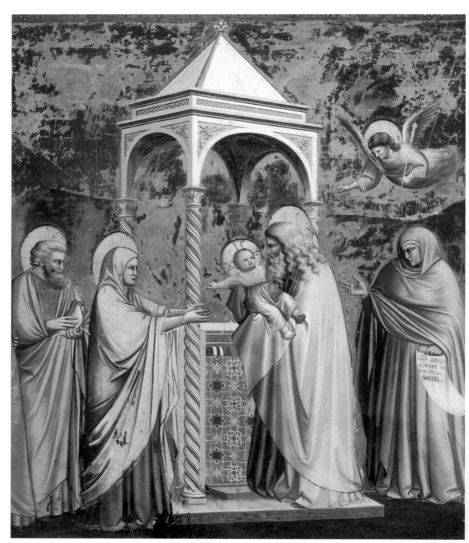

Presentation of Jesus in the Temple, by Giotto Di Bondone, 1276–1337

LUKE 2:21–40

21 And when eight days were accomplished for the circumcising of the child, his name was called JESUS, which was so named of the angel before he was conceived in the womb.

22 And when the days of her purification according to the law of Moses were accomplished, they brought him to Jerusalem, to present him to the Lord;

23 (As it is written in the law of the Lord, Every male that openeth the womb shall be called holy to the Lord;)

24 And to offer a sacrifice according to that which is said in the law of the Lord, A pair of turtledoves, or two young pigeons.

25 And, behold, there was a man in Jerusalem, whose name was Simeon; and the same man was just and devout, waiting for the consolation of Israel: and the Holy Ghost was upon him.

26 And it was revealed unto him by the Holy Ghost, that he should not see death, before he had seen the Lord's Christ.

27 And he came by the Spirit into the temple: and when the parents brought in the child Jesus, to do for him after the custom of the law,

28 Then took he him up in his arms, and blessed God, and said,

29 Lord, now lettest thou thy servant depart in peace, according to thy word:

30 For mine eyes have seen thy salvation,

31 Which thou hast prepared before the face of all people;

32 A light to lighten the Gentiles, and the glory of thy people Israel.

33 And Joseph and his mother marvelled at those things which were spoken of him.

34 And Simeon blessed them, and said unto Mary his mother, Behold, this child is set for the fall and rising again of many in Israel; and for a sign which shall be spoken against;

35 (Yea, a sword shall pierce through thy own soul also,) that the thoughts of many hearts may be revealed.

36 And there was one Anna, a prophetess, the daughter of Phanuel, of the tribe of Aser: she was of a great age, and had lived with an husband seven years from her virginity.

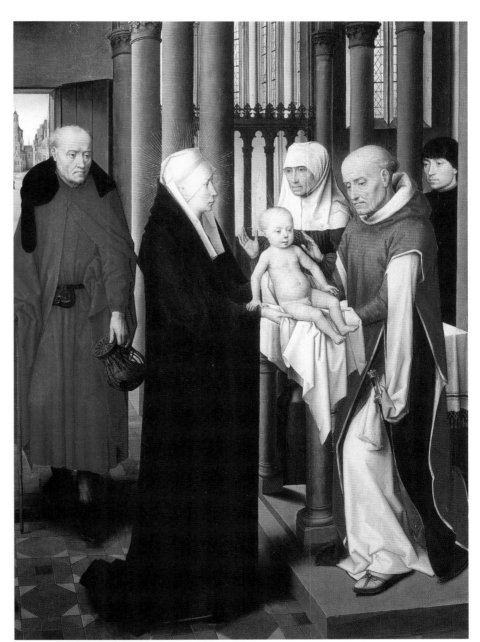

Christ's Presentation in the Temple, 1463, by Hans Memling, 1425/40–94

37 And she was a widow of about fourscore and four years, which departed not from the temple, but served God with fastings and prayers night and day.

38 And she coming in that instant gave thanks likewise unto the Lord, and spake of him to all them that looked for redemption in Jerusalem.

39 And when they had performed all things according to the law of the Lord, they returned into Galilee, to their own city Nazareth.

40 And the child grew, and waxed strong in spirit, filled with wisdom: and the grace of God was upon him.

TWELVE–YEAR–OLD JESUS IN THE TEMPLE

In the last scene of Jesus' early life, Luke shows Jesus once again in the Temple—a central Lukan theme. Jesus and his parents have come to Jerusalem for the feast—as he will once more in this story. Even as a child, Jesus is fulfilling his mission: "I must be about my Father's business." His mother "kept all these things in her heart." Mary is the only person from the infancy stories who continues to appear in Jesus' ministry. Luke presents her as the first believer, as her kinswoman Elizabeth notes in the first chapter: "Blessed is she that believed…those things which were told her from the Lord." In Luke's second volume, the Acts of the Apostles, she will be present in the community of the risen Jesus' disciples.

LUKE 2:41–52

41 Now his parents went to Jerusalem every year at the feast of the passover.

42 And when he was twelve years old, they went up to Jerusalem after the custom of the feast.

43 And when they had fulfilled the days, as they returned, the child Jesus tarried behind in Jerusalem; and Joseph and his mother knew not of it.

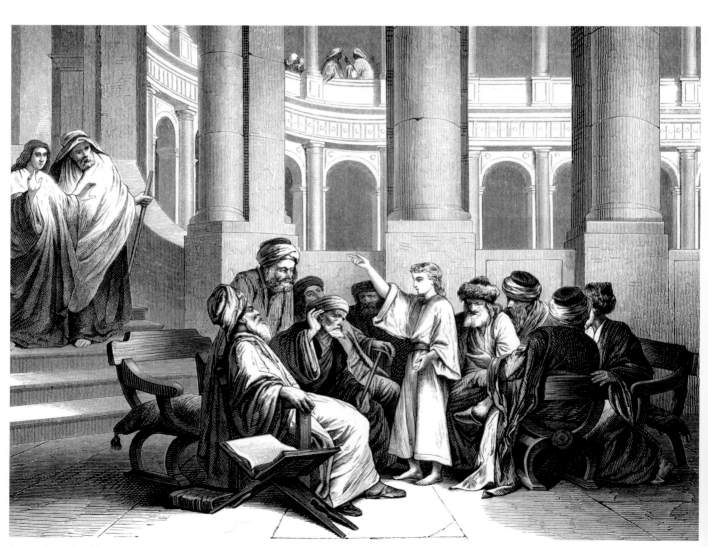

Jesus in the Midst of the Doctors, by Alexander Bida, 1813–1895

44 But they, supposing him to have been in the company, went a day's journey; and they sought him among their kinsfolk and acquaintance.

45 And when they found him not, they turned back again to Jerusalem, seeking him.

46 And it came to pass, that after three days they found him in the temple, sitting in the midst of the doctors, both hearing them, and asking them questions.

47 And all that heard him were astonished at his understanding and answers.

48 And when they saw him, they were amazed: and his mother said unto him, Son, why hast thou thus dealt with us? behold, thy father and I have sought thee sorrowing.

49 And he said unto them, How is it that ye sought me? wist ye not that I must be about my Father's business?

50 And they understood not the saying which he spake unto them.

51 And he went down with them, and came to Nazareth, and was subject unto them: but his mother kept all these sayings in her heart.

52 And Jesus increased in wisdom and stature, and in favour with God and man.

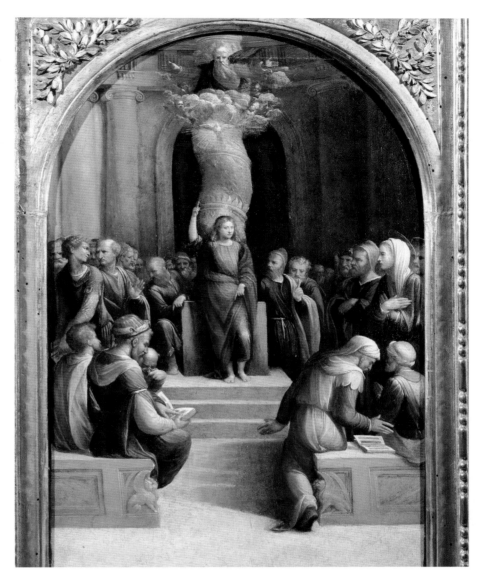

Jesus at the Temple Among the Doctors, by Benvenuto Tisi or Garofalo, 1481–1559

And he said unto them, How is it that ye sought me? wist ye not that I must be about my Father's business?

And they understood not the saying which he spake unto them.

—LUKE 2:49–50

LIFE of JESUS

The Ministry of John the Baptist

The Ministry of John the Baptist

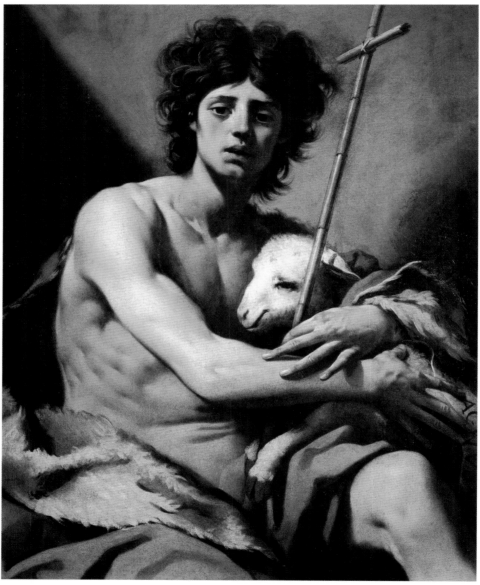

Saint John the Baptist, by Luca Ferrari, 1671-1753

IN ALL FOUR GOSPELS, THE "GOOD NEWS" BEGINS with John the Baptist, whom they portray as "the voice of one crying in the wilderness, Prepare ye the way of the Lord, make his paths straight" (Isaiah 40:3). The baptism of repentance was an outward sign of an inward change of attitude—in preparation for the coming of God's Kingdom. All four gospels mention Jesus' coming to John, his being baptized, and the Spirit of God descending upon him.

JOHN THE BAPTIST'S MESSAGE AND MISSION

Mark and Matthew describe John the Baptist as being dressed in a shirt of camels' hair and a leather belt—the outfit the prophet Elijah wears in 2 Kings 1:8. The prophet Malachi (chapter 4, verses 5-6) declares: "Behold, I will send you Elijah the prophet before the coming of the…day of the LORD; and he shall turn the heart of the fathers to the children and…the children to their fathers…" In addition to his mention in the gospels, the story of John the Baptist and his story is told by the first century Jewish historian Flavius Josephus. In John's Gospel, the Baptist becomes the first witness to Jesus and his mission: "Behold the Lamb of God, which taketh away the sins of the world." Each of the gospels (and Josephus) report the arrest of John. In Mark and Matthew it is the starting point of Jesus' public ministry.

MATTHEW 3:1–12

1 In those days came John the Baptist, preaching in the wilderness of Judaea,

2 And saying, Repent ye: for the kingdom of heaven is at hand.

3 For this is he that was spoken of by the prophet Esaias, saying, The voice of one crying in the wilderness, Prepare ye the way of the Lord, make his paths straight.

4 And the same John had his raiment of camel's hair, and a leathern girdle about his loins; and his meat was locusts and wild honey.

5 Then went out to him Jerusalem, and all Judaea, and all the region round about Jordan,

6 And were baptized of him in Jordan, confessing their sins.

7 But when he saw many of the Pharisees and Sadducees come to his baptism, he said unto them, O generation of vipers, who hath warned you to flee from the wrath to come?

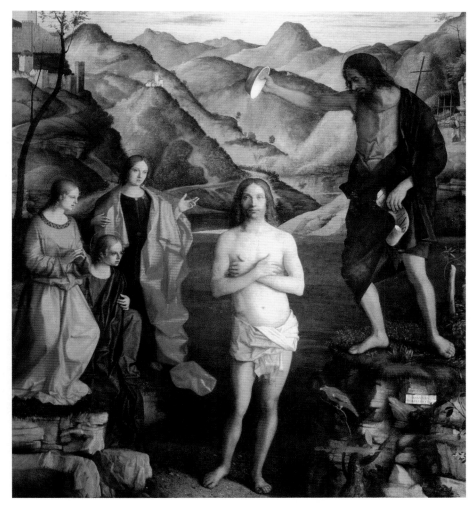

The Baptism of Christ by John the Baptist, by Giovanni Bellini, 1430–1516

For this is he that was spoken of by the prophet Esaias, saying, The voice of one crying in the wilderness, Prepare ye the way of the Lord, make his paths straight.

And the same John had his raiment of camel's hair, and a leathern girdle about his loins; and his meat was locusts and wild honey.

—MATTHEW 3:3–4

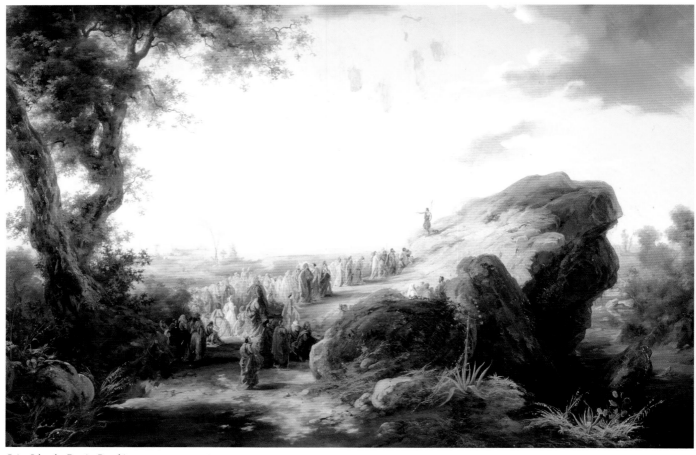

Saint John the Baptist Preaching, 19th century, by Giuseppe Camino, 1818–90

8 Bring forth therefore fruits meet for repentance:

9 And think not to say within your-selves, We have Abraham to our father: for I say unto you, that God is able of these stones to raise up children unto Abraham.

10 And now also the axe is laid unto the root of the trees: therefore every tree which bringeth not forth good fruit is hewn down, and cast into the fire.

11 I indeed baptize you with water unto repentance: but he that cometh after me is mightier than I, whose shoes I am not worthy to bear: he shall baptize you with the Holy Ghost, and with fire:

12 Whose fan is in his hand, and he will throughly purge his floor, and gather his wheat into the garner; but he will burn up the chaff with unquenchable fire.

MARK 1:2–8

2 As it is written in the prophets, Behold, I send my messenger before thy face, which shall prepare thy way before thee.

3 The voice of one crying in the wilderness, Prepare ye the way of the Lord, make his paths straight.

4 John did baptize in the wilderness, and preach the baptism of repentance for the remission of sins.

5 And there went out unto him all the land of Judaea, and they of Jerusalem, and were all baptized of him in the river of Jordan, confessing their sins.

6 And John was clothed with camel's hair, and with a girdle of a skin about his loins; and he did eat locusts and wild honey;

7 And preached, saying, There cometh one mightier than I after me, the latchet of whose shoes I am not worthy to stoop down and unloose.

8 I indeed have baptized you with water: but he shall baptize you with the Holy Ghost.

LUKE 3:1–18

1 Now in the fifteenth year of the reign of Tiberius Caesar, Pontius Pilate being governor of Judaea, and Herod being tetrarch of Galilee, and his brother Philip tetrarch of Ituraea and of the region of Trachonitis, and Lysanias the tetrarch of Abilene,

2 Annas and Caiaphas being the high priests, the word of God came unto John the son of Zacharias in the wilderness.

3 And he came into all the country about Jordan, preaching the baptism of repentance for the remission of sins;

4 As it is written in the book of the words of Esaias the prophet, saying, The voice of one crying in the wilderness, Prepare ye the way of the Lord, make his paths straight.

5 Every valley shall be filled, and every mountain and hill shall be brought low; and the crooked shall be made straight, and the rough ways shall be made smooth;

6 And all flesh shall see the salvation of God.

7 Then said he to the multitude that came forth to be baptized of him, O generation of vipers, who hath warned you to flee from the wrath to come?

8 Bring forth therefore fruits worthy of repentance, and begin not to say within yourselves, We have Abraham to our father: for I say unto you, That God is able of these stones to raise up children unto Abraham.

9 And now also the axe is laid unto the root of the trees: every tree therefore which bringeth not forth good fruit is hewn down, and cast into the fire.

10 And the people asked him, saying, What shall we do then?

11 He answereth and saith unto them, He that hath two coats, let him impart to him that hath none; and he that hath meat, let him do likewise.

12 Then came also publicans to be baptized, and said unto him, Master, what shall we do?

13 And he said unto them, Exact no more than that which is appointed you.

14 And the soldiers likewise demanded of him, saying, And what shall we do? And he said unto them, Do violence to no man, neither accuse any falsely; and be content with your wages.

15 And as the people were in expectation, and all men mused in their hearts of John, whether he were the Christ, or not;

16 John answered, saying unto them all, I indeed baptize you with water; but one mightier than I cometh, the latchet of whose shoes I am not worthy to unloose: he shall baptize you with the Holy Ghost and with fire:

17 Whose fan is in his hand, and he will throughly purge his floor, and will gather the wheat into his garner; but the chaff he will burn with fire unquenchable.

18 And many other things in his exhortation preached he unto the people.

JOHN 1:19–28

19 And this is the record of John, when the Jews sent priests and Levites from Jerusalem to ask him, Who art thou?

20 And he confessed, and denied not; but confessed, I am not the Christ.

21 And they asked him, What then? Art thou Elias? And he saith, I am not. Art thou that prophet? And he answered, No.

22 Then said they unto him, Who art thou? that we may give an answer to them that sent us. What sayest thou of thyself?

23 He said, I am the voice of one crying in the wilderness, Make straight the way of the Lord, as said the prophet Esaias.

24 And they which were sent were of the Pharisees.

25 And they asked him, and said unto him, Why baptizest thou then, if thou be not that Christ, nor Elias, neither that prophet?

26 John answered them, saying, I baptize with water: but there standeth one among you, whom ye know not;

27 He it is, who coming after me is preferred before me, whose shoe's latchet I am not worthy to unloose.

28 These things were done in Bethabara beyond Jordan, where John was baptizing.

JESUS IS BAPTIZED BY JOHN

MATTHEW 3:13–17

13 Then cometh Jesus from Galilee to Jordan unto John, to be baptized of him.

14 But John forbad him, saying, I have need to be baptized of thee, and comest thou to me?

15 And Jesus answering said unto him, Suffer it to be so now: for thus it becometh us to fulfill all righteousness. Then he suffered him.

16 And Jesus, when he was baptized, went up straightway out of the water: and, lo, the heavens were opened unto him, and he saw the Spirit of God descending like a dove, and lighting upon him:

And preached, saying, There cometh one mightier than I after me, the latchet of whose shoes I am not worthy to stoop down and unloose.

—MARK 1:7

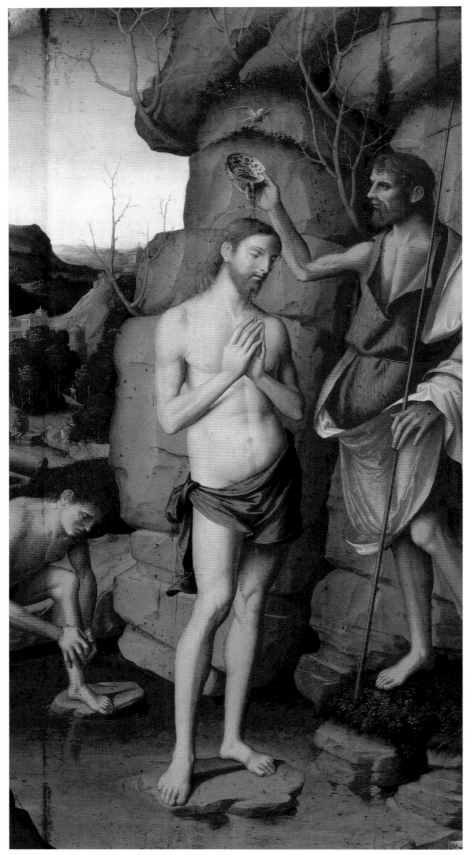

The Baptism of Jesus Christ by Saint John the Baptist, Marco Palmezzano, 1457-1539

And lo a voice from heaven, saying, This is my beloved Son, in whom I am well pleased.

—MATTHEW 3:17

17 And lo a voice from heaven, saying, This is my beloved Son, in whom I am well pleased.

MARK 1:9–11

9 And it came to pass in those days, that Jesus came from Nazareth of Galilee, and was baptized of John in Jordan.

10 And straightway coming up out of the water, he saw the heavens opened, and the Spirit like a dove descending upon him:

11 And there came a voice from heaven, saying, Thou art my beloved Son, in whom I am well pleased.

LUKE 3:19–22

19 But Herod the tetrarch, being reproved by him for Herodias his brother Philip's wife, and for all the evils which Herod had done,

20 Added yet this above all, that he shut up John in prison.

21 Now when all the people were baptized, it came to pass, that Jesus also being baptized, and praying, the heaven was opened,

22 And the Holy Ghost descended in a bodily shape like a dove upon him, and a voice came from heaven, which said, Thou art my beloved Son; in thee I am well pleased.

JOHN 1:29–34

29 The next day John seeth Jesus coming unto him, and saith, Behold the Lamb of God, which taketh away the sin of the world.

30 This is he of whom I said, After me cometh a man which is preferred before me: for he was before me.

31 And I knew him not: but that he should be made manifest to Israel, therefore am I come baptizing with water.

32 And John bare record, saying, I saw the Spirit descending from heaven like a dove, and it abode upon him.

33 And I knew him not: but he that sent me to baptize with water, the same said unto me, Upon whom thou shalt see the Spirit descending, and remaining on him, the same is he which baptizeth with the Holy Ghost.

34 And I saw, and bare record that this is the Son of God.

JOHN'S ARREST

MATTHEW 14: 3–4

3 For Herod had laid hold on John, and bound him, and put him in prison for Herodias' sake, his brother Philip's wife.

4 For John said unto him, It is not lawful for thee to have her.

MARK 6:17–18

17 For Herod himself had sent forth and laid hold upon John, and bound him in prison for Herodias' sake, his brother Philip's wife: for he had married her.

18 For John had said unto Herod, It is not lawful for thee to have thy brother's wife.

LUKE 3:19–20

19 But Herod the tetrarch, being reproved by him for Herodias his brother Philip's wife, and for all the evils which Herod had done,

20 Added yet this above all, that he shut up John in prison.

JOHN 3:24

24 And he that keepeth his commandments dwelleth in him, and he in him. And hereby we know that he abideth in us, by the Spirit which he hath given us.

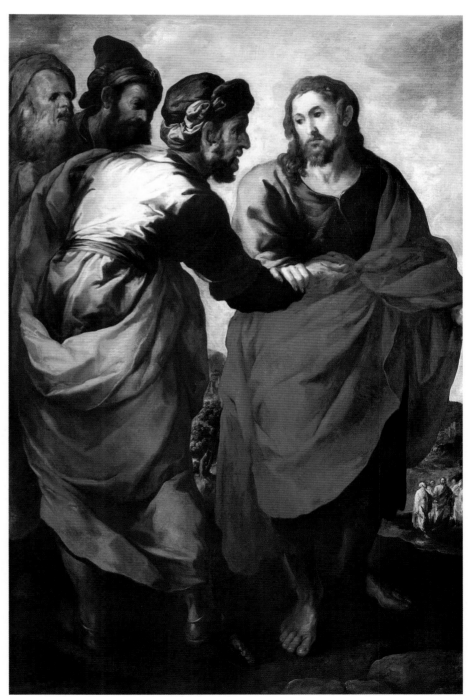

The Jews Asking Saint John the Baptist if He is the Christ, by Francisco de Herrera, 1576–1657

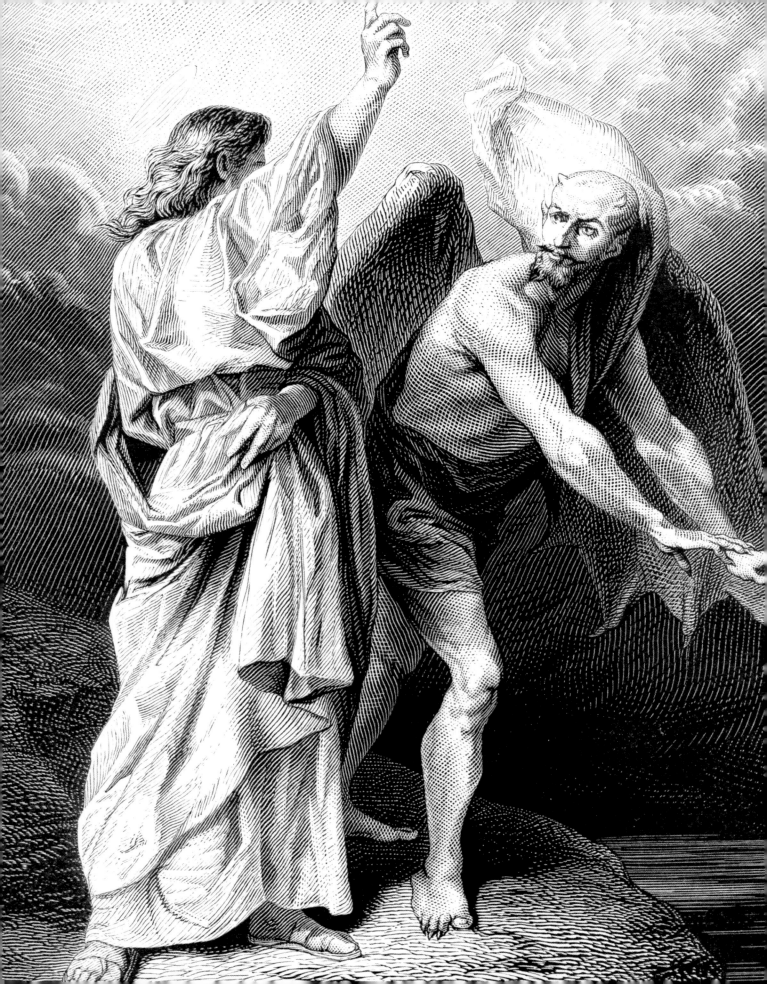

The Temptation of Jesus

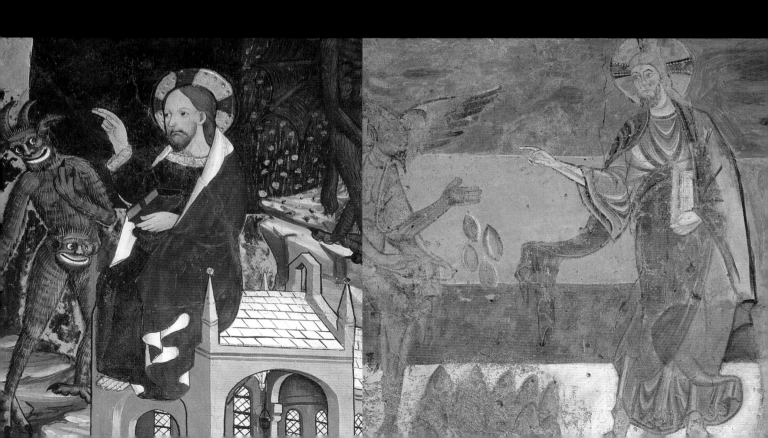

The Temptation of Jesus

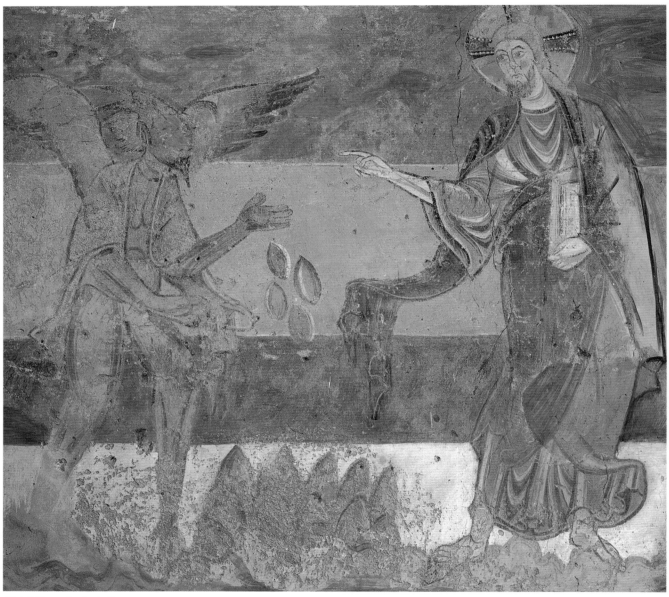

Christ's Temptation in the Desert, 12th century, by Artist Unknown

As he emerges from the Jordan, Jesus, filled with the Spirit, is driven into the desert—the abode of demons—to be tested. Mark, the earliest and shortest gospel, masterfully unfolds the dramatic events that reveal Jesus' true identity to the world. The reader knows it from the first verse. Jesus hears it as the heavens split open and a voice declares, "Thou art my beloved Son…." Now immersed into the age-old struggle of good and evil, Jesus engages the enemy.

JESUS IS TEMPTED IN THE DESERT

Jesus comes face to face with evil in the desert. Mark calls him Satan; in Matthew and Luke, drawing on a common tradition, he is the Devil. These two draw the comparison between Jesus' forty-day and Israel's forty-year testing. Jesus receives the same three tests that proved to be Israel's downfall in the desert. Jesus conquers each one, quoting the Book of Deuteronomy—Moses' instructions to the children, entering the promised land, for avoiding the mistakes their parents made—and "tempting the LORD their God." The enemy takes his leave—as Luke slyly adds—"for a time." The last temptation is still to come.

MATTHEW 4:1–11

1 Then was Jesus led up of the Spirit into the wilderness to be tempted of the devil.

2 And when he had fasted forty days and forty nights, he was afterward an hungred.

3 And when the tempter came to him, he said, If thou be the Son of God, command that these stones be made bread.

4 But he answered and said, It is written, Man shall not live by bread alone, but by every word that proceedeth out of the mouth of God.

5 Then the devil taketh him up into the holy city, and setteth him on a pinnacle of the temple,

6 And saith unto him, If thou be the Son of God, cast thyself down: for it is written, He shall give his angels charge concerning thee: and in their hands they shall bear thee up, lest at any time thou dash thy foot against a stone.

7 Jesus said unto him, It is written again, Thou shalt not tempt the Lord thy God.

8 Again, the devil taketh him up into an exceeding high mountain, and sheweth him all the kingdoms of the world, and the glory of them;

9 And saith unto him, All these things will I give thee, if thou wilt fall down and worship me.

10 Then saith Jesus unto him, Get thee hence, Satan: for it is written, Thou shalt worship the Lord thy God, and him only shalt thou serve.

11 Then the devil leaveth him, and, behold, angels came and ministered unto him.

MARK 1:12–13

12 And immediately the Spirit driveth him into the wilderness.

13 And he was there in the wilderness forty days, tempted of Satan; and was with the wild beasts; and the angels ministered unto him.

LUKE 4:1–13

1 And Jesus being full of the Holy Ghost returned from Jordan, and was led by the Spirit into the wilderness,

2 Being forty days tempted of the devil. And in those days he did eat nothing: and when they were ended, he afterward hungered.

3 And the devil said unto him, If thou be the Son of God, command this stone that it be made bread.

4 And Jesus answered him, saying, It is written, That man shall not live by bread alone, but by every word of God.

5 And the devil, taking him up into an high mountain, shewed unto him all the kingdoms of the world in a moment of time.

6 And the devil said unto him, All this power will I give thee, and the glory of them: for that is delivered unto me; and to whomsoever I will I give it.

7 If thou therefore wilt worship me, all shall be thine.

8 And Jesus answered and said unto him, Get thee behind me, Satan: for it is written, Thou shalt worship the Lord thy God, and him only shalt thou serve.

9 And he brought him to Jerusalem, and set him on a pinnacle of the temple, and said unto him, If thou be the Son of God, cast thyself down from hence:

10 For it is written, He shall give his angels charge over thee, to keep thee:

11 And in their hands they shall bear thee up, lest at any time thou dash thy foot against a stone.

12 And Jesus answering said unto him, It is said, Thou shalt not tempt the Lord thy God.

13 And when the devil had ended all the temptation, he departed from him for a season.

JOHN 1:51

51 And he saith unto him, Verily, verily, I say unto you, Hereafter ye shall see heaven open, and the angels of God ascending and descending upon the Son of man.

Jesus' Early Ministry

Jesus' Early Ministry

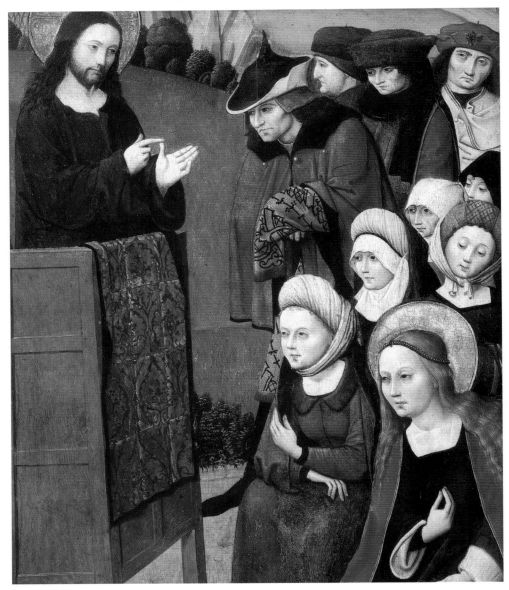

Christ Preaching, by Master of the Low Countries, 15th century

JOHN'S PROLOGUE REMINDS THE READER that in Jesus, "the Word was made flesh, and dwelt among us, (and we beheld his glory, glory as of the only begotten of the Father) full of grace and truth." In the first part of John's two-part story often called "the Book of Signs," Jesus "reveals his glory" through works of power called "signs." These are directed toward the world as testimonies to Jesus' identity and mission, and some come to faith through them and become his disciples. Others take issue with the works he does and misunderstand him, and these controversies give Jesus an opportunity to clarify his teaching.

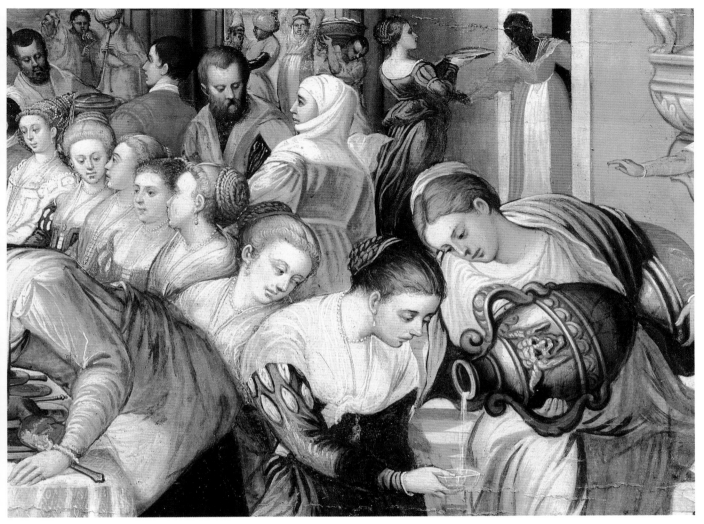

The Marriage Feast at Cana, 16th century, Venetian Graeco-School

THE MARRIAGE AT CANA

The people Jesus meets illustrate different stumbling blocks that can hinder the growth of faith. Some, like the Samaritan woman, quickly respond to his welcome, going out and bringing others to Jesus. Others, like Nicodemus, who first comes to Jesus by night, reappear several times in the gospel, gradually coming to "see the light." John's gospel contains healings and dialogues similar to those found in Mark, Matthew, and Luke (called the Synoptic Gospels, as they "see things together"). John's, however, are fewer and more elaborately developed. The first sign takes place at a marriage, to which Jesus

and his mother are invited. Jesus changes the water set aside for purification rites into wine. Far from being a "publicity stunt," (only the caterers and the disciples know where the wine came from), it is the quiet announcement of the Bridegroom's arrival, come to bring his bride (God's people) home, with joy as close as the 180 gallons of fine wine: "Thou hast kept the good wine until now."

JOHN 2:1–11

1 And the third day there was a marriage in Cana of Galilee; and the mother of Jesus was there:

2 And both Jesus was called, and his disciples, to the marriage.

3 And when they wanted wine, the mother of Jesus saith unto him, They have no wine.

4 Jesus saith unto her, Woman, what have I to do with thee? mine hour is not yet come.

5 His mother saith unto the servants, Whatsoever he saith unto you, do it.

6 And there were set there six waterpots of stone, after the manner of the purifying of the Jews, containing two or three firkins apiece.

7 Jesus saith unto them, Fill the waterpots with water. And they filled them up to the brim.

8 And he saith unto them, Draw out now, and bear unto the governor of the feast. And they bare it.

9 When the ruler of the feast had tasted the water that was made wine, and knew not whence it was: (but the servants which drew the water knew;) the governor of the feast called the bridegroom,

10 And saith unto him, Every man at the beginning doth set forth good wine; and when men have well drunk, then that which is worse: but thou hast kept the good wine until now.

11 This beginning of miracles did Jesus in Cana of Galilee, and manifested forth his glory; and his disciples believed on him.

JESUS' FIRST JOURNEY TO JERUSALEM

Jesus makes the first of his several trips to Jerusalem mentioned by John this time to celebrate the Passover feast. While there, he drives the money-changers from the the Temple. In Matthew, Mark, and Luke, Jesus does this during the week of his arrest, trial, and crucifixion—the only time during his ministry that he journeys to Jerusalem for the Passover. John mentions Jesus celebrating three Passovers during his ministry, suggesting that Jesus' earthly ministry lasted at least two, possibly three years. All four accounts will be examined together, during the final Passover/Last Supper, as it is closely interrelated to the events of that week.

JOHN 2:12–25

12 After this he went down to Capernaum, he, and his mother, and his brethren, and his disciples: and they continued there not many days.

13 And the Jews' passover was at hand, and Jesus went up to Jerusalem.

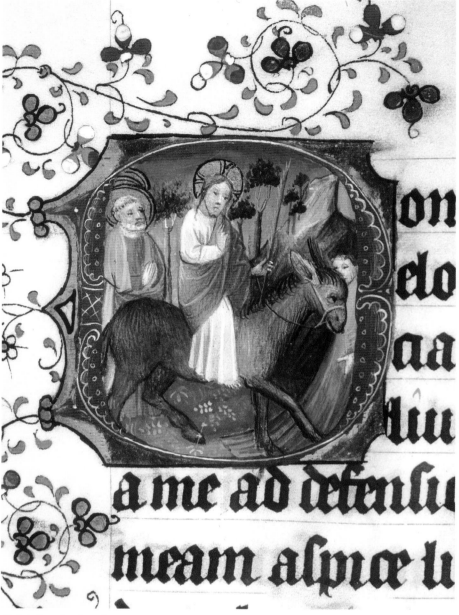

Christ's Entry into Jerusalem, from 1430 Missal of Master Pancratius

14 And found in the temple those that sold oxen and sheep and doves, and the changers of money sitting:

15 And when he had made a scourge of small cords, he drove them all out of the temple, and the sheep, and the oxen; and poured out the changers' money, and overthrew the tables;

16 And said unto them that sold doves, Take these things hence; make not my Father's house an house of merchandise.

17 And his disciples remembered that it was written, The zeal of thine house hath eaten me up.

18 Then answered the Jews and said unto him, What sign shewest thou unto us, seeing that thou doest these things?

19 Jesus answered and said unto them, Destroy this temple, and in three days I will raise it up.

20 Then said the Jews, Forty and six years was this temple in building, and wilt thou rear it up in three days?

21 But he spake of the temple of his body.

22 When therefore he was risen from the dead, his disciples remembered that he had said this unto them; and they believed the scripture, and the word which Jesus had said.

23 Now when he was in Jerusalem at the passover, in the feast day, many believed in his name, when they saw the miracles which he did.

24 But Jesus did not commit himself unto them, because he knew all men,

25 And needed not that any should testify of man: for he knew what was in man.

JESUS' DIALOGUE WITH NICODEMUS

Nicodemus, a teacher of the Pharisees, comes to Jesus by night, because he hears of the "signs" Jesus does and concludes that he must come from God. Jesus tells him: "Except a man be born again, he cannot see the kingdom of God." Nicodemus' misunderstanding of "born again" provides Jesus an opportunity to talk about the Spirit: "Except a man be born of water and of the Spirit, he cannot enter the Kingdom of God." Jesus then prophesies that as Moses in the wilderness lifted up a brazen serpent—a sign for the healing of those bitten by poisonous snakes—so would he ("the Son of man") be "lifted up, that whosoever believeth in him should not perish, but have eternal life." Later in the gospel, Jesus will connect the outpouring of the Spirit with his being lifted up—thus allowing the reader to learn about Jesus in the same way that Nicodemus does—in the coming revelations of the story.

JOHN 3:1–21

1 There was a man of the Pharisees, named Nicodemus, a ruler of the Jews:

2 The same came to Jesus by night, and said unto him, Rabbi, we know that thou art a teacher come from God: for no man can do these miracles that thou doest, except God be with him.

3 Jesus answered and said unto him, Verily, verily, I say unto thee, Except a man be born again, he cannot see the kingdom of God.

4 Nicodemus saith unto him, How can a man be born when he is old? can he enter the second time into his mother's womb, and be born?

5 Jesus answered, Verily, verily, I say unto thee, Except a man be born of water and of the Spirit, he cannot enter into the kingdom of God.

6 That which is born of the flesh is flesh; and that which is born of the Spirit is spirit.

7 Marvel not that I said unto thee, Ye must be born again.

8 The wind bloweth where it listeth, and thou hearest the sound thereof, but canst not tell whence it cometh, and whither it goeth: so is every one that is born of the Spirit.

9 Nicodemus answered and said unto him, How can these things be?

10 Jesus answered and said unto him, Art thou a master of Israel, and knowest not these things?

11 Verily, verily, I say unto thee, We speak that we do know, and testify that we have seen; and ye receive not our witness.

12 If I have told you earthly things, and ye believe not, how shall ye believe, if I tell you of heavenly things?

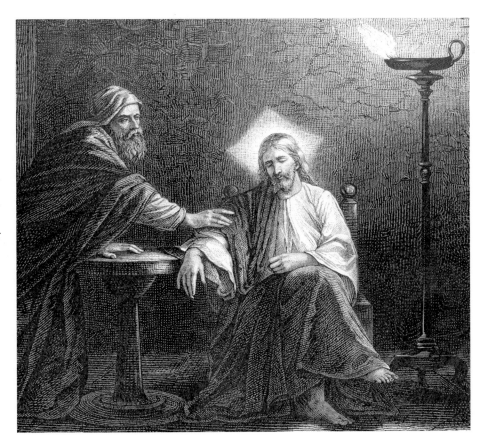

Nicodemus Seeks Jesus by Night, by Alexander Bida, 1813–1895

18 He that believeth on him is not condemned: but he that believeth not is condemned already, because he hath not believed in the name of the only begotten Son of God.

19 And this is the condemnation, that light is come into the world, and men loved darkness rather than light, because their deeds were evil.

20 For every one that doeth evil hateth the light, neither cometh to the light, lest his deeds should be reproved.

21 But he that doeth truth cometh to the light, that his deeds may be made manifest, that they are wrought in God.

JOHN THE BAPTIST TESTIFIES ABOUT JESUS

Jesus then moves out of Jerusalem, (the last location mentioned) and into the Judean countryside. There he baptizes, while John and his disciples are baptizing further north. When John's disciples mention this to John, and that now "all men come to him," John again states what he said earlier in the story, that he was not the Christ, but the one who has been sent ahead of him. John then compares himself to the "friend of the bridegroom," whose job it was to stand guard at the bride's house until the bridegroom arrived to bring her to his home, where the customary three days of feasting would begin. Having heard the bridegroom's voice, his purpose is fulfilled. "He must increase, but I must decrease." John's last words are spoken joyfully, like Simeon in Luke's Christmas story, for the one of whom he testified is now at work, the one who "baptizeth with the Holy Ghost."

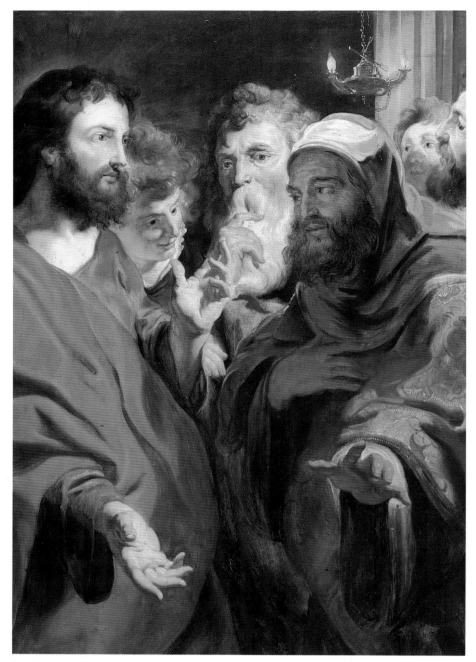

Jesus Instructing Nicodemus, by Jacob Jordaens, 1593–1678

13 And no man hath ascended up to heaven, but he that came down from heaven, even the Son of man which is in heaven.

14 And as Moses lifted up the serpent in the wilderness, even so must the Son of man be lifted up:

15 That whosoever believeth in him should not perish, but have eternal life.

16 For God so loved the world, that he gave his only begotten Son, that whosoever believeth in him should not perish, but have everlasting life.

17 For God sent not his Son into the world to condemn the world; but that the world through him might be saved.

JOHN 3:23–36

23 And John also was baptizing in Aenon near to Salim, because there was much water there: and they came, and were baptized.

24 For John was not yet cast into prison.

25 Then there arose a question between some of John's disciples and the Jews about purifying.

26 And they came unto John, and said unto him, Rabbi, he that was with thee beyond Jordan, to whom thou barest witness, behold, the same baptizeth, and all men come to him

27 John answered and said, A man can receive nothing, except it be given him from heaven.

28 Ye yourselves bear me witness, that I said, I am not the Christ, but that I am sent before him.

29 He that hath the bride is the bridegroom: but the friend of the bridegroom, which standeth and heareth him, rejoiceth greatly because of the bridegroom's voice: this my joy therefore is fulfilled.

30 He must increase, but I must decrease.

31 He that cometh from above is above all: he that is of the earth is earthly, and speaketh of the earth: he that cometh from heaven is above all.

32 And what he hath seen and heard, that he testifieth; and no man receiveth his testimony.

33 He that hath received his testimony hath set to his seal that God is true.

34 For he whom God hath sent speaketh the words of God: for God giveth not the Spirit by measure unto him.

35 The Father loveth the Son, and hath given all things into his hand.

36 He that believeth on the Son hath everlasting life: and he that believeth not the Son shall not see life; but the wrath of God abideth on him.

JESUS JOURNEYS INTO GALILEE

John's Jesus now journeys from Judea into Galilee, the place where Jesus' public ministry in Mark, Matthew, and Luke begins. The geographical pattern of Mark, picked up with extensive additions by Matthew and Luke, has Jesus doing the biggest part of his ministry, healings, and teaching in Galilee. In the dramatic highlighting of all three, Jesus' ministry quickly generates opposition and hostility, as we shall see. We will see the Jesus who graciously welcomes all who come to him, causing many to reject him as one who cares not about the observance of the law, and its regulations for the purity of the community. Jesus' focus will turn more inward, as he begins to "turn his face toward Jerusalem" and to tell the disciples plainly that there he will be despised, rejected, condemned, put to death—and in three days be raised to life again.

MATTHEW 4:12–17

12 Now when Jesus had heard that John was cast into prison, he departed into Galilee.

13 And leaving Nazareth, he came and dwelt in Capernaum, which is upon the sea coast, in the borders of Zabulon and Nephthalim.

14 That it might be fulfilled which was spoken by Esaias the prophet, saying,

15 The land of Zabulon, and the land of Nephthalim, by the way of the sea, beyond Jordan, Galilee of the Gentiles.

16 The people which sat in darkness saw great light; and to them which sat in the region and shadow of death light is sprung up.

17 From that time Jesus began to preach, and to say, Repent: for the kingdom of heaven is at hand.

MARK 1:14–15

14 Now after that John was put in prison, Jesus came into Galilee, preaching the gospel of the kingdom of God,

15 And saying, The time is fulfilled, and the kingdom of God is at hand: repent ye, and believe the gospel.

LUKE 4:14–15

14 And Jesus returned in the power of the Spirit into Galilee: and there went out a fame of him through all the region round about.

15 And he taught in their synagogues, being glorified of all.

JOHN 4:1–3

1 When therefore the LORD knew how the Pharisees had heard that Jesus made and baptized more disciples than John,

2 (Though Jesus himself baptized not, but his disciples,)

3 He left Judaea, and departed again into Galilee.

And Jesus returned in the power of the Spirit into Galilee: and there went out a fame of him through all the region round about.

—LUKE 4:14

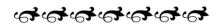

Christ and the Samaritan Woman, by Bernardo Strozzi, 1581–1644

JESUS SPEAKS WITH A SAMARITAN WOMAN

Jesus travels south from Galilee to Sychar or Shechem, a place with a history dating back to Jacob, who buried all his family's foreign gods under an oak tree in Shechem and promised to worship only the LORD (Genesis 35:4). For some time Shechem had continued to be the place the annual covenant renewal liturgy was held. Now, at Jacob's well, Jesus asks for a drink from a Samaritan woman. Several hundred years of political and religious animosity stood between Jews and Samaritans, the remnant of the Northern Kingdom destroyed by the Assyrian Empire. Jesus accepts her unconditionally, moving her to bring everyone she finds to see the man who "told me all that I ever did." In John's masterful orchestration of this story, Jesus' "living water" washes away all the barriers, not only for the woman, but for all people as well. And many Samaritans come to believe in him.

JOHN 4:4–42

4 And he must needs go through Samaria.

5 Then cometh he to a city of Samaria, which is called Sychar, near to the parcel of ground that Jacob gave to his son Joseph.

6 Now Jacob's well was there. Jesus therefore, being wearied with his journey, sat thus on the well: and it was about the sixth hour.

7 There cometh a woman of Samaria to draw water: Jesus saith unto her, Give me to drink.

8 (For his disciples were gone away unto the city to buy meat.)

9 Then saith the woman of Samaria unto him, How is it that thou, being a Jew, askest drink of me, which am a woman of Samaria? for the Jews have no dealings with the Samaritans.

10 Jesus answered and said unto her, If thou knewest the gift of God, and who it is that saith to thee, Give me to drink; thou wouldest have asked of him, and he would have given thee living water.

11 The woman saith unto him, Sir, thou hast nothing to draw with, and the well is deep: from whence then hast thou that living water?

12 Art thou greater than our father Jacob, which gave us the well, and drank thereof himself, and his children, and his cattle?

13 Jesus answered and said unto her, Whosoever drinketh of this water shall thirst again:

14 But whosoever drinketh of the water that I shall give him shall never thirst; but the water that I shall give him shall be in him a well of water springing up into everlasting life.

15 The woman saith unto him, Sir, give me this water, that I thirst not, neither come hither to draw.

16 Jesus saith unto her, Go, call thy husband, and come hither.

17 The woman answered and said, I have no husband. Jesus said unto her, Thou hast well said, I have no husband:

18 For thou hast had five husbands; and he whom thou now hast is not thy husband: in that saidst thou truly.

19 The woman saith unto him, Sir, I perceive that thou art a prophet.

20 Our fathers worshipped in this mountain; and ye say, that in Jerusalem is the place where men ought to worship.

21 Jesus saith unto her, Woman, believe me, the hour cometh, when ye shall neither in this mountain, nor yet at Jerusalem, worship the Father.

22 Ye worship ye know not what: we know what we worship: for salvation is of the Jews.

23 But the hour cometh, and now is, when the true worshippers shall worship the Father in spirit and in truth: for the Father seeketh such to worship him.

⁂⁂⁂⁂⁂⁂⁂⁂⁂

The people which sat in darkness saw great light; and to them which sat in the region and shadow of death light is sprung up.

—MATTHEW 4:16

⁂⁂⁂⁂⁂⁂⁂⁂⁂

24 God is a Spirit: and they that worship him must worship him in spirit and in truth.

25 The woman saith unto him, I know that Messias cometh, which is called Christ: when he is come, he will tell us all things.

26 Jesus saith unto her, I that speak unto thee am he.

27 And upon this came his disciples, and marvelled that he talked with the woman: yet no man said, What seekest thou? or, Why talkest thou with her?

28 The woman then left her waterpot, and went her way into the city, and saith to the men,

29 Come, see a man, which told me all things that ever I did: is not this the Christ?

30 Then they went out of the city, and came unto him.

31 In the mean while his disciples prayed him, saying, Master, eat.

32 But he said unto them, I have meat to eat that ye know not of.

33 Therefore said the disciples one to another, Hath any man brought him ought to eat?

34 Jesus saith unto them, My meat is to do the will of him that sent me, and to finish his work.

35 Say not ye, There are yet four months, and then cometh harvest? behold, I say unto you, Lift up your eyes, and look on the fields; for they are white already to harvest.

36 And he that reapeth receiveth wages, and gathereth fruit unto life eternal: that both he that soweth and he that reapeth may rejoice together.

37 And herein is that saying true, One soweth, and another reapeth.

38 I sent you to reap that whereon ye bestowed no labour: other men

laboured, and ye are entered into their labours.

39 And many of the Samaritans of that city believed on him for the saying of the woman, which testified, He told me all that ever I did.

40 So when the Samaritans were come unto him, they besought him that he would tarry with them: and he abode there two days.

41 And many more believed because of his own word;

42 And said unto the woman, Now we believe, not because of thy saying: for we have heard him ourselves, and know that this is indeed the Christ, the Saviour of the world.

JESUS' MINISTRY IN GALILEE

MATTHEW 4:13–17

13 And leaving Nazareth, he came and dwelt in Capernaum, which is upon the sea coast, in the borders of Zabulon and Nephthalim:

14 That it might be fulfilled which was spoken by Esaias the prophet, saying,

15 The land of Zabulon, and the land of Nephthalim, by the way of the sea, beyond Jordan, Galilee of the Gentiles;

16 The people which sat in darkness saw great light; and to them which sat in the region and shadow of death light is sprung up.

17 From that time Jesus began to preach, and to say, Repent: for the kingdom of heaven is at hand.

MARK 1:14B–15

14 Jesus came into Galilee, preaching the gospel of the kingdom of God,

15 And saying, The time is fulfilled, and the kingdom of God is at hand: repent ye, and believe the gospel.

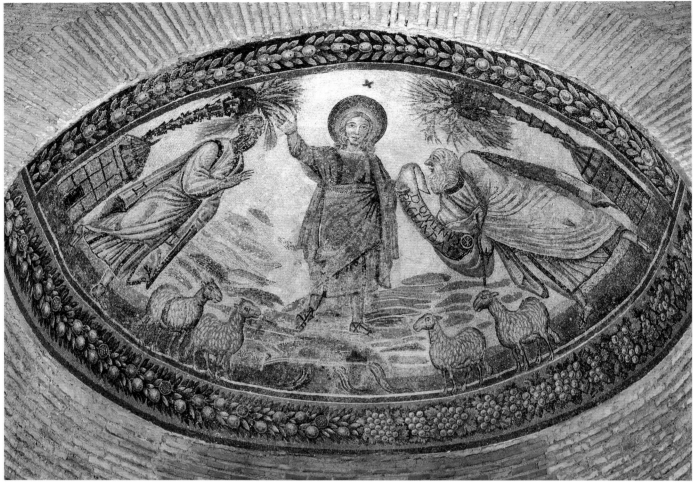

Mosaic in Lunette of Christ Giving Word of God to Saint Peter and Paul, 5th–6th century, by Artist Unknown

LUKE 4:14B–15

14 And there went out a fame of him through all the region round about.

15 And he taught in their synagogues, being glorified of all.

JOHN 4:43–46A

43 After the two days he departed to Galilee.

44 For Jesus himself testified that a prophet has no honor in his own country.

45 So when he came to Galilee, the Galileans welcomed him, having seen all that he had done in Jerusalem at the feast, for they too had gone to the feast.

46 So he came again to Cana in Galilee, where he had made the water wine.

JESUS' PREACHING IN NAZARETH

Christian preaching, from its beginnings, has been closely connected to the books of the prophets, and especially the prophet Isaiah. Jesus' first disciples, all Jewish, used texts from the prophets to tell the story of Jesus at the Sabbath worship in the local synagogues. Any man who had made his Bar Mitzvah was eligible to preach in them. A typical service would follow a cycle of readings from the Torah (the "Books of Moses") and a reading from the prophets selected by the one who read and commented that day. Luke begins his narration of the Galilean ministry with Jesus doing this in his hometown synagogue. Matthew opens his Galilean report with a formula quotation from Isaiah 9, noting that Jesus' ministry begins in "Galilee of the Gentiles" in order to fulfill what was spoken by Esaias the prophet: "The people that sat in darkness have seen a great light; and to them which sat in the region of the shadow of death light is sprung up." After reading from Isaiah 61, Jesus begins his inaugural sermon: "This day is this scripture fulfilled in your ears." Luke draws out the suspense as people begin to react favorably, then quickly the crowd sours, eventually leading him out to stone him to death. Jesus' word, related in all four gospels comes true: "No prophet is accepted in his home country."

MATTHEW 13:53–58

53 And it came to pass, that when Jesus had finished these parables, he departed thence.

54 And when he was come into his own country, he taught them in their synagogue, insomuch that they were astonished, and said, Whence hath this man this wisdom, and these mighty works?

55 Is not this the carpenter's son? is not his mother called Mary? and his brethren, James, and Joses, and Simon, and Judas?

56 And his sisters, are they not all with us? Whence then hath this man all these things?

57 And they were offended in him. But Jesus said unto them, A prophet is not without honour, save in his own country, and in his own house.

58 And he did not many mighty works there because of their unbelief.

MARK 6:1–6

1 And he went out from thence, and came into his own country; and his disciples follow him.

2 And when the sabbath day was come, he began to teach in the synagogue: and many hearing him were astonished, saying, From whence hath this man these things? and what wisdom is this which is given unto him, that even such mighty works are wrought by his hands?

3 Is not this the carpenter, the son of Mary, the brother of James, and Joses, and of Juda, and Simon? and are not his sisters here with us? And they were offended at him.

4 But Jesus said unto them, A prophet is not without honour, but in his own country, and among his own kin, and in his own house.

5 And he could there do no mighty work, save that he laid his hands upon a few sick folk, and healed them.

6 And he marvelled because of their unbelief. And he went round about the villages, teaching.

LUKE 4:16–30

16 And he came to Nazareth, where he had been brought up: and, as his custom was, he went into the synagogue on the sabbath day, and stood up for to read.

17 And there was delivered unto him the book of the prophet Esaias. And when he had opened the book, he found the place where it was written,

18 The Spirit of the Lord is upon me, because he hath anointed me to preach the gospel to the poor; he hath sent me to heal the brokenhearted, to preach deliverance to the captives, and recovering of sight to the blind, to set at liberty them that are bruised,

19 To preach the acceptable year of the Lord.

20 And he closed the book, and he gave it again to the minister, and sat down. And the eyes of all them that were in the synagogue were fastened on him.

21 And he began to say unto them, This day is this scripture fulfilled in your ears.

22 And all bare him witness, and wondered at the gracious words which proceeded out of his mouth. And they said, Is not this Joseph's son?

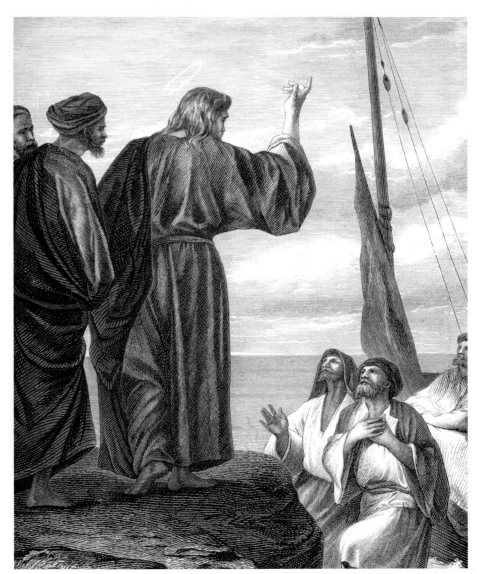

The Calling of the Fishermen, by Alexander Bida, 1813–1895

23 And he said unto them, Ye will surely say unto me this proverb, Physician, heal thyself: whatsoever we have heard done in Capernaum, do also here in thy country.

24 And he said, Verily I say unto you, No prophet is accepted in his own country.

25 But I tell you of a truth, many widows were in Israel in the days of Elias, when the heaven was shut up three years and six months, when great famine was throughout all the land;

26 But unto none of them was Elias sent, save unto Sarepta, a city of Sidon, unto a woman that was a widow.

27 And many lepers were in Israel in the time of Eliseus the prophet; and none of them was cleansed, saving Naaman the Syrian.

28 And all they in the synagogue, when they heard these things, were filled with wrath,

29 And rose up, and thrust him out of the city, and led him unto the brow of the hill whereon their city was built, that they might cast him down headlong.

30 But he passing through the midst of them went his way,

JOHN 7:15

15 And the Jews marvelled, saying, How knoweth this man letters, having never learned?

And he saith unto them, Follow me, and I will make you fishers of men.

—MATTHEW 4:19

JOHN 6:42

42 And they said, Is not this Jesus, the son of Joseph, whose father and mother we know? how is it then that he saith, I came down from heaven?

JOHN 4:44

44 For Jesus himself testified, that a prophet hath no honour in his own country.

JOHN 10:39

39 Therefore they sought again to take him: but he escaped out of their hand,

THE CALLING OF THE FIRST DISCIPLES

The first of Jesus' followers were fishermen, plying their trade on the Sea of Galilee, a lake about thirteen miles long and six miles wide. Archaelologists have discovered a well-preserved specimen of a boat from the first century similar to those used by Simon, Andrew, James, and John. The summons was simply, "Follow me, and I will make you fishers of men." And they left everything and followed him. John, drawing on another source, tells us that two of these first disciples were followers of John the Baptist, whose witness to "the Lamb of God" sends them after Jesus. One of these is Andrew, who brings his brother Simon, who came to be known as Peter or Cephas— "the Rock." John mentions another pair who follow him—Philip, and his brother Nathanael, whose surprise at Jesus' "seeing" him even before they met, causes him to exclaim: "You are the Son of God…the King of Israel." Luke has Jesus borrowing the bow of Peter's boat as a pulpit from which to teach the crowds on the shore. Later, Jesus sends Peter into the deep—to catch an extraordinary number of fish, enough for two boats—a sign of what is to come as "fishers of men." John places a very similar "call" story after Jesus' resurrection.

MATTHEW 4:18–22

18 And Jesus, walking by the sea of Galilee, saw two brethren, Simon called Peter, and Andrew his brother, casting a net into the sea: for they were fishers.

19 And he saith unto them, Follow me, and I will make you fishers of men.

20 And they straightway left their nets, and followed him.

21 And going on from thence, he saw other two brethren, James the son of Zebedee, and John his brother, in a ship with Zebedee their father, mending their nets; and he called them.

22 And they immediately left the ship and their father, and followed him.

MARK 1:16–20

16 Now as he walked by the sea of Galilee, he saw Simon and Andrew his brother casting a net into the sea: for they were fishers.

17 And Jesus said unto them, Come ye after me, and I will make you to become fishers of men.

18 And straightway they forsook their nets, and followed him.

19 And when he had gone a little further thence, he saw James the son of Zebedee, and John his brother, who also were in the ship mending their nets.

20 And straightway he called them: and they left their father Zebedee in the ship with the hired servants, and went after him.

LUKE 5:1–11

1 And it came to pass, that, as the people pressed upon him to hear the word of God, he stood by the lake of Gennesaret,

2 And saw two ships standing by the lake: but the fishermen were gone out of them, and were washing their nets.

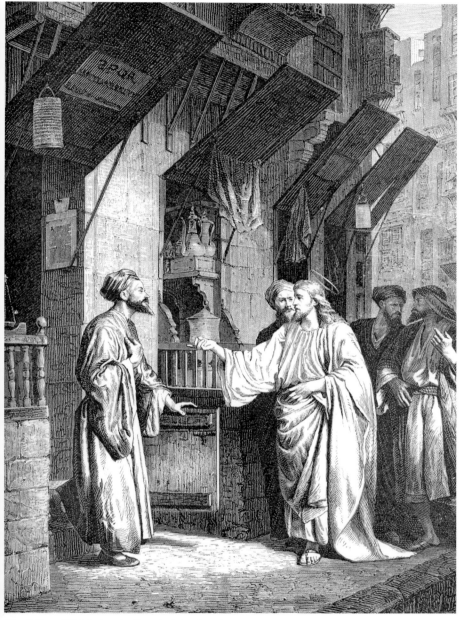

The Calling of St. Matthew, by Alexander Bida, 1813–1895

8 When Simon Peter saw it, he fell down at Jesus' knees, saying, Depart from me; for I am a sinful man, O Lord.

9 For he was astonished, and all that were with him, at the draught of the fishes which they had taken:

10 And so was also James, and John, the sons of Zebedee, which were partners with Simon. And Jesus said unto Simon, Fear not; from henceforth thou shalt catch men.

11 And when they had brought their ships to land, they forsook all, and followed him.

JOHN 1:35–51

35 Again the next day after John stood, and two of his disciples;

36 And looking upon Jesus as he walked, he saith, Behold the Lamb of God!

37 And the two disciples heard him speak, and they followed Jesus.

38 Then Jesus turned, and saw them following, and saith unto them, What seek ye? They said unto him, Rabbi, (which is to say, being interpreted, Master,) where dwellest thou?

39 He saith unto them, Come and see. They came and saw where he dwelt, and abode with him that day: for it was about the tenth hour.

40 One of the two which heard John speak, and followed him, was Andrew, Simon Peter's brother.

41 He first findeth his own brother Simon, and saith unto him, We have found the Messias, which is, being interpreted, the Christ.

42 And he brought him to Jesus. And when Jesus beheld him, he said, Thou art Simon the son of Jona: thou shalt be called Cephas, which is by interpretation, A stone.

43 The day following Jesus would go forth into Galilee, and findeth Philip, and saith unto him, Follow me.

3 And he entered into one of the ships, which was Simon's, and prayed him that he would thrust out a little from the land. And he sat down, and taught the people out of the ship.

4 Now when he had left speaking, he said unto Simon, Launch out into the deep, and let down your nets for a draught.

5 And Simon answering said unto him, Master, we have toiled all the night, and have taken nothing: nevertheless at thy word I will let down the net.

6 And when they had this done, they inclosed a great multitude of fishes: and their net brake.

7 And they beckoned unto their partners, which were in the other ship, that they should come and help them. And they came, and filled both the ships, so that they began to sink.

44 Now Philip was of Bethsaida, the city of Andrew and Peter.

45 Philip findeth Nathanael, and saith unto him, We have found him, of whom Moses in the law, and the prophets, did write, Jesus of Nazareth, the son of Joseph.

46 And Nathanael said unto him, Can there any good thing come out of Nazareth? Philip saith unto him, Come and see.

47 Jesus saw Nathanael coming to him, and saith of him, Behold an Israelite indeed, in whom is no guile.

48 Nathanael saith unto him, Whence knowest thou me? Jesus answered and said unto him, Before that Philip called thee, when thou wast under the fig tree, I saw thee.

49 Nathanael answered and saith unto him, Rabbi, thou art the Son of God; thou art the King of Israel.

50 Jesus answered and said unto him, Because I said unto thee, I saw thee under the fig tree, believest thou? thou shalt see greater things than these.

51 And he saith unto him, Verily, verily, I say unto you, Hereafter ye shall see heaven open, and the angels of God ascending and descending upon the Son of man.

JESUS' TEACHING AND HEALING IN CAPERNAUM

The house of Simon (Peter) becomes a base of operations for Jesus' early Galilean ministry. Located between the lakeshore the local synagogue, it becomes the site of Jesus' first encounter with a man possessed with a demon. For Mark this story is important to the drama around Jesus' true identity—for this demon (and others yet to come) know who he is, making it necessary for Jesus to "muzzle" the demon—as though to keep Jesus' identity secret (at least for

now). In their editing and expansion of Mark's story, Luke includes it, while Matthew leaves it out. What becomes immediately clear is the power of Jesus' word as it brings screaming demons into line, dispatches a fever from Simon's mother-in-law, and even restores a man disfigured by leprosy—all of them happening "immediately," to the astonishment of the onlookers. The word the King James Version renders with "immediately" or "straightway" is a favorite of Mark's. He uses it to connect stories or sayings with one another into the dramatic and powerful story that Mark calls "the Gospel of Jesus Christ, Son of God." It is well to take note that in John's story, while Jesus does seven "signs," none of those John relates are exorcisms of demons.

AT THE SYNAGOGUE

MATTHEW 4:13

13 And leaving Nazareth, he came and dwelt in Capernaum, which is upon the sea coast, in the borders of Zabulon and Nephthalim:

MARK 1:21–28

21 And they went into Capernaum; and straightway on the sabbath day he entered into the synagogue, and taught.

22 And they were astonished at his doctrine: for he taught them as one that had authority, and not as the scribes.

23 And there was in their synagogue a man with an unclean spirit; and he cried out,

24 Saying, Let us alone; what have we to do with thee, thou Jesus of Nazareth? art thou come to destroy us? I know thee who thou art, the Holy One of God.

25 And Jesus rebuked him, saying, Hold thy peace, and come out of him.

26 And when the unclean spirit had torn him, and cried with a loud voice, he came out of him.

27 And they were all amazed, insomuch that they questioned among themselves, saying, What thing is this? what new doctrine is this? for with authority commandeth he even the unclean spirits, and they do obey him.

28 And immediately his fame spread abroad throughout all the region round about Galilee.

LUKE 4:31–37

31 And came down to Capernaum, a city of Galilee, and taught them on the sabbath days.

32 And they were astonished at his doctrine: for his word was with power.

33 And in the synagogue there was a man, which had a spirit of an unclean devil, and cried out with a loud voice,

34 Saying, Let us alone; what have we to do with thee, thou Jesus of Nazareth? art thou come to destroy us? I know thee who thou art; the Holy One of God.

35 And Jesus rebuked him, saying, Hold thy peace, and come out of him. And when the devil had thrown him in the midst, he came out of him, and hurt him not.

And immediately his fame spread abroad throughout all the region round about Galilee.

—MARK 1:28

Christ Teaching at the Synagogue, late 13th century, by Artist Unknown

AT THE HOUSE OF SIMON (PETER)

MATTHEW 8:14–17

14 And when Jesus was come into Peter's house, he saw his wife's mother laid, and sick of a fever.

15 And he touched her hand, and the fever left her: and she arose, and ministered unto them.

16 When the even was come, they brought unto him many that were possessed with devils: and he cast out the spirits with his word, and healed all that were sick:

17 That it might be fulfilled which was spoken by Esaias the prophet, saying, Himself took our infirmities, and bare our sicknesses.

MARK 1:29–38

29 And forthwith, when they were come out of the synagogue, they entered into the house of Simon and Andrew, with James and John.

30 But Simon's wife's mother lay sick of a fever, and anon they tell him of her.

31 And he came and took her by the hand, and lifted her up; and immediately the fever left her, and she ministered unto them.

32 And at even, when the sun did set, they brought unto him all that were diseased, and them that were possessed with devils.

33 And all the city was gathered together at the door.

34 And he healed many that were sick of divers diseases, and cast out many devils; and suffered not the devils to speak, because they knew him.

35 And in the morning, rising up a great while before day, he went out, and departed into a solitary place, and there prayed.

36 And Simon and they that were with him followed after him.

36 And they were all amazed, and spake among themselves, saying, What a word is this! for with authority and power he commandeth the unclean spirits, and they come out.

37 And the fame of him went out into every place of the country round about.

JOHN 2:12

12 After this he went down to Capernaum, he, and his mother, and his brethren, and his disciples: and they continued there not many days.

MATTHEW 7:28–29

28 And it came to pass, when Jesus had ended these sayings, the people were astonished at his doctrine:

29 For he taught them as one having authority, and not as the scribes.

JOHN 7:46

46 The officers answered, Never man spake like this man.

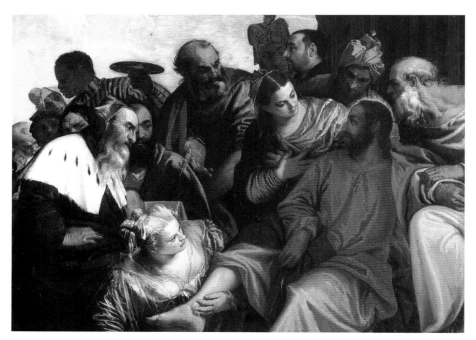

Meal at the House of Simon: Mary Magdalen Washes Feet of Jesus Christ, c.1560, by Paolo Veronese, 1528-1588

CLEANSING OF A MAN WITH LEPROSY

MATTHEW 8:1–4

1 When he was come down from the mountain, great multitudes followed him.

2 And, behold, there came a leper and worshipped him, saying, Lord, if thou wilt, thou canst make me clean.

3 And Jesus put forth his hand, and touched him, saying, I will; be thou clean. And immediately his leprosy was cleansed.

4 And Jesus saith unto him, See thou tell no man; but go thy way, shew thyself to the priest, and offer the gift that Moses commanded, for a testimony unto them.

MARK 1:40–45

40 And there came a leper to him, beseeching him, and kneeling down to him, and saying unto him, If thou wilt, thou canst make me clean.

41 And Jesus, moved with compassion, put forth his hand, and touched him, and saith unto him, I will; be thou clean.

42 And as soon as he had spoken, immediately the leprosy departed from him, and he was cleansed.

43 And he straitly charged him, and forthwith sent him away;

44 And saith unto him, See thou say nothing to any man: but go thy way, shew thyself to the priest, and offer for thy cleansing those things which Moses commanded, for a testimony unto them.

45 But he went out, and began to publish it much, and to blaze abroad the matter, insomuch that Jesus could no more openly enter into the city, but was without in desert places: and they came to him from every quarter.

37 And when they had found him, they said unto him, All men seek for thee.

38 And he said unto them, Let us go into the next towns, that I may preach there also: for therefore came I forth.

LUKE 4:38–43

38 And he arose out of the synagogue, and entered into Simon's house. And Simon's wife's mother was taken with a great fever; and they besought him for her.

39 And he stood over her, and rebuked the fever; and it left her: and immediately she arose and ministered unto them.

40 Now when the sun was setting, all they that had any sick with divers diseases brought them unto him; and he laid his hands on every one of them, and healed them.

41 And devils also came out of many, crying out, and saying, Thou art Christ the Son of God. And he rebuking them suffered them not to speak: for they knew that he was Christ.

42 And when it was day, he departed and went into a desert place: and the people sought him, and came unto him, and stayed him, that he should not depart from them.

43 And he said unto them, I must preach the kingdom of God to other cities also: for therefore am I sent.

JESUS PREACHES AROUND GALILEE

MATTHEW 4:23

23 And Jesus went about all Galilee, teaching in their synagogues, and preaching the gospel of the kingdom, and healing all manner of sickness and all manner of disease among the people.

MARK 1:39

39 And he preached in their synagogues throughout all Galilee, and cast out devils.

LUKE 4:44

44 And he preached in the synagogues of Galilee.

12 And it came to pass, when he was in a certain city, behold a man full of leprosy: who seeing Jesus fell on his face, and besought him, saying, Lord, if thou wilt, thou canst make me clean.

13 And he put forth his hand, and touched him, saying, I will: be thou clean. And immediately the leprosy departed from him.

14 And he charged him to tell no man: but go, and shew thyself to the priest, and offer for thy cleansing, according as Moses commanded, for a testimony unto them.

15 But so much the more went there a fame abroad of him: and great multitudes came together to hear, and to be healed by him of their infirmities.

16 And he withdrew himself into the wilderness, and prayed.

HEALING OF A PARALYTIC

Once again a house in Capernaum becomes the scene of Jesus' healing, as four men come carrying a paralyzed man on a bed to Jesus. Because of the crowd, they need to climb to the roof of the house and open a hole in the roof to bring him close to Jesus. Seeing the faith of those who bear this paralytic, Jesus declares—to everyone's surprise—"Son, thy sins be forgiven thee." What man, indeed, has the authority to forgive sins? Jesus, in answer to the onlookers' unspoken question demonstrates his authority by telling the paralytic to rise, take up his bed, and walk home. John records the healing of a paralytic somewhat differently, but that healing, at the Pool of Bethesda, creates a similar controversy, as the man who carries his bed is seen doing it on the Sabbath day, when work is forbidden.

MATTHEW 9:1–8

1 And he entered into a ship, and passed over, and came into his own city.

The Leper, by Alexander Bida, 1813–1895

2 And, behold, they brought to him a man sick of the palsy, lying on a bed: and Jesus seeing their faith said unto the sick of the palsy; Son, be of good cheer; thy sins be forgiven thee.

3 And, behold, certain of the scribes said within themselves, This man blasphemeth.

4 And Jesus knowing their thoughts said, Wherefore think ye evil in your hearts?

5 For whether is easier, to say, Thy sins be forgiven thee; or to say, Arise, and walk?

6 But that ye may know that the Son of man hath power on earth to forgive sins, (then saith he to the sick of the palsy,) Arise, take up thy bed, and go unto thine house.

7 And he arose, and departed to his house.

8 But when the multitudes saw it, they marvelled, and glorified God, which had given such power unto men.

MARK 2:1–12

1 And again he entered into Capernaum, after some days; and it was noised that he was in the house.

2 And straightway many were gathered together, insomuch that there was no room to receive them, no, not so much as about the door: and he preached the word unto them.

3 And they come unto him, bringing one sick of the palsy, which was borne of four.

4 And when they could not come nigh unto him for the press, they uncovered the roof where he was: and when they had broken it up, they let down the bed wherein the sick of the palsy lay.

5 When Jesus saw their faith, he said unto the sick of the palsy, Son, thy sins be forgiven thee.

6 But there were certain of the scribes sitting there, and reasoning in their hearts,

7 Why doth this man thus speak blasphemies? who can forgive sins but God only?

8 And immediately when Jesus perceived in his spirit that they so rea-soned within themselves, he said unto them, Why reason ye these things in your hearts?

9 Whether is it easier to say to the sick of the palsy, Thy sins be forgiven thee; or to say, Arise, and take up thy bed, and walk?

10 But that ye may know that the Son of man hath power on earth to forgive sins, (he saith to the sick of the palsy,)

11 I say unto thee, Arise, and take up thy bed, and go thy way into thine house.

12 And immediately he arose, took up the bed, and went forth before them all; insomuch that they were all amazed, and glorified God, saying, We never saw it on this fashion.

LUKE 5:17–26

17 And it came to pass on a certain day, as he was teaching, that there were Pharisees and doctors of the law sitting by, which were come out of every town of Galilee, and Judaea, and Jerusalem: and the power of the Lord was present to heal them.

18 And, behold, men brought in a bed a man which was taken with a palsy: and they sought means to bring him in, and to lay him before him.

19 And when they could not find by what way they might bring him in because of the multitude, they went upon the housetop, and let him down through the tiling with his couch into the midst before Jesus.

20 And when he saw their faith, he said unto him, Man, thy sins are forgiven thee.

21 And the scribes and the Pharisees began to reason, saying, Who is this which speaketh blasphemies? Who can forgive sins, but God alone?

22 But when Jesus perceived their thoughts, he answering said unto them, What reason ye in your hearts?

Healing of the Impotent Man at the Pool, by Alexander Bida, 1813-1895

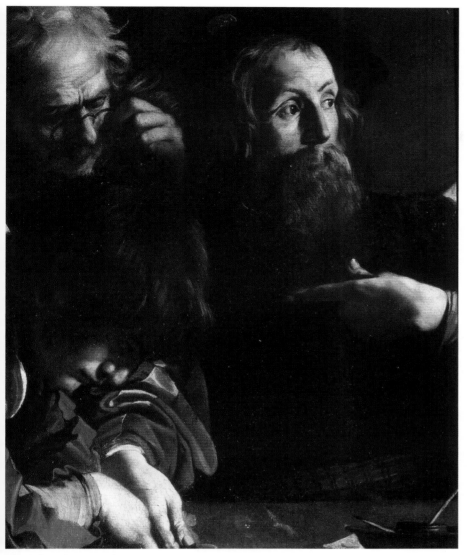

The Calling of Saint Matthew, 1599–1600, by Michelangelo Merisi da Caravaggio, 1571–1610

23 Whether is easier, to say, Thy sins be forgiven thee; or to say, Rise up and walk?

24 But that ye may know that the Son of man hath power upon earth to forgive sins, (he said unto the sick of the palsy,) I say unto thee, Arise, and take up thy couch, and go into thine house.

25 And immediately he rose up before them, and took up that whereon he lay, and departed to his own house, glorifying God.

26 And they were all amazed, and they glorified God, and were filled with fear, saying, We have seen strange things to day.

JOHN 5:1–9

1 After this there was a feast of the Jews; and Jesus went up to Jerusalem.

2 Now there is at Jerusalem by the sheep market a pool, which is called in the Hebrew tongue Bethesda, having five porches.

3 In these lay a great multitude of impotent folk, of blind, halt, withered, waiting for the moving of the water.

4 For an angel went down at a certain season into the pool, and troubled the water: whosoever then first after the troubling of the water stepped in

was made whole of whatsoever disease he had.

5 And a certain man was there, which had an infirmity thirty and eight years.

6 When Jesus saw him lie, and knew that he had been now a long time in that case, he saith unto him, Wilt thou be made whole?

7 The impotent man answered him, Sir, I have no man, when the water is troubled, to put me into the pool: but while I am coming, another steppeth down before me.

8 Jesus saith unto him, Rise, take up thy bed, and walk.

9 And immediately the man was made whole, and took up his bed, and walked: and on the same day was the sabbath.

CALLING LEVI (MATTHEW), THE TAX COLLECTOR

Among Jesus' followers were many tax collectors (or "publicans"). One of these Mark and Luke call by the name Levi. Matthew's version identifies him as "Matthew." By whatever name, tax collectors, because they bought the franchise for collecting tribute for the Roman government—and often used their "authority" to extort money from their peers and make themselves wealthy—were almost universally despised. "Almost," for Jesus invites this one to "follow me," and he too, leaves everything to follow him. (Could he be the "Matthew" by whose name the gospel is called?) Jesus comes to eat at his house, where many other "publicans and sinners" gather. Here as above, there is a "chorus" in the wings— Mark identifies them as "scribes and Pharisees"—who take issue with the company Jesus keeps. As the story progresses, these and others will become the foils of the story—the characters in the drama that provide the reason why Jesus, who does many

healings and works of compassion winds up being notorious enough to get nailed to a Roman cross.

MATTHEW 9:9–13

9 And as Jesus passed forth from thence, he saw a man, named Matthew, sitting at the receipt of custom: and he saith unto him, Follow me. And he arose, and followed him.

10 And it came to pass, as Jesus sat at meat in the house, behold, many publicans and sinners came and sat down with him and his disciples.

11 And when the Pharisees saw it, they said unto his disciples, Why eateth your Master with publicans and sinners?

12 But when Jesus heard that, he said unto them, They that be whole need not a physician, but they that are sick.

13 But go ye and learn what that meaneth, I will have mercy, and not sacrifice: for I am not come to call the righteous, but sinners to repentance.

MARK 2:13–17

13 And he went forth again by the sea side; and all the multitude resorted unto him, and he taught them.

14 And as he passed by, he saw Levi the son of Alphaeus sitting at the receipt of custom, and said unto him, Follow me. And he arose and followed him.

15 And it came to pass, that, as Jesus sat at meat in his house, many publicans and sinners sat also together with Jesus and his disciples for there were many, and they followed him.

16 And when the scribes and Pharisees saw him eat with publicans and sinners, they said unto his disciples, How is it that he eateth and drinketh with publicans and sinners?

17 When Jesus heard it, he saith unto them, They that are whole have no need of the physician, but they that are sick: I came not to call the righteous, but sinners to repentance.

LUKE 5: 27–32

27 And after these things he went forth, and saw a publican, named Levi, sitting at the receipt of custom: and he said unto him, Follow me.

28 And he left all, rose up, and followed him.

29 And Levi made him a great feast in his own house: and there was a great company of publicans and of others that sat down with them.

30 But their scribes and Pharisees murmured against his disciples, saying, Why do ye eat and drink with publicans and sinners?

31 And Jesus answering said unto them, They that are whole need not a physician; but they that are sick.

32 I came not to call the righteous, but sinners to repentance.

ANSWERING QUESTIONS ABOUT FASTING AND KEEPING THE SABBATH

Now some disciples of John come to Jesus and ask why, while they and the Pharisees practice regular fasting, Jesus and his disciples do not. The question brings a response from Jesus about what happens when "new wine" gets put in "old wineskins;" and what needs to be done, if one would preserve both the wine and the skins. A similar question is raised about Jesus' disciples plucking heads of grain on the Sabbath, a question which brings Jesus' declaration in Mark that "the Sabbath was made for man and not man for the Sabbath." Luke and Matthew join him in his conclusion—that "the Son of Man is Lord also of the Sabbath."

MATTHEW 9:14–17

14 Then came to him the disciples of John, saying, Why do we and the Pharisees fast oft, but thy disciples fast not?

Casting a Net, Artist Unknown

Oriental Mode of Threshing, Artist Unknown

25 And he said unto them, Have ye never read what David did, when he had need, and was an hungred, he, and they that were with him?

26 How he went into the house of God in the days of Abiathar the high priest, and did eat the shew-bread, which is not lawful to eat but for the priests, and gave also to them which were with him?

27 And he said unto them, The sabbath was made for man, and not man for the sabbath:

28 Therefore the Son of man is Lord also of the sabbath.

LUKE 5:33–39

33 And they said unto him, Why do the disciples of John fast often, and make prayers, and likewise the disciples of the Pharisees; but thine eat and drink?

34 And he said unto them, Can ye make the children of the bridechamber fast, while the bridegroom is with them?

35 But the days will come, when the bridegroom shall be taken away from them, and then shall they fast in those days.

36 And he spake also a parable unto them; No man putteth a piece of a new garment upon an old; if otherwise, then both the new maketh a rent, and the piece that was taken out of the new agreeth not with the old.

37 And no man putteth new wine into old bottles; else the new wine will burst the bottles, and be spilled, and the bottles shall perish.

38 But new wine must be put into new bottles; and both are preserved.

39 No man also having drunk old wine straightway desireth new: for he saith, The old is better.

15 And Jesus said unto them, Can the children of the bridechamber mourn, as long as the bridegroom is with them? but the days will come, when the bridegroom shall be taken from them, and then shall they fast.

16 No man putteth a piece of new cloth unto an old garment, for that which is put in to fill it up taketh from the garment, and the rent is made worse.

17 Neither do men put new wine into old bottles: else the bottles break, and the wine runneth out, and the bottles perish: but they put new wine into new bottles, and both are preserved.

MARK 2:18–28

18 And the disciples of John and of the Pharisees used to fast: and they come and say unto him, Why do the disciples of John and of the Pharisees fast, but thy disciples fast not?

19 And Jesus said unto them, Can the children of the bridechamber fast, while the bridegroom is with them? as long as they have the bridegroom with them, they cannot fast.

20 But the days will come, when the bridegroom shall be taken away from them, and then shall they fast in those days.

21 No man also seweth a piece of new cloth on an old garment else the new piece that filled it up taketh away from the old, and the rent is made worse.

22 And no man putteth new wine into old bottles: else the new wine doth burst the bottles, and the wine is spilled, and the bottles will be marred: but new wine must be put into new bottles.

23 And it came to pass, that he went through the corn fields on the sabbath day; and his disciples began, as they went, to pluck the ears of corn.

24 And the Pharisees said unto him, Behold, why do they on the sab-bath day that which is not lawful?

MATTHEW 12:1-8

1 At that time Jesus went on the sabbath day through the corn; and his disciples were an hungred, and began to pluck the ears of corn, and to eat.

2 But when the Pharisees saw it, they said unto him, Behold, thy disciples do that which is not lawful to do upon the sabbath day.

3 But he said unto them, Have ye not read what David did, when he was an hungred, and they that were with him;

4 How he entered into the house of God, and did eat the shewbread, which was not lawful for him to eat, neither for them which were with him, but only for the priests?

5 Or have ye not read in the law, how that on the sabbath days the priests in the temple profane the sabbath, and are blameless?

6 But I say unto you, That in this place is one greater than the temple.

7 But if ye had known what this meaneth, I will have mercy, and not sacrifice, ye would not have condemned the guiltless.

8 For the Son of man is Lord even of the sabbath day.

LUKE 6:1–5

1 And it came to pass on the second sabbath after the first, that he went through the corn fields; and his disciples plucked the ears of corn, and did eat, rubbing them in their hands.

2 And certain of the Pharisees said unto them, Why do ye that which is not lawful to do on the sabbath days?

3 And Jesus answering them said, Have ye not read so much as this, what David did, when himself was an hungred, and they which were with him;

4 How he went into the house of God, and did take and eat the shewbread, and gave also to them that were with him; which it is not lawful to eat but for the priests alone?

5 And he said unto them, That the Son of man is Lord also of the sabbath.

RESTORING A MAN'S WITHERED HAND ON THE SABBATH

Again in a synagogue on the Sabbath, Jesus sees a man with a withered hand and asks whether it is lawful to do good or to do harm on the Sabbath. Here, the "chorus" remains silent. Matthew and Luke, from the tradition they have in common, add a comparison Jesus makes between the lawfulness of caring for an animal on the Sabbath—and, if that is considered lawful, how much more should healing a human? Jesus restores the man's hand—and the opposition, in which a new group, the Herodians, are now added, take counsel against him, "that they might destroy him."

MATTHEW 12:9–14

9 And when he was departed thence, he went into their synagogue:

10 And, behold, there was a man which had his hand withered. And they asked him, saying, Is it lawful to heal on the sabbath days? that they might accuse him.

11 And he said unto them, What man shall there be among you, that shall have one sheep, and if it fall into a pit on the sabbath day, will he not lay hold on it, and lift it out?

12 How much then is a man better than a sheep? Wherefore it is lawful to do well on the sabbath days.

13 Then saith he to the man, Stretch forth thine hand. And he stretched it forth; and it was restored whole, like as the other.

14 Then the Pharisees went out, and held a council against him, how they might destroy him.

MARK 5:1–6

1 And they came over unto the other side of the sea, into the country of the Gadarenes.

2 And when he was come out of the ship, immediately there met him out of the tombs a man with an unclean spirit,

3 Who had his dwelling among the tombs; and no man could bind him, no, not with chains:

And he came down with them, and stood in the plain, and the company of his disciples, and a great multitude of people out of all Judaea and Jerusalem, and from the sea coast of Tyre and Sidon, which came to hear him, and to be healed of their diseases.

—LUKE 6:17

7 And the scribes and Pharisees watched him, whether he would heal on the sabbath day; that they might find an accusation against him.

8 But he knew their thoughts, and said to the man which had the withered hand, Rise up, and stand forth in the midst. And he arose and stood forth.

9 Then said Jesus unto them, I will ask you one thing; Is it lawful on the sabbath days to do good, or to do evil? to save life, or to destroy it?

10 And looking round about upon them all, he said unto the man, Stretch forth thy hand. And he did so: and his hand was restored whole as the other.

11 And they were filled with madness; and communed one with another what they might do to Jesus.

HEALING A CROWD BY THE SEA

From there, Jesus withdraws to the sea, where the crowds follow from Galilee and from Judea. Jesus is portrayed as being almost constantly surrounded by crowds, eager to hear his teaching and bringing people sick with many diseases to be healed by him. Matthew sees in these a latter-day fulfillment of the prophet Isaiah's description of the Servant of the Lord in Isaiah 42: "Behold my servant, whom I have chosen…he shall show judgment… and in him shall the Gentiles trust."

MATTHEW 4:24–25

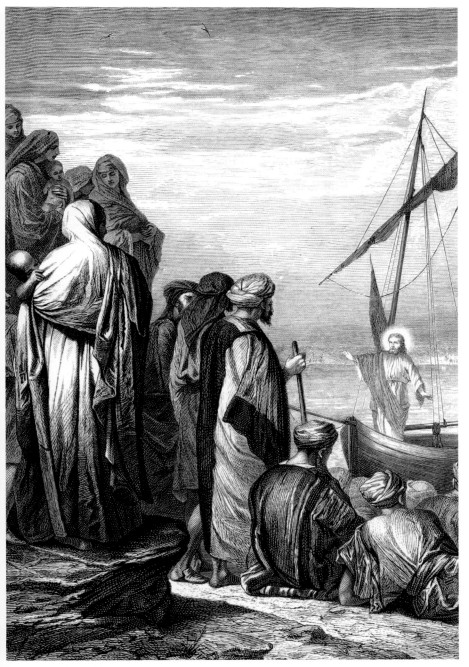

Jesus Preaches from a Ship, by Alexander Bida, 1813–1895

4 Because that he had been often bound with fetters and chains, and the chains had been plucked asunder by him, and the fetters broken in pieces: neither could any man tame him.

5 And always, night and day, he was in the mountains, and in the tombs, crying, and cutting himself with stones.

6 But when he saw Jesus afar off, he ran and worshipped him,

LUKE 6:6–11

6 And it came to pass also on ano ther sabbath, that he entered into the synagogue and taught: and there was a man whose right hand was withered.

24 And his fame went throughout all Syria: and they brought unto him all sick people that were taken with divers diseases and torments, and those which were possessed with devils, and those which were lunatick, and those that had the palsy; and he healed them.

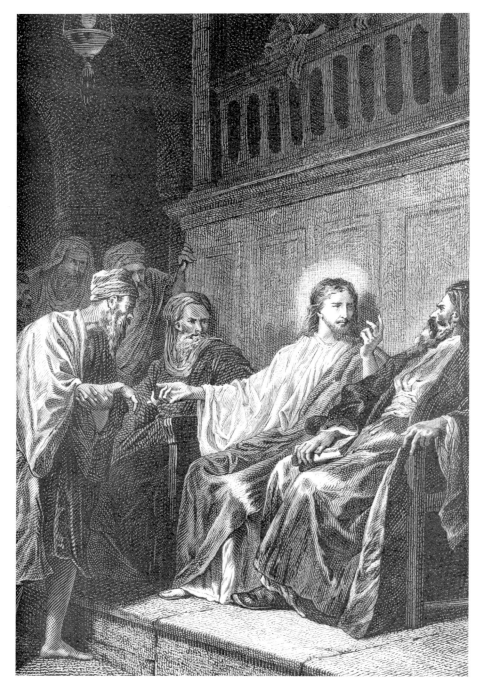

The Man with the Withered Hand, by Alexander Bida, 1813–1895

9 And he spake to his disciples, that a small ship should wait on him because of the multitude, lest they should throng him.

10 For he had healed many; insomuch that they pressed upon him for to touch him, as many as had plagues.

11 And unclean spirits, when they saw him, fell down before him, and cried, saying, Thou art the Son of God.

12 And he straitly charged them that they should not make him known.

LUKE 6:17–19

17 And he came down with them, and stood in the plain, and the company of his disciples, and a great multitude of people out of all Judaea and Jerusalem, and from the sea coast of Tyre and Sidon, which came to hear him, and to be healed of their diseases;

18 And they that were vexed with unclean spirits: and they were healed.

19 And the whole multitude sought to touch him: for there went virtue out of him, and healed them all.

MATTHEW 12:15–21

15 But when Jesus knew it, he withdrew himself from thence: and great multitudes followed him, and he healed them all;

16 And charged them that they should not make him known:

17 That it might be fulfilled which was spoken by Esaias the prophet, saying,

18 Behold my servant, whom I have chosen; my beloved, in whom my soul is well pleased: I will put my spirit upon him, and he shall shew judgment to the Gentiles.

19 He shall not strive, nor cry; neither shall any man hear his voice in the streets.

25 And there followed him great multitudes of people from Galilee, and from Decapolis, and from erusalem, and from Judaea, and from beyond Jordan.

MARK 3:7–12

7 But Jesus withdrew himself with his disciples to the sea: and a great mul-titude from Galilee followed him, and from Judaea,

8 And from Jerusalem, and from Idumaea, and from beyond Jordan; and they about Tyre and Sidon, a great multitude, when they had heard what great things he did, came unto him.

20 A bruised reed shall he not break, and smoking flax shall he not quench, till he send forth judgment unto victory.

21 And in his name shall the Gentiles trust.

LUKE 4:41

41 And devils also came out of many, crying out, and saying, Thou art Christ the Son of God. And he rebuking them suffered them not to speak: for they knew that he was Christ.

MATTHEW 14:35–36

35 And when the men of that place had knowledge of him, they sent out into all that country round about, and brought unto him all that were diseased;

36 And besought him that they might only touch the hem of his garment: and as many as touched were made perfectly whole.

MARK 6:54–56

54 And when they were come out of the ship, straightway they knew him,

55 And ran through that whole region round about, and began to carry about in beds those that were sick, where they heard he was.

56 And whithersoever he entered, into villages, or cities, or country, they laid the sick in the streets, and besought him that they might touch if it were but the border of his garment: and as many as touched him were made whole.

MATTHEW 9:20–21

20 And, behold, a woman, which was diseased with an issue of blood twelve years, came behind him, and touched the hem of his garment:

21 For she said within herself, If I may but touch his garment, I shall be whole.

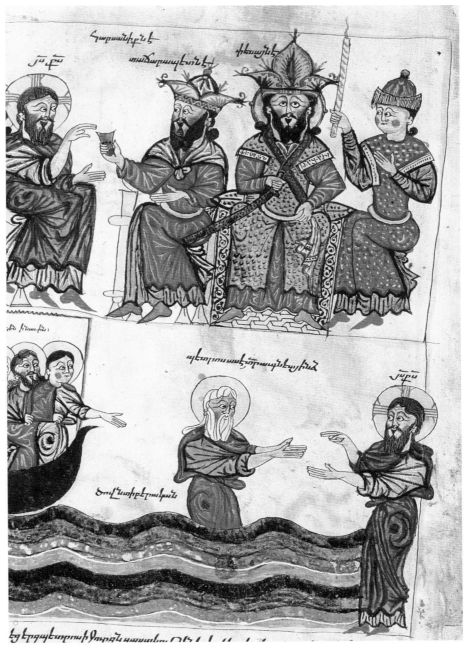

The Marriage Feast at Cana: Christ Walking on Water, 12th–13th century, Artist Unknown

MARK 5:27–28

27 When she had heard of Jesus, came in the press behind, and touched his garment.

28 For she said, If I may touch but his clothes, I shall be whole.

LUKE 8:44

44 Came behind him, and touched the border of his garment: and immediately her issue of blood stanched.

MARK 1:34

34 And he healed many that were sick of divers diseases, and cast out many devils; and suffered not the devils to speak, because they knew him.

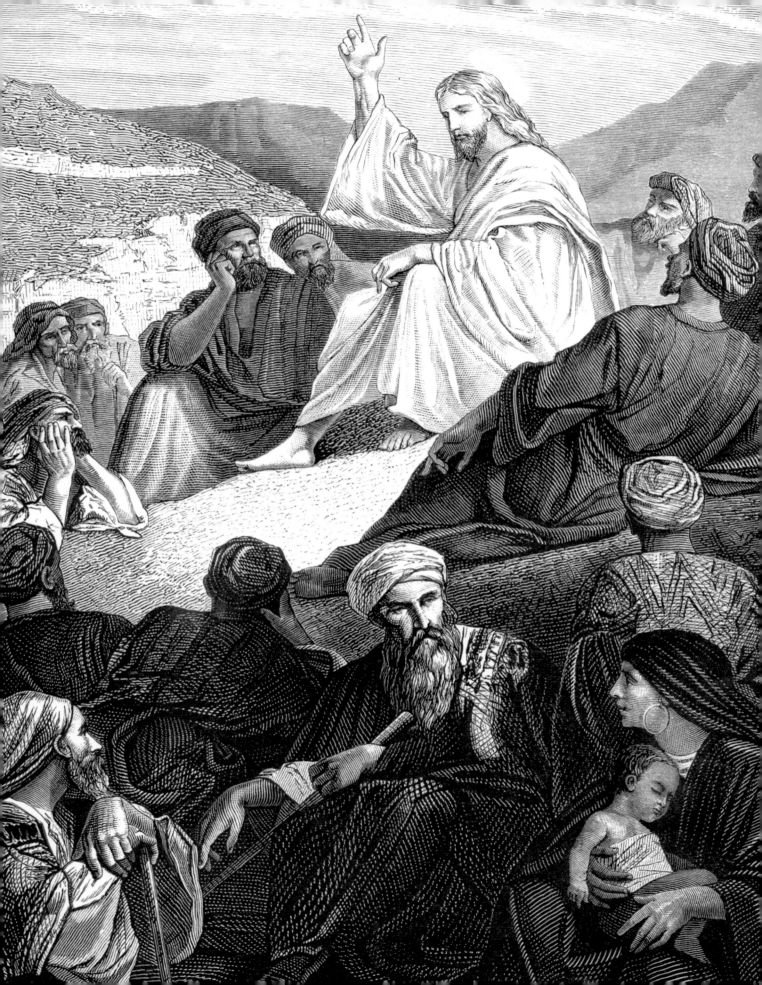

LIFE of JESUS

Jesus Teaches the Crowds

Jesus Teaches the Crowds

Christ Blessing, by Fernando Gallegos, c.1440–after 1507

MATTHEW AND LUKE, while they both know and make use of Mark's story, also have access to a common source containing an extensive collection of Jesus' sayings and teachings. Matthew brings large amounts of it together into five large "sermons" which are inserted into the simple, two-part, Galilee/Jerusalem outline of Mark. The first of these is the well-beloved "Sermon on the Mount," where, in a fashion modeled after and drawn from Moses, Jesus teaches about the "Kingdom of Heaven." Luke brings together a significant amount of the story in what has come to be known as "the Sermon on the Plain."

THE OCCASION OF THE SERMON

Matthew, writing for a primarily Jewish audience, portrays Jesus' teachings of the Laws and the Prophets. Luke, writing for a largely Gentile audience, makes frequent use of contrasts.

MATTHEW 4:24–5:2A

24 And his fame went throughout all Syria: and they brought unto him all sick people that were taken with divers diseases and torments, and those which were possessed with devils, and those which were lunatick, and those that had the palsy; and he healed them.

25 And there followed him great multitudes of people from Galilee, and from Decapolis, and from Jerusalem, and from Judaea, and from beyond Jordan.

MATTHEW 5

1 And seeing the multitudes, he went up into a mountain: and when he was set, his disciples came unto him:

2 And he opened his mouth, and taught them.

MARK 3:7–13

7 But Jesus withdrew himself with his disciples to the sea: and a great multitude from Galilee followed him, and from Judaea,

8 And from Jerusalem, and from Idumaea, and from beyond Jordan; and they about Tyre and Sidon, a great multitude, when they had heard what great things he did, came unto him.

9 And he spake to his disciples, that a small ship should wait on him because of the multitude, lest they should throng him.

10 For he had healed many; insomuch that they pressed upon him for to touch him, as many as had plagues.

The Sermon on the Mount, by Alexander Bida, 1813–1895

And from Jerusalem, and from Idumaea, and from beyond Jordan; and they about Tyre and Sidon, a great multitude, when they had heard what great things he did, came unto him.

—MARK 3:8

The Sermon on the Mount, Our Father, by Domenico Morelli, 1826–1901

11 And unclean spirits, when they saw him, fell down before him, and cried, saying, Thou art the Son of God.

12 And he straitly charged them that they should not make him known.

13 And he goeth up into a mountain, and calleth unto him whom he would: and they came unto him.

LUKE 6:17–20

17 And he came down with them, and stood in the plain, and the company of his disciples, and a great multitude of people out of all Judaea and Jerusalem, and from the sea coast of Tyre and Sidon, which came to hear him, and to be healed of their diseases;

18 And they that were vexed with unclean spirits: and they were healed.

19 And the whole multitude sought to touch him: for there went virtue out of him, and healed them all.

20 And he lifted up his eyes on his disciples, and said, Blessed be ye poor: for yours is the kingdom of God.

THE BEATITUDES (AND THE WOES IN LUKE)

Both Matthew and Luke begin with the Beatitudes, statements use the form: "How blessed are those who...." Where Matthew contains eight beatitudes, Luke offers four beatitudes with four corresponding "woes"—setting apart the blessed poor and the rich, the hungry and satisfied, the mourners and the laughers, the prophets and the false prophets—and noting the reversal that will take place for each, when the kingdom comes.

And unclean spirits, when they saw him, fell down before him, and cried, saying, Thou art the Son of God.

—MARK 3:11

MATTHEW 5:3–12

3 Blessed are the poor in spirit: for theirs is the kingdom of heaven.

4 Blessed are they that mourn: for they shall be comforted.

5 Blessed are the meek: for they shall inherit the earth.

6 Blessed are they which do hunger and thirst after righteousness: for they shall be filled.

7 Blessed are the merciful: for they shall obtain mercy.

8 Blessed are the pure in heart: for they shall see God.

9 Blessed are the peacemakers: for they shall be called the children of God.

10 Blessed are they which are persecuted for righteousness' sake: for theirs is the kingdom of heaven.

11 Blessed are ye, when men shall revile you, and persecute you, and shall say all manner of evil against you falsely, for my sake.

12 Rejoice, and be exceeding glad: for great is your reward in heaven: for so persecuted they the prophets which were before you.

LUKE 6:20–26

20 And he lifted up his eyes on his disciples, and said, Blessed be ye poor: for yours is the kingdom of God.

21 Blessed are ye that hunger now: for ye shall be filled. Blessed are ye that weep now: for ye shall laugh.

22 Blessed are ye, when men shall hate you, and when they shall separate you from their company, and shall reproach you, and cast out your name as evil, for the Son of man's sake.

23 Rejoice ye in that day, and leap for joy: for, behold, your reward is great in heaven: for in the like manner did their fathers unto the prophets.

24 But woe unto you that are rich! for ye have received your consolation.

25 Woe unto you that are full! for ye shall hunger. Woe unto you that laugh now! for ye shall mourn and weep.

26 Woe unto you, when all men shall speak well of you! for so did their fathers to the false prophets.

SALT OF THE EARTH, LIGHT OF THE WORLD

MATTHEW 5:13–16

13 Ye are the salt of the earth: but if the salt have lost his savour, wherewith shall it be salted? it is thenceforth good for nothing, but to be cast out, and to be trodden under foot of men.

14 Ye are the light of the world. A city that is set on an hill cannot be hid.

15 Neither do men light a candle, and put it under a bushel, but on a candlestick; and it giveth light unto all that are in the house.

16 Let your light so shine before men, that they may see your good works, and glorify your Father which is in heaven.

MARK 9:49–50

49 For every one shall be salted with fire, and every sacrifice shall be salted with salt.

50 Salt is good: but if the salt have lost his saltness, wherewith will ye season it? Have salt in yourselves, and have peace one with another.

LUKE 14:34–35

34 Salt is good: but if the salt have lost his savour, wherewith shall it be seasoned?

35 It is neither fit for the land, nor yet for the dunghill; but men cast it out. He that hath ears to hear, let him hear.

MARK 4:21

21 And he said unto them, Is a candle brought to be put under a bushel, or under a bed? and not to be set on a candlestick?

LUKE 8:16

16 And they reasoned among themselves, saying, It is because we have no bread.

JOHN 8:12

12 Then spake Jesus again unto them, saying, I am the light of the world: he that followeth me shall not walk in darkness, but shall have the light of life.

Blessed are ye, when men shall hate you, and when they shall separate you from their company, and shall reproach you, and cast out your name as evil, for the Son of man's sake.

—LUKE 6:22

ON THE LAW AND THE PROPHETS

Jesus, having stated his theme, comments on the Ten Commandments, noting that God's intention for people is not merely the avoiding of evil, but also the active doing of righteousness. Not only is killing forbidden, but anything, even a thoughtless remark, that makes another "less of a person." Not only is the act of adultery forbidden, but also the lustful desire that "commits adultery already" in his heart Jesus comes, "not to destroy the law and the prophets, but to fulfill them." Jesus sums up God's will for God's people: "Be ye therefore perfect, as thy Father which is in heaven is perfect." Be complete, the same on the inside as on the outside.

MATTHEW 5:17–20

17 Think not that I am come to destroy the law, or the prophets: I am not come to destroy, but to fulfill.

18 For verily I say unto you, Till heaven and earth pass, one jot or one tittle shall in no wise pass from the law, till all be fulfilled.

19 Whosoever therefore shall break one of these least commandments, and shall teach men so, he shall be called the least in the kingdom of heaven: but whosoever shall do and teach them, the same shall be called great in the kingdom of heaven.

20 For I say unto you, That except your righteousness shall exceed the righteousness of the scribes and Pharisees, ye shall in no case enter into the kingdom of heaven.

LUKE 16:16–17

16 And Simon Peter answered and said, Thou art the Christ, the Son of the living God.

17 And Jesus answered and said unto him, Blessed art thou, Simon Barjona: for flesh and blood hath not revealed it unto thee, but my Father which is in heaven.

JESUS INTERPRETS THE COMMANDMENTS: ON MURDER AND ANGER

MATTHEW 5:21–26

21 Ye have heard that it was said by them of old time, Thou shalt not kill; and whosoever shall kill shall be in danger of the judgment:

22 But I say unto you, That whosoever is angry with his brother without a cause shall be in danger of the judgment: and whosoever shall say to his brother, Raca, shall be in danger of the council: but whosoever shall say, Thou fool, shall be in danger of hell fire.

23 Therefore if thou bring thy gift to the altar, and there rememberest that thy brother hath ought against thee;

24 Leave there thy gift before the altar, and go thy way; first be reconciled to thy brother, and then come and offer thy gift.

25 Agree with thine adversary quickly, whiles thou art in the way with him; lest at any time the adversary deliver thee to the judge, and the judge deliver thee to the officer, and thou be cast into prison.

26 Verily I say unto thee, Thou shalt by no means come out thence, till thou hast paid the uttermost farthing.

MARK 11:25

25 And when ye stand praying, forgive, if ye have ought against any: that your Father also which is in heaven may forgive you your trespasses.

LUKE 12:57–59

57 Yea, and why even of yourselves judge ye not what is right?

58 When thou goest with thine adversary to the magistrate, as thou art in the way, give diligence that thou mayest be delivered from him; lest he hale thee to the judge, and the judge deliver thee to the officer, and the officer cast thee into prison.

59 I tell thee, thou shalt not depart thence, till thou hast paid the very last mite.

Whosoever therefore shall break one of these least commandments, and shall teach men so, he shall be called the least in the kingdom of heaven: but whosoever shall do and teach them, the same shall be called great in the kingdom of heaven.

For I say unto you, That except your righteousness shall exceed the righteousness of the scribes and Pharisees, ye shall in no case enter into the kingdom of heaven.

—MATTHEW 5:19–20

ON ADULTERY AND DIVORCE

MATTHEW 5:27–32

27 Ye have heard that it was said by them of old time, Thou shalt not commit adultery:

28 But I say unto you, That whosoever looketh on a woman to lust after her hath committed adultery with her already in his heart.

29 And if thy right eye offend thee, pluck it out, and cast it from thee: for it is profitable for thee that one of thy members should perish, and not that thy whole body should be cast into hell.

30 And if thy right hand offend thee, cut if off, and cast it from thee: for it is profitable for thee that one of thy members should perish, and not that thy whole body should be cast into hell.

31 It hath been said, Whosoever shall put away his wife, let him give her a writing of divorcement:

32 But I say unto you, That whosoever shall put away his wife, saving for the cause of fornication, causeth her to commit adultery: and whosoever shall marry her that is divorced committeth adultery.

MARK 9:43–48

43 And if thy hand offend thee, cut it off: it is better for thee to enter into life maimed, than having two hands to go into hell, into the fire that never shall be quenched:

44 Where their worm dieth not, and the fire is not quenched.

45 And if thy foot offend thee, cut it off: it is better for thee to enter halt into life, than having two feet to be cast into hell, into the fire that never shall be quenched:

46 Where their worm dieth not, and the fire is not quenched.

47 And if thine eye offend thee, pluck it out: it is better for thee to enter into the kingdom of God with one eye, than having two eyes to be cast into hell fire:

48 Where their worm dieth not, and the fire is not quenched.

LUKE 16:18

18 Whosoever putteth away his wife, and marrieth another, committeth adultery: and whosoever marrieth her that is put away from her husband committeth adultery.

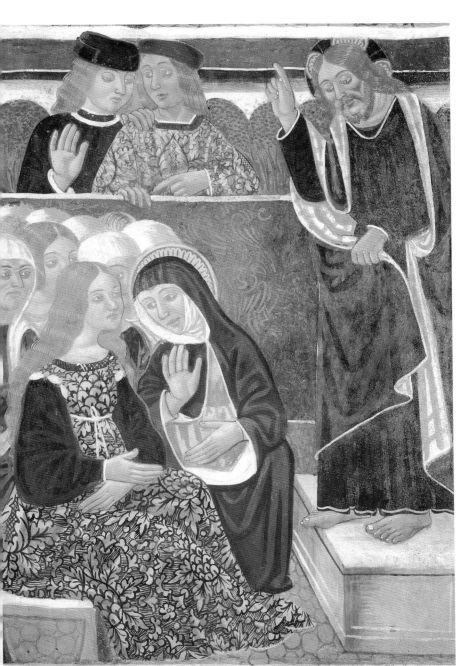

Christ's Sermon to the Women, 15th century, by Francesco & Sperindio Cagnola

MATTHEW 18:8–9

8 Wherefore if thy hand or thy foot offend thee, cut them off, and cast them from thee: it is better for thee to enter into life halt or maimed, rather than having two hands or two feet to be cast into everlasting fire.

9 And if thine eye offend thee, pluck it out, and cast it from thee: it is better for thee to enter into life with one eye, rather than having two eyes to be cast into hell fire.

MATTHEW 19:7–9

7 They say unto him, Why did Moses then command to give a writing of divorcement, and to put her away?

8 He saith unto them, Moses because of the hardness of your hearts suffered you to put away your wives: but from the beginning it was not so.

9 And I say unto you, Whosoever shall put away his wife, except it be for fornication, and shall marry another, committeth adultery: and whoso

And he said unto them, When ye pray, say, Our Father which art in heaven, Hallowed be thy name. Thy kingdom come. Thy will be done, as in heaven, so in earth.

—LUKE 11:2

marrieth her which is put away doth commit adultery.

MARK 10:3–4

3 And he answered and said unto them, What did Moses command you?

4 And they said, Moses suffered to write a bill of divorcement, and to put her away.

MARK 10:11–12

11 And he saith unto them, Whosoever shall put away his wife, and marry another, committeth adultery against her.

12 And if a woman shall put away her husband, and be married to another, she committeth adultery.

ON SWEARING OATHS

MATTHEW 5:33–37

33 Again, ye have heard that it hath been said by them of old time, Thou shalt not forswear thyself, but shalt perform unto the Lord thine oaths:

34 But I say unto you, Swear not at all; neither by heaven; for it is God's throne:

35 Nor by the earth; for it is his footstool: neither by Jerusalem; for it is the city of the great King.

36 Neither shalt thou swear by thy head, because thou canst not make one hair white or black.

37 But let your communication be, Yea, yea; Nay, nay: for whatsoever is more than these cometh of evil.

ON RETALIATING

MATTHEW 5:38–42

38 Ye have heard that it hath been said, An eye for an eye, and a tooth for a tooth:

39 But I say unto you, That ye resist not evil: but whosoever shall smite thee on thy right cheek, turn to him the other also.

40 And if any man will sue thee at the law, and take away thy coat, let him have thy cloke also.

41 And whosoever shall compel thee to go a mile, go with him twain.

42 Give to him that asketh thee, and from him that would borrow of thee turn not thou away.

LUKE 6:29–30

29 And unto him that smiteth thee on the one cheek offer also the other; and him that taketh away thy cloke forbid not to take thy coat also.

30 Give to every man that asketh of thee; and of him that taketh away thy goods ask them not again.

ON LOVING ONE'S ENEMIES

MATTHEW 5:43–48

43 Ye have heard that it hath been said, Thou shalt love thy neighbour, and hate thine enemy.

44 But I say unto you, Love your enemies, bless them that curse you, do good to them that hate you, and pray for them which despitefully use you, and persecute you;

45 That ye may be the children of your Father which is in heaven: for he maketh his sun to rise on the evil and on the good, and sendeth rain on the just and on the unjust.

46 For if ye love them which love you, what reward have ye? do not even the publicans the same?

47 And if ye salute your brethren only, what do ye more than others? do not even the publicans so?

48 Be ye therefore perfect, even as your Father which is in heaven is perfect.

LUKE 6:27–28

27 But I say unto you which hear, Love your enemies, do good to them which hate you,

28 Bless them that curse you, and pray for them which despitefully use you.

LUKE 6:32–36

32 For if ye love them which love you, what thank have ye? for sinners also love those that love them.

33 And if ye do good to them which do good to you, what thank have ye? for sinners also do even the same.

34 And if ye lend to them of whom ye hope to receive, what thank have ye? for sinners also lend to sinners, to receive as much again.

35 But love ye your enemies, and do good, and lend, hoping for nothing again; and your reward shall be great, and ye shall be the children of the Highest: for he is kind unto the unthankful and to the evil.

36 Be ye therefore merciful, as your Father also is merciful.

ON ALMSGIVING

Jesus continues in Matthew 6 to comment on the three traditional acts by which God's people "do righteousness," or express their devotion to God: sharing with the needy, praying, and fasting—going without in order to become more aware of the One from whom all good things come. The motive, in every case, is to do these things with one's heart fixed on God, not on what people will think of oneself. The approval that counts is the approval which your Father, who sees what is on the inside as well as the outside, will give you. In the section on prayer, the Lord's prayer is offered as the model prayer of those who would share in the Kingdom of Heaven.

And if ye lend to them of whom ye hope to receive, what thank have ye? for sinners also lend to sinners, to receive as much again.

—LUKE 6:34

Jewish Priest Offering Incense, Artist Unknown

The Prayer in Secret, by Alexander Bida, 1813–1895

MATTHEW 6:1–4

1 Take heed that ye do not your alms before men, to be seen of them: otherwise ye have no reward of your Father which is in heaven.

2 Therefore when thou doest thine alms, do not sound a trumpet before thee, as the hypocrites do in the synagogues and in the streets, that they may have glory of men. Verily I say unto you, They have their reward.

3 But when thou doest alms, let not thy left hand know what thy right hand doeth:

4 That thine alms may be in secret: and thy Father which seeth in secret himself shall reward thee openly.

ON PRAYER

MATTHEW 6:5–6

5 And when thou prayest, thou shalt not be as the hypocrites are: for they love to pray standing in the synagogues and in the corners of the streets, that they may be seen of men. Verily I say unto you, They have their reward.

6 But thou, when thou prayest, enter into thy closet, and when thou hast shut thy door, pray to thy Father which is in secret; and thy Father which seeth in secret shall reward thee openly.

THE LORD'S PRAYER

MATTHEW 6:7–15

7 But when ye pray, use not vain repetitions, as the heathen do: for they think that they shall be heard for their much speaking.

8 Be not ye therefore like unto them: for your Father knoweth what things ye have need of, before ye ask him.

9 After this manner therefore pray ye: Our Father which art in heaven, Hallowed be thy name.

10 Thy kingdom come. Thy will be done in earth, as it is in heaven.

11 Give us this day our daily bread.

12 And forgive us our debts, as we forgive our debtors.

13 And lead us not into temptation, but deliver us from evil: For thine is the kingdom, and the power, and the glory, for ever. Amen.

14 For if ye forgive men their trespasses, your heavenly Father will also forgive you:

15 But if ye forgive not men their trespasses, neither will your Father forgive your trespasses.

MARK 11:25–26

25 And when ye stand praying, forgive, if ye have ought against any: that your Father also which is in heaven may forgive you your trespasses.

26 But if ye do not forgive, neither will your Father which is in heaven forgive your trespasses.

LUKE 11:1–4

1 And it came to pass, that, as he was praying in a certain place, when he ceased, one of his disciples said unto him, Lord, teach us to pray, as John also taught his disciples.

2 And he said unto them, When ye pray, say, Our Father which art in heaven, Hallowed be thy name. Thy kingdom come. Thy will be done, as in heaven, so in earth.

3 Give us day by day our daily bread.

4 And forgive us our sins; for we also forgive every one that is indebted to us. And lead us not into temptation; but deliver us from evil.

ON FASTING

MATTHEW 6:16–18

16 Moreover when ye fast, be not, as the hypocrites, of a sad countenance: for they disfigure their faces, that they may appear unto men to fast. Verily I say unto you, They have their reward.

17 But thou, when thou fastest, anoint thine head, and wash thy face;

18 That thou appear not unto men to fast, but unto thy Father which is in secret: and thy Father, which seeth in secret, shall reward thee openly.

ON STORING UP TREASURES

MATTHEW 6:19–21

19 Lay not up for yourselves treasures upon earth, where moth and rust doth corrupt, and where thieves break through and steal:

20 But lay up for yourselves treasures in heaven, where neither moth nor rust doth corrupt, and where thieves do not break through nor steal:

21 For where your treasure is, there will your heart be also.

LUKE 12:33–34

33 Sell that ye have, and give alms; provide yourselves bags which wax not old, a treasure in the heavens that faileth not, where no thief approacheth, neither moth corrupteth.

34 For where your treasure is, there will your heart be also.

MARK 10:21

21 Then Jesus beholding him loved him, and said unto him, One thing thou lackest: go thy way, sell whatsoever thou hast, and give to the poor, and thou shalt have treasure in heaven: and come, take up the cross, and follow me.

LUKE 18:22

22 Now when Jesus heard these things, he said unto him, Yet lackest thou one thing: sell all that thou hast, and distribute unto the poor, and thou shalt have treasure in heaven: and come, follow me.

ON THE EYE AS LIGHT OF THE BODY

MATTHEW 6:22–23

22 The light of the body is the eye: if therefore thine eye be single, thy whole body shall be full of light.

23 But if thine eye be evil, thy whole body shall be full of darkness. If therefore the light that is in thee be darkness, how great is that darkness!

LUKE 11:34–36

34 The light of the body is the eye: therefore when thine eye is single, thy whole body also is full of light; but when thine eye is evil, thy body also is full of darkness.

35 Take heed therefore that the light which is in thee be not darkness.

36 If thy whole body therefore be full of light, having no part dark, the whole shall be full of light, as when the bright shining of a candle doth give thee light.

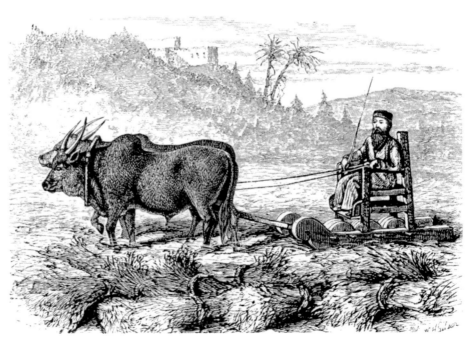

Oriental Mode of Threshing, Artist Unknown

But seek ye first the kingdom of God, and his righteousness; and all these things shall be added unto you.

Take therefore no thought for the morrow: for the morrow shall take thought for the things of itself. Sufficient unto the day is the evil thereof.

—MATTHEW 6:33–34

ON SERVING TWO MASTERS

MATTHEW 6:24

6 But thou, when thou prayest, enter into thy closet, and when thou hast shut thy door, pray to thy Father which is in secret; and thy Father which seeth in secret shall reward thee openly.

7 But when ye pray, use not vain repetitions, as the heathen do: for they think that they shall be heard for their much speaking.

8 Be not ye therefore like unto them: for your Father knoweth what things ye have need of, before ye ask him.

9 After this manner therefore pray ye: Our Father which art in heaven, Hallowed be thy name.

10 Thy kingdom come. Thy will be done in earth, as it is in heaven.

11 Give us this day our daily bread.

12 And forgive us our debts, as we forgive our debtors.

13 And lead us not into temptation, but deliver us from evil: For thine is the kingdom, and the power, and the glory, for ever. Amen.

14 For if ye forgive men their trespasses, your heavenly Father will also forgive you:

15 But if ye forgive not men their trespasses, neither will your Father forgive your trespasses.

16 Moreover when ye fast, be not, as the hypocrites, of a sad countenance: for they disfigure their faces, that they may appear unto men to fast. Verily I say unto you, They have their reward.

17 But thou, when thou fastest, anoint thine head, and wash thy face;

18 That thou appear not unto men to fast, but unto thy Father which is in secret: and thy Father, which seeth in secret, shall reward thee openly.

19 Lay not up for yourselves treasures upon earth, where moth and rust doth corrupt, and where thieves break through and steal:

20 But lay up for yourselves treasures in heaven, where neither moth nor rust doth corrupt, and where thieves do not break through nor steal:

21 For where your treasure is, there will your heart be also.

22 The light of the body is the eye: if therefore thine eye be single, thy whole body shall be full of light.

23 But if thine eye be evil, thy whole body shall be full of darkness. If therefore the light that is in thee be darkness, how great is that darkness!

24 No man can serve two masters: for either he will hate the one, and love the other; or else he will hold to the one, and despise the other. Ye cannot serve God and mammon.

LUKE 16:13

13 No servant can serve two masters: for either he will hate the one, and love the other; or else he will hold to the one, and despise the other. Ye cannot serve God and mammon.

ON BEING ANXIOUS

MATTHEW 6:25–34

25 Therefore I say unto you, Take no thought for your life, what ye shall eat, or what ye shall drink; nor yet for your body, what ye shall put on. Is not the life more than meat, and the body than raiment?

26 Behold the fowls of the air: for they sow not, neither do they reap, nor gather into barns; yet your heavenly Father feedeth them. Are ye not much better than they?

27 Which of you by taking thought can add one cubit unto his stature?

28 And why take ye thought for raiment? Consider the lilies of the field, how they grow; they toil not, neither do they spin:

29 And yet I say unto you, That even Solomon in all his glory was not arrayed like one of these.

30 Wherefore, if God so clothe the grass of the field, which to day is, and to morrow is cast into the oven, shall he not much more clothe you, O ye of little faith?

31 Therefore take no thought, saying, What shall we eat? or, What shall we drink? or, Wherewithal shall we be clothed?

32 (For after all these things do the Gentiles seek:) for your heavenly Father knoweth that ye have need of all these things.

33 But seek ye first the kingdom of God, and his righteousness; and all these things shall be added unto you.

34 Take therefore no thought for the morrow: for the morrow shall take thought for the things of itself. Sufficient unto the day is the evil thereof.

LUKE 12:22–32

22 And he said unto his disciples, Therefore I say unto you, Take no thought for your life, what ye shall eat; neither for the body, what ye shall put on.

23 The life is more than meat, and the body is more than raiment.

24 Consider the ravens: for they neither sow nor reap; which neither have storehouse nor barn; and God feedeth them: how much more are ye better than the fowls?

25 And which of you with taking thought can add to his stature one cubit?

26 If ye then be not able to do that thing which is least, why take ye thought for the rest?

27 Consider the lilies how they grow: they toil not, they spin not; and yet I say unto you, that Solomon in all his glory was not arrayed like one of these.

28 If then God so clothe the grass, which is to day in the field, and to

morrow is cast into the oven; how much more will he clothe you, O ye of little faith?

29 And seek not ye what ye shall eat, or what ye shall drink, neither be ye of doubtful mind.

30 For all these things do the nations of the world seek after: and your Father knoweth that ye have need of these things.

31 But rather seek ye the kingdom of God; and all these things shall be added unto you.

32 Fear not, little flock; for it is your Father's good pleasure to give you the kingdom.

ON JUDGING OTHERS

In Chapter 7 Matthew's Jesus continues his discussion about what it means to be the same on the inside as one is on the outside. He reminds his hearers to leave the judging of others to God—yet be bold and tireless in making prayer to God— "for everyone that asketh, receiveth; he that seeketh findeth…" Yet, remember, Jesus adds, that calling on the Lord's name involves walking with the Lord in one's actions, too. "Not every one that saith unto me, 'Lord, Lord,' shall enter into the kingdom of heaven; but he that doeth the will of my Father which is in heaven." Jesus concludes his sermon with a parable about building houses on rock versus on sand, suggesting that those who hear and do his words will be building on the former, while those who don't will have built on the latter. Matthew closes off the sermon by noting the astonishment of the crowd at Jesus' teaching—for, unlike the scribes, he teaches with authority, with a power greater than this world.

MATTHEW 7:1–5

1 Judge not, that ye be not judged.

2 For with what judgment ye judge, ye shall be judged: and with what measure ye mete, it shall be measured to you again.

3 And why beholdest thou the mote that is in thy brother's eye, but considerest not the beam that is in thine own eye?

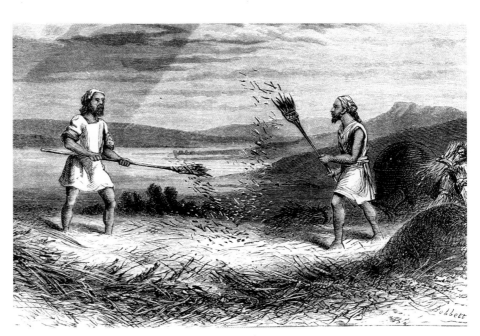

Eastern Method of Winnowing Grain, Artist Unknown

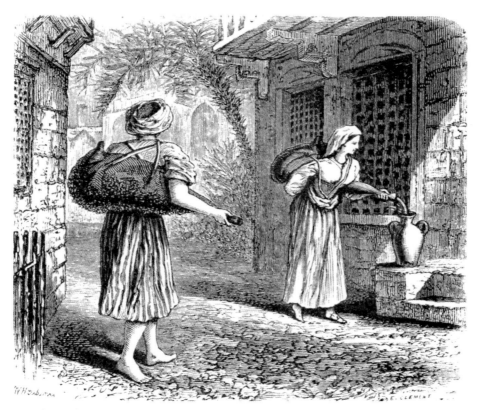

Goat-skin Bottles, Artist Unknown

4 Or how wilt thou say to thy brother, Let me pull out the mote out of thine eye; and, behold, a beam is in thine own eye?

5 Thou hypocrite, first cast out the beam out of thine own eye; and then shalt thou see clearly to cast out the mote out of thy brother's eye.

MARK 4:24–25

24 And he said unto them, Take heed what ye hear: with what measure ye mete, it shall be measured to you: and unto you that hear shall more be given.

25 For he that hath, to him shall be given: and he that hath not, from him shall be taken even that which he hath.

LUKE 6:37–42

37 Judge not, and ye shall not be judged: condemn not, and ye shall not be condemned: forgive, and ye shall be forgiven:

38 Give, and it shall be given unto you; good measure, pressed down, and shaken together, and running over, shall men give into your bosom. For with the same measure that ye mete withal it shall be measured to you again.

39 And he spake a parable unto them, Can the blind lead the blind? shall they not both fall into the ditch?

40 The disciple is not above his master: but every one that is perfect shall be as his master.

41 And why beholdest thou the mote that is in thy brother's eye, but perceivest not the beam that is in thine own eye?

42 Either how canst thou say to thy brother, Brother, let me pull out the mote that is in thine eye, when thou thyself beholdest not the beam that is in thine own eye? Thou hypocrite, cast out first the beam out of thine own eye, and then shalt thou see clearly to pull out the mote that is in thy brother's eye.

JOHN 7:53–8:11

53 And every man went unto his own house.

JOHN 8

1 Jesus went unto the mount of Olives.

2 And early in the morning he came again into the temple, and all the people came unto him; and he sat down, and taught them.

3 And the scribes and Pharisees brought unto him a woman taken in adultery; and when they had set her in the midst,

4 They say unto him, Master, this woman was taken in adultery, in the very act.

5 Now Moses in the law commanded us, that such should be stoned: but what sayest thou?

6 This they said, tempting him, that they might have to accuse him. But Jesus stooped down, and with his finger wrote on the ground, as though he heard them not.

7 So when they continued asking him, he lifted up himself, and said unto them, He that is without sin among you, let him first cast a stone at her.

8 And again he stooped down, and wrote on the ground.

9 And they which heard it, being convicted by their own conscience, went out one by one, beginning at the eldest, even unto the last: and Jesus was left alone, and the woman standing in the midst.

10 When Jesus had lifted up himself, and saw none but the woman, he said unto her, Woman, where are those thine accusers? hath no man condemned thee?

11 She said, No man, Lord. And Jesus said unto her, Neither do I condemn thee: go, and sin no more.

12 For whosoever hath, to him shall be given, and he shall have more abundance: but whosoever hath not, from him shall be taken away even that he hath.

LUKE 8:18

18 Take heed therefore how ye hear: for whosoever hath, to him shall be given; and whosoever hath not, from him shall be taken even that which he seemeth to have.

ON PROFANING
WHAT IS HOLY

MATTHEW 7:6

6 Give not that which is holy unto the dogs, neither cast ye your pearls before swine, lest they trample them under their feet, and turn again and rend you.

ON GOD'S
ANSWERING PRAYER

MATTHEW 7:7–11

7 Ask, and it shall be given you; seek, and ye shall find; knock, and it shall be opened unto you:

8 For every one that asketh receiveth; and he that seeketh findeth; and to him that knocketh it shall be opened.

9 Or what man is there of you, whom if his son ask bread, will he give him a stone?

10 Or if he ask a fish, will he give him a serpent?

11 If ye then, being evil, know how to give good gifts unto your children, how much more shall your Father which is in heaven give good things to them that ask him?

LUKE 11:9–13

9 And I say unto you, Ask, and it shall be given you; seek, and ye shall find; knock, and it shall be opened unto you.

10 For every one that asketh receiveth; and he that seeketh findeth; and to him that knocketh it shall be opened.

11 If a son shall ask bread of any of you that is a father, will he give him a stone? or if he ask a fish, will he for a fish give him a serpent?

12 Or if he shall ask an egg, will he offer him a scorpion?

13 If ye then, being evil, know how to give good gifts unto your children: how much more shall your heavenly Father give the Holy Spirit to them that ask him?

JOHN 16:24

24 Hitherto have ye asked nothing in my name: ask, and ye shall receive, that your joy may be full.

JOHN 14:13–14

13 And whatsoever ye shall ask in my name, that will I do, that the Father may be glorified in the Son.

14 If ye shall ask any thing in my name, I will do it.

JOHN 15:7

7 If ye abide in me, and my words abide in you, ye shall ask what ye will, and it shall be done unto you.

THE GOLDEN RULE

MATTHEW 7:12

12 Therefore all things whatsoever ye would that men should do to you, do ye even so to them: for this is the law and the prophets.

LUKE 6:31

31 And as ye would that men should do to you, do ye also to them likewise.

When Jesus had lifted up himself, and saw none but the woman, he said unto her, Woman, where are those thine accusers? hath no man condemned thee?

She said, No man, Lord. And Jesus said unto her, Neither do I condemn thee: go, and sin no more.

—JOHN 8:10–11

For every tree is known by his own fruit. For of thorns men do not gather figs, nor of a bramble bush gather they grapes.

—LUKE 6:44

ON THE TWO WAYS

MATTHEW 7:13–14

13 Enter ye in at the strait gate: for wide is the gate, and broad is the way, that leadeth to destruction, and many there be which go in thereat:

14 Because strait is the gate, and narrow is the way, which leadeth unto life, and few there be that find it.

LUKE 13:23–24

23 Then said one unto him, Lord, are there few that be saved? And he said unto them,

24 Strive to enter in at the strait gate: for many, I say unto you, will seek to enter in, and shall not be able.

ON FALSE PROPHETS: KNOW THEM BY THEIR FRUITS

MATTHEW 7:15–20

15 Beware of false prophets, which come to you in sheep's clothing, but inwardly they are ravening wolves.

16 Ye shall know them by their fruits. Do men gather grapes of thorns, or figs of thistles?

17 Even so every good tree bringeth forth good fruit; but a corrupt tree bringeth forth evil fruit.

18 A good tree cannot bring forth evil fruit, neither can a corrupt tree bring forth good fruit.

19 Every tree that bringeth not forth good fruit is hewn down, and cast into the fire.

20 Wherefore by their fruits ye shall know them.

MATTHEW 12:33–35

33 Either make the tree good, and his fruit good; or else make the tree corrupt, and his fruit corrupt: for the tree is known by his fruit.

34 O generation of vipers, how can ye, being evil, speak good things? for out of the abundance of the heart the mouth speaketh.

35 A good man out of the good treasure of the heart bringeth forth good things: and an evil man out of the evil treasure bringeth forth evil things.

LUKE 6:43–45

43 For a good tree bringeth not forth corrupt fruit; neither doth a corrupt tree bring forth good fruit.

44 For every tree is known by his own fruit. For of thorns men do not gather figs, nor of a bramble bush gather they grapes.

45 A good man out of the good treasure of his heart bringeth forth that which is good; and an evil man out of the evil treasure of his heart bringeth forth that which is evil: for of the abundance of the heart his mouth speaketh.

ON SAYING AND DOING

MATTHEW 7:21–23

21 Not every one that saith unto me, Lord, Lord, shall enter into the kingdom of heaven; but he that doeth the will of my Father which is in heaven.

22 Many will say to me in that day, Lord, Lord, have we not prophesied in thy name? and in thy name have cast out devils? and in thy name done many wonderful works?

23 And then will I profess unto them, I never knew you: depart from me, ye that work iniquity.

LUKE 6:46

46 And why call ye me, Lord, Lord, and do not the things which I say?

LUKE 13:25–27

25 When once the master of the house is risen up, and hath shut to the door, and ye begin to stand without, and to knock at the door, saying, Lord, Lord, open unto us; and he shall answer and say unto you, I know you not whence ye are:

26 Then shall ye begin to say, We have eaten and drunk in thy presence, and thou hast taught in our streets.

27 But he shall say, I tell you, I know you not whence ye are; depart from me, all ye workers of iniquity.

THE HOUSE
BUILT ON A ROCK

MATTHEW 7:24–27

24 Therefore whosoever heareth these sayings of mine, and doeth them, I will liken him unto a wise man, which built his house upon a rock:

25 And the rain descended, and the floods came, and the winds blew, and beat upon that house; and it fell not: for it was founded upon a rock.

26 And every one that heareth these sayings of mine, and doeth them not, shall be likened unto a foolish man, which built his house upon the sand:

27 And the rain descended, and the floods came, and the winds blew, and beat upon that house; and it fell: and great was the fall of it.

LUKE 6:47–49

47 Whosoever cometh to me, and heareth my sayings, and doeth them, I will shew you to whom he is like:

48 He is like a man which built an house, and digged deep, and laid the foundation on a rock: and when the flood arose, the stream beat vehemently upon that house, and could not shake it: for it was founded upon a rock.

49 But he that heareth, and doeth not, is like a man that without a foundation built an house upon the earth; against which the stream did beat vehemently, and immediately it fell; and the ruin of that house was great.

THE PEOPLE'S
REACTION TO
JESUS' TEACHING

MATTHEW 7:28–29

28 And it came to pass, when Jesus had ended these sayings, the people were

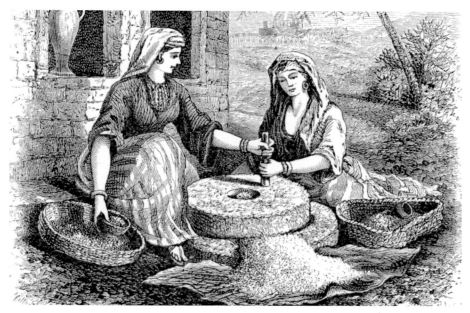

Women Gringing at a Mill, Artist Unknown

astonished at his doctrine:

29 For he taught them as one having authority, and not as the scribes.

MARK 1:20–22

20 And straightway he called them: and they left their father Zebedee in the ship with the hired servants, and went after him.

21 And they went into Capernaum; and straightway on the sabbath day he entered into the synagogue, and taught.

22 And they were astonished at his doc-

trine: for he taught them as one that had authority, and not as the scribes.

LUKE 7:1

1 Now when he had ended all his sayings in the audience of the people, he entered into Capernaum.

LUKE 4:32

32 And they were astonished at his doctrine: for his word was with power.

JOHN 7:46

46 The officers answered, Never man spake like this man.

And it came to pass, when Jesus had ended these sayings, the people were astonished at his doctrine:

For he taught them as one having authority, and not as the scribes.

—MATTHEW 7:28–29

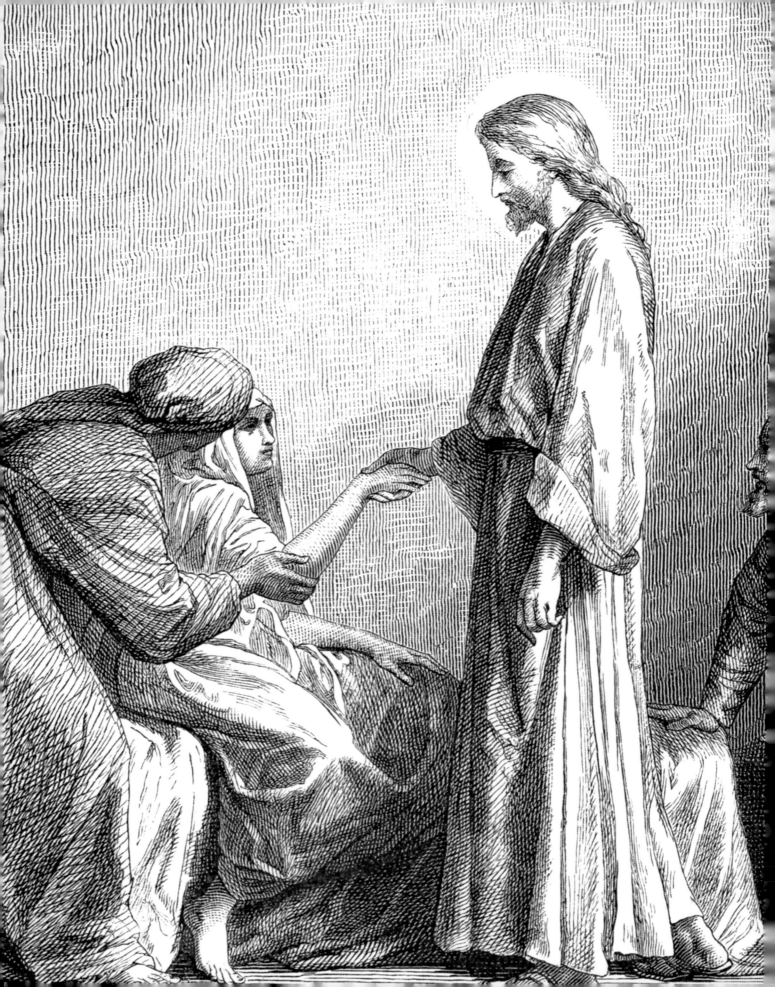

LIFE of JESUS

Jesus in Galilee

Jesus in Galilee

Jesus Christ Healing the Sick, Artist Unknown

MATTHEW NOW RETURNS TO TELL TEN MIRACLE STORIES (the first two of that series, the leper and Simon's mother-in-law, were mentioned earlier. He interprets these acts with another so-called "formula quote," where Jesus actions once again brings new meaning to Isaiah's description of the suffering Servant of the LORD: "[He] Himself took our infirmities, and bare our diseases" (Matthew 8:17, Isaiah 53:4).

THE CENTURION FROM CAPERNAUM

Matthew relates the faith of a Roman centurion, who comes to Jesus with a request for the healing of his son (or, in Luke, the centurion slave). Except for the slave/son Luke's version is very similar, probably taken from the source they have in common. (Mark does not have it). Mark makes the same point later as he tells of a Gentile woman whose daughter is healed by Jesus' word spoken from some distance, as with the centurion and the sick boy. Luke and Matthew both stress how God's mercy was never only for the children of Israel, but for all of every nation who come to him in faith. John's version has many common details—for him it is the second of Jesus' "signs"—taking place (as did his first) in Cana. The one with the request is a "royal official" whose son is ill in Capernaum. This one asks Jesus to come, before his son dies. In Matthew the centurion does not ask Jesus to enter his house, respectful of Jesus' potential defilement, were he to enter a Gentile house. Luke has local Jewish elders relaying the centurion's request, noting how he is "worthy" to have this done for him. John's Jesus simply tells the man to go, for his son will live—the point being that Jesus' word gets immediate results, even at a distance.

MATTHEW 8:5–13

5 And when Jesus was entered into Capernaum, there came unto him a centurion, beseeching him,

6 And saying, Lord, my servant lieth at home sick of the palsy, grievously tormented.

7 And Jesus saith unto him, I will come and heal him.

8 The centurion answered and said, Lord, I am not worthy that thou shouldest come under my roof: but speak the word only, and my servant shall be healed.

Healing the Centurion's Servant, by Alexander Bida, 1813-1895

And saying, Lord, my servant lieth at home sick of the palsy, grievously tormented.

And Jesus saith unto him, I will come and heal him.

The centurion answered and said, Lord, I am not worthy that thou shouldest come under my roof: but speak the word only, and my servant shall be healed.

—MATTHEW 8:6–8

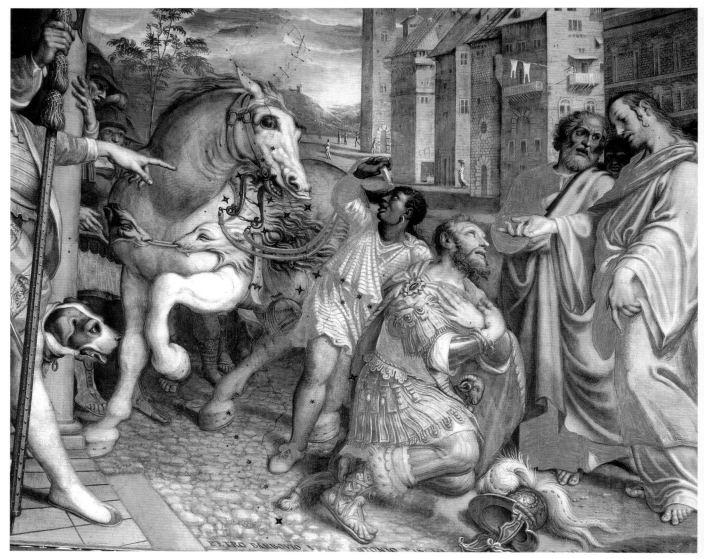

The Centurion Kneeling Before Christ, 1581, by Antonio Campi, 1536–1591

9 For I am a man under authority, having soldiers under me: and I say to this man, Go, and he goeth; and to another, Come, and he cometh; and to my servant, Do this, and he doeth it.

10 When Jesus heard it, he marvelled, and said to them that followed, Verily I say unto you, I have not found so great faith, no, not in Israel.

11 And I say unto you, That many shall come from the east and west, and shall sit down with Abraham, and Isaac, and Jacob, in the kingdom of heaven.

12 But the children of the kingdom shall be cast out into outer darkness: there shall be weeping and gnashing of teeth.

13 And Jesus said unto the centurion, Go thy way; and as thou hast believed, so be it done unto thee. And his servant was healed in the selfsame hour.

MARK 7:30

30 And when she was come to her house, she found the devil gone out, and her daughter laid upon the bed.

LUKE 7:1–10

1 Now when he had ended all his sayings in the audience of the people, he entered into Capernaum.

2 And a certain centurion's servant, who was dear unto him, was sick, and ready to die.

3 And when he heard of Jesus, he sent unto him the elders of the Jews, beseeching him that he would come and heal his servant.

4 And when they came to Jesus, they besought him instantly, saying, That he was worthy for whom he should do this:

5 For he loveth our nation, and he hath built us a synagogue.

6 Then Jesus went with them. And when he was now not far from the house, the centurion sent friends to him, saying unto him, Lord, trouble not thyself: for I am not worthy that thou shouldest enter under my roof:

7 Wherefore neither thought I myself worthy to come unto thee: but say in a word, and my servant shall be healed.

8 For I also am a man set under authority, having under me soldiers, and I say unto one, Go, and he goeth; and to another, Come, and he cometh; and to my servant, Do this, and he doeth it.

9 When Jesus heard these things, he marvelled at him, and turned him about, and said unto the people that followed him, I say unto you, I have not found so great faith, no, not in Israel.

10 And they that were sent, returning to the house, found the servant whole that had been sick.

JOHN 4:46–54

46 So Jesus came again into Cana of Galilee, where he made the water wine. And there was a certain nobleman, whose son was sick at Capernaum.

47 When he heard that Jesus was come out of Judaea into Galilee, he went unto him, and besought him that he would come down, and heal his son: for he was at the point of death.

48 Then said Jesus unto him, Except ye see signs and wonders, ye will not believe.

49 The nobleman saith unto him, Sir, come down ere my child die.

50 Jesus saith unto him, Go thy way; thy son liveth. And the man believed the word that Jesus had spoken unto him, and he went his way.

51 And as he was now going down, his servants met him, and told him, saying, Thy son liveth.

52 Then inquired he of them the hour when he began to amend. And they said unto him, Yesterday at the seventh hour the fever left him.

53 So the father knew that it was at the same hour, in the which Jesus said unto him, Thy son liveth: and himself believed, and his whole house.

54 This is again the second miracle that Jesus did, when he was come out of Judaea into Galilee.

LUKE 13:28–29

28 There shall be weeping and gnashing of teeth, when ye shall see Abraham, and Isaac, and Jacob, and all the prophets, in the kingdom of God, and you yourselves thrust out.

29 And they shall come from the east, and from the west, and from the north, and from the south, and shall sit down in the kingdom of God.

JESUS RAISES A WIDOW'S SON IN NAIN

In a story unique to Luke, Jesus stops a funeral procession to raise a widow's son (and probably her sole means of support) from the dead. The story reminds the reader of the mighty works of prophets Elijah and Elisha in the First and Second Books of Kings, who restored widows' sons to life. The power of Jesus' word, as that of the prophets of old, comes from God and extends even beyond death. Luke also mentions that, "when the Lord saw her, he had compassion on her…The word Luke uses for compassion comes from the Greek word for belly, heart, or entrails, i.e. the inner seat of one's emotions. It frequently translates the Hebrew word "rachamim," used for compassion, which literally means womb—a powerful image of the depth of God's care, and that of Jesus, for those who grieve. It is a haunting reminder of Simeon's prophecy to Jesus' mother, "a sword shall pierce through thy own soul also," not to mention a foreshadowing of Jesus' own passion.

LUKE 7:11–17

11 And it came to pass the day after, that he went into a city called Nain; and many of his disciples went with him, and much people.

12 Now when he came nigh to the gate of the city, behold, there was a dead man carried out, the only son of his mother, and she was a widow: and much people of the city was with her.

And he said unto them, Why are ye so fearful? how is it that ye have no faith?

And they feared exceedingly, and said one to another, What manner of man is this, that even the wind and the sea obey him?

—MARK 4:40–41

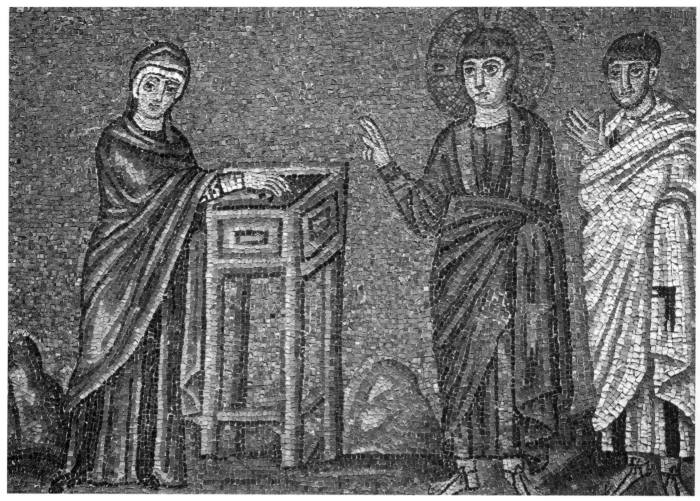

The Widow's Mite, 6th century. Artist Unknown

13 And when the Lord saw her, he had compassion on her, and said unto her, Weep not.

14 And he came and touched the bier: and they that bare him stood still. And he said, Young man, I say unto thee, Arise.

15 And he that was dead sat up, and began to speak. And he delivered him to his mother.

16 And there came a fear on all: and they glorified God, saying, That a great prophet is risen up among us; and, That God hath visited his people.

17 And this rumour of him went forth throughout all Judaea, and throughout all the region round about.

ON FOLLOWING JESUS

As Matthew and Mark make ready to journey with Jesus to the other side of the sea, Jesus speaks clearly about the demands of discipleship to two (in Luke:3) who come seeking to follow after him. Those demands take precedence over having a home, even over burying the dead (one of the higher duties of rabbinical tradition). Luke alone presents a third would-be disciple, who wants to bid farewell to family first. Jesus compares being a disciple to plowing a field—one cannot look backwards and plow a straight row for the seed. One who does is unfit for the Kingdom.

MATTHEW 8:18–22

18 Now when Jesus saw great multitudes about him, he gave commandment to depart unto the other side.

19 And a certain scribe came, and said unto him, Master, I will follow thee whithersoever thou goest.

20 And Jesus saith unto him, The foxes have holes, and the birds of the air have nests; but the Son of man hath not where to lay his head.

21 And another of his disciples said unto him, Lord, suffer me first to go and bury my father.

22 But Jesus said unto him, Follow me; and let the dead bury their dead.

MARK 4:35

35 And the same day, when the even was come, he saith unto them, Let us pass over unto the other side.

LUKE 9:57–62

57 And it came to pass, that, as they went in the way, a certain man said unto him, Lord, I will follow thee whithersoever thou goest.

58 And Jesus said unto him, Foxes have holes, and birds of the air have nests; but the Son of man hath not where to lay his head.

59 And he said unto another, Follow me. But he said, Lord, suffer me first to go and bury my father.

60 Jesus said unto him, Let the dead bury their dead: but go thou and preach the kingdom of God.

61 And another also said, Lord, I will follow thee; but let me first go bid them farewell, which are at home at my house.

62 And Jesus said unto him, No man, having put his hand to the plough, and looking back, is fit for the kingdom of God.

JESUS STILLS A STORM AT SEA

Long before the stories of Jesus came to be written down in our gospels, they were told and retold from memory by evangelists preaching on texts from the prophets. Surely this story—as the gospel writers present it—has its roots in the story of Jonah, who, like the disciples (and the congregations among whom the gospels were first written down), was sent on a mission "to the other side," i.e., to unfamiliar territory. Unlike Jonah, the disciples are not running away from their mission, but heading for it when a storm blows up and they fear for their lives in its watery chaos. Every disciple has times when fear gets

The Miraculous Draught of Fishes, by Alexander Bida, 1813–1895

ahead of faith. This story points out those things disciples need to remember when that happens: (1) the ability of Jesus' word to overpower all that comes against it—even legions of demons, and the ultimate worst case scenario: death; and (2) Jesus is immediately aware of the needs of all who reach out for him for power. He has not forgotten and will not abandon his disciples he sends immediate power to those who reach out for it, such as the nameless woman sandwiched into the story of Jairus. Like Jonah, these are stories about the great mercy of God.

MATTHEW 8:23–27

23 And when he was entered into a ship, his disciples followed him.

24 And, behold, there arose a great tempest in the sea, insomuch that the ship was covered with the waves: but he was asleep.

25 And his disciples came to him, and awoke him, saying, Lord, save us: we perish.

26 And he saith unto them, Why are ye fearful, O ye of little faith? Then he arose, and rebuked the winds and the sea; and there was a great calm.

27 But the men marvelled, saying, What manner of man is this, that even the winds and the sea obey him!

MARK 4:35–41

35 And the same day, when the even was come, he saith unto them, Let us pass over unto the other side.

36 And when they had sent away the multitude, they took him even as he was in the ship. And there were also with him other little ships.

37 And there arose a great storm of wind, and the waves beat into the ship, so that it was now full.

38 And he was in the hinder part of the ship, asleep on a pillow: and they awake him, and say unto him, Master, carest thou not that we perish?

39 And he arose, and rebuked the wind, and said unto the sea, Peace, be still. And the wind ceased, and there was a great calm.

40 And he said unto them, Why are ye so fearful? how is it that ye have no faith?

41 And they feared exceedingly, and said one to another, What manner of man is this, that even the wind and the sea obey him?

LUKE 8:22–25

22 Now it came to pass on a certain day, that he went into a ship with his disciples: and he said unto them, Let us go over unto the other side of the lake. And they launched forth.

23 But as they sailed he fell asleep: and there came down a storm of wind on the lake; and they were filled with water, and were in jeopardy.

24 And they came to him, and awoke him, saying, Master, master, we perish. Then he arose, and rebuked the wind and the raging of the water: and they ceased, and there was a calm.

25 And he said unto them, Where is your faith? And they being afraid wondered, saying one to another, What manner of man is this! for he commandeth even the winds and water, and they obey him.

JESUS RESTORES A DEMON-POSSESSED MAN FROM GERASA/ GADARA

MATTHEW 8:28–34

28 And when he was come to the other side into the country of the Gergesenes, there met him two possessed with devils, coming out of the tombs, exceeding fierce, so that no man might pass by that way.

29 And, behold, they cried out, saying, What have we to do with thee, Jesus, thou Son of God? art thou come hither to torment us before the time?

30 And there was a good way off from them an herd of many swine feeding.

31 So the devils besought him, saying, If thou cast us out, suffer us to go away into the herd of swine.

32 And he said unto them, Go. And when they were come out, they went into the herd of swine: and, behold, the whole herd of swine ran violently down a steep place into the sea, and perished in the waters.

33 And they that kept them fled, and went their ways into the city, and told every thing, and what was befallen to the possessed of the devils.

34 And, behold, the whole city came out to meet Jesus: and when they saw him, they besought him that he would depart out of their coasts.

MARK 5:1–20

1 And they came over unto the other side of the sea, into the country of the Gadarenes.

2 And when he was come out of the ship, immediately there met him out of the tombs a man with an unclean spirit,

3 Who had his dwelling among the tombs; and no man could bind him, no, not with chains:

4 Because that he had been often bound with fetters and chains, and the chains had been plucked asunder by him, and the fetters broken in pieces: neither could any man tame him.

5 And always, night and day, he was in the mountains, and in the tombs, crying, and cutting himself with stones.

6 But when he saw Jesus afar off, he ran and worshipped him,

7 And cried with a loud voice, and said, What have I to do with thee, Jesus, thou Son of the most high God? I adjure thee by God, that thou torment me not.

8 For he said unto him, Come out of the man, thou unclean spirit.

9 And he asked him, What is thy name? And he answered, saying, My name is Legion: for we are many.

10 And he besought him much that he would not send them away out of the country.

11 Now there was there nigh unto the mountains a great herd of swine feeding.

12 And all the devils besought him, saying, Send us into the swine, that we may enter into them.

13 And forthwith Jesus gave them leave. And the unclean spirits went out, and entered into the swine: and the herd ran violently down a steep place into the sea, (they were about two thousand;) and were choked in the sea.

14 And they that fed the swine fled, and told it in the city, and in the country. And they went out to see what it was that was done.

15 And they come to Jesus, and see him that was possessed with the devil, and had the legion, sitting, and clothed, and in his right mind: and they were afraid.

16 And they that saw it told them how it befell to him that was possessed with the devil, and also concerning the swine.

17 And they began to pray him to depart out of their coasts.

18 And when he was come into the ship, he that had been possessed with the devil prayed him that he might be with him.

19 Howbeit Jesus suffered him not, but saith unto him, Go home to thy

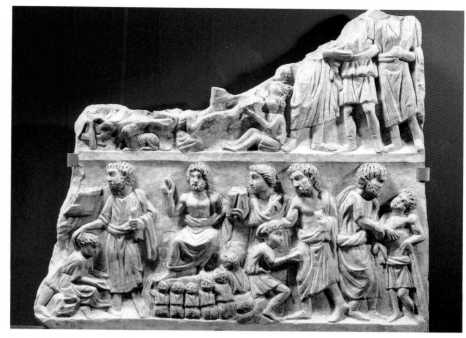

Miracle of the Curing of the Woman of Issue of Blood, Sermon on Mount, Curing of Blind and Cripple,
4th century, Artist Unknown

friends, and tell them how great things the Lord hath done for thee, and hath had compassion on thee.

20 And he departed, and began to publish in Decapolis how great things Jesus had done for him: and all men did marvel.

LUKE 8:26–39

26 And they arrived at the country of the Gadarenes, which is over against Galilee.

27 And when he went forth to land, there met him out of the city a certain man, which had devils long time, and ware no clothes, neither abode in any house, but in the tombs.

28 When he saw Jesus, he cried out, and fell down before him, and with a loud voice said, What have I to do with thee, Jesus, thou Son of God most high? I beseech thee, torment me not.

29 (For he had commanded the unclean spirit to come out of the man. For oftentimes it had caught him: and he was kept bound with chains and in

fetters; and he brake the bands, and was driven of the devil into the wilderness.)

30 And Jesus asked him, saying, What is thy name? And he said, Legion: because many devils were entered into him.

Then went the devils out of the man, and entered into the swine: and the herd ran violently down a steep place into the lake, and were choked.

—LUKE 8:33

that he might be with him: but Jesus sent him away, saying,

39 Return to thine own house, and shew how great things God hath done unto thee. And he went his way, and published throughout the whole city how great things Jesus had done unto him.

JESUS RAISES JAIRUS' DAUGHTER AND HEALS A WOMAN WITH A HEMORRHAGE

MATTHEW 9:18–26

18 While he spake these things unto them, behold, there came a certain ruler, and worshipped him, saying, My daughter is even now dead: but come and lay thy hand upon her, and she shall live.

19 And Jesus arose, and followed him, and so did his disciples.

20 And, behold, a woman, which was diseased with an issue of blood twelve years, came behind him, and touched the hem of his garment:

21 For she said within herself, If I may but touch his garment, I shall be whole.

22 But Jesus turned him about, and when he saw her, he said, Daughter, be of good comfort; thy faith hath made thee whole. And the woman was made whole from that hour.

23 And when Jesus came into the ruler's house, and saw the minstrels and the people making a noise,

24 He said unto them, Give place: for the maid is not dead, but sleepeth. And they laughed him to scorn.

25 But when the people were put forth, he went in, and took her by the hand, and the maid arose.

26 And the fame hereof went abroad into all that land.

A Woman Healed by Touching the Garment of Jesus, by Alexander Bida, 1813–1895

31 And they besought him that he would not command them to go out into the deep.

32 And there was there an herd of many swine feeding on the mountain: and they besought him that he would suffer them to enter into them. And he suffered them.

33 Then went the devils out of the man, and entered into the swine: and the herd ran violently down a steep place into the lake, and were choked.

34 When they that fed them saw what was done, they fled, and went and told it in the city and in the country.

35 Then they went out to see what was done; and came to Jesus, and found the man, out of whom the devils were departed, sitting at the feet of Jesus, clothed, and in his right mind: and they were afraid.

36 They also which saw it told them by what means he that was possessed of the devils was healed.

37 Then the whole multitude of the country of the Gadarenes round about besought him to depart from them; for they were taken with great fear: and he went up into the ship, and returned back again.

38 Now the man out of whom the devils were departed besought him

21 And when Jesus was passed over again by ship unto the other side, much people gathered unto him: and he was nigh unto the sea.

22 And, behold, there cometh one of the rulers of the synagogue, Jairus by name; and when he saw him, he fell at his feet,

23 And besought him greatly, saying, My little daughter lieth at the point of death: I pray thee, come and lay thy hands on her, that she may be healed; and she shall live.

24 And Jesus went with him; and much people followed him, and thronged him.

25 And a certain woman, which had an issue of blood twelve years,

26 And had suffered many things of many physicians, and had spent all that she had, and was nothing bettered, but rather grew worse,

27 When she had heard of Jesus, came in the press behind, and touched his garment.

28 For she said, If I may touch but his clothes, I shall be whole.

29 And straightway the fountain of her blood was dried up; and she felt in her body that she was healed of that plague.

30 And Jesus, immediately knowing in himself that virtue had gone out of him, turned him about in the press, and said, Who touched my clothes?

31 And his disciples said unto him, Thou seest the multitude thronging thee, and sayest thou, Who touched me?

32 And he looked round about to see her that had done this thing.

33 But the woman fearing and trembling, knowing what was done in her, came and fell down before him, and told him all the truth.

34 And he said unto her, Daughter, thy faith hath made thee whole; go in peace, and be whole of thy plague.

The Daughter of Jairus Raised from the Dead, by Alexander Bida, 1813–1895

And they laughed him to scorn, knowing that she was dead.

And he put them all out, and took her by the hand, and called, saying, Maid, arise.

And her spirit came again, and she arose straightway: and he commanded to give her meat.

—LUKE 8:53–55

35 While he yet spake, there came from the ruler of the synagogue's house certain which said, Thy daughter is dead: why troublest thou the Master any further?

36 As soon as Jesus heard the word that was spoken, he saith unto the ruler of the synagogue, Be not afraid, only believe.

37 And he suffered no man to follow him, save Peter, and James, and John the brother of James.

38 And he cometh to the house of the ruler of the synagogue, and seeth the tumult, and them that wept and wailed greatly.

39 And when he was come in, he saith unto them, Why make ye this ado, and weep? the damsel is not dead, but sleepeth.

40 And they laughed him to scorn. But when he had put them all out, he taketh the father and the mother of the damsel, and them that were with him, and entereth in where the damsel was lying.

41 And he took the damsel by the hand, and said unto her, Talitha cumi; which is, being interpreted, Damsel, I say unto thee, arise.

42 And straightway the damsel arose, and walked; for she was of the age of twelve years. And they were astonished with a great astonishment.

43 And he charged them straitly that no man should know it; and commanded that something should be given her to eat.

LUKE 8:40–56

40 And it came to pass, that, when Jesus was returned, the people gladly received him: for they were all waiting for him.

41 And, behold, there came a man named Jairus, and he was a ruler of the synagogue: and he fell down at Jesus' feet, and besought him that he would come into his house:

42 For he had one only daughter, about twelve years of age, and she lay a dying. But as he went the people thronged him.

43 And a woman having an issue of blood twelve years, which had spent all her living upon physicians, neither could be healed of any,

44 Came behind him, and touched the border of his garment: and immediately her issue of blood stanched.

45 And Jesus said, Who touched me? When all denied, Peter and they that were with him said, Master, the multitude throng thee and press thee, and sayest thou, Who touched me?

46 And Jesus said, Somebody hath touched me: for I perceive that virtue is gone out of me.

47 And when the woman saw that she was not hid, she came trembling, and falling down before him, she declared unto him before all the people for what cause she had touched him and how she was healed immediately.

48 And he said unto her, Daughter, be of good comfort: thy faith hath made thee whole; go in peace.

49 While he yet spake, there cometh one from the ruler of the synagogue's house, saying to him, Thy daughter is dead; trouble not the Master.

50 But when Jesus heard it, he answered him, saying, Fear not: believe only, and she shall be made whole.

51 And when he came into the house, he suffered no man to go in, save Peter, and James, and John, and the father and the mother of the maiden.

52 And all wept, and bewailed her: but he said, Weep not; she is not dead, but sleepeth.

53 And they laughed him to scorn, knowing that she was dead.

54 And he put them all out, and took her by the hand, and called, saying, Maid, arise.

55 And her spirit came again, and she arose straightway: and he commanded to give her meat.

56 And her parents were astonished: but he charged them that they should tell no man what was done.

Miracle of Jesus Christ Curing Man Born Blind, 1072, Artist Unknown

MARK 10:46–52

46 And they came to Jericho: and as he went out of Jericho with his disciples and a great number of people, blind Bartimaeus, the son of Timaeus, sat by the highway side begging.

47 And when he heard that it was Jesus of Nazareth, he began to cry out, and say, Jesus, thou Son of David, have mercy on me.

48 And many charged him that he should hold his peace: but he cried the more a great deal, Thou Son of David, have mercy on me.

49 And Jesus stood still, and commanded him to be called. And they call the blind man, saying unto him, Be of good comfort, rise; he calleth thee.

50 And he, casting away his garment, rose, and came to Jesus.

51 And Jesus answered and said unto him, What wilt thou that I should do unto thee? The blind man said unto him, Lord, that I might receive my sight.

52 And Jesus said unto him, Go thy way; thy faith hath made thee whole. And immediately he received his sight, and followed Jesus in the way.

LUKE 18:35–43

35 And it came to pass, that as he was come nigh unto Jericho, a certain blind man sat by the way side begging:

36 And hearing the multitude pass by, he asked what it meant.

37 And they told him, that Jesus of Nazareth passeth by.

38 And he cried, saying, Jesus, thou Son of David, have mercy on me.

39 And they which went before rebuked him, that he should hold his peace: but he cried so much the more, Thou Son of David, have mercy on me.

JESUS OPENS BLIND MEN'S EYES

MATTHEW 9:27–31

27 And when Jesus departed thence, two blind men followed him, crying, and saying, Thou Son of David, have mercy on us.

28 And when he was come into the house, the blind men came to him: and Jesus saith unto them, Believe ye that I am able to do this? They said unto him, Yea, Lord.

29 Then touched he their eyes, saying, According to your faith be it unto you.

30 And their eyes were opened; and Jesus straitly charged them, saying, See that no man know it.

31 But they, when they were departed, spread abroad his fame in all that country.

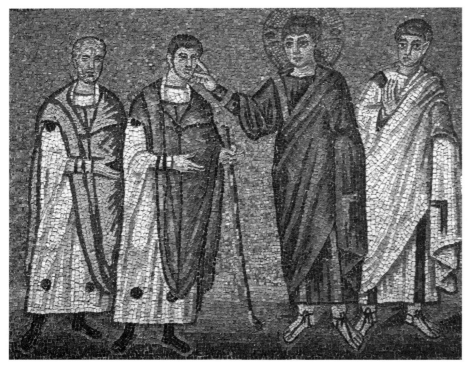

Christ Heals the Blind Man from Jericho, 6th century, Artist Unknown

34 But the Pharisees said, He casteth out devils through the prince of the devils.

MARK 3:22

22 And the scribes which came down from Jerusalem said, He hath Beelzebub, and by the prince of the devils casteth he out devils.

LUKE 11:14–15

14 And he was casting out a devil, and it was dumb. And it came to pass, when the devil was gone out, the dumb spake; and the people wondered.

15 But some of them said, He casteth out devils through Beelzebub the chief of the devils.

THE HARVEST IS GREAT

MATTHEW 9:35–38

35 And Jesus went about all the cities and villages, teaching in their synagogues, and preaching the gospel of the kingdom, and healing every sickness and every disease among the people.

36 But when he saw the multitudes, he was moved with compassion on them, because they fainted, and were scattered abroad, as sheep having no shepherd.

37 Then saith he unto his disciples, The harvest truly is plenteous, but the labourers are few;

38 Pray ye therefore the Lord of the harvest, that he will send forth labourers into his harvest.

MARK 6:6

6 And he marvelled because of their unbelief. And he went round about the villages, teaching.

40 And Jesus stood, and commanded him to be brought unto him: and when he was come near, he asked him,

41 Saying, What wilt thou that I shall do unto thee? And he said, Lord, that I may receive my sight.

42 And Jesus said unto him, Receive thy sight: thy faith hath saved thee.

43 And immediately he received his sight, and followed him, glorifying God: and all the people, when they saw it, gave praise unto God.

MATTHEW 20:29–34

29 And as they departed from Jericho, a great multitude followed him.

30 And, behold, two blind men sitting by the way side, when they heard that Jesus passed by, cried out, saying, Have mercy on us, O Lord, thou Son of David.

31 And the multitude rebuked them, because they should hold their peace: but they cried the more, say-ing, Have mercy on us, O Lord, thou Son of David.

32 And Jesus stood still, and called them, and said, What will ye that I shall do unto you?

33 They say unto him, Lord, that our eyes may be opened.

34 So Jesus had compassion on them, and touched their eyes: and immediately their eyes received sight, and they followed him.

JESUS DRIVES OUT A DEMON AND CAUSES A CONTROVERSY

MATTHEW 9:32–34

32 As they went out, behold, they brought to him a dumb man possessed with a devil.

33 And when the devil was cast out, the dumb spake: and the multitudes marvelled, saying, It was never so seen in Israel.

LUKE 8:1

1 And it came to pass afterward, that he went throughout every city and village, preaching and shewing the glad tidings of the kingdom of God: and the twelve were with him,

MARK 6:34

34 And Jesus, when he came out, saw much people, and was moved with compassion toward them, because they were as sheep not having a shepherd: and he began to teach them many things.

LUKE 10:2

2 Therefore said he unto them, The harvest truly is great, but the labourers are few: pray ye therefore the Lord of the harvest, that he would send forth labourers into his harvest.

JOHN 4:35

35 Say not ye, There are yet four months, and then cometh harvest? behold, I say unto you, Lift up your eyes, and look on the fields; for they are white already to harvest.

JESUS SENDS HIS DISCIPLES OUT

Looking with compassion at the crowds of broken ones wherever he goes, Jesus calls twelve by name as his disciples and sends them out on his own authority to preach the good news and to heal. Here Matthew launches into the second of his five great "sermons" or collections of Jesus' teachings—this one addressed to the disciples. In it he instructs them on what to preach, those to whom they should and should not preach, what they can expect to encounter on the way, what they will and will not need—to equip them and those who come after them for the task of carrying on his mission. Matthew's Jesus sends them first to the lost sheep of the house of Israel, those bound to God by covenant. After his resurrection

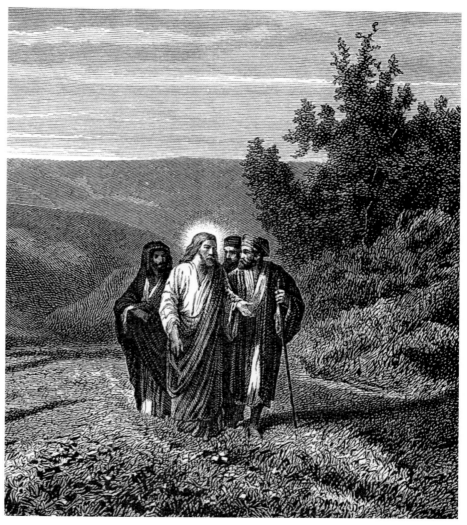

Jesus and His Disciples on the Road to Caesarea, by Alexander Bida, 1813–1895

he will send them to the Gentiles. Most importantly, disciples need not be anxious about what they will say, "for it is not ye that speak, but the spirit of your Father which speaketh in you."

MATTHEW 10:1–16

1 And when he had called unto him his twelve disciples, he gave them power against unclean spirits, to cast them out, and to heal all manner of sickness and all manner of disease.

2 Now the names of the twelve apostles are these; The first, Simon, who is called Peter, and Andrew his brother; James the son of Zebedee, and John his brother;

3 Philip, and Bartholomew; Thomas, and Matthew the publican; James the son of Alphaeus, and Lebbaeus, whose surname was Thaddaeus;

4 Simon the Canaanite, and Judas Iscariot, who also betrayed him.

5 These twelve Jesus sent forth, and commanded them, saying, Go not into the way of the Gentiles, and into any city of the Samaritans enter ye not:

6 But go rather to the lost sheep of the house of Israel.

7 And as ye go, preach, saying, The kingdom of heaven is at hand.

8 Heal the sick, cleanse the lepers, raise the dead, cast out devils: freely ye have received, freely give.

9 Provide neither gold, nor silver, nor brass in your purses,

10 Nor scrip for your journey, neither two coats, neither shoes, nor yet staves: for the workman is worthy of his meat.

11 And into whatsoever city or town ye shall enter, inquire who in it is worthy; and there abide till ye go thence.

12 And when ye come into an house, salute it.

13 And if the house be worthy, let your peace come upon it: but if it be not worthy, let your peace return to you.

14 And whosoever shall not receive you, nor hear your words, when ye depart out of that house or city, shake off the dust of your feet.

15 Verily I say unto you, It shall be more tolerable for the land of Sodom and Gomorrha in the day of judgment, than for that city.

16 Behold, I send you forth as sheep in the midst of wolves: be ye therefore wise as serpents, and harmless as doves.

MARK 6:7

7 And he called unto him the twelve, and began to send them forth by two and two; and gave them power over unclean spirits;

LUKE 9:1

1 Then he called his twelve disciples together, and gave them power and authority over all devils, and to cure diseases.

MARK 3:13–19

13 And he goeth up into a mountain, and calleth unto him whom he would: and they came unto him.

14 And he ordained twelve, that they should be with him, and that he might send them forth to preach,

15 And to have power to heal sicknesses, and to cast out devils:

16 And Simon he surnamed Peter;

17 And James the son of Zebedee, and John the brother of James; and he surnamed them Boanerges, which is, The sons of thunder:

18 And Andrew, and Philip, and Bartholomew, and Matthew, and Thomas, and James the son of Alphaeus, and Thaddaeus, and Simon the Canaanite,

19 And Judas Iscariot, which also betrayed him: and they went into an house.

LUKE 6:12–16

12 And it came to pass in those days, that he went out into a mountain to pray, and continued all night in prayer to God.

13 And when it was day, he called unto him his disciples: and of them he chose twelve, whom also he named apostles;

14 Simon, (whom he also named Peter,) and Andrew his brother, James and John, Philip and Bartholomew,

15 Matthew and Thomas, James the son of Alphaeus, and Simon called Zelotes,

16 And Judas the brother of James, and Judas Iscariot, which also was the traitor.

JOHN 1:42

42 And he brought him to Jesus. And when Jesus beheld him, he said, Thou art Simon the son of Jona: thou shalt be called Cephas, which is by interpretation, A stone.

MARK 6:8–11

8 And commanded them that they should take nothing for their journey, save a staff only; no scrip, no bread, no money in their purse:

9 But be shod with sandals; and not put on two coats.

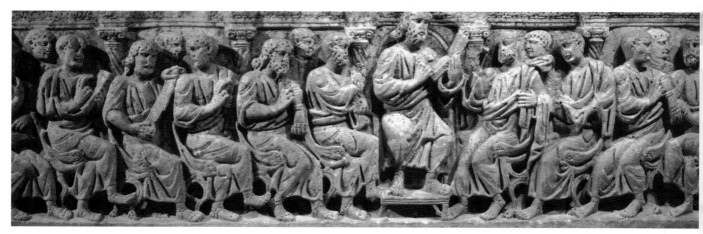

Christ Teaching the Apostles, 4th century, Artist Unknown

10 And he said unto them, In what place soever ye enter into an house, there abide till ye depart from that place.

11 And whosoever shall not receive you, nor hear you, when ye depart thence, shake off the dust under your feet for a testimony against them. Verily I say unto you, It shall be more tolerable for Sodom and Gomorrha in the day of judgment, than for that city.

LUKE 9:2–5

2 And he sent them to preach the kingdom of God, and to heal the sick.

3 And he said unto them, Take nothing for your journey, neither staves, nor scrip, neither bread, neither money; neither have two coats apiece.

4 And whatsoever house ye enter into, there abide, and thence depart.

5 And whosoever will not receive you, when ye go out of that city, shake off the very dust from your feet for a testimony against them.

LUKE 10:3

3 Go your ways: behold, I send you forth as lambs among wolves.

JESUS PREPARES HIS DISCIPLES FOR HARDSHIPS ON THE WAY

MATTHEW 10:17–25

17 But beware of men: for they will deliver you up to the councils, and they will scourge you in their synagogues;

18 And ye shall be brought before governors and kings for my sake, for a testimony against them and the Gentiles.

19 But when they deliver you up, take no thought how or what ye shall speak: for it shall be given you in that same hour what ye shall speak.

20 For it is not ye that speak, but the Spirit of your Father which speaketh in you.

21 And the brother shall deliver up the brother to death, and the father the child: and the children shall rise up against their parents, and cause them to be put to death.

22 And ye shall be hated of all men for my name's sake: but he that endureth to the end shall be saved.

23 But when they persecute you in this city, flee ye into another: for verily I say unto you, Ye shall not have gone over the cities of Israel, till the Son of man be come.

24 The disciple is not above his master, nor the servant above his lord.

25 It is enough for the disciple that he be as his master, and the servant as his lord. If they have called the master of the house Beelzebub, how much more shall they call them of his household?

MARK 13:9–13

9 But take heed to yourselves: for they shall deliver you up to councils; and in the synagogues ye shall be beaten: and ye shall be brought before rulers and kings for my sake, for a testimony against them.

10 And the gospel must first be published among all nations.

11 But when they shall lead you, and deliver you up, take no thought beforehand what ye shall speak, neither do ye premeditate: but whatsoever shall be given you in that hour, that speak ye: for it is not ye that speak, but the Holy Ghost.

12 Now the brother shall betray the brother to death, and the father the son; and children shall rise up against their parents, and shall cause them to be put to death.

13 And ye shall be hated of all men for my name's sake: but he that shall endure unto the end, the same shall be saved.

The disciple is not above his master, nor the servant above his lord.

It is enough for the disciple that he be as his master, and the servant as his lord. If they have called the master of the house Beelzebub, how much more shall they call them of his household?

—MATTHEW 10:24–25

LUKE 12:11–12

11 And when they bring you unto the synagogues, and unto magistrates, and powers, take ye no thought how or what thing ye shall answer, or what ye shall say:

12 For the Holy Ghost shall teach you in the same hour what ye ought to say.

JOHN 16:2

2 They shall put you out of the synagogues: yea, the time cometh, that whosoever killeth you will think that he doeth God service.

JOHN 14:26

26 But the Comforter, which is the Holy Ghost, whom the Father will send in my name, he shall teach you all things, and bring all things to your remembrance, whatsoever I have said unto you.

LUKE 6:40

40 The disciple is not above his master: but every one that is perfect shall be as his master.

JOHN 13:16

16 Verily, verily, I say unto you, The servant is not greater than his lord; neither he that is sent greater than he that sent him.

"HAVE NO FEAR!"

MATTHEW 10:26–33

26 Fear them not therefore: for there is nothing covered, that shall not be revealed; and hid, that shall not be known.

27 What I tell you in darkness, that speak ye in light: and what ye hear in the ear, that preach ye upon the housetops.

28 And fear not them which kill the body, but are not able to kill the soul: but rather fear him which is able to destroy both soul and body in hell.

29 Are not two sparrows sold for a farthing? and one of them shall not fall on the ground without your Father.

30 But the very hairs of your head are all numbered.

31 Fear ye not therefore, ye are of more value than many sparrows.

32 Whosoever therefore shall confess me before men, him will I confess also before my Father which is in heaven.

33 But whosoever shall deny me before men, him will I also deny before my Father which is in heaven.

MARK 4:22

22 For there is nothing hid, which shall not be manifested; neither was any thing kept secret, but that it should come abroad.

LUKE 12:2–9

2 For there is nothing covered, that shall not be revealed; neither hid, that shall not be known.

3 Therefore whatsoever ye have spoken in darkness shall be heard in the light; and that which ye have spoken in the ear in closets shall be proclaimed upon the housetops.

4 And I say unto you my friends, Be not afraid of them that kill the body, and after that have no more that they can do.

5 But I will forewarn you whom ye shall fear: Fear him, which after he hath killed hath power to cast into hell; yea, I say unto you, Fear him.

6 Are not five sparrows sold for two farthings, and not one of them is forgotten before God?

7 But even the very hairs of your head are all numbered. Fear not therefore: ye are of more value than many sparrows.

8 Also I say unto you, Whosoever shall confess me before men, him shall the Son of man also confess before the angels of God:

9 But he that denieth me before men shall be denied before the angels of God.

MARK 8:38

38 Whosoever therefore shall be ashamed of me and of my words in this adulterous and sinful generation; of him also shall the Son of man be ashamed, when he cometh in the glory of his Father with the holy angels.

LUKE 9:26

26 For whosoever shall be ashamed of me and of my words, of him shall the Son of man be ashamed, when he shall come in his own glory, and in his Father's, and of the holy angels.

DIVISIONS WITHIN HOUSEHOLDS

MATTHEW 10:34–36

34 Think not that I am come to send peace on earth: I came not to send peace, but a sword.

35 For I am come to set a man at variance against his father, and the daughter against her mother, and the daughter in law against her mother in law.

36 And a man's foes shall be they of his own household.

LUKE 12:51–53

51 Suppose ye that I am come to give peace on earth? I tell you, Nay; but rather division:

52 For from henceforth there shall be five in one house divided, three against two, and two against three.

The Apostles Preaching the Gospel to the Nations, 1580. Artist Unknown

LUKE 14:25–27

25 And there went great multitudes with him: and he turned, and said unto them,

26 If any man come to me, and hate not his father, and mother, and wife, and children, and brethren, and sisters, yea, and his own life also, he cannot be my disciple.

27 And whosoever doth not bear his cross, and come after me, cannot be my disciple.

LUKE 17:33

33 Whosoever shall seek to save his life shall lose it; and whosoever shall lose his life shall preserve it.

JOHN 12:25

25 He that loveth his life shall lose it; and he that hateth his life in this world shall keep it unto life eternal.

MATTHEW 10:40–42

40 He that receiveth you receiveth me, and he that receiveth me receiveth him that sent me.

41 He that receiveth a prophet in the name of a prophet shall receive a prophet's reward; and he that receiveth a righteous man in the name of a righteous man shall receive a righteous man's reward.

42 And whosoever shall give to drink unto one of these little ones a cup of cold water only in the name of a disciple, verily I say unto you, he shall in no wise lose his reward.

MARK 9:41

41 For whosoever shall give you a cup of water to drink in my name, because ye belong to Christ, verily I say unto you, he shall not lose his reward.

53 The father shall be divided against the son, and the son against the father; the mother against the daughter, and the daughter against the mother; the mother in law against her daughter in law, and the daughter in law against her mother in law.

THE CONDITIONS AND REWARDS OF BEING A DISCIPLE

MATTHEW 10:37–39

37 He that loveth father or mother more than me is not worthy of me: and he that loveth son or daughter more than me is not worthy of me.

38 And he that taketh not his cross, and followeth after me, is not worthy of me.

39 He that findeth his life shall lose it: and he that loseth his life for my sake shall find it.

LUKE 10:16

16 He that heareth you heareth me; and he that despiseth you despiseth me; and he that despiseth me despiseth him that sent me.

JOHN 13:20

20 Verily, verily, I say unto you, He that receiveth whomsoever I send receiveth me; and he that receiveth me receiveth him that sent me.

A QUESTION FROM JOHN THE BAPTIST IN PRISON AND JESUS' REPLY

As Jesus finishes instructing his disciples, he continues on his way teaching and preaching. From the source common to Matthew and Luke comes the question put to Jesus by John from prison through his disciples: "Art thou he that should come, or do we look for another?" Jesus points to the works he has been doing on those who are sick—works that bring to life the vision expressed in Isaiah 35: "Behold, your God will come with vengeance…he will come and save you. Then the eyes of the blind will be opened, and the ears of the deaf shall be unstopped. Then shall the lame man leap like a hart, and the tongue of the dumb sing…" Jesus then laments the way people of their day missed the point both of John's message and his own, denouncing John who fasted as demon possessed, and Jesus who ate and drank with sinners as a drunkard. This leads into Jesus' judgments on the cities where his works were done—who refused to repent and believe his message. Jesus ends this section with one of the most comforting invitations of the New Testament: "Come unto me, all ye that labor and are heavy laden, and I will give you rest…"

MATTHEW 11:2–6

2 Now when John had heard in the prison the works of Christ, he sent two of his disciples,

3 And said unto him, Art thou he that should come, or do we look for another?

4 Jesus answered and said unto them, Go and shew John again those things which ye do hear and see:

5 The blind receive their sight, and the lame walk, the lepers are cleansed, and the deaf hear, the dead are raised up, and the poor have the gospel preached to them.

6 And blessed is he, whosoever shall not be offended in me.

LUKE 7:18–23

18 And the disciples of John shewed him of all these things.

19 And John calling unto him two of his disciples sent them to Jesus, saying, Art thou he that should come? or look we for another?

20 When the men were come unto him, they said, John Baptist hath sent us unto thee, saying, Art thou he that should come? or look we for another?

21 And in that same hour he cured many of their infirmities and plagues, and of evil spirits; and unto many that were blind he gave sight.

22 Then Jesus answering said unto them, Go your way, and tell John what things ye have seen and heard; how that the blind see, the lame walk, the lepers are cleansed, the deaf hear, the dead are raised, to the poor the gospel is preached.

23 And blessed is he, whosoever shall not be offended in me.

JESUS WITNESSES ABOUT JOHN THE BAPTIST

MATTHEW 11:7–19

7 And as they departed, Jesus began to say unto the multitudes concerning John, What went ye out into the wilderness to see? A reed shaken with the wind?

8 But what went ye out for to see? A man clothed in soft raiment? behold, they that wear soft clothing are in kings' houses.

9 But what went ye out for to see? A prophet? yea, I say unto you, and more than a prophet.

10 For this is he, of whom it is written, Behold, I send my messenger before thy face, which shall prepare thy way before thee.

11 Verily I say unto you, Among them that are born of women there hath not risen a greater than John the Baptist: notwithstanding he that is least in the kingdom of heaven is greater than he.

12 And from the days of John the Baptist until now the kingdom of heaven suffereth violence, and the violent take it by force.

13 For all the prophets and the law prophesied until John.

14 And if ye will receive it, this is Elias, which was for to come.

15 He that hath ears to hear, let him hear.

16 But whereunto shall I liken this generation? It is like unto children sitting in the markets, and calling unto their fellows,

17 And saying, We have piped unto you, and ye have not danced; we have mourned unto you, and ye have not lamented.

18 For John came neither eating nor drinking, and they say, He hath a devil.

19 The Son of man came eating and drinking, and they say, Behold a man gluttonous, and a winebibber, a friend of publicans and sinners. But wisdom is justified of her children.

LUKE 7:24–35

24 And when the messengers of John were departed, he began to speak unto the people concerning John, What went ye out into the wilderness for to see? A reed shaken with the wind?

25 But what went ye out for to see? A man clothed in soft raiment? Behold, they which are gorgeously apparelled, and live delicately, are in kings' courts.

26 But what went ye out for to see? A prophet? Yea, I say unto you, and much more than a prophet.

27 This is he, of whom it is written, Behold, I send my messenger before thy face, which shall prepare thy way before thee.

28 For I say unto you, Among those that are born of women there is not a greater prophet than John the Baptist: but he that is least in the kingdom of God is greater than he.

29 And all the people that heard him, and the publicans, justified God, being baptized with the baptism of John.

30 But the Pharisees and lawyers rejected the counsel of God against themselves, being not baptized of him.

31 And the Lord said, Whereunto then shall I liken the men of this generation? and to what are they like?

32 They are like unto children sitting in the marketplace, and calling one to another, and saying, We have piped unto you, and ye have not danced; we have mourned to you, and ye have not wept.

33 For John the Baptist came neither eating bread nor drinking wine; and ye say, He hath a devil.

34 The Son of man is come eating and drinking; and ye say, Behold a gluttonous man, and a winebibber, a friend of publicans and sinners!

35 But wisdom is justified of all her children.

LUKE 16:16

16 The law and the prophets were until John: since that time the kingdom of God is preached, and every man presseth into it.

WOES ON THE CITIES OF GALILEE

MATTHEW 11:20–24

20 Then began he to upbraid the cities wherein most of his mighty works were done, because they repented not:

21 Woe unto thee, Chorazin! woe unto thee, Bethsaida! for if the mighty works, which were done in you, had been done in Tyre and Sidon, they would have repented long ago in sackcloth and ashes.

22 But I say unto you, It shall be more tolerable for Tyre and Sidon at the day of judgment, than for you.

23 And thou, Capernaum, which art exalted unto heaven, shalt be brought down to hell: for if the mighty works, which have been done in thee, had been done in Sodom, it would have remained until this day.

24 But I say unto you, That it shall be more tolerable for the land of Sodom in the day of judgment, than for thee.

LUKE 10:12–15

12 But I say unto you, that it shall be more tolerable in that day for Sodom, than for that city.

13 Woe unto thee, Chorazin! woe unto thee, Bethsaida! for if the mighty

works had been done in Tyre and Sidon, which have been done in you, they had a great while ago repented, sitting in sackcloth and ashes.

14 But it shall be more tolerable for Tyre and Sidon at the judgment, than for you.

15 And thou, Capernaum, which art exalted to heaven, shalt be thrust down to hell.

MATTHEW 11:25–27

25 At that time Jesus answered and said, I thank thee, O Father, Lord of heaven and earth, because thou hast hid these things from the wise and prudent, and hast revealed them unto babes.

26 Even so, Father: for so it seemed good in thy sight.

27 All things are delivered unto me of my Father: and no man knoweth the Son, but the Father; neither knoweth any man the Father, save the Son, and he to whomsoever the Son will reveal him.

LUKE 10:21–22

21 In that hour Jesus rejoiced in spirit, and said, I thank thee, O Father, Lord of heaven and earth, that thou hast hid these things from the wise and prudent, and hast revealed them unto babes: even so, Father; for so it seemed good in thy sight.

22 All things are delivered to me of my Father: and no man knoweth who the Son is, but the Father; and who the Father is, but the Son, and he to whom the Son will reveal him.

"COME UNTO ME... AND I WILL GIVE YOU REST"

MATTHEW 11:28–30

28 Come unto me, all ye that labour and are heavy laden, and I will give you rest.

29 Take my yoke upon you, and learn of me; for I am meek and lowly in heart: and ye shall find rest unto your souls.

30 For my yoke is easy, and my burden is light.

PEOPLE RAISE QUESTIONS ABOUT JESUS

Jesus' teaching and works lead some to ask if he might be the Messiah, the Son of David, while others come to different conclusions about the "power" behind his actions: Is He "Out of His Mind"? Mark relates that in the intensity of Jesus' ministry, which often left him with no time even to eat, those close to him took him away by force, thinking "he is beside himself."

MARK 3:20–21

20 And the multitude cometh together again, so that they could not so much as eat bread.

21 And when his friends heard of it, they went out to lay hold on him: for they said, He is beside himself.

IS HE IN LEAGUE WITH SATAN?

Still others thought that it was the "prince of demons" who gave Jesus the power to order the demons around. To them Jesus makes the suggestion that if Satan's forces are divided, they are "coming to an end." Speaking in parables, Jesus sug-

gests that if one wants to plunder a strong man's house, one must first "bind the strong man"——a perfect caricature of what Jesus is doing in Satan's house by his healings and exorcisms. This is one of three subtle parables that summarize the direction and eventual outcome of Mark's story of Jesus.

MATTHEW 12:22–30

22 Then was brought unto him one possessed with a devil, blind, and dumb: and he healed him, insomuch that the blind and dumb both spake and saw.

23 And all the people were amazed, and said, Is not this the son of David?

24 But when the Pharisees heard it, they said, This fellow doth not cast out devils, but by Beelzebub the prince of the devils.

25 And Jesus knew their thoughts, and said unto them, Every kingdom divided against itself is brought to desolation; and every city or house divided against itself shall not stand:

26 And if Satan cast out Satan, he is divided against himself; how shall then his kingdom stand?

27 And if I by Beelzebub cast out devils, by whom do your children cast them out? therefore they shall be your judges.

28 But if I cast out devils by the Spirit of God, then the kingdom of God is come unto you.

29 Or else how can one enter into a strong man's house, and spoil his goods, except he first bind the strong man? and then he will spoil his house.

30 He that is not with me is against me; and he that gathereth not with me scattereth abroad.

MARK 3:22–27

22 And the scribes which came down from Jerusalem said, He hath Beelzebub, and by the prince of the devils casteth he out devils.

23 And he called them unto him, and said unto them in parables, How can Satan cast out Satan?

24 And if a kingdom be divided against itself, that kingdom cannot stand.

25 And if a house be divided against itself, that house cannot stand.

When the unclean spirit is gone out of a man, he walketh through dry places, seeking rest; and finding none, he saith, I will return unto my house whence I came out.

And when he cometh, he findeth it swept and garnished.

—LUKE 11:24–25

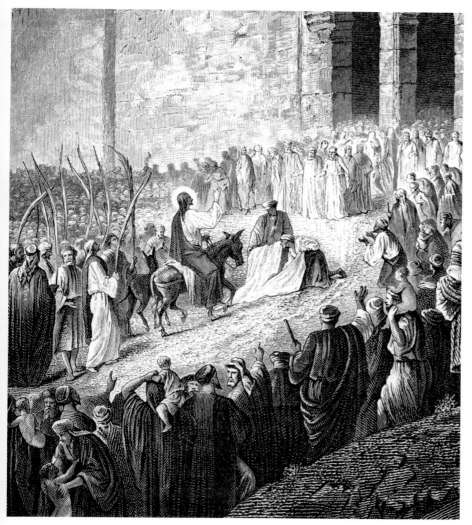

Triumphal Entry into Jerusalem, by Alexander Bida, 1813–1895

and a house divided against a house falleth.

18 If Satan also be divided against himself, how shall his kingdom stand? because ye say that I cast out devils through Beelzebub.

19 And if I by Beelzebub cast out devils, by whom do your sons cast them out? therefore shall they be your judges.

20 But if I with the finger of God cast out devils, no doubt the kingdom of God is come upon you.

21 When a strong man armed keepeth his palace, his goods are in peace:

22 But when a stronger than he shall come upon him, and overcome him, he taketh from him all his armour wherein he trusted, and divideth his spoils.

23 He that is not with me is against me: and he that gathereth not with me scattereth.

JOHN 7:20

20 The people answered and said, Thou hast a devil: who goeth about to kill thee?

JOHN 10:20

20 And many of them said, He hath a devil, and is mad; why hear ye him?

JOHN 8:48

48 Then answered the Jews, and said unto him, Say we not well that thou art a Samaritan, and hast a devil?

JOHN 8:52

52 Then said the Jews unto him, Now we know that thou hast a devil. Abraham is dead, and the prophets; and thou sayest, If a man keep my saying, he shall never taste of death.

26 And if Satan rise up against himself, and be divided, he cannot stand, but hath an end.

27 No man can enter into a strong man's house, and spoil his goods, except he will first bind the strong man; and then he will spoil his house.

LUKE 11:14–15

14 And he was casting out a devil, and it was dumb. And it came to pass, when the devil was gone out, the dumb spake; and the people wondered.

15 But some of them said, He casteth out devils through Beelzebub the chief of the devils.

MATTHEW 9:32–34

32 As they went out, behold, they brought to him a dumb man possessed with a devil.

33 And when the devil was cast out, the dumb spake: and the multitudes marvelled, saying, It was never so seen in Israel.

34 But the Pharisees said, He casteth out devils through the prince of the devils.

LUKE 11:17–23

17 But he, knowing their thoughts, said unto them, Every kingdom divided against itself is brought to desolation;

THE SIN AGAINST THE HOLY SPIRIT

MATTHEW 12:31–37

31 Wherefore I say unto you, All manner of sin and blasphemy shall be forgiven unto men: but the blasphemy against the Holy Ghost shall not be forgiven unto men.

32 And whosoever speaketh a word against the Son of man, it shall be forgiven him: but whosoever speaketh against the Holy Ghost, it shall not be forgiven him, neither in this world, neither in the world to come.

33 Either make the tree good, and his fruit good; or else make the tree corrupt, and his fruit corrupt: for the tree is known by his fruit.

34 O generation of vipers, how can ye, being evil, speak good things? for out of the abundance of the heart the mouth speaketh.

35 A good man out of the good treasure of the heart bringeth forth good things: and an evil man out of the evil treasure bringeth forth evil things.

36 But I say unto you, That every idle word that men shall speak, they shall give account thereof in the day of judgment.

37 For by thy words thou shalt be justified, and by thy words thou shalt be condemned.

MARK 3:28–30

28 Verily I say unto you, All sins shall be forgiven unto the sons of men, and blasphemies wherewith soever they shall blaspheme:

29 But he that shall blaspheme against the Holy Ghost hath never forgiveness, but is in danger of eternal damnation:

30 Because they said, He hath an unclean spirit.

LUKE 12:10

10 And whosoever shall speak a word against the Son of man, it shall be forgiven him: but unto him that blasphemeth against the Holy Ghost it shall not be forgiven.

MATTHEW 7:16–20

16 Ye shall know them by their fruits. Do men gather grapes of thorns, or figs of thistles?

17 Even so every good tree bringeth forth good fruit; but a corrupt tree bringeth forth evil fruit.

18 A good tree cannot bring forth evil fruit, neither can a corrupt tree bring forth good fruit.

19 Every tree that bringeth not forth good fruit is hewn down, and cast into the fire.

20 Wherefore by their fruits ye shall know them.

LUKE 6:43–45

43 For a good tree bringeth not forth corrupt fruit; neither doth a corrupt tree bring forth good fruit.

44 For every tree is known by his own fruit. For of thorns men do not gather figs, nor of a bramble bush gather they grapes.

45 A good man out of the good treasure of his heart bringeth forth that which is good; and an evil man out of the evil treasure of his heart bringeth forth that which is evil: for of the abundance of the heart his mouth speaketh.

THE SIGN OF THE PROPHET JONAH

Some Pharisees (Matthew adds "and scribes") come to Jesus looking for a sign from him. In Luke, Jesus accuses "this generation" of seeking a sign. Mark's Jesus simply refuses their request outright. In the source Matthew and Luke share, the response goes "…there shall no sign be given to [this generation], but the sign of the Prophet Jonah." Luke seems to follow the common source closely, speaking about how Jonah was a sign for the men of Nineveh, even as the Son of man is a sign for his generation. Matthew's version adds yet another wrinkle—using the three days and nights in the belly of the whale as a foreshadowing of Jesus' three days in the bosom of the earth. Perhaps yet another dimension underlies "the sign of Jonah." For the story of Jonah figures into the worship on the Day of Atonement (Yom Kippur). Its message is: if the nonbelieving nations repented at Jonah's preaching, how much more ought God's covenant people do the same?

MATTHEW 12:28–32

28 But if I cast out devils by the Spirit of God, then the kingdom of God is come unto you.

29 Or else how can one enter into a strong man's house, and spoil his goods, except he first bind the strong man? and then he will spoil his house.

30 He that is not with me is against me; and he that gathereth not with me scattereth abroad.

31 Wherefore I say unto you, All manner of sin and blasphemy shall be forgiven unto men: but the blasphemy against the Holy Ghost shall not be forgiven unto men.

32 And whosoever speaketh a word against the Son of man, it shall be forgiven him: but whosoever speaketh against the Holy Ghost, it shall not be forgiven him, neither in this world, neither in the world to come.

MATTHEW 16:1–2, 4

1 The Pharisees also with the Sadducees came, and tempting desired him that he would shew them a sign from heaven.

2 He answered and said unto them,
When it is evening, ye say, It will be
fair weather: for the sky is red.

4 A wicked and adulterous generation
seeketh after a sign; and there shall
no sign be given unto it, but the sign
of the prophet Jonas. And he left
them, and departed.

MARK 8:11–12

11 And the Pharisees came forth, and
began to question with him, seeking of
him a sign from heaven, tempting him.

12 And he sighed deeply in his spirit,
and saith, Why doth this generation
seek after a sign? verily I say unto
you, There shall no sign be given
unto this generation.

LUKE 11:16

16 And others, tempting him, sought of
him a sign from heaven.

JOHN 6:30

30 They said therefore unto him, What
sign shewest thou then, that we may
see, and believe thee? what dost thou
work?

LUKE 11:29–32

29 And when the people were gathered
thick together, he began to say, This
is an evil generation: they seek a
sign; and there shall no sign be given
it, but the sign of Jonas the prophet.

30 For as Jonas was a sign unto the
Ninevites, so shall also the Son of
man be to this generation.

31 The queen of the south shall rise up
in the judgment with the men of
this generation, and condemn them:
for she came from the utmost parts
of the earth to hear the wisdom of
Solomon; and, behold, a greater than
Solomon is here.

32 The men of Nineve shall rise up in
the judgment with this generation,
and shall condemn it: for they repent-
ed at the preaching of Jonas; and,
behold, a greater than Jonas is here.

THE RETURN OF AN EVIL SPIRIT

MATTHEW 12:43–45

43 When the unclean spirit is gone out
of a man, he walketh through dry
places, seeking rest, and findeth
none.

44 Then he saith, I will return into my
house from whence I came out; and
when he is come, he findeth it
empty, swept, and garnished.

45 Then goeth he, and taketh with
himself seven other spirits more
wicked than himself, and they enter
in and dwell there: and the last state
of that man is worse than the first.
Even so shall it be also unto this
wicked generation.

LUKE 11:24–26

24 When the unclean spirit is gone out
of a man, he walketh through dry
places, seeking rest; and finding
none, he saith, I will return unto my
house whence I came out.

25 And when he cometh, he findeth it
swept and garnished.

26 Then goeth he, and taketh to him
seven other spirits more wicked than
himself; and they enter in, and dwell
there: and the last state of that man is
worse than the first.

THE MOTHER AND BROTHERS OF JESUS

MATTHEW 12:46–50

46 While he yet talked to the people,
behold, his mother and his brethren
stood without, desiring to speak
with him.

47 Then one said unto him, Behold, thy
mother and thy brethren stand with-
out, desiring to speak with thee.

48 But he answered and said unto him
that told him, Who is my mother?
and who are my brethren?

49 And he stretched forth his hand
toward his disciples, and said, Behold
my mother and my brethren!

50 For whosoever shall do the will of
my Father which is in heaven, the
same is my brother, and sister, and
mother.

MARK 3:31–35

31 There came then his brethren and
his mother, and, standing without,
sent unto him, calling him.

32 And the multitude sat about him,
and they said unto him, Behold, thy
mother and thy brethren without
seek for thee.

33 And he answered them, saying, Who
is my mother, or my brethren?

34 And he looked round about on
them which sat about him, and said,
Behold my mother and my brethren!

35 For whosoever shall do the will of
God, the same is my brother, and my
sister, and mother.

LUKE 8:19–21

19 Then came to him his mother and
his brethren, and could not come at
him for the press.

20 And it was told him by certain
which said, Thy mother and thy
brethren stand without, desiring to
see thee.

21 And he answered and said unto
them, My mother and my brethren
are these which hear the word of
God, and do it.

JOHN 15:14

14 Ye are my friends, if ye do
whatsoever I command you.

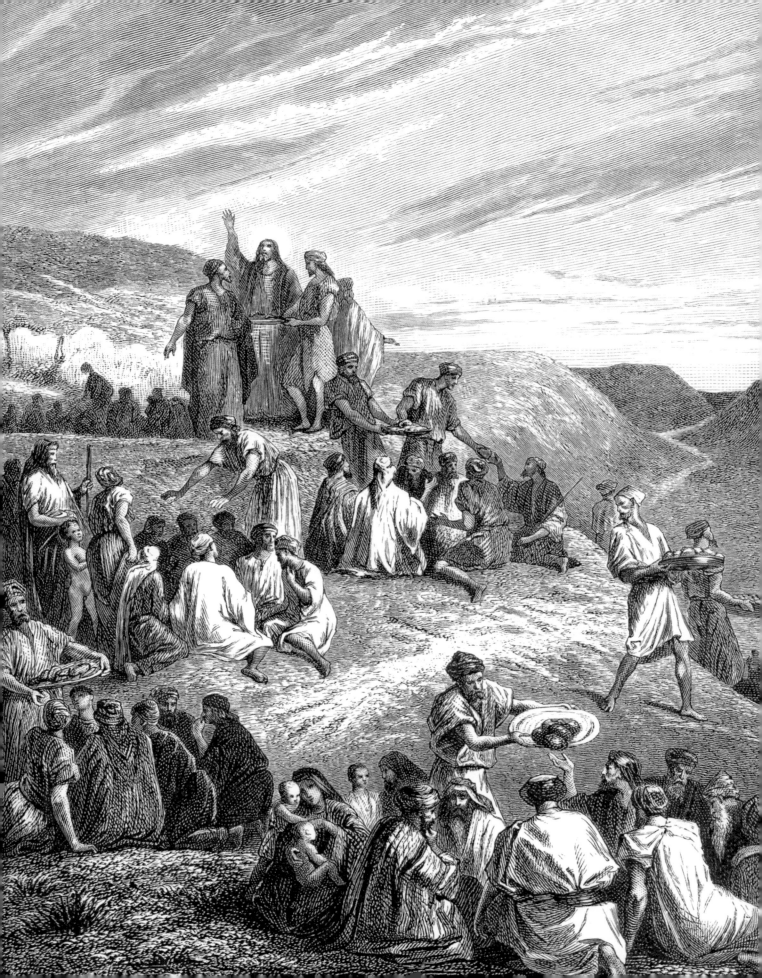

Jesus Teaches in Parables

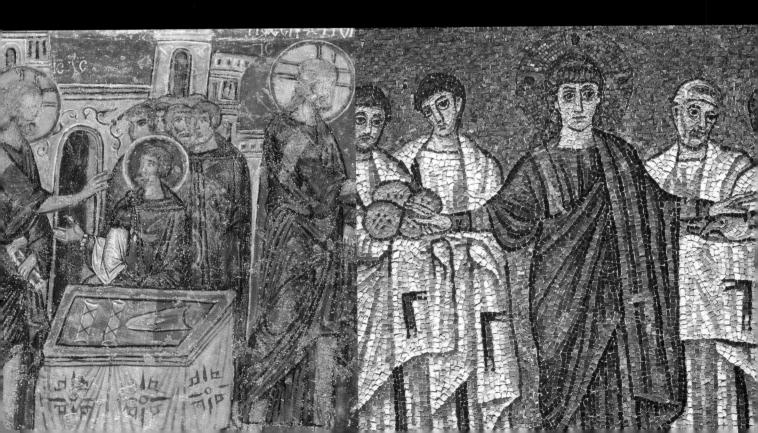

Jesus Teaches in Parables

Christ Raising Hand in Blessing, 19th century, Artist Unknown

HOW WILL PEOPLE RECOGNIZE THE SIGNS OF THAT KINGDOM WHEN IT COMES? Central to Jesus' teaching is the parable. Simply stated, a parable is an analogy drawn from nature or everyday life that catches the hearer's attention, teasing him or her to figure it out by raising questions or doubts. Mark's gospel, the first and shortest, put a whole chapter of them in the middle of Jesus' Galilean ministry. Matthew adds other parables, expanding the chapter into the third of five great sermons. Luke adds several more parables unique to his gospel. They are invitations to look at all of life in a new way—as the place where God is waiting to meet us.

A PARABLE ABOUT A SOWER PLANTING SEEDS

This first parable is one of the three that represent Jesus' story and its outcome—miniatures of the major dramatic sections of the gospel. Jesus, as the sower, plants the seed, casting it with abandon into all kinds of places. Some of it grows, matures, and bears fruit, some doesn't. Nevertheless, the harvest will come —and abundant it will be. For God is the guarantor of that. Therefore, the effort of sower and reaper will not be in vain. This parable, and really all the parables, are about Jesus and his ministry: as it now is, and as it will be.

MATTHEW 13:1–9

1 The same day went Jesus out of the house, and sat by the sea side.

2 And great multitudes were gathered together unto him, so that he went into a ship, and sat; and the whole multitude stood on the shore.

3 And he spake many things unto them in parables, saying, Behold, a sower went forth to sow;

4 And when he sowed, some seeds fell by the way side, and the fowls came and devoured them up:

5 Some fell upon stony places, where they had not much earth: and forthwith they sprung up, because they had no deepness of earth:

6 And when the sun was up, they were scorched; and because they had no root, they withered away.

7 And some fell among thorns; and the thorns sprung up, and choked them:

8 But other fell into good ground, and brought forth fruit, some an hundredfold, some sixtyfold, some thirtyfold.

9 Who hath ears to hear, let him hear.

Parable of the Sower, by Alexander Bida, 1813–1895

ઉ&ઉ&ઉ&ઉ&ઉ&ઉ&ઉ&ઉ&ઉ&ઉ&ઉ&ઉ&ઉ&ઉ&ઉ&

He answered and said unto them, Because it is given unto you to know the mysteries of the kingdom of heaven, but to them it is not given.

For whosoever hath, to him shall be given, and he shall have more abundance: but whosoever hath not, from him shall be taken away even that he hath.

—MATTHEW 13:11–12

ઉ&ઉ&ઉ&ઉ&ઉ&ઉ&ઉ&ઉ&ઉ&ઉ&ઉ&ઉ&ઉ&ઉ&ઉ&

MARK 4:1–9

1 And he began again to teach by the sea side: and there was gathered unto him a great multitude, so that he entered into a ship, and sat in the sea; and the whole multitude was by the sea on the land.

2 And he taught them many things by parables, and said unto them in his doctrine,

3 Hearken; Behold, there went out a sower to sow:

4 And it came to pass, as he sowed, some fell by the way side, and the fowls of the air came and devoured it up.

5 And some fell on stony ground, where it had not much earth; and immediately it sprang up, because it had no depth of earth:

6 But when the sun was up, it was scorched; and because it had no root, it withered away.

7 And some fell among thorns, and the thorns grew up, and choked it, and it yielded no fruit.

8 And other fell on good ground, and did yield fruit that sprang up and increased; and brought forth, some thirty, and some sixty, and some an hundred.

9 And he said unto them, He that hath ears to hear, let him hear.

LUKE 8:4–8

4 And when much people were gathered together, and were come to him out of every city, he spake by a parable:

5 A sower went out to sow his seed: and as he sowed, some fell by the way side; and it was trodden down, and the fowls of the air devoured it.

6 And some fell upon a rock; and as soon as it was sprung up, it withered away, because it lacked moisture.

7 And some fell among thorns; and the thorns sprang up with it, and choked it.

8 And other fell on good ground, and sprang up, and bare fruit an hundredfold. And when he had said these things, he cried, He that hath ears to hear, let him hear.

THE REASON FOR TEACHING IN PARABLES

Mark, Mathew, and Luke all find the impetus for Jesus' teaching with parables in Isaiah 6—the story of Isaiah's prophetic call and mission—and their outcome: "that seeing they may see, and not perceive; and hearing they may hear and not understand; lest at any time they should be converted, and their sins be forgiven them." John, who prefers the more direct "I am…" statements ("I am the good shepherd, the bread of life, the light of the world," etc.) to parables, makes the same point about Jesus' ministry, its rejection, and its ultimate success—also quoting the same passage.

MATTHEW 13:10–17

10 And the disciples came, and said unto him, Why speakest thou unto them in parables?

11 He answered and said unto them, Because it is given unto you to know the mysteries of the kingdom of heaven, but to them it is not given.

12 For whosoever hath, to him shall be given, and he shall have more abundance: but whosoever hath not, from him shall be taken away even that he hath.

13 Therefore speak I to them in parables: because they seeing see not; and hearing they hear not, neither do they understand.

14 And in them is fulfilled the prophecy of Esaias, which saith, By hearing ye shall hear, and shall not understand; and seeing ye shall see, and shall not perceive:

15 For this people's heart is waxed gross, and their ears are dull of hearing, and their eyes they have closed; lest at any time they should see with their eyes, and hear with their ears, and should understand with their heart, and should be converted, and I should heal them.

16 But blessed are your eyes, for they see: and your ears, for they hear.

17 For verily I say unto you, That many prophets and righteous men have desired to see those things which ye see, and have not seen them; and to hear those things which ye hear, and have not heard them.

MARK 4:10–11

10 And when he was alone, they that were about him with the twelve asked of him the parable.

11 And he said unto them, Unto you it is given to know the mystery of the kingdom of God: but unto them that are without, all these things are done in parables:

And the cares of this world, and the deceitfulness of riches, and the lusts of other things entering in, choke the word, and it becometh unfruitful.

—MARK 4:19

LUKE 8:9–10

9 And his disciples asked him, saying, What might this parable be?

10 And he said, Unto you it is given to know the mysteries of the kingdom of God: but to others in parables; that seeing they might not see, and hearing they might not understand.

MARK 4:25

25 For he that hath, to him shall be given: and he that hath not, from him shall be taken even that which he hath.

LUKE 8:18

18 Take heed therefore how ye hear: for whosoever hath, to him shall be given; and whosoever hath not, from him shall be taken even that which he seemeth to have.

MARK 4:12

12 That seeing they may see, and not perceive; and hearing they may hear, and not understand; lest at any time they should be converted, and their sins should be forgiven them.

LUKE 8:10

10 And he said, Unto you it is given to know the mysteries of the kingdom of God: but to others in parables; that seeing they might not see, and hearing they might not understand.

JOHN 9:39

39 And Jesus said, For judgment I am come into this world, that they which see not might see; and that they which see might be made blind.

MARK 8:17–18

17 And when Jesus knew it, he saith unto them, Why reason ye, because ye have no bread? perceive ye not yet, neither understand? have ye your heart yet hardened?

18 Having eyes, see ye not? and having ears, hear ye not? and do ye not remember?

JOHN 12:37–40

37 But though he had done so many miracles before them, yet they believed not on him:

38 That the saying of Esaias the prophet might be fulfilled, which he spake, Lord, who hath believed our report? and to whom hath the arm of the Lord been revealed?

39 Therefore they could not believe, because that Esaias said again,

40 He hath blinded their eyes, and hardened their heart; that they should not see with their eyes, nor understand with their heart, and be converted, and I should heal them.

LUKE 10:23–24

23 And he turned him unto his disciples, and said privately, Blessed are the eyes which see the things that ye see:

24 For I tell you, that many prophets and kings have desired to see those things which ye see, and have not seen them; and to hear those things which ye hear, and have not heard them.

THE INTERPRETATION OF THE SOWER PARABLE

MATTHEW 13:18–23

18 Hear ye therefore the parable of the sower.

19 When any one heareth the word of the kingdom, and understandeth it not, then cometh the wicked one, and catcheth away that which was sown in his heart. This is he which received seed by the way side.

20 But he that received the seed into stony places, the same is he that heareth the word, and anon with joy receiveth it;

21 Yet hath he not root in himself, but dureth for a while: for when tribulation or persecution ariseth because of the word, by and by he is offended.

22 He also that received seed among the thorns is he that heareth the word; and the care of this world, and the deceitfulness of riches, choke the word, and he becometh unfruitful.

23 But he that received seed into the good ground is he that heareth the word, and understandeth it; which also beareth fruit, and bringeth forth, some an hundredfold, some sixty, some thirty.

MARK 4:13–20

13 And he said unto them, Know ye not this parable? and how then will ye know all parables?

14 The sower soweth the word.

15 And these are they by the way side, where the word is sown; but when they have heard, Satan cometh immediately, and taketh away the word that was sown in their hearts.

16 And these are they likewise which are sown on stony ground; who, when they have heard the word, immediately receive it with gladness;

17 And have no root in themselves, and so endure but for a time: afterward, when affliction or persecution ariseth for the word's sake, immediately they are offended.

18 And these are they which are sown among thorns; such as hear the word,

19 And the cares of this world, and the deceitfulness of riches, and the lusts of other things entering in, choke the word, and it becometh unfruitful.

20 And these are they which are sown on good ground; such as hear the word, and receive it, and bring forth fruit, some thirtyfold, some sixty, and some an hundred.

LUKE 8:11–15

11 Now the parable is this: The seed is the word of God.

12 Those by the way side are they that hear; then cometh the devil, and taketh away the word out of their hearts, lest they should believe and be saved.

13 They on the rock are they, which, when they hear, receive the word with joy; and these have no root, which for a while believe, and in time of temptation fall away.

14 And that which fell among thorns are they, which, when they have heard, go forth, and are choked with cares and riches and pleasures of this life, and bring no fruit to perfection.

15 But that on the good ground are they, which in an honest and good heart, having heard the word, keep it, and bring forth fruit with patience.

WHOEVER HAS EARS, LISTEN!

MATTHEW 5:15

15 Neither do men light a candle, and put it under a bushel, but on a candlestick; and it giveth light unto all that are in the house.

MATTHEW 10:26

26 Fear them not therefore: for there is nothing covered, that shall not be revealed; and hid, that shall not be known.

MARK 4:21–25

21 And he said unto them, Is a candle brought to be put under a bushel, or under a bed? and not to be set on a candlestick?

22 For there is nothing hid, which shall not be manifested; neither was any thing kept secret, but that it should come abroad.

23 If any man have ears to hear, let him hear.

24 And he said unto them, Take heed what ye hear: with what measure ye mete, it shall be measured to you: and unto you that hear shall more be given.

25 For he that hath, to him shall be given: and he that hath not, from him shall be taken even that which he hath.

LUKE 8:16–18

16 No man, when he hath lighted a candle, covereth it with a vessel, or putteth it under a bed; but setteth it on a candlestick, that they which enter in may see the light.

17 For nothing is secret, that shall not be made manifest; neither any thing hid, that shall not be known and come abroad.

18 Take heed therefore how ye hear: for whosoever hath, to him shall be given; and whosoever hath not, from him shall be taken even that which he seemeth to have.

MATTHEW 13:12

12 For whosoever hath, to him shall be given, and he shall have more abundance: but whosoever hath not, from him shall be taken away even that he hath.

A PARABLE ABOUT A SEED GROWING SECRETLY

Closely related to the sower parable (perhaps that is why Matthew and Luke choose not to include it in their gospels) is this parable. The earth produces fruit "of herself"—for that is the way God made it. While the sower parable emphasizes the planting and its interpretation emphasizes the soil, this parable focuses on the harvest, which happens immediately, when the time is right.

MARK 4:26–29

26 And he said, So is the kingdom of God, as if a man should cast seed into the ground;

27 And should sleep, and rise night and day, and the seed should spring and grow up, he knoweth not how.

28 For the earth bringeth forth fruit of herself; first the blade, then the ear, after that the full corn in the ear.

29 But when the fruit is brought forth, immediately he putteth in the sickle, because the harvest is come.

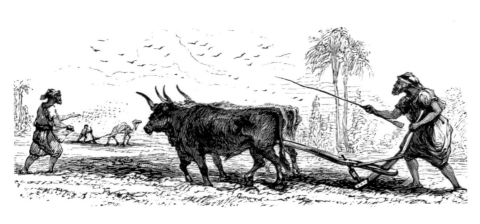

Eastern Plowing and Sowing, Artist Unknown

A PARABLE ABOUT WEEDS GROWING AMONG THE WHEAT

Unique to Matthew is this related parable—and its explanation below. It raises the question, What should we do, if, in God's acre—even though God planted good seed there—the field grows to be full of weeds? Should we pull them up? No, says the one who does the planting. For it is God's harvest. It is the servant's job to sow, to wait, and to leave the harvesting to God, lest some of the wheat be lost in the weeding process.

MATTHEW 13:24–30

24 Another parable put he forth unto them, saying, The kingdom of heaven is likened unto a man which sowed good seed in his field:

25 But while men slept, his enemy came and sowed tares among the wheat, and went his way.

26 But when the blade was sprung up, and brought forth fruit, then appeared the tares also.

27 So the servants of the householder came and said unto him, Sir, didst not thou sow good seed in thy field? from whence then hath it tares?

28 He said unto them, An enemy hath done this. The servants said unto him, Wilt thou then that we go and gather them up?

29 But he said, Nay; lest while ye gather up the tares, ye root up also the wheat with them.

30 Let both grow together until the harvest: and in the time of harvest I will say to the reapers, Gather ye together first the tares, and bind them in bundles to burn them: but gather the wheat into my barn.

A PARABLE ABOUT A MUSTARD SEED

MATTHEW 13:31–32

31 Another parable put he forth unto them, saying, The kingdom of heaven is like to a grain of mustard seed, which a man took, and sowed in his field:

32 Which indeed is the least of all seeds: but when it is grown, it is the greatest among herbs, and becometh a tree, so that the birds of the air come and lodge in the branches thereof.

MARK 4:30–32

30 And he said, Whereunto shall we liken the kingdom of God? or with what comparison shall we compare it?

31 It is like a grain of mustard seed, which, when it is sown in the earth, is less than all the seeds that be in the earth:

32 But when it is sown, it groweth up, and becometh greater than all herbs, and shooteth out great branches; so that the fowls of the air may lodge under the shadow of it.

LUKE 13:18–19

18 Then said he, Unto what is the kingdom of God like? and whereunto shall I resemble it?

19 It is like a grain of mustard seed, which a man took, and cast into his garden; and it grew, and waxed a great tree; and the fowls of the air lodged in the branches of it.

ABOUT JESUS' USE OF PARABLES

In this further summary statement Mark notes a distinction between Jesus' disciples and the crowds. Jesus speaks in parables to those who "see, but do not yet perceive." Privately, among his disciples, he explains everything. But then, they, too, are learners—as the term disciple indicates. Matthew points our yet another scripture, Psalm 78:2, which Jesus' teaching in parables brings to fulfillment: "I will open my mouth in parables; I will utter things which have been kept secret from the foundation of the world."

MATTHEW 13:34–35

34 All these things spake Jesus unto the multitude in parables; and without a parable spake he not unto them:

35 That it might be fulfilled which was spoken by the prophet, saying, I will open my mouth in parables; I will utter things which have been kept secret from the foundation of the world.

MARK 4:33–34

33 And with many such parables spake he the word unto them, as they were able to hear it.

34 But without a parable spake he not unto them: and when they were alone, he expounded all things to his disciples.

Wheat, by Artist Unknown

THE INTERPRETATION OF THE WEEDS AMONG THE WHEAT

MATTHEW 13:36–43

36 Then Jesus sent the multitude away, and went into the house: and his disciples came unto him, saying, Declare unto us the parable of the tares of the field.

37 He answered and said unto them, He that soweth the good seed is the Son of man;

38 The field is the world; the good seed are the children of the kingdom; but the tares are the children of the wicked one;

39 The enemy that sowed them is the devil; the harvest is the end of the world; and the reapers are the angels.

40 As therefore the tares are gathered and burned in the fire; so shall it be in the end of this world.

41 The Son of man shall send forth his angels, and they shall gather out of his kingdom all things that offend, and them which do iniquity;

42 And shall cast them into a furnace of fire: there shall be wailing and gnashing of teeth.

43 Then shall the righteous shine forth as the sun in the kingdom of their Father. Who hath ears to hear, let him hear.

Mustard, Artist Unknown

PARABLES ABOUT A HIDDEN TREASURE AND A PEARL

MATTHEW 13:44–46

44 Again, the kingdom of heaven is like unto treasure hid in a field; the which when a man hath found, he hideth, and for joy thereof goeth and selleth all that he hath, and buyeth that field.

45 Again, the kingdom of heaven is like unto a merchant man, seeking goodly pearls:

46 Who, when he had found one pearl of great price, went and sold all that he had, and bought it.

A PARABLE ABOUT A FISHING NET

MATTHEW 13:47–50

47 Again, the kingdom of heaven is like unto a net, that was cast into the sea, and gathered of every kind:

48 Which, when it was full, they drew to shore, and sat down, and gathered the good into vessels, but cast the bad away.

Casting a Net, by Artist Unknown

49 So shall it be at the end of the world: the angels shall come forth, and sever the wicked from among the just,

50 And shall cast them into the furnace of fire: there shall be wailing and gnashing of teeth.

ABOUT GATHERING TREASURES NEW AND OLD

In this summary peculiar to Matthew, Jesus asks his disciples whether they have understood everything. We who listen to his lesson after nearly twenty centuries of separation between the church and the synagogue, do well to note Jesus' mention of every scribe—those well versed in the Torah, God's instruction or law as written in the Books of Moses and their commentaries. Jesus—and Matthew—think, speak, and write as Jews—members of God's covenant people. Matthew's community of faith had scribes; perhaps Matthew was himself a scribe—one of those trained by Jesus for the kingdom of heaven. Both old and new treasures belong in the stores of those who would be well versed in the ways of God. "Have ye understood all these things? Yea, Lord."

MATTHEW 13:51–52

51 Jesus saith unto them, Have ye understood all these things? They say unto him, Yea, Lord.

52 Then said he unto them, Therefore every scribe which is instructed unto the kingdom of heaven is like unto a man that is an householder, which bringeth forth out of his treasure things new and old.

JESUS HEALS A PARALYTIC AT THE POOL OF BETHESDA

JOHN 5:2–47

Now there is at Jerusalem by the sheep market a pool, which is called in the Hebrew tongue Bethesda, having five porches.

In these lay a great multitude of impotent folk, of blind, halt, withered, waiting for the moving of the water.

For an angel went down at a certain season into the pool, and troubled the water: whosoever then first after the troubling of the water stepped in was made whole of whatsoever disease he had.

5 And a certain man was there, which had an infirmity thirty and eight years.

6 When Jesus saw him lie, and knew that he had been now a long time in that case, he saith unto him, Wilt thou be made whole?

7 The impotent man answered him, Sir, I have no man, when the water is troubled, to put me into the pool: but while I am coming, another steppeth down before me.

8 Jesus saith unto him, Rise, take up thy bed, and walk.

9 And immediately the man was made whole, and took up his bed, and walked: and on the same day was the sabbath.

10 The Jews therefore said unto him that was cured, It is the sabbath day: it is not lawful for thee to carry thy bed.

11 He answered them, He that made me whole, the same said unto me, Take up thy bed, and walk.

12 Then asked they him, What man is that which said unto thee, Take up thy bed, and walk?

13 And he that was healed wist not who it was: for Jesus had conveyed himself away, a multitude being in that place.

14 Afterward Jesus findeth him in the temple, and said unto him, Behold, thou art made whole: sin no more, lest a worse thing come unto thee.

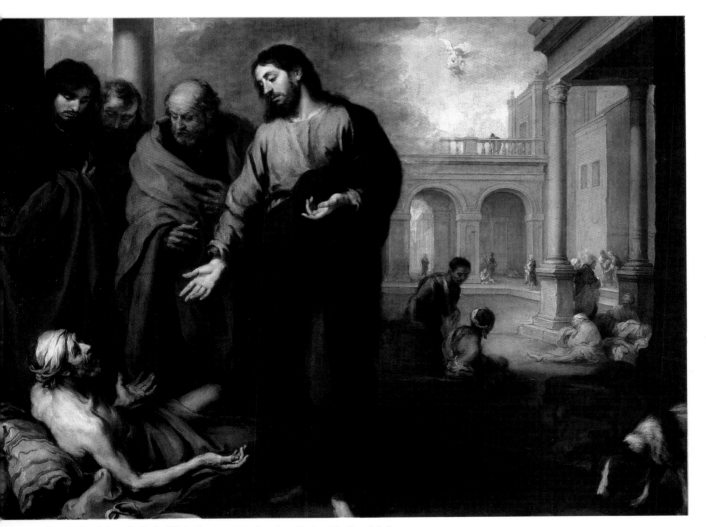

Christ Healing the Paralytic at the Pool of Bethesda, late 1660s, Bartolome Esteban Murillo, 1618–82

15 The man departed, and told the Jews that it was Jesus, which had made him whole.

16 And therefore did the Jews persecute Jesus, and sought to slay him, because he had done these things on the sabbath day.

17 But Jesus answered them, My Father worketh hitherto, and I work.

18 Therefore the Jews sought the more to kill him, because he not only had broken the sabbath, but said also that God was his Father, making himself equal with God.

19 Then answered Jesus and said unto them, Verily, verily, I say unto you, The Son can do nothing of himself, but what he seeth the Father do: for what things soever he doeth, these also doeth the Son likewise.

20 For the Father loveth the Son, and sheweth him all things that himself doeth: and he will shew him greater works than these, that ye may marvel.

21 For as the Father raiseth up the dead, and quickeneth them; even so the Son quickeneth whom he will.

22 For the Father judgeth no man, but hath committed all judgment unto the Son:

23 That all men should honour the Son, even as they honour the Father. He that honoureth not the Son honoureth not the Father which hath sent him.

24 Verily, verily, I say unto you, He that heareth my word, and believeth on him that sent me, hath everlasting life, and shall not come into condemnation; but is passed from death unto life.

25 Verily, verily, I say unto you, The hour is coming, and now is, when the dead shall hear the voice of the Son of God: and they that hear shall live.

26 For as the Father hath life in himself; so hath he given to the Son to have life in himself;

27 And hath given him authority to execute judgment also, because he is the Son of man.

28 Marvel not at this: for the hour is coming, in the which all that are in the graves shall hear his voice,

29 And shall come forth; they that have done good, unto the resurrection of life; and they that have done evil, unto the resurrection of damnation.

30 I can of mine own self do nothing: as I hear, I judge: and my judgment is just; because I seek not mine own will, but the will of the Father which hath sent me.

31 If I bear witness of myself, my witness is not true.

32 There is another that beareth witness of me; and I know that the witness which he witnesseth of me is true.

33 Ye sent unto John, and he bare witness unto the truth.

34 But I receive not testimony from man: but these things I say, that ye might be saved.

35 He was a burning and a shining light: and ye were willing for a season to rejoice in his light.

36 But I have greater witness than that of John: for the works which the Father hath given me to finish, the same works that I do, bear witness of me, that the Father hath sent me.

37 And the Father himself, which hath sent me, hath borne witness of me. Ye have neither heard his voice at any time, nor seen his shape.

38 And ye have not his word abiding in you: for whom he hath sent, him ye believe not.

39 Search the scriptures; for in them ye think ye have eternal life: and they are they which testify of me.

40 And ye will not come to me, that ye might have life.

41 I receive not honour from men.

42 But I know you, that ye have not the love of God in you.

43 I am come in my Father's name, and ye receive me not: if another shall come in his own name, him ye will receive.

44 How can ye believe, which receive honour one of another, and seek not the honour that cometh from God only?

45 Do not think that I will accuse you to the Father: there is one that accuseth you, even Moses, in whom ye trust.

46 For had ye believed Moses, ye would have believed me; for he wrote of me.

47 But if ye believe not his writings, how shall ye believe my words?

KING HEROD'S QUESTION ABOUT JESUS

Herod Antipas, ruler over the Roman province of Galilee, hears of the exploits of Jesus and wonders whether John the Baptist, whom he had himself beheaded, might, in fact, have been raised from the dead. Mark uses these verses as a bridge to telling the story of John's demise—a grim reminder of what frequently happens to prophets, and what eventually will happen to Jesus. It also demonstrates the different ways Matthew and Luke edit Mark's story as the retell it. Matthew often simplifies Mark's elaborate stories, as he does here. Luke, who normally follows Mark closely, leaves out the infamous dance of Salome scene, popularly portrayed in art and music. Luke mentions how Herod seeks to see Jesus, about whom he has heard much. Luke brings Herod back on stage in his passion account.

MATTHEW 14:1–2

1 At that time Herod the tetrarch heard of the fame of Jesus,

2 And said unto his servants, This is John the Baptist; he is risen from the dead; and therefore mighty works do shew forth themselves in him.

MARK 6:14–16

14 And king Herod heard of him; (for his name was spread abroad:) and he said, That John the Baptist was risen from the dead, and therefore mighty works do shew forth themselves in him.

15 Others said, That it is Elias. And others said, That it is a prophet, or as one of the prophets.

16 But when Herod heard thereof, he said, It is John, whom I beheaded: he is risen from the dead.

LUKE 9:7–9

7 Now Herod the tetrarch heard of all that was done by him: and he was perplexed, because that it was said of some, that John was risen from the dead;

8 And of some, that Elias had appeared; and of others, that one of the old prophets was risen again.

9 And Herod said, John have I beheaded: but who is this, of whom I hear such things? And he desired to see him.

THE DEATH OF JOHN THE BAPTIST

MATTHEW 14:3–12

3 For Herod had laid hold on John, and bound him, and put him in prison for Herodias' sake, his brother Philip's wife.

4 For John said unto him, It is not lawful for thee to have her.

5 And when he would have put him to death, he feared the multitude, because they counted him as a prophet.

6 But when Herod's birthday was kept, the daughter of Herodias danced before them, and pleased Herod.

7 Whereupon he promised with an oath to give her whatsoever she would ask.

8 And she, being before instructed of her mother, said, Give me here John Baptist's head in a charger.

9 And the king was sorry: nevertheless for the oath's sake, and them which sat with him at meat, he commanded it to be given her.

10 And he sent, and beheaded John in the prison.

11 And his head was brought in a charger, and given to the damsel: and she brought it to her mother.

12 And his disciples came, and took up the body, and buried it, and went and told Jesus.

MARK 6:17–29

17 But thou, when thou fastest, anoint thine head, and wash thy face;

18 That thou appear not unto men to fast, but unto thy Father which is in secret: and thy Father, which seeth in secret, shall reward thee openly.

19 Lay not up for yourselves treasures upon earth, where moth and rust doth corrupt, and where thieves break through and steal:

20 But lay up for yourselves treasures in heaven, where neither moth nor rust doth corrupt, and where thieves do not break through nor steal:

21 For where your treasure is, there will your heart be also.

22 The light of the body is the eye: if therefore thine eye be single, thy whole body shall be full of light.

23 But if thine eye be evil, thy whole body shall be full of darkness. If therefore the light that is in thee be darkness, how great is that darkness!

24 No man can serve two masters: for either he will hate the one, and love the other; or else he will hold to the one, and despise the other. Ye cannot serve God and mammon.

25 Therefore I say unto you, Take no thought for your life, what ye shall eat, or what ye shall drink; nor yet for your body, what ye shall put on. Is not the life more than meat, and the body than raiment?

26 Behold the fowls of the air: for they sow not, neither do they reap, nor gather into barns; yet your heavenly Father feedeth them. Are ye not much better than they?

27 Which of you by taking thought can add one cubit unto his stature?

28 And why take ye thought for raiment? Consider the lilies of the field, how they grow; they toil not, neither do they spin:

29 And yet I say unto you, That even Solomon in all his glory was not arrayed like one of these.

LUKE 3:19–20

19 But Herod the tetrarch, being reproved by him for Herodias his brother Philip's wife, and for all the evils which Herod had done,

20 Added yet this above all, that he shut up John in prison.

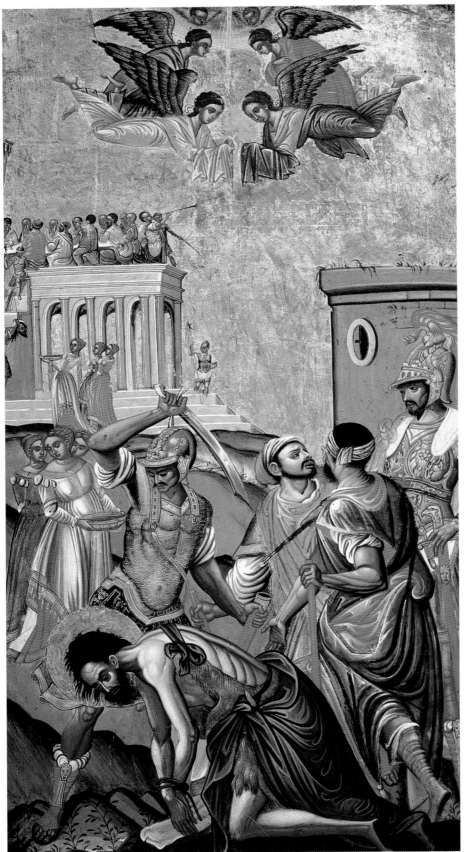

The Beheading of Saint John the Baptist, 17th century, Artist Unknown

THE RETURN OF JESUS' DISCIPLES

Mark and Luke relate how Jesus' disciples return, reporting on what they have done and taught. Mark's Jesus invites them to come away by themselves to a "desert place" and rest awhile—even as Jesus, after a long day of healing, goes away "a great while before day" to "a desert place" to pray in Chapter 1. In both cases, the "rest" is interrupted by those who come seeking Jesus. Matthew cites Herod's beheading of John as the reason Jesus and the Twelve withdraw.

MATTHEW 14:12–13

12 And his disciples came, and took up the body, and buried it, and went and told Jesus.

13 When Jesus heard of it, he departed thence by ship into a desert place apart: and when the people had heard thereof, they followed him on foot out of the cities.

MARK 6:30–31

30 And the apostles gathered themselves together unto Jesus, and told him all things, both what they had done, and what they had taught.

31 And he said unto them, Come ye yourselves apart into a desert place, and rest a while: for there were many coming and going, and they had no leisure so much as to eat.

LUKE 9:10

10 And the apostles, when they were returned, told him all that they had done. And he took them, and went aside privately into a desert place belonging to the city called Bethsaida.

JESUS FEEDS FIVE THOUSAND

Jesus receives the crowds with compassion and heals those who are sick. As the day wears on, the disciples come to Jesus and ask him to send the people away, as they have gone without food the whole day. Out of this situation comes the only miracle story common to all four gospels. The details they share—five loaves, two fishes, 5,000 men, 100 denarii, twelve baskets—all point to the widespread retelling of this story by many preachers. The story operates on several levels of meaning, reminding the reader of the feeding miracles the prophets Elijah and Elisha did (1 Kings 17 and 2 Kings 4). As people are seated by hundreds and fifties, one recalls Israel, also in a "desert place", and the manna from heaven that fed them. John notes that it took place at Passover time. The way Jesus takes, blesses, breaks, and shares the bread points forward to the Passover before his death—and to the liturgy by which the Christian community blesses the bread and cup for Holy Communion. Unique to John are the lad who shares his lunch and the discussion that follows the meal where Jesus describes himself as the bread of life—thereby becoming the replacement of the Passover for the Christian community.

MATTHEW 14:13–21

13 When Jesus heard of it, he departed thence by ship into a desert place apart: and when the people had heard thereof, they followed him on foot out of the cities.

14 And Jesus went forth, and saw a great multitude, and was moved with compassion toward them, and he healed their sick.

15 And when it was evening, his disciples came to him, saying, This is a desert place, and the time is now past; send the multitude away, that they may go into the villages, and buy themselves victuals.

16 But Jesus said unto them, They need not depart; give ye them to eat.

17 And they say unto him, We have here but five loaves, and two fishes.

18 He said, Bring them hither to me.

19 And he commanded the multitude to sit down on the grass, and took the five loaves, and the two fishes, and looking up to heaven, he blessed, and brake, and gave the loaves to his disciples, and the disciples to the multitude.

20 And they did all eat, and were filled: and they took up of the fragments that remained twelve baskets full.

21 And they that had eaten were about five thousand men, beside women and children.

MARK 6:32–44

32 And they departed into a desert place by ship privately.

33 And the people saw them departing, and many knew him, and ran afoot thither out of all cities, and outwent them, and came together unto him.

34 And Jesus, when he came out, saw much people, and was moved with compassion toward them, because they were as sheep not having a shepherd: and he began to teach them many things.

35 And when the day was now far spent, his disciples came unto him, and said, This is a desert place, and now the time is far passed:

36 Send them away, that they may go into the country round about, and into the villages, and buy themselves bread: for they have nothing to eat.

37 He answered and said unto them, Give ye them to eat. And they say unto him, Shall we go and buy two hundred pennyworth of bread, and give them to eat?

38 He saith unto them, How many loaves have ye? go and see. And when they knew, they say, Five, and two fishes.

39 And he commanded them to make all sit down by companies upon the green grass.

40 And they sat down in ranks, by hundreds, and by fifties.

41 And when he had taken the five loaves and the two fishes, he looked up to heaven, and blessed, and brake the loaves, and gave them to his disciples to set before them; and the two fishes divided he among them all.

42 And they did all eat, and were filled.

And when he had taken the five loaves and the two fishes, he looked up to heaven, and blessed, and brake the loaves, and gave them to his disciples to set before them; and the two fishes divided he among them all.

—MARK 6:41

43 And they took up twelve baskets full of the fragments, and of the fishes.

44 And they that did eat of the loaves were about five thousand men.

LUKE 9:10–17

10 And the apostles, when they were returned, told him all that they had done. And he took them, and went aside privately into a desert place belonging to the city called Bethsaida.

11 And the people, when they knew it, followed him: and he received them, and spake unto them of the kingdom of God, and healed them that had need of healing.

12 And when the day began to wear away, then came the twelve, and said unto him, Send the multitude away, that they may go into the towns and country round about, and lodge, and get victuals: for we are here in a desert place.

13 But he said unto them, Give ye them to eat. And they said, We have no more but five loaves and two fishes; except we should go and buy meat for all this people.

14 For they were about five thousand men. And he said to his disciples, Make them sit down by fifties in a company.

15 And they did so, and made them all sit down.

16 Then he took the five loaves and the two fishes, and looking up to heaven, he blessed them, and brake, and gave to the disciples to set before the multitude.

17 And they did eat, and were all filled: and there was taken up of fragments that remained to them twelve baskets.

JOHN 6:1–15

1 After these things Jesus went over the sea of Galilee, which is the sea of Tiberias.

2 And a great multitude followed him, because they saw his miracles which he did on them that were diseased.

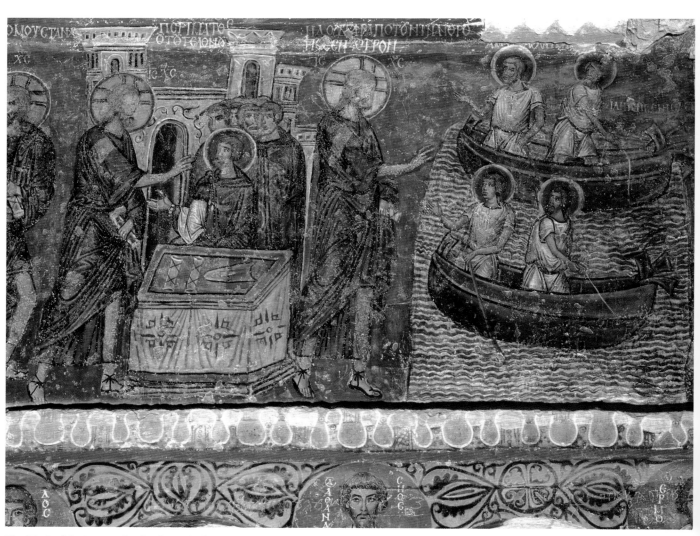

The Miracle of the Loaves and Fishes, from Life of Jesus Christ, by Artist Unknown

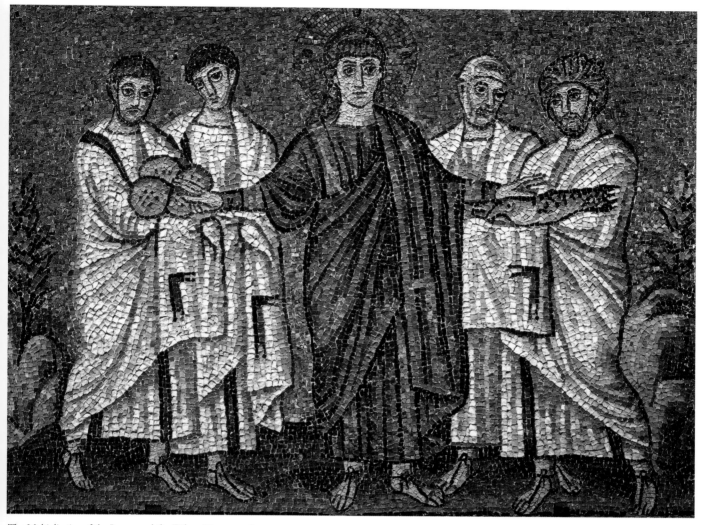

The Multiplication of the Loaves and the Fishes, 6th century, by Artist Unknown

3 And Jesus went up into a mountain, and there he sat with his disciples.

4 And the passover, a feast of the Jews, was nigh.

5 When Jesus then lifted up his eyes, and saw a great company come unto him, he saith unto Philip, Whence shall we buy bread, that these may eat?

6 And this he said to prove him: for he himself knew what he would do.

7 Philip answered him, Two hundred pennyworth of bread is not sufficient for them, that every one of them may take a little.

8 One of his disciples, Andrew, Simon Peter's brother, saith unto him,

9 There is a lad here, which hath five barley loaves, and two small fishes: but what are they among so many?

10 And Jesus said, Make the men sit down. Now there was much grass in the place. So the men sat down, in number about five thousand.

11 And Jesus took the loaves; and when he had given thanks, he distributed to the disciples, and the disciples to them that were set down; and likewise of the fishes as much as they would.

12 When they were filled, he said unto his disciples, Gather up the fragments that remain, that nothing be lost.

13 Therefore they gathered them together, and filled twelve baskets with the fragments of the five barley loaves, which remained over and above unto them that had eaten.

14 Then those men, when they had seen the miracle that Jesus did, said, This is of a truth that prophet that should come into the world.

15 When Jesus therefore perceived that they would come and take him by force, to make him a king, he departed again into a mountain himself alone.

JESUS WALKS ON THE SEA

As the evening progresses, Jesus sends the disciples across the sea to the other side. Mark and Matthew have Jesus going up the mountain to pray. In John, it was getting dark and Jesus had not yet caught up with them. After a lot of rowing against the wind and waves, Jesus catches up with them, walking on the sea. Overcome with fear, they cry out. In Mark, Matthew, and John, Jesus' words to them are the same: "It is I; be not afraid." The expression for "It is I" can also be translated "I am!" Mark's Jesus will later answer the High Priest's question "Are you the Christ, the Son of the living God?" with the same words—also the words in the Greek Bible that God used to tell Moses his name: I AM. Unique to Matthew's version is Peter's walking on the water and his subsequent rescue by Jesus when, again, his fear got ahead of his faith.

MATTHEW 14:22–33

22 And straightway Jesus constrained his disciples to get into a ship, and to go before him unto the other side, while he sent the multitudes away.

23 And when he had sent the multitudes away, he went up into a mountain apart to pray: and when the evening was come, he was there alone.

24 But the ship was now in the midst of the sea, tossed with waves: for the wind was contrary.

25 And in the fourth watch of the night Jesus went unto them, walking on the sea.

26 And when the disciples saw him walking on the sea, they were troubled, saying, It is a spirit; and they cried out for fear.

27 But straightway Jesus spake unto them, saying, Be of good cheer; it is I; be not afraid.

28 And Peter answered him and said, Lord, if it be thou, bid me come unto thee on the water.

29 And he said, Come. And when Peter was come down out of the ship, he walked on the water, to go to Jesus.

30 But when he saw the wind boisterous, he was afraid; and beginning to sink, he cried, saying, Lord, save me.

31 And immediately Jesus stretched forth his hand, and caught him, and said unto him, O thou of little faith, wherefore didst thou doubt?

32 And when they were come into the ship, the wind ceased.

33 Then they that were in the ship came and worshipped him, saying, Of a truth thou art the Son of God.

MARK 6:45–52

45 And straightway he constrained his disciples to get into the ship, and to go to the other side before unto Bethsaida, while he sent away the people.

46 And when he had sent them away, he departed into a mountain to pray.

47 And when even was come, the ship was in the midst of the sea, and he alone on the land.

48 And he saw them toiling in rowing; for the wind was contrary unto them: and about the fourth watch of the night he cometh unto them, walking upon the sea, and would have passed by them.

49 But when they saw him walking upon the sea, they supposed it had been a spirit, and cried out:

And in the fourth watch of the night Jesus went unto them, walking on the sea.

—MATTHEW 14:25

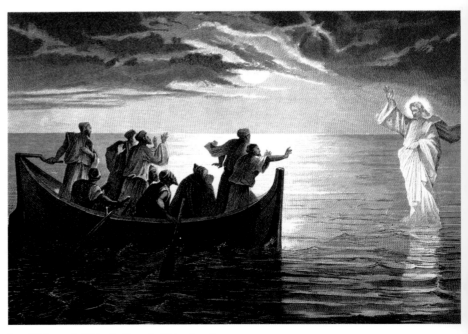

Jesus Walks on the Water, by ALEXANDER BIDA, 1813–1895

50 For they all saw him, and were troubled. And immediately he talked with them, and saith unto them, Be of good cheer: it is I; be not afraid.

51 And he went up unto them into the ship; and the wind ceased: and they were sore amazed in themselves beyond measure, and wondered.

52 For they considered not the miracle of the loaves: for their heart was hardened.

JOHN 6:16–21

16 And when even was now come, his disciples went down unto the sea,

17 And entered into a ship, and went over the sea toward Capernaum. And it was now dark, and Jesus was not come to them.

18 And the sea arose by reason of a great wind that blew.

19 So when they had rowed about five and twenty or thirty furlongs, they see Jesus walking on the sea, and drawing nigh unto the ship: and they were afraid.

20 But he saith unto them, It is I; be not afraid.

21 Then they willingly received him into the ship: and immediately the ship was at the land whither they went.

HEALINGS AT GENNESARET, ACROSS THE SEA OF GALILEE

In yet another summary statement, people from all around are looking for Jesus. Every place he goes becomes a mobile hospital. So powerful is he that those who touch even the fringe of his clothes are made well.

MATTHEW 14:34–36

34 And when they were gone over, they came into the land of Gennesaret.

35 And when the men of that place had knowledge of him, they sent out into all that country round about, and brought unto him all that were diseased;

36 And besought him that they might only touch the hem of his garment: and as many as touched were made perfectly whole.

MARK 6:53–56

53 And when they had passed over, they came into the land of Gennesaret, and drew to the shore.

54 And when they were come out of the ship, straightway they knew him,

55 And ran through that whole region round about, and began to carry about in beds those that were sick, where they heard he was.

56 And whithersoever he entered, into villages, or cities, or country, they laid the sick in the streets, and besought him that they might touch if it were but the border of his garment: and as many as touched him were made whole.

JOHN 6:22–25

22 The day following, when the people which stood on the other side of the sea saw that there was none other boat there, save that one whereinto his disciples were entered, and that Jesus went not with his disciples into the boat, but that his disciples were gone away alone;

23 (Howbeit there came other boats from Tiberias nigh unto the place where they did eat bread, after that the Lord had given thanks:)

24 When the people therefore saw that Jesus was not there, neither his disciples, they also took shipping, and came to Capernaum, seeking for Jesus.

25 And when they had found him on the other side of the sea, they said unto him, Rabbi, when camest thou hither?

"I AM THE BREAD OF LIFE"

As he travels to the other side of the sea, Jesus is followed by people in boats. He asks why they follow him. Is it because his signs have made believers out of them, or is it because they are looking for a free lunch? "Labor not for the meat which perisheth, but for the meat which endureth unto everlasting life, which the Son of man shall give unto you…." People ask him for a sign, as Moses gave the manna in the desert. This launches Jesus into lengthy discussion about the bread of life. "I am the bread of life," not like the manna in the desert. Those who ate that "bread from heaven" all died. Those who eat the bread he gives them will live forever. Bread of life has a twofold meaning. It is his teaching; and it is his flesh, given for the life of the world. Many see the statements about eating his flesh and drinking his blood as John's version of the Words of Institution—since John's passion, unlike Mark, Matthew, and Luke's, does not have the institution of the Lord's Supper.

JOHN 6:26–59

26 Jesus answered them and said, Verily, verily, I say unto you, Ye seek me, not because ye saw the miracles, but because ye did eat of the loaves, and were filled.

27 Labour not for the meat which perisheth, but for that meat which endureth unto everlasting life, which the Son of man shall give unto you: for him hath God the Father sealed.

28 Then said they unto him, What shall we do, that we might work the works of God?

29 Jesus answered and said unto them, This is the work of God, that ye believe on him whom he hath sent.

30 They said therefore unto him, What sign shewest thou then, that we may see, and believe thee? what dost thou work?

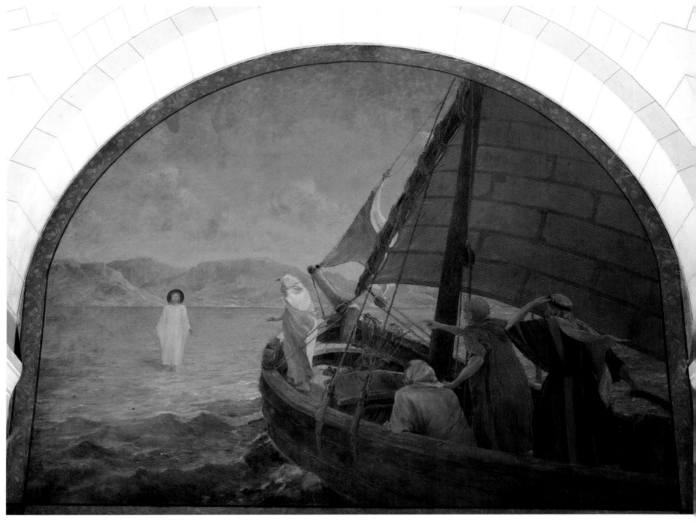

Jesus Walking on Water, 1917, by Frederic Montenard, 1845–1927

31 Our fathers did eat manna in the desert; as it is written, He gave them bread from heaven to eat.

32 Then Jesus said unto them, Verily, verily, I say unto you, Moses gave you not that bread from heaven; but my Father giveth you the true bread from heaven.

33 For the bread of God is he which cometh down from heaven, and giveth life unto the world.

34 Then said they unto him, Lord, evermore give us this bread.

35 And Jesus said unto them, I am the bread of life: he that cometh to me shall never hunger; and he that believeth on me shall never thirst.

36 But I said unto you, That ye also have seen me, and believe not.

37 All that the Father giveth me shall come to me; and him that cometh to me I will in no wise cast out.

38 For I came down from heaven, not to do mine own will, but the will of him that sent me.

39 And this is the Father's will which hath sent me, that of all which he hath given me I should lose nothing, but should raise it up again at the last day.

40 And this is the will of him that sent me, that every one which seeth the Son, and believeth on him, may have everlasting life: and I will raise him up at the last day.

41 The Jews then murmured at him, because he said, I am the bread which came down from heaven.

42 And they said, Is not this Jesus, the son of Joseph, whose father and mother we know? how is it then that he saith, I came down from heaven?

43 Jesus therefore answered and said unto them, Murmur not among yourselves.

44 No man can come to me, except the Father which hath sent me draw him: and I will raise him up at the last day.

5 It is written in the prophets, And they shall be all taught of God. Every man therefore that hath heard, and hath learned of the Father, cometh unto me.

6 Not that any man hath seen the Father, save he which is of God, he hath seen the Father.

7 Verily, verily, I say unto you, He that believeth on me hath everlasting life.

8 I am that bread of life.

9 Your fathers did eat manna in the wilderness, and are dead.

o This is the bread which cometh down from heaven, that a man may eat thereof, and not die.

1 I am the living bread which came down from heaven: if any man eat of this bread, he shall live for ever: and the bread that I will give is my flesh, which I will give for the life of the world.

2 The Jews therefore strove among themselves, saying, How can this man give us his flesh to eat?

3 Then Jesus said unto them, Verily, verily, I say unto you, Except ye eat the flesh of the Son of man, and drink his blood, ye have no life in you.

4 Whoso eateth my flesh, and drinketh my blood, hath eternal life; and I will raise him up at the last day.

5 For my flesh is meat indeed, and my blood is drink indeed.

6 He that eateth my flesh, and drinketh my blood, dwelleth in me, and I in him.

7 As the living Father hath sent me, and I live by the Father: so he that eateth me, even he shall live by me.

8 This is that bread which came down from heaven: not as your fathers did eat manna, and are dead: he that eateth of this bread shall live for ever.

59 These things said he in the synagogue, as he taught in Capernaum.

A CONTROVERSY ABOUT WHAT MAKES A PERSON UNCLEAN

MATTHEW 15:1–20

1 Then came to Jesus scribes and Pharisees, which were of Jerusalem, saying,

2 Why do thy disciples transgress the tradition of the elders? for they wash not their hands when they eat bread.

3 But he answered and said unto them, Why do ye also transgress the commandment of God by your tradition?

4 For God commanded, saying, Honour thy father and mother: and, He that curseth father or mother, let him die the death.

5 But ye say, Whosoever shall say to his father or his mother, It is a gift, by whatsoever thou mightest be profited by me;

6 And honour not his father or his mother, he shall be free. Thus have ye made the commandment of God of none effect by your tradition.

7 Ye hypocrites, well did Esaias prophesy of you, saying,

8 This people draweth nigh unto me with their mouth, and honoureth me with their lips; but their heart is far from me.

9 But in vain they do worship me, teaching for doctrines the commandments of men.

10 And he called the multitude, and said unto them, Hear, and understand:

11 Not that which goeth into the mouth defileth a man; but that which cometh out of the mouth, this defileth a man.

12 Then came his disciples, and said unto him, Knowest thou that the Pharisees were offended, after they heard this saying?

13 But he answered and said, Every plant, which my heavenly Father hath not planted, shall be rooted up.

14 Let them alone: they be blind leaders of the blind. And if the blind lead the blind, both shall fall into the ditch.

15 Then answered Peter and said unto him, Declare unto us this parable.

16 And Jesus said, Are ye also yet without understanding?

17 Do not ye yet understand, that whatsoever entereth in at the mouth goeth into the belly, and is cast out into the draught?

I am the living bread which came down from heaven: if any man eat of this bread, he shall live for ever: and the bread that I will give is my flesh, which I will give for the life of the world.

—JOHN 6:51

18 But those things which proceed out of the mouth come forth from the heart; and they defile the man.

19 For out of the heart proceed evil thoughts, murders, adulteries, fornications, thefts, false witness, blasphemies:

20 These are the things which defile a man: but to eat with unwashen hands defileth not a man.

MARK 7:1–23

1 Then came together unto him the Pharisees, and certain of the scribes, which came from Jerusalem.

2 And when they saw some of his disciples eat bread with defiled, that is to say, with unwashen, hands, they found fault.

3 For the Pharisees, and all the Jews, except they wash their hands oft, eat not, holding the tradition of the elders.

4 And when they come from the market, except they wash, they eat not. And many other things there be, which they have received to hold, as the washing of cups, and pots, brasen vessels, and of tables.

For God commanded, saying, Honour thy father and mother: and, He that curseth father or mother, let him die the death.

—MATTHEW 15:4

5 Then the Pharisees and scribes asked him, Why walk not thy disciples according to the tradition of the elders, but eat bread with unwashen hands?

6 He answered and said unto them, Well hath Esaias prophesied of you hypocrites, as it is written, This people honoureth me with their lips, but their heart is far from me.

7 Howbeit in vain do they worship me, teaching for doctrines the commandments of men.

8 For laying aside the commandment of God, ye hold the tradition of men, as the washing of pots and cups: and many other such like things ye do.

9 And he said unto them, Full well ye reject the commandment of God, that ye may keep your own tradition.

10 For Moses said, Honour thy father and thy mother; and, Whoso curseth father or mother, let him die the death:

11 But ye say, If a man shall say to his father or mother, It is Corban, that is to say, a gift, by whatsoever thou mightest be profited by me; he shall be free.

12 And ye suffer him no more to do ought for his father or his mother;

13 Making the word of God of none effect through your tradition, which ye have delivered: and many such like things do ye.

14 And when he had called all the people unto him, he said unto them, Hearken unto me every one of you, and understand:

15 There is nothing from without a man, that entering into him can defile him: but the things which come out of him, those are they that defile the man.

16 If any man have ears to hear, let him hear.

17 And when he was entered into the house from the people, his disciples asked him concerning the parable.

18 And he saith unto them, Are ye so without understanding also? Do ye not perceive, that whatsoever thing from without entereth into the man, it cannot defile him;

19 Because it entereth not into his heart, but into the belly, and goeth out into the draught, purging all meats?

20 And he said, That which cometh out of the man, that defileth the man.

21 For from within, out of the heart of men, proceed evil thoughts, adulteries, fornications, murders,

22 Thefts, covetousness, wickedness, deceit, lasciviousness, an evil eye, blasphemy, pride, foolishness:

23 All these evil things come from within, and defile the man.

LUKE 11:37–41

37 And as he spake, a certain Pharisee besought him to dine with him: and he went in, and sat down to meat.

38 And when the Pharisee saw it, he marvelled that he had not first washed before dinner.

39 And the Lord said unto him, Now do ye Pharisees make clean the outside of the cup and the platter; but your inward part is full of ravening and wickedness.

40 Ye fools, did not he that made that which is without make that which is within also?

41 But rather give alms of such things as ye have; and, behold, all things are clean unto you.

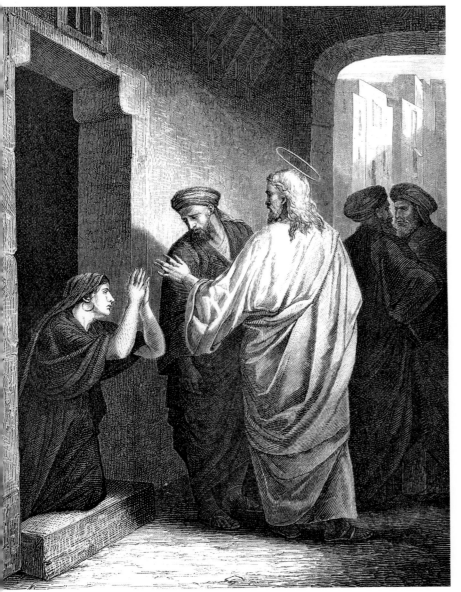

The Syrophoenician Woman, by Alexander Bida, 1813–1895

A SYROPHOENICIAN (CANAANITE) WOMAN COMES TO JESUS

MATTHEW 15:21–28

21 Then Jesus went thence, and departed into the coasts of Tyre and Sidon.

22 And, behold, a woman of Canaan came out of the same coasts, and cried unto him, saying, Have mercy on me, O Lord, thou Son of David; my daughter is grievously vexed with a devil.

23 But he answered her not a word. And his disciples came and besought him, saying, Send her away; for she crieth after us.

24 But he answered and said, I am not sent but unto the lost sheep of the house of Israel.

25 Then came she and worshipped him, saying, Lord, help me.

26 But he answered and said, It is not meet to take the children's bread, and to cast it to dogs.

27 And she said, Truth, Lord: yet the dogs eat of the crumbs which fall from their masters' table.

28 Then Jesus answered and said unto her, O woman, great is thy faith: be it unto thee even as thou wilt. And her daughter was made whole from that very hour.

MARK 7:24–30

24 And from thence he arose, and went into the borders of Tyre and Sidon, and entered into an house, and would have no man know it: but he could not be hid.

25 For a certain woman, whose young daughter had an unclean spirit, heard of him, and came and fell at his feet:

26 The woman was a Greek, a Syrophenician by nation; and she besought him that he would cast forth the devil out of her daughter.

Then Jesus answered and said unto her, O woman, great is thy faith: be it unto thee even as thou wilt. And her daughter was made whole from that very hour.

—MATTHEW 15:28

27 But Jesus said unto her, Let the children first be filled: for it is not meet to take the children's bread, and to cast it unto the dogs.

28 And she answered and said unto him, Yes, Lord: yet the dogs under the table eat of the children's crumbs.

29 And he said unto her, For this saying go thy way; the devil is gone out of thy daughter.

30 And when she was come to her house, she found the devil gone out, and her daughter laid upon the bed.

JESUS HEALS A DEAF-MUTE AND OTHERS

MATTHEW 15:29–31

29 And Jesus departed from thence, and came nigh unto the sea of Galilee; and went up into a mountain, and sat down there.

30 And great multitudes came unto him, having with them those that were lame, blind, dumb, maimed, and many others, and cast them down at Jesus' feet; and he healed them:

31 Insomuch that the multitude wondered, when they saw the dumb to speak, the maimed to be whole, the

Miracle of Feeding of Five Thousand with Two Apostles Distributing Food, 6th century, Artist Unknown

lame to walk, and the blind to see: and they glorified the God of Israel.

MARK 7:31–37

31 And again, departing from the coasts of Tyre and Sidon, he came unto the sea of Galilee, through the midst of the coasts of Decapolis.

32 And they bring unto him one that was deaf, and had an impediment in his speech; and they beseech him to put his hand upon him.

33 And he took him aside from the multitude, and put his fingers into his ears, and he spit, and touched his tongue;

34 And looking up to heaven, he sighed, and saith unto him, Ephphatha, that is, Be opened.

35 And straightway his ears were opened, and the string of his tongue was loosed, and he spake plain.

36 And he charged them that they should tell no man: but the more he charged them, so much the more a great deal they published it;

37 And were beyond measure astonished, saying, He hath done all things well: he maketh both the deaf to hear, and the dumb to speak.

JESUS FEEDS A CROWD OF FOUR THOUSAND

MATTHEW 15:32–39

32 Then Jesus called his disciples unto him, and said, I have compassion on the multitude, because they continue with me now three days, and have nothing to eat: and I will not send them away fasting, lest they faint in the way.

33 And his disciples say unto him, Whence should we have so much bread in the wilderness, as to fill so great a multitude?

34 And Jesus saith unto them, How many loaves have ye? And they said, Seven, and a few little fishes.

5 And he commanded the multitude to sit down on the ground.

6 And he took the seven loaves and the fishes, and gave thanks, and brake them, and gave to his disciples, and the disciples to the multitude.

7 And they did all eat, and were filled: and they took up of the broken meat that was left seven baskets full.

8 And they that did eat were four thousand men, beside women and children.

9 And he sent away the multitude, and took ship, and came into the coasts of Magdala,

MARK 8:1–10

In those days the multitude being very great, and having nothing to eat, Jesus called his disciples unto him, and saith unto them,

2 I have compassion on the multitude, because they have now been with me three days, and have nothing to eat:

3 And if I send them away fasting to their own houses, they will faint by the way: for divers of them came from far.

4 And his disciples answered him, From whence can a man satisfy these men with bread here in the wilderness?

5 And he asked them, How many loaves have ye? And they said, Seven.

6 And he commanded the people to sit down on the ground: and he took the seven loaves, and gave thanks, and brake, and gave to his disciples to set before them; and they did set them before the people.

7 And they had a few small fishes: and he blessed, and commanded to set them also before them.

8 So they did eat, and were filled: and they took up of the broken meat that was left seven baskets.

The Miracle of the Loaves, by Alexander Bida, 1813–1895

9 And they that had eaten were about four thousand: and he sent them away.

10 And straightway he entered into a ship with his disciples, and came into the parts of Dalmanutha.

THOSE WHO ASK JESUS FOR A SIGN

MATTHEW 16:1–4

1 The Pharisees also with the Sadducees came, and tempting desired him that he would shew them a sign from heaven.

2 He answered and said unto them, When it is evening, ye say, It will be fair weather: for the sky is red.

3 And in the morning, It will be foul weather to day: for the sky is red and lowring. O ye hypocrites, ye can discern the face of the sky; but can ye not discern the signs of the times?

4 A wicked and adulterous generation seeketh after a sign; and there shall no sign be given unto it, but the sign of the prophet Jonas. And he left them, and departed.

MARK 8:11–13

11 And the Pharisees came forth, and began to question with him, seeking of him a sign from heaven, tempting him.

12 And he sighed deeply in his spirit, and saith, Why doth this generation seek after a sign? verily I say unto you, There shall no sign be given unto this generation.

13 And he left them, and entering into the ship again departed to the other side.

LUKE 11:16

16 And others, tempting him, sought of him a sign from heaven.

JOHN 6:30

30 They said therefore unto him, What sign shewest thou then, that we may see, and believe thee? what dost thou work?

And he took the blind man by the hand, and led him out of the town; and when he had spit on his eyes, and put his hands upon him, he asked him if he saw ought.
—MARK 8:23

LUKE 12:54–56

54 And he said also to the people, When ye see a cloud rise out of the west, straightway ye say, There cometh a shower; and so it is.

55 And when ye see the south wind blow, ye say, There will be heat; and it cometh to pass.

56 Ye hypocrites, ye can discern the face of the sky and of the earth; but how is it that ye do not discern this time?

LUKE 11:29

29 And when the people were gathered thick together, he began to say, This is an evil generation: they seek a sign; and there shall no sign be given it, but the sign of Jonas the prophet.

THE YEAST OF THE PHARISEES

MATTHEW 16:5–12

5 And when his disciples were come to the other side, they had forgotten to take bread.

6 Then Jesus said unto them, Take heed and beware of the leaven of the Pharisees and of the Sadducees.

7 And they reasoned among themselves, saying, It is because we have taken no bread.

8 Which when Jesus perceived, he said unto them, O ye of little faith, why reason ye among yourselves, because ye have brought no bread?

9 Do ye not yet understand, neither remember the five loaves of the five thousand, and how many baskets ye took up?

10 Neither the seven loaves of the four thousand, and how many baskets ye took up?

11 How is it that ye do not understand that I spake it not to you concerning bread, that ye should beware of the leaven of the Pharisees and of the Sadducees?

12 Then understood they how that he bade them not beware of the leaven of bread, but of the doctrine of the Pharisees and of the Sadducees.

MARK 8:14–21

14 Now the disciples had forgotten to take bread, neither had they in the ship with them more than one loaf.

15 And he charged them, saying, Take heed, beware of the leaven of the Pharisees, and of the leaven of Herod.

16 And they reasoned among themselves, saying, It is because we have no bread.

17 And when Jesus knew it, he saith unto them, Why reason ye, because ye have no bread? perceive ye not yet, neither understand? have ye your heart yet hardened?

18 Having eyes, see ye not? and having ears, hear ye not? and do ye not remember?

19 When I brake the five loaves among five thousand, how many baskets full of fragments took ye up? They say unto him, Twelve.

20 And when the seven among four thousand, how many baskets full of fragments took ye up? And they said, Seven.

21 And he said unto them, How is it that ye do not understand?

LUKE 12:1

1 In the mean time, when there were gathered together an innumerable multitude of people, insomuch that they trode one upon another, he began to say unto his disciples first of all, Beware ye of the leaven of the Pharisees, which is hypocrisy.

THE HEALING OF A BLIND MAN IN BETHSAIDA

"Wilt thou be made whole?" Jesus asks a man who has come for healing to the Pool of Bethesda—a man who has suffered from a debilitating illness for 38 years. Jesus tells him to take up his bed and walk. Immediately he is cured, takes up his bed, and walks. Since this happens on the Sabbath, the man is questioned about why he is carrying his bed—for "work" is forbidden. This encounter brings Jesus into a hostile debate with ones John calls "the Jews." John masterfully uses this debate to point up the way Jesus' word "raises" this helpless man to life. There is no mystery about Jesus'

true identity in John. Jesus states freely that his Father works on the Sabbath, and, therefore so does he. In Mark, Matthew, and Luke's healing of the paralytic, the central issue is Jesus' authority to forgive sins. In John Jesus replaces the Sabbath as the provider of rest and wholeness. John's caricature of Jesus' detractors as "the Jews" suggests that the community where John's gospel was written could be going through a painful split with the synagogue.

MARK 8:22–26

22 And he cometh to Bethsaida; and they bring a blind man unto him, and besought him to touch him.

23 And he took the blind man by the hand, and led him out of the town;

and when he had spit on his eyes, and put his hands upon him, he asked him if he saw ought.

24 And he looked up, and said, I see men as trees, walking.

25 After that he put his hands again upon his eyes, and made him look up: and he was restored, and saw every man clearly.

26 And he sent him away to his house, saying, Neither go into the town, nor tell it to any in the town.

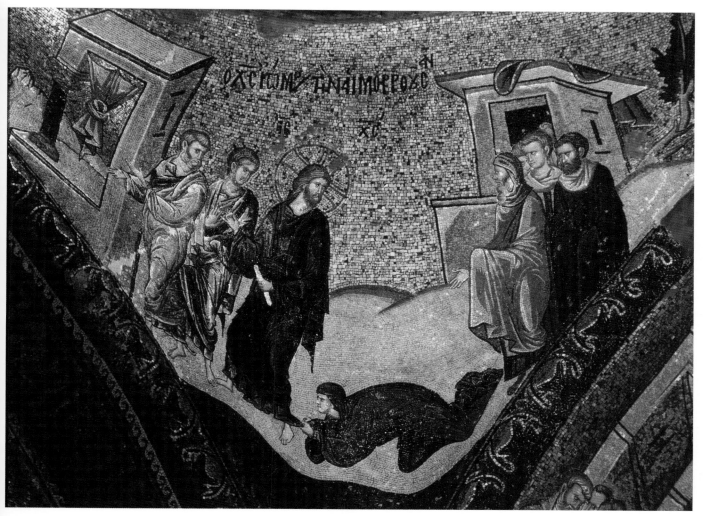

Healing a Deaf-mute, Artist Unknown

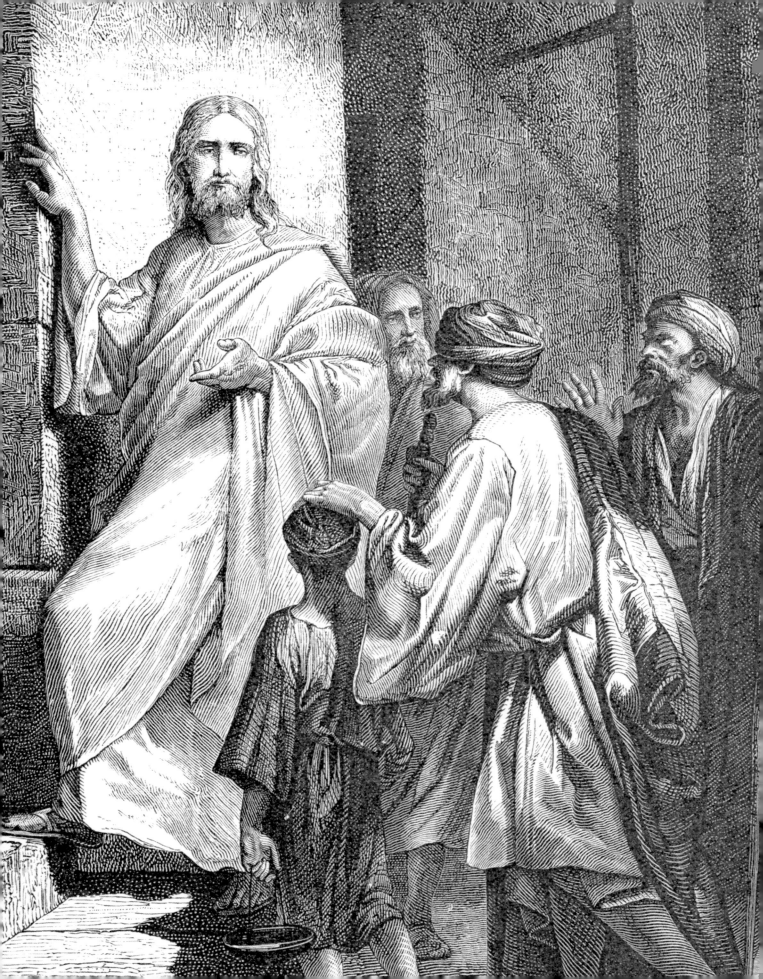

Jesus Begins the Journey

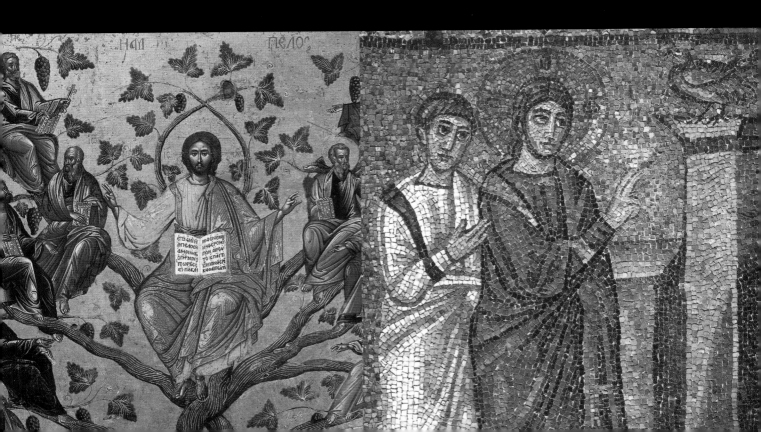

Jesus Begins the Journey

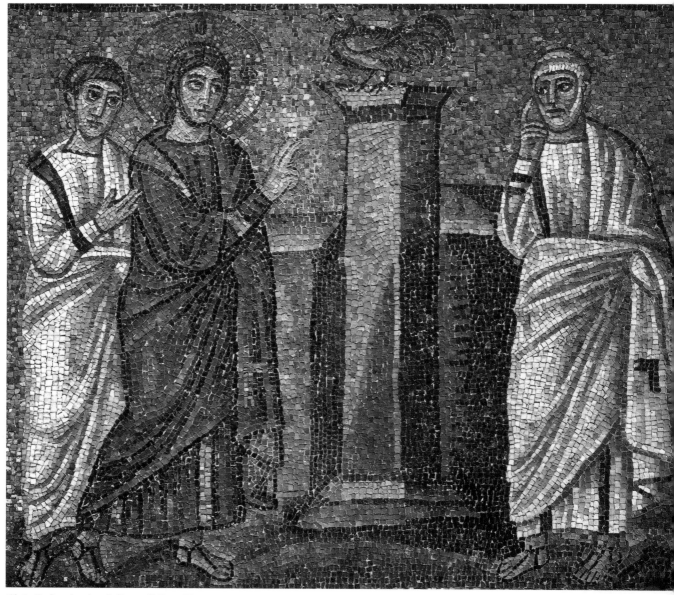

Christ Predicts that Apostle Peter will Deny Him, 6th century, Artist Unknown

THE GALILEAN MINISTRY OF JESUS HAS PUT HIM FACE-TO-FACE with the power of evil in many forms: demons, diseases, deformities, defamations…and death. What may not yet be apparent to the reader—for it is surely not yet apparent to his disciples—is that the road to deliverance that Jesus comes to travel is not the road of earthly power and glory, but the path of self-sacrificing love. It is a path for which the Songs of the Suffering Servant in the book of Isaiah becomes the model.

PETER'S CONFESSION

The events at Caesarea Philippi are a turning point—a scene that is at the same time glorious and disheartening. The choice of Caesarea Philippi was surely not accidental. Formerly known as Paneas, it got its name from its sacred grotto to the god Pan. Herod the Great (the father of Jesus' Herod), who had done a magnificent renovation of the Temple in Jerusalem, built a temple in honor of Augustus, the Roman Emperor. Centuries before it was a place for worship of the Baals. It is here that Jesus asks the disciples two questions: "Who do people say that I am?" and, more personally, "Who do all of you say that I am?" In John, the commitment question gets asked as many of his disciples are drawing away and no longer following him. He asks them, "Will you, too, go away?" In all four gospels it is Peter who is the first with the answer. "Thou art the Christ," i.e., the Anointed One, David's son, who would restore the kingdom of his famous ancestor as God's agent of deliverance.

MATTHEW 16:13–20

13 When Jesus came into the coasts of Caesarea Philippi, he asked his disciples, saying, Whom do men say that I the Son of man am?

14 And they said, Some say that thou art John the Baptist: some, Elias; and others, Jeremias, or one of the prophets.

15 He saith unto them, But whom say ye that I am?

16 And Simon Peter answered and said, Thou art the Christ, the Son of the living God.

17 And Jesus answered and said unto him, Blessed art thou, Simon Barjona: for flesh and blood hath not revealed it unto thee, but my Father which is in heaven.

18 And I say also unto thee, That thou art Peter, and upon this rock I will build my church; and the gates of hell shall not prevail against it.

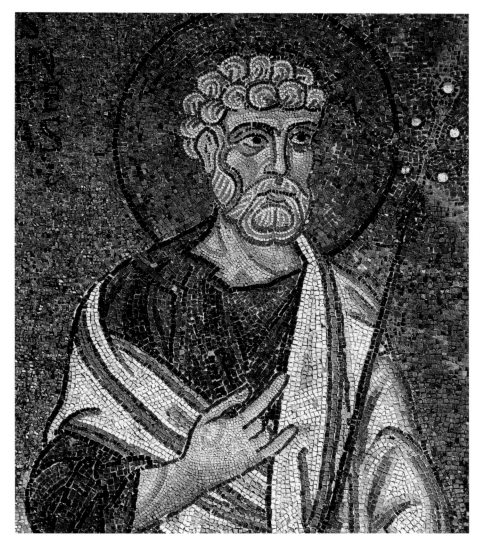

Saint Peter, 12th century, Artist Unknown

And I will give unto thee the keys of the kingdom of heaven: and whatsoever thou shalt bind on earth shall be bound in heaven: and whatsoever thou shalt loose on earth shall be loosed in heaven.

Then charged he his disciples that they should tell no man that he was Jesus the Christ.

—MATTHEW 16:19–20

Jesus in Prayer, by Alexander Bida, 1813–1895

19 And I will give unto thee the keys of the kingdom of heaven: and whatsoever thou shalt bind on earth shall be bound in heaven: and whatsoever thou shalt loose on earth shall be loosed in heaven.

20 Then charged he his disciples that they should tell no man that he was Jesus the Christ.

MARK 8:27–30

27 And Jesus went out, and his disciples, into the towns of Caesarea Philippi: and by the way he asked his disciples, saying unto them, Whom do men say that I am?

28 And they answered, John the Baptist: but some say, Elias; and others, One of the prophets.

29 And he saith unto them, But whom say ye that I am? And Peter answereth and saith unto him, Thou art the Christ.

30 And he charged them that they should tell no man of him.

LUKE 9:18–21

18 And it came to pass, as he was alone praying, his disciples were with him: and he asked them, saying, Whom say the people that I am?

19 They answering said, John the Baptist; but some say, Elias; and others say, that one of the old prophets is risen again.

20 He said unto them, But whom say ye that I am? Peter answering said, The Christ of God.

And he saith unto them, But whom say ye that I am? And Peter answereth and saith unto him, Thou art the Christ.

And he charged them that they should tell no man of him.

—MARK 8:29–30

21 And he straitly charged them, and commanded them to tell no man that thing;

JOHN 6:60–71

60 Many therefore of his disciples, when they had heard this, said, This is an hard saying; who can hear it?

61 When Jesus knew in himself that his disciples murmured at it, he said unto them, Doth this offend you?

62 What and if ye shall see the Son of man ascend up where he was before?

63 It is the spirit that quickeneth; the flesh profiteth nothing: the words that I speak unto you, they are spirit, and they are life.

64 But there are some of you that believe not. For Jesus knew from the beginning who they were that believed not, and who should betray him.

65 And he said, Therefore said I unto you, that no man can come unto me, except it were given unto him of my Father.

66 From that time many of his disciples went back, and walked no more with him.

67 Then said Jesus unto the twelve, Will ye also go away?

68 Then Simon Peter answered him, Lord, to whom shall we go? thou hast the words of eternal life.

69 And we believe and are sure that thou art that Christ, the Son of the living God.

70 Jesus answered them, Have not I chosen you twelve, and one of you is a devil?

71 He spake of Judas Iscariot the son of Simon: for he it was that should betray him, being one of the twelve.

JESUS FORETELLS HIS PASSION: THE COST OF BEING A DISCIPLE

Peter's confession was a dramatic recognition scene. In Mark's story, Jesus' identity has been a closely guarded secret. Though the reader knows, Jesus knows, and the demons know, Peter is the first human to acknowledge him as Israel's Messiah (Greek—Christ). Matthew has Peter going further in his confession, calling him also "the Son of the Living God." Matthew's Jesus praises Peter for his confession, calls him the rock (Petros, in Greek) on which Jesus will build his church, and gives him "the keys to the kingdom of heaven." Having sworn the disciples to "tell no one," Jesus goes on to tell them plainly: "The Son of man must suffer many things,…and be killed, and after three days rise again." When Peter refuses to hear this, Jesus calls him "Satan," i.e. the voice that is "not of God." Jesus concludes with the classic statement on the cost of being a disciple: "Whosoever will save his life shall lose it; but whosoever shall lose his life for my sake and the gospel's, he shall save it."

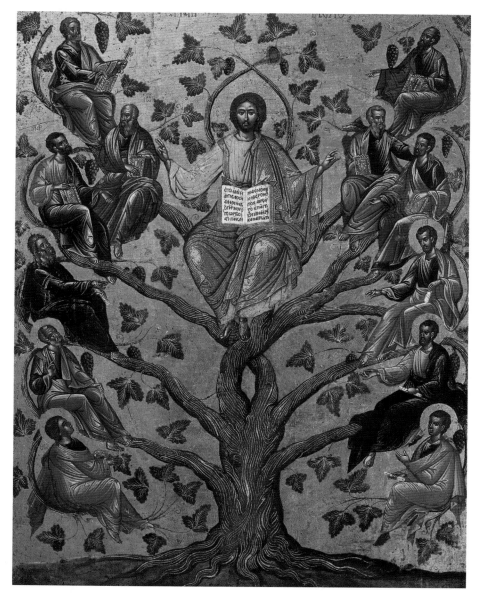

I am the Vine, with Christ and the Apostles, Artist Unknown

25 For whosoever will save his life shall lose it: and whosoever will lose his life for my sake shall find it.

26 For what is a man profited, if he shall gain the whole world, and lose his own soul? or what shall a man give in exchange for his soul?

27 For the Son of man shall come in the glory of his Father with his angels; and then he shall reward every man according to his works.

28 Verily I say unto you, There be some standing here, which shall not taste of death, till they see the Son of man coming in his kingdom.

MARK 8:31–9:1

31 And he began to teach them, that the Son of man must suffer many things, and be rejected of the elders, and of the chief priests, and scribes, and be killed, and after three days rise again.

32 And he spake that saying openly. And Peter took him, and began to rebuke him.

33 But when he had turned about and looked on his disciples, he rebuked Peter, saying, Get thee behind me, Satan: for thou savourest not the things that be of God, but the things that be of men.

34 And when he had called the people unto him with his disciples also, he said unto them, Whosoever will come after me, let him deny himself, and take up his cross, and follow me.

35 For whosoever will save his life shall lose it; but whosoever shall lose his life for my sake and the gospel's, the same shall save it.

36 For what shall it profit a man, if he shall gain the whole world, and lose his own soul?

37 Or what shall a man give in exchange for his soul?

38 Whosoever therefore shall be ashamed of me and of my words in

Saint Peter Preaching, by Pedro Serra, 14th century

MATTHEW 16:21–28

21 From that time forth began Jesus to shew unto his disciples, how that he must go unto Jerusalem, and suffer many things of the elders and chief priests and scribes, and be killed, and be raised again the third day.

22 Then Peter took him, and began to rebuke him, saying, Be it far from thee, Lord: this shall not be unto thee.

23 But he turned, and said unto Peter, Get thee behind me, Satan: thou art an offence unto me: for thou savourest not the things that be of God, but those that be of men.

24 Then said Jesus unto his disciples, If any man will come after me, let him deny himself, and take up his cross, and follow me.

this adulterous and sinful generation; of him also shall the Son of man be ashamed, when he cometh in the glory of his Father with the holy angels.

MARK 9

And he said unto them, Verily I say unto you, That there be some of them that stand here, which shall not taste of death, till they have seen the kingdom of God come with power.

LUKE 9:22–27

22 Saying, The Son of man must suffer many things, and be rejected of the elders and chief priests and scribes, and be slain, and be raised the third day.

23 And he said to them all, If any man will come after me, let him deny himself, and take up his cross daily, and follow me.

24 For whosoever will save his life shall lose it: but whosoever will lose his life for my sake, the same shall save it.

25 For what is a man advantaged, if he gain the whole world, and lose himself, or be cast away?

26 For whosoever shall be ashamed of me and of my words, of him shall the Son of man be ashamed, when he shall come in his own glory, and in his Father's, and of the holy angels.

27 But I tell you of a truth, there be some standing here, which shall not taste of death, till they see the kingdom of God.

JESUS' TRANSFIGURATION

Six days later (eight days in Luke), Jesus takes Peter, James, and John and goes up to a high mountain apart, Luke adds, "to pray." While Jesus prays, his face and his garments become altered, bright as the sun. It is a scene that resembles the scenes where Moses and, later Elijah encounter the presence of God and are given instructions on carrying out their missions. Indeed, they are present, Luke adds "in glory," and speaking with Jesus about "his decease" (in Greek, his "exodos") which he would accomplish in Jerusalem. As a cloud overshadowed them all, a voice spoke, the voice Jesus heard at his Baptism, declaring: "This is my beloved Son, in whom I am well pleased. Hear ye him." As they head down the mountain, Jesus tells them: "Tell the vision to no man, until the Son of man be risen again from the dead."

MATTHEW 17:1-9

1 And after six days Jesus taketh Peter, James, and John his brother, and bringeth them up into an high mountain apart,

2 And was transfigured before them: and his face did shine as the sun, and his raiment was white as the light.

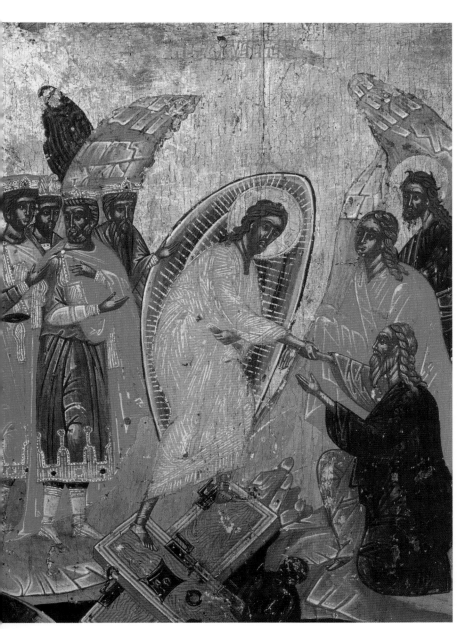

The Transfiguration (Anastasis) of Jesus Christ to the Apostles, 18th century, Artist Unknown

And there was a cloud that overshadowed them: and a voice came out of the cloud, saying, This is my beloved Son: hear him.

—MARK 9:7

3 And, behold, there appeared unto them Moses and Elias talking with him.

4 Then answered Peter, and said unto Jesus, Lord, it is good for us to be here: if thou wilt, let us make here three tabernacles; one for thee, and one for Moses, and one for Elias.

5 While he yet spake, behold, a bright cloud overshadowed them: and behold a voice out of the cloud, which said, This is my beloved Son, in whom I am well pleased; hear ye him.

6 And when the disciples heard it, they fell on their face, and were sore afraid.

7 And Jesus came and touched them, and said, Arise, and be not afraid.

8 And when they had lifted up their eyes, they saw no man, save Jesus only.

9 And as they came down from the mountain, Jesus charged them, saying, Tell the vision to no man, until the Son of man be risen again from the dead.

MARK 9:2–10

2 And after six days Jesus taketh with him Peter, and James, and John, and leadeth them up into an high mountain apart by themselves: and he was transfigured before them.

3 And his raiment became shining, exceeding white as snow; so as no fuller on earth can white them.

4 And there appeared unto them Elias with Moses: and they were talking with Jesus.

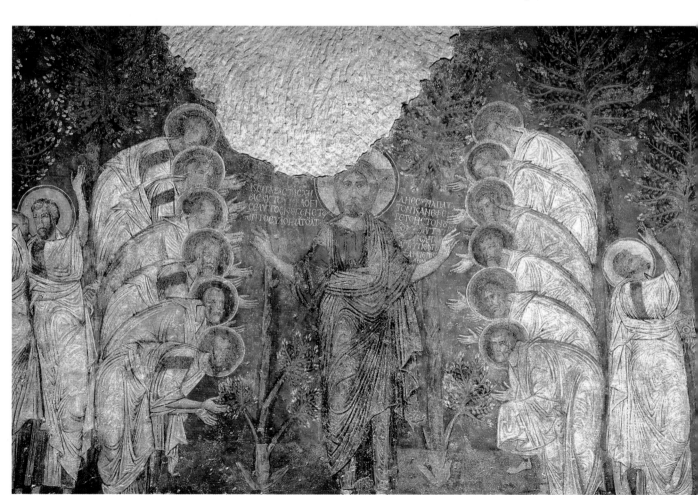

Transfiguration with Christ and the Apostles, 10th century, Artist Unknown

5 And Peter answered and said to Jesus, Master, it is good for us to be here: and let us make three tabernacles; one for thee, and one for Moses, and one for Elias.

6 For he wist not what to say; for they were sore afraid.

7 And there was a cloud that overshadowed them: and a voice came out of the cloud, saying, This is my beloved Son: hear him.

8 And suddenly, when they had looked round about, they saw no man any more, save Jesus only with themselves.

9 And as they came down from the mountain, he charged them that they should tell no man what things they had seen, till the Son of man were risen from the dead.

10 And they kept that saying with themselves, questioning one with another what the rising from the dead should mean.

LUKE 9:28–36

28 And it came to pass about an eight days after these sayings, he took Peter and John and James, and went up into a mountain to pray.

29 And as he prayed, the fashion of his countenance was altered, and his raiment was white and glistering.

30 And, behold, there talked with him two men, which were Moses and Elias:

31 Who appeared in glory, and spake of his decease which he should accomplish at Jerusalem.

32 But Peter and they that were with him were heavy with sleep: and when they were awake, they saw his glory, and the two men that stood with him.

33 And it came to pass, as they departed from him, Peter said unto Jesus, Master, it is good for us to be here: and let us make three tabernacles;

one for thee, and one for Moses, and one for Elias: not knowing what he said.

34 While he thus spake, there came a cloud, and overshadowed them: and they feared as they entered into the cloud.

35 And there came a voice out of the cloud, saying, This is my beloved Son: hear him.

36 And when the voice was past, Jesus was found alone. And they kept it close, and told no man in those days any of those things which they had seen.

JOHN 12:28–30

28 Father, glorify thy name. Then came there a voice from heaven, saying, I have both glorified it, and will glorify it again.

29 The people therefore, that stood by, and heard it, said that it thundered: others said, An angel spake to him.

30 Jesus answered and said, This voice came not because of me, but for your sakes.

ON THE RETURN OF ELIJAH

MATTHEW 17:10–13

10 And his disciples asked him, saying, Why then say the scribes that Elias must first come?

11 And Jesus answered and said unto them, Elias truly shall first come, and restore all things.

12 But I say unto you, That Elias is come already, and they knew him not, but have done unto him whatsoever they listed. Likewise shall also the Son of man suffer of them.

13 Then the disciples understood that he spake unto them of John the Baptist.

MARK 9:11–13

11 And they asked him, saying, Why say the scribes that Elias must first come?

12 And he answered and told them, Elias verily cometh first, and restoreth all things; and how it is written of the Son of man, that he must suffer many things, and be set at nought.

13 But I say unto you, That Elias is indeed come, and they have done unto him whatsoever they listed, as it is written of him.

And as they came down from the mountain, he charged them that they should tell no man what things they had seen, till the Son of man were risen from the dead.

And they kept that saying with themselves, questioning one with another what the rising from the dead should mean.

—MARK 9:9–10

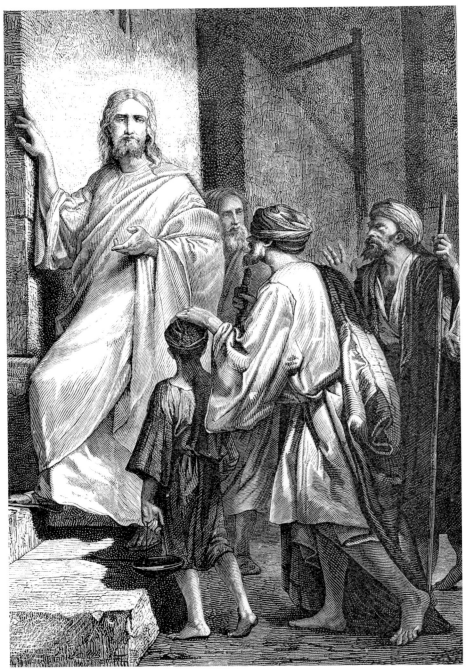

Healing of Two Blind Men, by Alexander Bida, 1813–1895

JESUS HEALS A BOY POSSESSED BY A SPIRIT

Quickly the vision of Peter, James, and John disappears, as they come down the mountain to find a man who has brought his son to Jesus' disciples to have a demon cast out, but they were not able to do it. Mark gives a graphic account of this exorcism, which bears a haunting resemblance to Jesus' death, where he, like this boy as the demon leaves him, cries out with a loud voice and "gives up the ghost." Later, when they are by themselves, the disciples ask Jesus why they were unable to drive this demon out. Mark's Jesus answers: "This kind can come forth by nothing, but by prayer and fasting." Matthew and Luke, drawing on their common source, attribute the failure to lack of faith. However one evaluates, the disciples still have much to learn.

MATTHEW 17:14–21

14 And when they were come to the multitude, there came to him a certain man, kneeling down to him, and saying,

15 Lord, have mercy on my son: for he is lunatick, and sore vexed: for ofttimes he falleth into the fire, and oft into the water.

16 And I brought him to thy disciples, and they could not cure him.

17 Then Jesus answered and said, O faithless and perverse generation, how long shall I be with you? how long shall I suffer you? bring him hither to me.

18 And Jesus rebuked the devil; and he departed out of him: and the child was cured from that very hour.

19 Then came the disciples to Jesus apart, and said, Why could not we cast him out?

20 And Jesus said unto them, Because of your unbelief: for verily I say unto you, If ye have faith as a grain of mustard seed, ye shall say unto this mountain, Remove hence to yonder place; and it shall remove; and nothing shall be impossible unto you.

21 Howbeit this kind goeth not out but by prayer and fasting.

MARK 9:14–29

14 And when he came to his disciples, he saw a great multitude about them, and the scribes questioning with them.

15 And straightway all the people, when they beheld him, were greatly amazed and running to him saluted him.

16 And he asked the scribes, What question ye with them?

17 And one of the multitude answered and said, Master, I have brought unto thee my son, which hath a dumb spirit;

18 And wheresoever he taketh him, he teareth him: and he foameth, and gnasheth with his teeth, and pineth away: and I spake to thy disciples that they should cast him out; and they could not.

19 He answereth him, and saith, O faithless generation, how long shall I be with you? how long shall I suffer you? bring him unto me.

20 And they brought him unto him: and when he saw him, straightway the spirit tare him; and he fell on the ground, and wallowed foaming.

21 And he asked his father, How long is it ago since this came unto him? And he said, Of a child.

22 And ofttimes it hath cast him into the fire, and into the waters, to destroy him: but if thou canst do any thing, have compassion on us, and help us.

23 Jesus said unto him, If thou canst believe, all things are possible to him that believeth.

24 And straightway the father of the child cried out, and said with tears, Lord, I believe; help thou mine unbelief.

25 When Jesus saw that the people came running together, he rebuked the foul spirit, saying unto him, Thou dumb and deaf spirit, I charge thee, come out of him, and enter no more into him.

26 And the spirit cried, and rent him sore, and came out of him: and he was as one dead; insomuch that many said, He is dead.

27 But Jesus took him by the hand, and lifted him up; and he arose.

28 And when he was come into the house, his disciples asked him privately, Why could not we cast him out?

29 And he said unto them, This kind can come forth by nothing, but by prayer and fasting.

LUKE 9:37–43A

37 And it came to pass, that on the next day, when they were come down from the hill, much people met him.

38 And, behold, a man of the company cried out, saying, Master, I beseech thee, look upon my son: for he is mine only child.

39 And, lo, a spirit taketh him, and he suddenly crieth out; and it teareth him that he foameth again, and bruising him hardly departeth from him.

40 And I besought thy disciples to cast him out; and they could not.

41 And Jesus answering said, O faithless and perverse generation, how long shall I be with you, and suffer you? Bring thy son hither.

42 And as he was yet a coming, the devil threw him down, and tare him. And Jesus rebuked the unclean spirit, and healed the child, and delivered him again to his father.

43 And they were all amazed at the mighty power of God.

JESUS FORETELLS HIS PASSION A SECOND TIME

Once again, Jesus speaks to his disciples about his being handed over to men, who will kill him, and his being raised on the third day. Their reaction: they were distressed, and afraid to ask him about it. In this second of three cycles, Jesus is trying to teach them many things, and, this time around, they are arguing with one another about who among them is the greatest.

MATTHEW 17:22–23

22 And while they abode in Galilee, Jesus said unto them, The Son of man shall be betrayed into the hands of men:

23 And they shall kill him, and the third day he shall be raised again. And they were exceeding sorry.

MARK 9:30–32

30 And they departed thence, and passed through Galilee; and he would not that any man should know it.

31 For he taught his disciples, and said unto them, The Son of man is delivered into the hands of men, and they shall kill him; and after that he is killed, he shall rise the third day.

32 But they understood not that saying, and were afraid to ask him.

LUKE 9:43–45

43 And they were all amazed at the mighty power of God. But while they wondered every one at all things which Jesus did, he said unto his disciples,

44 Let these sayings sink down into your ears: for the Son of man shall be delivered into the hands of men.

45 But they understood not this saying, and it was hid from them, that they perceived it not: and they feared to ask him of that saying.

46 Then there arose a reasoning among them, which of them should be greatest.

47 And Jesus, perceiving the thought of their heart, took a child, and set him by him,

48 And said unto them, Whosoever shall receive this child in my name receiveth me: and whosoever shall receive me receiveth him that sent me: for he that is least among you all, the same shall be great.

And he took a child, and set him in the midst them: and when he had taken him in his arms, he said unto them,

Whosoever shall receive one of such children in my name, receiveth me: and whosoever shall receive me, receiveth not me, but him that sent me.

—MARK 9:36–37

49 And John answered and said, Master, we saw one casting out devils in thy name; and we forbad him, because he followeth not with us.

THE TEMPLE TAX

MATTHEW 17:24–27

24 And when they were come to Capernaum, they that received tribute money came to Peter, and said, Doth not your master pay tribute?

25 He saith, Yes. And when he was come into the house, Jesus prevented him, saying, What thinkest thou, Simon? of whom do the kings of the earth take custom or tribute? of their own children, or of strangers?

26 Peter saith unto him, Of strangers. Jesus saith unto him, Then are the children free.

27 Notwithstanding, lest we should offend them, go thou to the sea, and cast an hook, and take up the fish that first cometh up; and when thou hast opened his mouth, thou shalt find a piece of money: that take, and give unto them for me and thee.

JESUS' DISCIPLES ARGUE ABOUT WHO IS THE GREATEST

As Jesus' disciples are afraid to ask him, he decides to ask them what they were talking about on the road. Again they do not want to answer, as they were arguing about who among them was the greatest. Jesus reorients them by putting a child into the center of them all. In Jesus' day a child had no status, no legal protection, no rights. Children were totally dependent on others for their care. If you would be great in the kingdom of God, be as dependent as a child on the Lord. This passage marks the beginning of Matthew's fourth Great Sermon, or collection of teachings, on the care and maintenance of the church, the community of disciples—a community in which all who believe in him are "little ones."

MATTHEW 18:1–5

1 At the same time came the disciples unto Jesus, saying, Who is the greatest in the kingdom of heaven?

2 And Jesus called a little child unto him, and set him in the midst of them,

3 And said, Verily I say unto you, Except ye be converted, and become as little children, ye shall not enter into the kingdom of heaven.

4 Whosoever therefore shall humble himself as this little child, the same is greatest in the kingdom of heaven.

5 And whoso shall receive one such little child in my name receiveth me.

MARK 9:33–37

33 And he came to Capernaum: and being in the house he asked them, What was it that ye disputed among yourselves by the way?

34 But they held their peace: for by the way they had disputed among themselves, who should be the greatest.

35 And he sat down, and called the twelve, and saith unto them, If any man desire to be first, the same shall be last of all, and servant of all.

36 And he took a child, and set him in the midst of them: and when he had taken him in his arms, he said unto them,

37 Whosoever shall receive one of such children in my name, receiveth me: and whosoever shall receive me, receiveth not me, but him that sent me.

LUKE 9:46–48

46 Then there arose a reasoning among them, which of them should be greatest.

47 And Jesus, perceiving the thought of their heart, took a child, and set him by him,

48 And said unto them, Whosoever shall receive this child in my name receiveth me: and whosoever shall receive me receiveth him that sent me: for he that is least among you all, the same shall be great.

PRACTICING TOLERANCE

MATTHEW 10:42

42 And whosoever shall give to drink unto one of these little ones a cup of cold water only in the name of a disciple, verily I say unto you, he shall in no wise lose his reward.

MARK 9:38–41

38 And John answered him, saying, Master, we saw one casting out devils in thy name, and he followeth not us: and we forbad him, because he followeth not us.

39 But Jesus said, Forbid him not: for there is no man which shall do a miracle in my name, that can lightly speak evil of me.

40 For he that is not against us is on our part.

41 For whosoever shall give you a cup of water to drink in my name, because ye belong to Christ, verily I say unto you, he shall not lose his reward.

LUKE 9:49–50

49 And John answered and said, Master, we saw one casting out devils in thy name; and we forbad him, because he followeth not with us.

50 And Jesus said unto him, Forbid him not: for he that is not against us is for us.

At the same time came the disciples unto Jesus, saying, Who is the greatest in the kingdom of heaven?

—MATTHEW 18:1

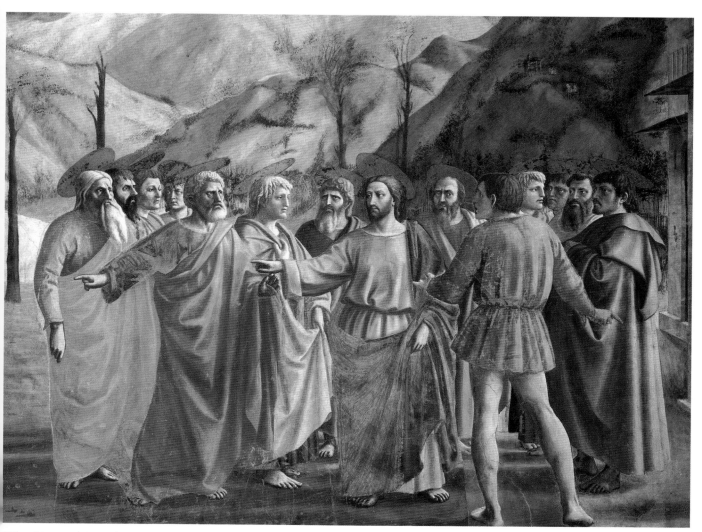

Tribute Money with Jesus Christ, Saint Thomas (right), Apostles and Tribute Collector, by Tommaso Masaccio, 1401–28

WARNINGS ABOUT TEMPTATIONS

MATTHEW 18:6–9

6 But whoso shall offend one of these little ones which believe in me, it were better for him that a millstone were hanged about his neck, and that he were drowned in the depth of the sea.

7 Woe unto the world because of offences! for it must needs be that offences come; but woe to that man by whom the offence cometh!

8 Wherefore if thy hand or thy foot offend thee, cut them off, and cast them from thee: it is better for thee to enter into life halt or maimed, rather than having two hands or two feet to be cast into everlasting fire.

9 And if thine eye offend thee, pluck it out, and cast it from thee: it is better for thee to enter into life with one eye, rather than having two eyes to be cast into hell fire.

MARK 9:42–50

42 And whosoever shall offend one of these little ones that believe in me, it is better for him that a millstone were hanged about his neck, and he were cast into the sea.

43 And if thy hand offend thee, cut it off: it is better for thee to enter into life maimed, than having two hands to go into hell, into the fire that never shall be quenched:

44 Where their worm dieth not, and the fire is not quenched.

45 And if thy foot offend thee, cut it off: it is better for thee to enter halt into life, than having two feet to be cast into hell, into the fire that never shall be quenched:

46 Where their worm dieth not, and the fire is not quenched.

47 And if thine eye offend thee, pluck it out: it is better for thee to enter into the kingdom of God with one eye, than having two eyes to be cast into hell fire:

48 Where their worm dieth not, and the fire is not quenched.

49 For every one shall be salted with fire, and every sacrifice shall be salted with salt.

50 Salt is good: but if the salt have lost his saltness, wherewith will ye season it? Have salt in yourselves, and have peace one with another.

LUKE 17:1–2

1 Then said he unto the disciples, It is impossible but that offences will come: but woe unto him, through whom they come!

2 It were better for him that a millstone were hanged about his neck, and he cast into the sea, than that he should offend one of these little ones.

LUKE 14:34–35

34 Salt is good: but if the salt have lost his savour, wherewith shall it be seasoned?

35 It is neither fit for the land, nor yet for the dunghill; but men cast it out. He that hath ears to hear, let him hear.

PARABLE OF THE LOST SHEEP

Matthew's sermon on the church has two parts, each one ending with a parable. The first part is about little ones, God's love, and care for them, what causes them to stumble, and how important it is not to stumble. It is important enough that one would be better off without an eye, a hand, or a foot, than to risk being cut off from the nurturing community. The Parable of the Lost Sheep is a marvelous illustration of the Father's love and concern. In Luke, it appears as the first of three parables about sheep, coins, sons that are lost and found—and the joy in heaven whenever one who is lost comes to be found. The "moral" of the story is the last verse: "Even so it is not the will of your Father which is in heaven, that one of these little ones should perish."

MATTHEW 18:10–14

10 Take heed that ye despise not one of these little ones; for I say unto you, That in heaven their angels do always behold the face of my Father which is in heaven.

11 For the Son of man is come to save that which was lost.

12 How think ye? if a man have an hundred sheep, and one of them be gone astray, doth he not leave the ninety and nine, and goeth into the mountains, and seeketh that which is gone astray?

13 And if so be that he find it, verily I say unto you, he rejoiceth more of that sheep, than of the ninety and nine which went not astray.

14 Even so it is not the will of your Father which is in heaven, that one of these little ones should perish.

LUKE 15:3–7

3 And he spake this parable unto them, saying,

4 What man of you, having an hundred sheep, if he lose one of them, doth not leave the ninety and nine in the wilderness, and go after that which is lost, until he find it?

5 And when he hath found it, he layeth it on his shoulders, rejoicing.

6 And when he cometh home, he calleth together his friends and neighbours, saying unto them, Rejoice with me; for I have found my sheep which was lost.

7 I say unto you, that likewise joy shall be in heaven over one sinner that repenteth, more than over ninety and nine just persons, which need no repentance.

ON CORRECTING ONE'S BROTHER

The second part of the sermon builds on the first part. If every "little one" is irreplaceable, and the Father's will is that none be lost, then preventing sisters and brothers from stumbling is everyone's concern. Jesus' three-step model begins with going to the erring sister or brother one-on-one. The objective is to gain back the sinner. If this one-on-one tactic does not succeed, take one or two others along as witnesses. Only if that fails should the matter become public church business. But, in the event that all three steps do not reconcile the sinner, put that one out—that the sinner might come to repentance. What makes this model work is Jesus' own promise to be present with those who practice it: "For wherever two or three are gathered together in my name, there am I in the midst of them." The parable that completes this section and the sermon itself is the one that follows: a dramatic reenactment of the prayer "Forgive us our trespasses, as we forgive those who trespass against us."

MATTHEW 18:15–22

15 Moreover if thy brother shall trespass against thee, go and tell him his fault between thee and him alone: if he shall hear thee, thou hast gained thy brother.

16 But if he will not hear thee, then take with thee one or two more, that in the mouth of two or three witnesses every word may be established.

17 And if he shall neglect to hear them, tell it unto the church: but if he neglect to hear the church, let him be unto thee as an heathen man and a publican.

18 Verily I say unto you, Whatsoever ye shall bind on earth shall be bound in heaven: and whatsoever ye shall loose on earth shall be loosed in heaven.

19 Again I say unto you, That if two of you shall agree on earth as touching any thing that they shall ask, it shall be done for them of my Father which is in heaven.

20 For where two or three are gathered together in my name, there am I in the midst of them.

21 Then came Peter to him, and said, Lord, how oft shall my brother sin against me, and I forgive him? till seven times?

22 Jesus saith unto him, I say not unto thee, Until seven times: but, Until seventy times seven.

LUKE 17:3–4

3 Take heed to yourselves: If thy brother trespass against thee, rebuke him; and if he repent, forgive him.

4 And if he trespass against thee seven times in a day, and seven times in a day turn again to thee, saying, I repent; thou shalt forgive him.

A PARABLE ABOUT AN UNFORGIVING SERVANT

MATTHEW 18:23–35

23 Therefore is the kingdom of heaven likened unto a certain king, which would take account of his servants.

24 And when he had begun to reckon, one was brought unto him, which owed him ten thousand talents.

25 But forasmuch as he had not to pay, his lord commanded him to be sold, and his wife, and children, and all that he had, and payment to be made.

26 The servant therefore fell down, and worshipped him, saying, Lord, have patience with me, and I will pay thee all.

27 Then the lord of that servant was moved with compassion, and loosed him, and forgave him the debt.

28 But the same servant went out, and found one of his fellowservants, which owed him an hundred pence: and he laid hands on him, and took him by the throat, saying, Pay me that thou owest.

29 And his fellowservant fell down at his feet, and besought him, saying, Have patience with me, and I will pay thee all.

30 And he would not: but went and cast him into prison, till he should pay the debt.

31 So when his fellowservants saw what was done, they were very sorry, and came and told unto their lord all that was done.

32 Then his lord, after that he had called him, said unto him, O thou wicked servant, I forgave thee all that debt, because thou desiredst me:

33 Shouldest not thou also have had compassion on thy fellowservant, even as I had pity on thee?

34 And his lord was wroth, and delivered him to the tormentors, till he should pay all that was due unto him.

35 So likewise shall my heavenly Father do also unto you, if ye from your hearts forgive not every one his brother their trespasses.

Frankincense and Myrrh, by Artist Unknown

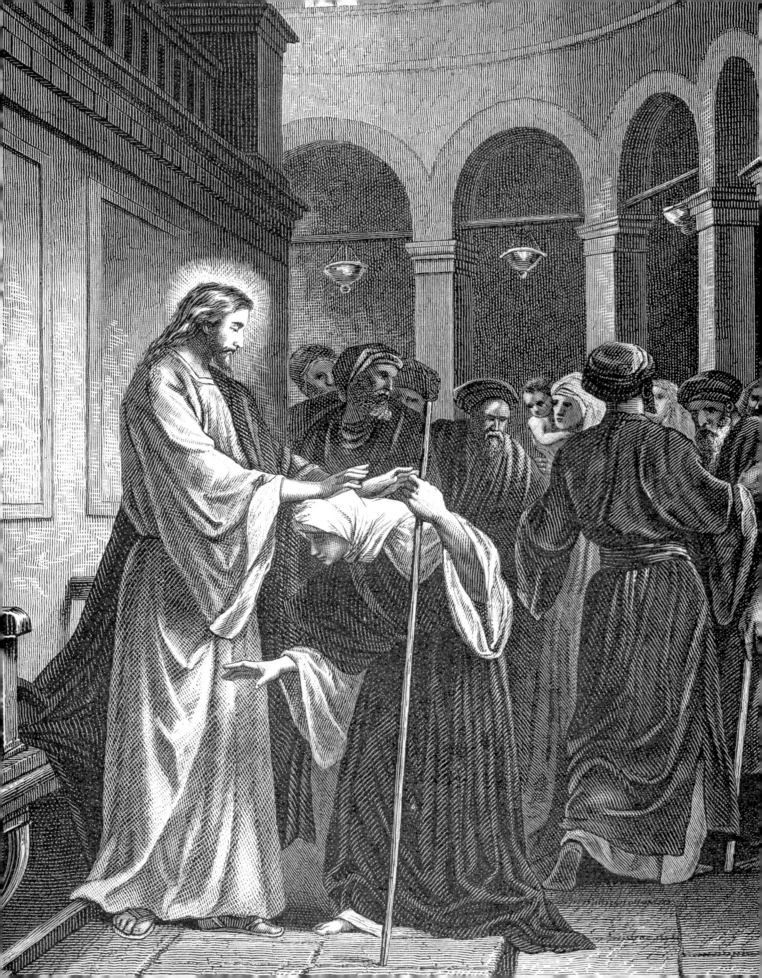

LIFE of JESUS

On the Way to Jerusalem

On the Way to Jerusalem

Entry of Christ into Jerusalem, 1460-85, by Artist Unknown

IN LUKE'S TWO VOLUMES—the Gospel and the Acts of the Apostles—the good news of Jesus is the basis of the story of God's mighty acts of deliverance. The good news is proclaimed and prophesied among God's covenant people in the (Hebrew) Scriptures, accomplished through the life, death, and resurrection of Jesus, and made known in the power of the Spirit through his apostles to the ends of the earth. As Luke's Jesus is the hinge of history, so Jerusalem is the central point in the life of Israel and in the mission of Jesus. And it is the home base of the apostles' mission as told in Acts. Luke portrays Jesus as the Prophet, through whom God visits his people.

JESUS IS REJECTED BY THE SAMARITANS

While Luke's story bears many interesting similarities to John's, Jesus' reception by the Samaritans is not one of them. Here, the Samaritans do not want to receive Jesus, because he is heading to Jerusalem. The disciples ask Jesus whether he will send down fire from heaven, but Jesus reprimands them. Later, in the Acts, he will send the disciples specifically to "Judea and Samaria" and then they (and he, through them) will be received.

LUKE 9:51–56

51 And it came to pass, when the time was come that he should be received up, he stedfastly set his face to go to Jerusalem,

52 And sent messengers before his face: and they went, and entered into a village of the Samaritans, to make ready for him.

53 And they did not receive him, because his face was as though he would go to Jerusalem.

54 And when his disciples James and John saw this, they said, Lord, wilt thou that we command fire to come down from heaven, and consume them, even as Elias did?

55 But he turned, and rebuked them, and said, Ye know not what manner of spirit ye are of.

56 For the Son of man is not come to destroy men's lives, but to save them. And they went to another village.

ON FOLLOWING JESUS

MATTHEW 8:18–22

18 Now when Jesus saw great multitudes about him, he gave commandment to depart unto the other side.

19 And a certain scribe came, and said unto him, Master, I will follow thee whithersoever thou goest.

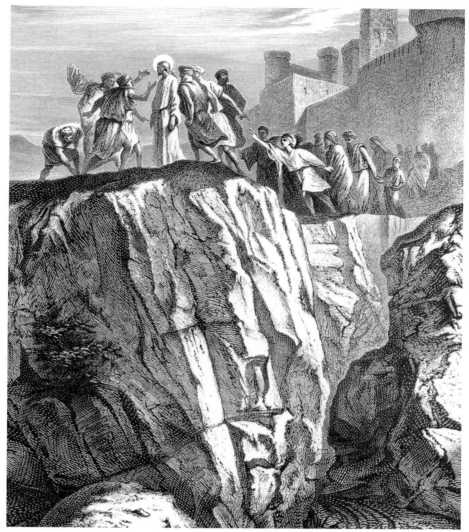

Jesus Rejected at Nazareth, by Alexander Bida, 1813-1895

And it came to pass, that, as they went in the way, a certain man said unto him, Lord, I will follow thee whithersoever thou goest.

And Jesus said unto him, Foxes have holes, and birds of the air have nests; but the Son of man hath not where to lay his head.

—LUKE 9:57–58

20 And Jesus saith unto him, The foxes have holes, and the birds of the air have nests; but the Son of man hath not where to lay his head.

21 And another of his disciples said unto him, Lord, suffer me first to go and bury my father.

22 But Jesus said unto him, Follow me; and let the dead bury their dead.

LUKE 9:57–62

57 And it came to pass, that, as they went in the way, a certain man said unto him, Lord, I will follow thee whithersoever thou goest.

58 And Jesus said unto him, Foxes have holes, and birds of the air have nests; but the Son of man hath not where to lay his head.

59 And he said unto another, Follow me. But he said, Lord, suffer me first to go and bury my father.

60 Jesus said unto him, Let the dead bury their dead: but go thou and preach the kingdom of God.

61 And another also said, Lord, I will follow thee; but let me first go bid them farewell, which are at home at my house.

He that heareth you heareth me; and he that despiseth you despiseth me; and he that despiseth me despiseth him that sent me.
—LUKE 10:16

Providing for the Religious, Following Christ's Teaching, 15th–16th century, Artist Unknown

62 And Jesus said unto him, No man, having put his hand to the plough, and looking back, is fit for the kingdom of God.

JESUS COMMISSIONS SEVENTY OTHERS

Reporting here that Jesus sends seventy "others" to go before him, Luke includes some of the material from the source he shares with Matthew, which Matthew uses in his account of the sending of the Twelve. The number seventy reminds us of Moses, who is told by the Lord to gather seventy elders, on whom the Lord will place a portion of Moses' spirit (Numbers 11), that these would assist Moses in his ministry among the people. Jesus' comment above to the disciples when they ask him about an unknown exorcist using his name points back to Moses' words: "Would that all the Lord's people were prophets, that the Lord would put his spirit upon them!" These seventy point forward to still "others," on whom the Spirit will be poured out, who will follow Jesus' instructions—and carry the good news to the "ends of the earth."

37 Then saith he unto his disciples, The harvest truly is plenteous, but the labourers are few;

38 Pray ye therefore the Lord of the harvest, that he will send forth labourers into his harvest.

LUKE 10:1–16

1 After these things the Lord appointed other seventy also, and sent them two and two before his face into every city and place, whither he himself would come.

2 Therefore said he unto them, The harvest truly is great, but the labourers are few: pray ye therefore the Lord of the harvest, that he would send forth labourers into his harvest.

3 Go your ways: behold, I send you forth as lambs among wolves.

4 Carry neither purse, nor scrip, nor shoes: and salute no man by the way.

5 And into whatsoever house ye enter, first say, Peace be to this house.

6 And if the son of peace be there, your peace shall rest upon it: if not, it shall turn to you again.

7 And in the same house remain, eating and drinking such things as they give: for the labourer is worthy of his hire. Go not from house to house.

8 And into whatsoever city ye enter, and they receive you, eat such things as are set before you:

9 And heal the sick that are therein, and say unto them, The kingdom of God is come nigh unto you.

10 But into whatsoever city ye enter, and they receive you not, go your ways out into the streets of the same, and say,

11 Even the very dust of your city, which cleaveth on us, we do wipe off against you: notwithstanding be ye sure of this, that the kingdom of God is come nigh unto you.

12 But I say unto you, that it shall be more tolerable in that day for Sodom, than for that city.

13 Woe unto thee, Chorazin! woe unto thee, Bethsaida! for if the mighty works had been done in Tyre and Sidon, which have been done in you, they had a great while ago repented, sitting in sackcloth and ashes.

14 But it shall be more tolerable for Tyre and Sidon at the judgment, than for you.

15 And thou, Capernaum, which art exalted to heaven, shalt be thrust down to hell.

16 He that heareth you heareth me; and he that despiseth you despiseth me; and he that despiseth me despiseth him that sent me.

Giving Bread to the Poor, Following Christ's Teaching, 15th–16th century, Artist Unknown

MATTHEW 10:7–16

7 And as ye go, preach, saying, The kingdom of heaven is at hand.

8 Heal the sick, cleanse the lepers, raise the dead, cast out devils: freely ye have received, freely give.

9 Provide neither gold, nor silver, nor brass in your purses,

10 Nor scrip for your journey, neither two coats, neither shoes, nor yet staves: for the workman is worthy of his meat.

11 And into whatsoever city or town ye shall enter, inquire who in it is worthy; and there abide till ye go thence.

12 And when ye come into an house, salute it.

13 And if the house be worthy, let your peace come upon it: but if it be not worthy, let your peace return to you.

14 And whosoever shall not receive you, nor hear your words, when ye depart out of that house or city, shake off the dust of your feet.

15 Verily I say unto you, It shall be more tolerable for the land of Sodom and Gomorrha in the day of judgment, than for that city.

16 Behold, I send you forth as sheep in the midst of wolves: be ye therefore wise as serpents, and harmless as doves.

THE RETURN OF THE SEVENTY

LUKE 10:17–20

17 And the seventy returned again with joy, saying, Lord, even the devils are subject unto us through thy name.

18 And he said unto them, I beheld Satan as lightning fall from heaven.

19 Behold, I give unto you power to tread on serpents and scorpions, and over all the power of the enemy: and nothing shall by any means hurt you.

20 Notwithstanding in this rejoice not, that the spirits are subject unto you; but rather rejoice, because your names are written in heaven.

JESUS THANKS THE FATHER

MATTHEW 11:25–27

25 At that time Jesus answered and said, I thank thee, O Father, Lord of heaven and earth, because thou hast hid these things from the wise and prudent, and hast revealed them unto babes.

26 Even so, Father: for so it seemed good in thy sight.

27 All things are delivered unto me of my Father: and no man knoweth the Son, but the Father; neither knoweth any man the Father, save the Son, and he to whomsoever the Son will reveal him.

LUKE 10:21–22

21 In that hour Jesus rejoiced in spirit, and said, I thank thee, O Father, Lord of heaven and earth, that thou hast hid these things from the wise and prudent, and hast revealed them unto babes: even so, Father; for so it seemed good in thy sight.

22 All things are delivered to me of my Father: and no man knoweth who the Son is, but the Father; and who the Father is, but the Son, and he to whom the Son will reveal him.

THE BLESSEDNESS OF THE DISCIPLES

MATTHEW 13:16–17

16 But blessed are your eyes, for they see: and your ears, for they hear.

17 For verily I say unto you, That many prophets and righteous men have desired to see those things which ye see, and have not seen them; and to hear those things which ye hear, and have not heard them.

And thou shalt love the Lord thy God with all thy heart, and with all thy soul, and with all thy mind, and with all thy strength: this is the first commandment.

And the second is like, namely this, Thou shalt love thy neighbour as thyself. There is none other commandment greater than these.

—MARK 12:30–31

23 And he turned him unto his disciples, and said privately, Blessed are the eyes which see the things that ye see:

24 For I tell you, that many prophets and kings have desired to see those things which ye see, and have not seen them; and to hear those things which ye hear, and have not heard them.

THE LAWYER ASKS: WHAT IS THE GREATEST COMMANDMENT?

Luke's focus now shifts from the disciples to Jesus' opponents, here the lawyers (experts on the Torah, the Law of God) who "tempted" (tested) Jesus with the question: "What shall I do to inherit eternal life?" (in Mark/Matthew: "What is the greatest commandment?") Jesus responds by quoting the Great Schema, Israel's confession of faith: "Hear, O Israel, the LORD your God, the LORD is one…" (Deuteronomy 6:40), then adding another from Leviticus 19:18: "You shall love your neighbor as yourself." As Luke's lawyer continues the repartee, asking "And who is my neighbor?" Jesus launches into one of several parables of contrast—colorful, masterful pictures of how one ought and ought not walk, if one would be "righteous." Note how the one who proves to be neighbor to the man who is robbed and left for dead is a Samaritan—Luke has already set the hook for the lawyer (and the reader).

MATTHEW 22:34–40

34 But when the Pharisees had heard that he had put the Sadducees to silence, they were gathered together.

35 Then one of them, which was a lawyer, asked him a question, tempting him, and saying,

36 Master, which is the great commandment in the law?

37 Jesus said unto him, Thou shalt love the Lord thy God with all thy heart, and with all thy soul, and with all thy mind.

38 This is the first and great commandment.

39 And the second is like unto it, Thou shalt love thy neighbour as thyself.

40 On these two commandments hang all the law and the prophets.

MARK 12:28–34

28 And one of the scribes came, and having heard them reasoning together, and perceiving that he had answered them well, asked him, Which is the first commandment of all?

29 And Jesus answered him, The first of all the commandments is, Hear, O Israel; The Lord our God is one Lord:

30 And thou shalt love the Lord thy God with all thy heart, and with all thy soul, and with all thy mind, and with all thy strength: this is the first commandment.

31 And the second is like, namely this, Thou shalt love thy neighbour as thyself. There is none other commandment greater than these.

32 And the scribe said unto him, Well, Master, thou hast said the truth: for there is one God; and there is none other but he:

Jesus and the Twelve Disciples, 1510, Artist Unknown

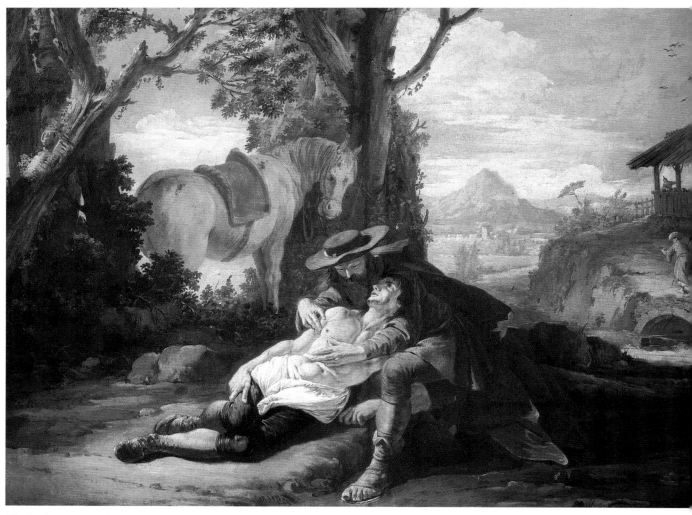

The Good Samaritan Helping Wounded Robbed Man, by Domenico Fontebasso, 1707–69

Now it came to pass,
as they went, that he
entered into a certain
village: and a certain
woman named
Martha received him
into her house.

—LUKE 10:38

33 And to love him with all the heart, and with all the understanding, and with all the soul, and with all the strength, and to love his neighbour as himself, is more than all whole burnt offerings and sacrifices.

34 And when Jesus saw that he answered discreetly, he said unto him, Thou art not far from the kingdom of God. And no man after that durst ask him any question.

LUKE 10:25–28

25 And, behold, a certain lawyer stood up, and tempted him, saying, Master, what shall I do to inherit eternal life?

26 He said unto him, What is written in the law? how readest thou?

27 And he answering said, Thou shalt love the Lord thy God with all thy heart, and with all thy soul, and with all thy strength, and with all thy mind; and thy neighbour as thyself.

28 And he said unto him, Thou hast answered right: this do, and thou shalt live.

THE PARABLE OF THE GOOD SAMARITAN

LUKE 10:29–37

29 But he, willing to justify himself, said unto Jesus, And who is my neighbour?

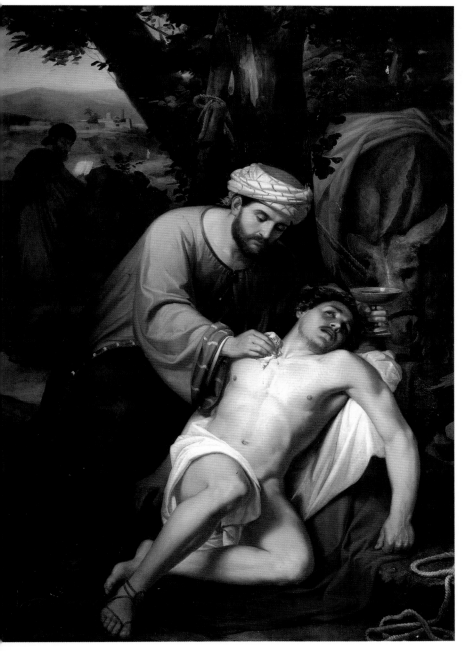

The Good Samaritan, 1857, by José Manchola

30 And Jesus answering said, A certain man went down from Jerusalem to Jericho, and fell among thieves, which stripped him of his raiment, and wounded him, and departed, leaving him half dead.

31 And by chance there came down a certain priest that way: and when he saw him, he passed by on the other side.

32 And likewise a Levite, when he was at the place, came and looked on him, and passed by on the other side.

33 But a certain Samaritan, as he journeyed, came where he was: and when he saw him, he had compassion on him,

34 And went to him, and bound up his wounds, pouring in oil and wine, and set him on his own beast, and brought him to an inn, and took care of him.

35 And on the morrow when he departed, he took out two pence, and gave them to the host, and said unto him, Take care of him; and whatsoever thou spendest more, when I come again, I will repay thee.

36 Which now of these three, thinkest thou, was neighbour unto him that fell among the thieves?

37 And he said, He that shewed mercy on him. Then said Jesus unto him, Go, and do thou likewise.

But a certain Samaritan, as he journeyed, came where he was: and when he saw him, he had compassion on him.

—LUKE 10:33

MARY AND MARTHA

LUKE 10:38–42

38 Now it came to pass, as they went, that he entered into a certain village: and a certain woman named Martha received him into her house.

39 And she had a sister called Mary, which also sat at Jesus' feet, and heard his word.

Jesus at the House of Martha and Mary, by Alexander Bida, 1813–1895

28 But he said, Yea rather, blessed are they that hear the word of God, and keep it.

AGAINST THE PHARISEES AND THE LAWYERS

MATTHEW 15:1–9

1 Then came to Jesus scribes and Pharisees, which were of Jerusalem, saying,

2 Why do thy disciples transgress the tradition of the elders? for they wash not their hands when they eat bread.

3 But he answered and said unto them, Why do ye also transgress the commandment of God by your tradition?

4 For God commanded, saying, Honour thy father and mother: and, He that curseth father or mother, let him die the death.

5 But ye say, Whosoever shall say to his father or his mother, It is a gift, by whatsoever thou mightest be profited by me;

6 And honour not his father or his mother, he shall be free. Thus have ye made the commandment of God of none effect by your tradition.

7 Ye hypocrites, well did Esaias prophesy of you, saying,

8 This people draweth nigh unto me with their mouth, and honoureth me with their lips; but their heart is far from me.

9 But in vain they do worship me, teaching for doctrines the commandments of men.

MARK 7:1–9

1 Then came together unto him the Pharisees, and certain of the scribes, which came from Jerusalem.

40 But Martha was cumbered about much serving, and came to him, and said, Lord, dost thou not care that my sister hath left me to serve alone? bid her therefore that she help me.

41 And Jesus answered and said unto her, Martha, Martha, thou art careful and troubled about many things:

42 But one thing is needful: and Mary hath chosen that good part, which shall not be taken away from her.

TRUE BLESSEDNESS: HEARING AND DOING THE WORD

LUKE 11:27–28

27 And it came to pass, as he spake these things, a certain woman of the company lifted up her voice, and said unto him, Blessed is the womb that bare thee, and the paps which thou hast sucked.

2 And when they saw some of his disciples eat bread with defiled, that is to say, with unwashen, hands, they found fault.

3 For the Pharisees, and all the Jews, except they wash their hands oft, eat not, holding the tradition of the elders.

4 And when they come from the market, except they wash, they eat not. And many other things there be, which they have received to hold, as the washing of cups, and pots, brasen vessels, and of tables.

5 Then the Pharisees and scribes asked him, Why walk not thy disciples according to the tradition of the elders, but eat bread with unwashen hands?

6 He answered and said unto them, Well hath Esaias prophesied of you hypocrites, as it is written, This people honoureth me with their lips, but their heart is far from me.

7 Howbeit in vain do they worship me, teaching for doctrines the commandments of men.

8 For laying aside the commandment of God, ye hold the tradition of men, as the washing of pots and cups: and many other such like things ye do.

9 And he said unto them, Full well ye reject the commandment of God, that ye may keep your own tradition.

LUKE 11:37–54

37 And as he spake, a certain Pharisee besought him to dine with him: and he went in, and sat down to meat.

38 And when the Pharisee saw it, he marvelled that he had not first washed before dinner.

39 And the Lord said unto him, Now do ye Pharisees make clean the outside of the cup and the platter; but your inward part is full of ravening and wickedness.

40 Ye fools, did not he that made that which is without make that which is within also?

41 But rather give alms of such things as ye have; and, behold, all things are clean unto you.

42 But woe unto you, Pharisees! for ye tithe mint and rue and all manner of herbs, and pass over judgment and the love of God: these ought ye to have done, and not to leave the other undone.

43 Woe unto you, Pharisees! for ye love the uppermost seats in the synagogues, and greetings in the markets.

44 Woe unto you, scribes and Pharisees, hypocrites! for ye are as graves which appear not, and the men that walk over them are not aware of them.

45 Then answered one of the lawyers, and said unto him, Master, thus saying thou reproachest us also.

46 And he said, Woe unto you also, ye lawyers! for ye lade men with burdens grievous to be borne, and ye yourselves touch not the burdens with one of your fingers.

47 Woe unto you! for ye build the sepulchres of the prophets, and your fathers killed them.

48 Truly ye bear witness that ye allow the deeds of your fathers: for they indeed killed them, and ye build their sepulchres.

49 Therefore also said the wisdom of God, I will send them prophets and apostles, and some of them they shall slay and persecute:

50 That the blood of all the prophets, which was shed from the foundation of the world, may be required of this generation;

51 From the blood of Abel unto the blood of Zacharias, which perished between the altar and the temple: verily I say unto you, It shall be required of this generation.

52 Woe unto you, lawyers! for ye have taken away the key of knowledge: ye entered not in yourselves, and them that were entering in ye hindered.

53 And as he said these things unto them, the scribes and the Pharisees began to urge him vehemently, and to provoke him to speak of many things:

54 Laying wait for him, and seeking to catch something out of his mouth, that they might accuse him.

LUKE 16:14–15

14 And the Pharisees also, who were covetous, heard all these things: and they derided him.

15 And he said unto them, Ye are they which justify yourselves before men; but God knoweth your hearts: for that which is highly esteemed among men is abomination in the sight of God.

THE PARABLE OF THE RICH FOOL

Luke's Jesus now turns to the crowd, from which comes the request that Jesus settle a dispute between brothers about an inheritance. Jesus responds with one of several parables about the dangers of greed, wealth, position, and where such misplaced attention can lead. These parables graphically, and memorably punctuate the points Jesus makes in the teaching sections— about the many pitfalls on the road to righteousness.

LUKE 12:13–21

13 And one of the company said unto him, Master, speak to my brother, that he divide the inheritance with me.

14 And he said unto him, Man, who made me a judge or a divider over you?

Take ye heed, watch and pray: for ye know not when the time is.

For the Son of man is as a man taking a far journey, who left his house, and gave authority to his servants, and to every man his work, and commanded the porter to watch.

—MARK 13:33–34

15 And he said unto them, Take heed, and beware of covetousness: for a man's life consisteth not in the abundance of the things which he possesseth.

16 And he spake a parable unto them, saying, The ground of a certain rich man brought forth plentifully:

17 And he thought within himself, saying, What shall I do, because I have no room where to bestow my fruits?

18 And he said, This will I do: I will pull down my barns, and build greater; and there will I bestow all my fruits and my goods.

19 And I will say to my soul, Soul, thou hast much goods laid up for many years; take thine ease, eat, drink, and be merry.

20 But God said unto him, Thou fool, this night thy soul shall be required of thee: then whose shall those things be, which thou hast provided?

21 So is he that layeth up treasure for himself, and is not rich toward God.

ON BEING WATCHFUL AND FAITHFUL

MATTHEW 24:42–51

42 Watch therefore: for ye know not what hour your Lord doth come.

43 But know this, that if the goodman of the house had known in what watch the thief would come, he would have watched, and would not have suffered his house to be broken up.

44 Therefore be ye also ready: for in such an hour as ye think not the Son of man cometh.

45 Who then is a faithful and wise servant, whom his lord hath made ruler over his household, to give them meat in due season?

46 Blessed is that servant, whom his lord when he cometh shall find so doing.

47 Verily I say unto you, That he shall make him ruler over all his goods.

48 But and if that evil servant shall say in his heart, My lord delayeth his coming;

49 And shall begin to smite his fellow servants, and to eat and drink with the drunken;

50 The lord of that servant shall come in a day when he looketh not for him, and in an hour that he is not aware of,

51 And shall cut him asunder, and appoint him his portion with the hypocrites: there shall be weeping and gnashing of teeth.

MARK 13:33–37

33 Take ye heed, watch and pray: for ye know not when the time is.

34 For the Son of man is as a man taking a far journey, who left his house, and gave authority to his servants, and to every man his work, and commanded the porter to watch.

35 Watch ye therefore: for ye know not when the master of the house cometh, at even, or at midnight, or at the cockcrowing, or in the morning:

36 Lest coming suddenly he find you sleeping.

37 And what I say unto you I say unto all, Watch.

LUKE 12:35–48

35 Let your loins be girded about, and your lights burning;

36 And ye yourselves like unto men that wait for their lord, when he will return from the wedding; that when he cometh and knocketh, they may open unto him immediately.

37 Blessed are those servants, whom the lord when he cometh shall find watching: verily I say unto you, that he shall gird himself, and make them to sit down to meat, and will come forth and serve them.

38 And if he shall come in the second watch, or come in the third watch, and find them so, blessed are those servants.

39 And this know, that if the goodman of the house had known what hour the thief would come, he would have watched, and not have suffered his house to be broken through.

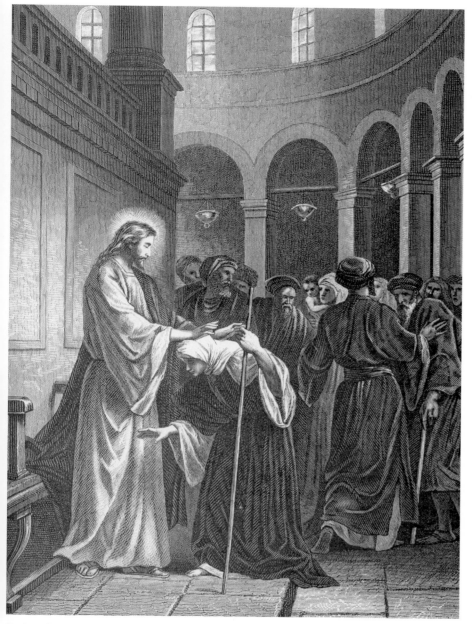

Healing of an Aged Woman, by Alexander Bida, 1813–1895

46 The lord of that servant will come in a day when he looketh not for him, and at an hour when he is not aware, and will cut him in sunder, and will appoint him his portion with the unbelievers.

47 And that servant, which knew his lord's will, and prepared not himself, neither did according to his will, shall be beaten with many stripes.

48 But he that knew not, and did commit things worthy of stripes, shall be beaten with few stripes. For unto whomsoever much is given, of him shall be much required: and to whom men have committed much, of him they will ask the more.

JESUS HEALS A CRIPPLED WOMAN ON THE SABBATH

In this account and the one below about the man with dropsy, Jesus again raises the issue of healing on the Sabbath. Is it "work"—doing what is forbidden on God's day of rest? Or is it "worship"—glorifying God by calling on His name to restore wholeness to body and spirit? Here as elsewhere, Luke tells of twin healings, one of a woman, the other of a man, to illustrate the equality, the inclusiveness that is characteristic of the Kingdom of God.

LUKE 13:10–17

10 And he was teaching in one of the synagogues on the sabbath.

11 And, behold, there was a woman which had a spirit of infirmity eighteen years, and was bowed together, and could in no wise lift up herself.

12 And when Jesus saw her, he called her to him, and said unto her, Woman, thou art loosed from thine infirmity.

13 And he laid his hands on her and immediately she was made straight, and glorified God.

40 Be ye therefore ready also: for the Son of man cometh at an hour when ye think not.

41 Then Peter said unto him, Lord, speakest thou this parable unto us, or even to all?

42 And the Lord said, Who then is that faithful and wise steward, whom his lord shall make ruler over his household, to give them their portion of meat in due season?

43 Blessed is that servant, whom his lord when he cometh shall find so doing.

44 Of a truth I say unto you, that he will make him ruler over all that he hath.

45 But and if that servant say in his heart, My lord delayeth his coming; and shall begin to beat the menservants and maidens, and to eat and drink, and to be drunken;

14 And the ruler of the synagogue answered with indignation, because that Jesus had healed on the sabbath day, and said unto the people, There are six days in which men ought to work: in them therefore come and be healed, and not on the sabbath day.

15 The Lord then answered him, and said, Thou hypocrite, doth not each one of you on the sabbath loose his ox or his ass from the stall, and lead him away to watering?

16 And ought not this woman, being a daughter of Abraham, whom Satan hath bound, lo, these eighteen years, be loosed from this bond on the sabbath day?

17 And when he had said these things, all his adversaries were ashamed: and all the people rejoiced for all the glorious things that were done by him.

WARNINGS AND LAMENTS

MATTHEW 23:37–39

37 O Jerusalem, Jerusalem, thou that killest the prophets, and stonest them which are sent unto thee, how often would I have gathered thy children together, even as a hen gathereth her chickens under her wings, and ye would not!

38 Behold, your house is left unto you desolate.

39 For I say unto you, Ye shall not see me henceforth, till ye shall say, Blessed is he that cometh in the name of the Lord.

LUKE 13:31–35

31 The same day there came certain of the Pharisees, saying unto him, Get thee out, and depart hence: for Herod will kill thee.

32 And he said unto them, Go ye, and tell that fox, Behold, I cast out devils, and I do cures to day and to morrow, and the third day I shall be perfected.

33 Nevertheless I must walk to day, and to morrow, and the day following: for it cannot be that a prophet perish out of Jerusalem.

34 O Jerusalem, Jerusalem, which killest the prophets, and stonest them that are sent unto thee; how often would I have gathered thy children together, as a hen doth gather her brood under her wings, and ye would not!

35 Behold, your house is left unto you desolate: and verily I say unto you, Ye shall not see me, until the time come when ye shall say, Blessed is he that cometh in the name of the Lord.

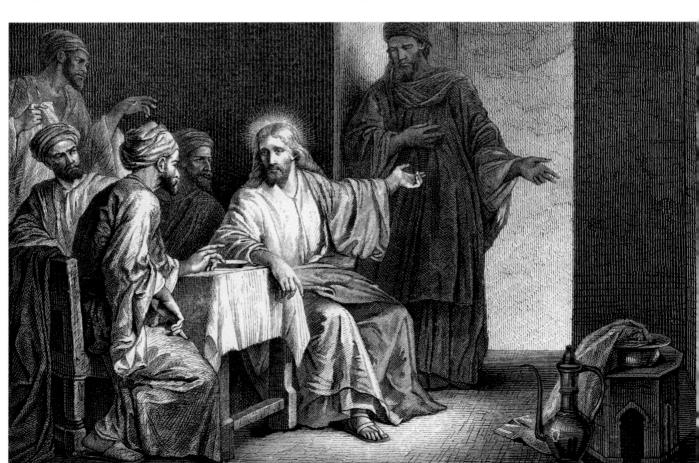

Healing of the Man with the Dropsy, by Alexander Bida, 1813–1895

JESUS HEALS A MAN WITH DROPSY

LUKE 14:1–6

1 And it came to pass, as he went into the house of one of the chief Pharisees to eat bread on the sabbath day, that they watched him.

2 And, behold, there was a certain man before him which had the dropsy.

3 And Jesus answering spake unto the lawyers and Pharisees, saying, Is it lawful to heal on the sabbath day?

4 And they held their peace. And he took him, and healed him, and let him go;

5 And answered them, saying, Which of you shall have an ass or an ox fallen into a pit, and will not straightway pull him out on the sabbath day?

6 And they could not answer him again to these things.

ON CHOOSING PLACES AT THE TABLE

This parable illustrates Luke's concern for the poor, the disabled, the blind, the lame—those on the bottom of society—making the same point as do the Beatitudes and Woes above. The message is simple: those who are concerned about being on top will wind up on the bottom, while those on the bottom will get to "come up higher." This is the "great reversal" of Mary, one of those "poor ones" who wait for the Lord, confident that, as Mary sings in the Magnificat, God's mercy will eventually be revealed. Indeed it does, turning the world right side up—"filling the hungry with good things" and "sending the rich empty away."

LUKE 14:7–14

7 And he put forth a parable to those which were bidden, when he

And Jesus answering spake unto the lawyers and Pharisees, saying, Is it lawful to heal on the sabbath day?

And they held their peace. And he took him, and healed him, and let him go.

—LUKE 14:3–4

marked how they chose out the chief rooms; saying unto them,

8 When thou art bidden of any man to a wedding, sit not down in the highest room; lest a more honourable man than thou be bidden of him;

9 And he that bade thee and him come and say to thee, Give this man place; and thou begin with shame to take the lowest room.

10 But when thou art bidden, go and sit down in the lowest room; that when he that bade thee cometh, he may say unto thee, Friend, go up higher: then shalt thou have worship in the presence of them that sit at meat with thee.

11 For whosoever exalteth himself shall be abased; and he that humbleth himself shall be exalted.

12 Then said he also to him that bade him, When thou makest a dinner or a supper, call not thy friends, nor thy brethren, neither thy kinsmen, nor thy rich neighbours; lest they also bid thee again, and a recompence be made thee.

13 But when thou makest a feast, call the poor, the maimed, the lame, the blind:

14 And thou shalt be blessed; for they cannot recompense thee: for thou shalt be recompensed at the resurrection of the just.

THREE PARABLES: SEARCHING, FINDING, AND REJOICING

Luke's Jesus now turns once again to his opponents who object to Jesus' keeping company with "sinners." He responds to them with three parables about the rejoicing that goes on in heaven over every sinner who returns home. The first two feature a man, who finds his lost sheep, and a woman, who finds her lost coin. Both celebrate their joy lavishly with friends and neighbors. Jesus leads up to the most wondrous of his contrasts: the difference between the self-centered, misplaced concerns of human hearts, and the almost foolishly compassionate heart of God! A man had two sons. He loved them both with all his heart. One of them leaves home with half his father's estate and comes back with nothing, to discover the place that is still waiting for him at the father's table—and, still more surprising, in his father's heart. Enter the older brother, whom the father also loves

with all his heart. He seems to be more concerned about his share of the father's inheritance than about his place in his father's heart. Does the older brother's heart melt? Will he take his place at the feast... in his father's heart? Jesus doesn't answer. He's waiting for his listeners' response.

And he said unto him, Son, thou art ever with me, and all that I have is thine.

It was meet that we should make merry, and be glad: for this thy brother was dead, and is alive again; and was lost, and is found.

—LUKE 15:31–32

THE LOST SHEEP

LUKE 15:1–7

1 Then drew near unto him all the publicans and sinners for to hear him.

2 And the Pharisees and scribes murmured, saying, This man receiveth sinners, and eateth with them.

3 And he spake this parable unto them, saying,

4 What man of you, having an hundred sheep, if he lose one of them, doth not leave the ninety and nine in the wilderness, and go after that which is lost, until he find it?

5 And when he hath found it, he layeth it on his shoulders, rejoicing.

6 And when he cometh home, he calleth together his friends and neighbours, saying unto them, Rejoice with me; for I have found my sheep which was lost.

7 I say unto you, that likewise joy shall be in heaven over one sinner that repenteth, more than over ninety and nine just persons, which need no repentance.

ABOUT A LOST COIN

LUKE 15:8–10

8 Either what woman having ten pieces of silver, if she lose one piece, doth not light a candle, and sweep the house, and seek diligently till she find it?

9 And when she hath found it, she calleth her friends and her neighbours together, saying, Rejoice with me; for I have found the piece which I had lost.

10 Likewise, I say unto you, there is joy in the presence of the angels of God over one sinner that repenteth.

ABOUT A LOST SON

LUKE 15:11–32

11 And he said, A certain man had two sons:

12 And the younger of them said to his father, Father, give me the portion of goods that falleth to me. And he divided unto them his living.

13 And not many days after the younger son gathered all together, and took his journey into a far country, and there wasted his substance with riotous living.

14 And when he had spent all, there arose a mighty famine in that land; and he began to be in want.

15 And he went and joined himself to a citizen of that country; and he sent him into his fields to feed swine.

16 And he would fain have filled his belly with the husks that the swine did eat: and no man gave unto him.

Silver Penny: Time of Caesar, ARTIST UNKNOWN

17 And when he came to himself, he said, How many hired servants of my father's have bread enough and to spare, and I perish with hunger!

18 I will arise and go to my father, and will say unto him, Father, I have sinned against heaven, and before thee,

19 And am no more worthy to be called thy son: make me as one of thy hired servants.

20 And he arose, and came to his father. But when he was yet a great way off, his father saw him, and had compassion, and ran, and fell on his neck, and kissed him.

21 And the son said unto him, Father, I have sinned against heaven, and in thy sight, and am no more worthy to be called thy son.

22 But the father said to his servants, Bring forth the best robe, and put it on him; and put a ring on his hand, and shoes on his feet:

23 And bring hither the fatted calf, and kill it; and let us eat, and be merry:

24 For this my son was dead, and is alive again; he was lost, and is found. And they began to be merry.

25 Now his elder son was in the field: and as he came and drew nigh to the house, he heard musick and dancing.

26 And he called one of the servants, and asked what these things meant.

27 And he said unto him, Thy brother is come; and thy father hath killed the fatted calf, because he hath received him safe and sound.

28 And he was angry, and would not go in: therefore came his father out, and intreated him.

29 And he answering said to his father, Lo, these many years do I serve thee, neither transgressed I at any time thy commandment: and yet thou never gavest me a kid, that I might make merry with my friends:

30 But as soon as this thy son was come, which hath devoured thy living with harlots, thou hast killed for him the fatted calf.

31 And he said unto him, Son, thou art ever with me, and all that I have is thine.

32 It was meet that we should make merry, and be glad: for this thy brother was dead, and is alive again; and was lost, and is found.

A PARABLE ABOUT A DISHONEST MANAGER

Jesus turns again to his disciples, and it is to them that he tells this parable. If the children of this world can make shrewd use of wealth ("the Mammon of unrighteousness") to secure their future positions, how much more ought the children of light to "make friends" by means of it, so that when it fails—as one day it will—they will be received "into everlasting habitations?" Who might those "friends" be? Perhaps the ones on the bottom now, the poor, the maimed, the lame, and the blind, the same ones who are not able to invite you back to their dinner parties. "Mammon" probably comes from the Hebrew word for trust, mammon being "that in which one puts one 's trust."

LUKE 16:1–9

1 And he said also unto his disciples, There was a certain rich man, which had a steward; and the same was accused unto him that he had wasted his goods.

2 And he called him, and said unto him, How is it that I hear this of thee? give an account of thy stewardship; for thou mayest be no longer steward.

3 Then the steward said within himself, What shall I do? for my lord taketh away from me the stewardship: I cannot dig; to beg I am ashamed.

4 I am resolved what to do, that, when I am put out of the stewardship, they may receive me into their houses.

5 So he called every one of his lord's debtors unto him, and said unto the first, How much owest thou unto my lord?

6 And he said, An hundred measures of oil. And he said unto him, Take thy bill, and sit down quickly, and write fifty.

7 Then said he to another, And how much owest thou? And he said, An hundred measures of wheat. And he said unto him, Take thy bill, and write fourscore.

8 And the lord commended the unjust steward, because he had done wisely: for the children of this world are in their generation wiser than the children of light.

9 And I say unto you, Make to yourselves friends of the mammon of unrighteousness; that, when ye fail, they may receive you into everlasting habitations.

ABOUT FAITHFULNESS IN LITTLE THINGS

LUKE 16:10–12

10 He that is faithful in that which is least is faithful also in much: and he that is unjust in the least is unjust also in much.

11 If therefore ye have not been faithful in the unrighteous mammon, who will commit to your trust the true riches?

12 And if ye have not been faithful in that which is another man's, who shall give you that which is your own?

ABOUT DIVORCE

MATTHEW 19:9

9 And I say unto you, Whosoever shall put away his wife, except it be for fornication, and shall marry another, committeth adultery: and whoso marrieth her which is put away doth commit adultery.

MARK 10:11–12

11 And he saith unto them, Whosoever shall put away his wife, and marry another, committeth adultery against her.

12 And if a woman shall put away her husband, and be married to another, she committeth adultery.

LUKE 16:18

18 Whosoever putteth away his wife, and marrieth another, committeth adultery: and whosoever marrieth her that is put away from her husband committeth adultery.

A PARABLE ABOUT A RICH MAN AND POOR LAZARUS

This parable is an ironic masterpiece about the twisted values of the wealthy, whose possessions block their view of those "poor ones" who trust God, and whom God loves and blesses. The parable is a vivid portrayal of Jesus' first beatitude and woe in his Sermon on the Plain (Luke 6:20, 24): "Blessed be ye poor: for yours is the kingdom of God… But woe unto you that are rich! For ye have received your consolation." The parable quickly cuts from Lazarus' misery at the rich man's gate to his "consolation," in Abraham's bosom. The rich man, who, in death, now experiences "the great reversal" in the torment of Hades, sees Lazarus (who seemed to have escaped his notice in life) and calls his Father Abraham across the great chasm: "Send Lazarus" to bring him a drop of refreshment amid the flames. Apparently the nameless rich man knows the poor man's name. Its Hebrew version means "my God helps." But, alas, Abraham and Lazarus cannot help him now. And the rich man, at last caring about others, asks for him to be sent to his brothers, to warn them of the coming torment. The irony reaches its zenith as Abraham responds: "If they hear not Moses and the prophets, neither will they be persuaded, though one rose from the dead." For Jesus (and Luke) the moral, hidden between the lines, is righteousness. The Biblical word for it has a double meaning: "doing what is right" and "giving to the needy." The parables and teachings that follow explore many sides of righteousness: divine and human, grace and gratitude, present and future, past and future. For Luke (and for the reader), they will all come together in Jerusalem.

LUKE 16:19–31

19 There was a certain rich man, which was clothed in purple and fine linen, and fared sumptuously every day:

Dives and Lazarus, by Alexander Bida, 1813–1895

20 And there was a certain beggar named Lazarus, which was laid at his gate, full of sores,

21 And desiring to be fed with the crumbs which fell from the rich man's table: moreover the dogs came and licked his sores.

22 And it came to pass, that the beggar died, and was carried by the angels into Abraham's bosom: the rich man also died, and was buried;

23 And in hell he lift up his eyes, being in torments, and seeth Abraham afar off, and Lazarus in his bosom.

24 And he cried and said, Father Abraham, have mercy on me, and send Lazarus, that he may dip the tip of his finger in water, and cool my tongue; for I am tormented in this flame.

25 But Abraham said, Son, remember that thou in thy lifetime receivedst thy good things, and likewise Lazarus evil things: but now he is comforted, and thou art tormented.

26 And beside all this, between us and you there is a great gulf fixed: so that they which would pass from hence to you cannot; neither can they pass to us, that would come from thence.

For as the lightning cometh out of the east, and shineth even unto the west; so shall also the coming of the Son of man be.

—MATTHEW 24:27

27 Then he said, I pray thee therefore, father, that thou wouldest send him to my father's house:

28 For I have five brethren; that he may testify unto them, lest they also come into this place of torment.

29 Abraham saith unto him, They have Moses and the prophets; let them hear them.

30 And he said, Nay, father Abraham: but if one went unto them from the dead, they will repent.

31 And he said unto him, If they hear not Moses and the prophets, neither will they be persuaded, though one rose from the dead.

ON FAITH

MATTHEW 17:19–21

19 Then came the disciples to Jesus apart, and said, Why could not we cast him out?

20 And Jesus said unto them, Because of your unbelief: for verily I say unto you, If ye have faith as a grain of mustard seed, ye shall say unto this mountain, Remove hence to yonder place; and it shall remove; and nothing shall be impossible unto you.

21 Howbeit this kind goeth not out but by prayer and fasting.

MARK 9:28–29

28 And when he was come into the house, his disciples asked him privately, Why could not we cast him out?

29 And he said unto them, This kind can come forth by nothing, but by prayer and fasting.

LUKE 17:5–6

5 And the apostles said unto the Lord, Increase our faith.

6 And the Lord said, If ye had faith as

a grain of mustard seed, ye might say unto this sycamine tree, Be thou plucked up by the root, and be thou planted in the sea; and it should obey you.

WE ARE ONLY UNWORTHY SERVANTS

LUKE 17:7–10

7 But which of you, having a servant plowing or feeding cattle, will say unto him by and by, when he is come from the field, Go and sit down to meat?

8 And will not rather say unto him, Make ready wherewith I may sup, and gird thyself, and serve me, till I have eaten and drunken; and afterward thou shalt eat and drink?

9 Doth he thank that servant because he did the things that were commanded him? I trow not.

10 So likewise ye, when ye shall have done all those things which are commanded you, say, We are unprofitable servants: we have done that which was our duty to do.

JESUS HEALS TEN MEN OF LEPROSY

LUKE 17:11–19

11 And it came to pass, as he went to Jerusalem, that he passed through the midst of Samaria and Galilee.

12 And as he entered into a certain village, there met him ten men that were lepers, which stood afar off:

13 And they lifted up their voices, and said, Jesus, Master, have mercy on us.

14 And when he saw them, he said unto them, Go shew yourselves unto the priests. And it came to pass, that, as they went, they were cleansed.

15 And one of them, when he saw that he was healed, turned back, and with a loud voice glorified God,

16 And fell down on his face at his feet, giving him thanks: and he was a Samaritan.

17 And Jesus answering said, Were there not ten cleansed? but where are the nine?

18 There are not found that returned to give glory to God, save this stranger.

19 And he said unto him, Arise, go thy way: thy faith hath made thee whole.

ON THE KINGDOM OF GOD

LUKE 17:20–21

20 And when he was demanded of the Pharisees, when the kingdom of God should come, he answered them and said, The kingdom of God cometh not with observation:

21 Neither shall they say, Lo here! or, lo there! for, behold, the kingdom of God is within you.

ON THE COMING OF THE SON OF MAN

MATTHEW 24:26–28

26 Wherefore if they shall say unto you, Behold, he is in the desert; go not forth: behold, he is in the secret chambers; believe it not.

27 For as the lightning cometh out of the east, and shineth even unto the west; so shall also the coming of the Son of man be.

28 For wheresoever the carcase is, there will the eagles be gathered together.

LUKE 17:22–37

22 And he said unto the disciples, The days will come, when ye shall desire to see one of the days of the Son of man, and ye shall not see it.

23 And they shall say to you, See here; or, see there: go not after them, nor follow them.

24 For as the lightning, that lighteneth out of the one part under heaven, shineth unto the other part under heaven; so shall also the Son of man be in his day.

25 But first must he suffer many things, and be rejected of this generation.

26 And as it was in the days of Noe, so shall it be also in the days of the Son of man.

27 They did eat, they drank, they married wives, they were given in marriage, until the day that Noe entered into the ark, and the flood came, and destroyed them all.

28 Likewise also as it was in the days of Lot; they did eat, they drank, they bought, they sold, they planted, they builded;

29 But the same day that Lot went out of Sodom it rained fire and brimstone from heaven, and destroyed them all.

30 Even thus shall it be in the day when the Son of man is revealed.

31 In that day, he which shall be upon the housetop, and his stuff in the house, let him not come down to take it away: and he that is in the field, let him likewise not return back.

32 Remember Lot's wife.

33 Whosoever shall seek to save his life shall lose it; and whosoever shall lose his life shall preserve it.

34 I tell you, in that night there shall be two men in one bed; the one shall be taken, and the other shall be left.

35 Two women shall be grinding together; the one shall be taken, and the other left.

36 Two men shall be in the field; the one shall be taken, and the other left.

37 And they answered and said unto him, Where, Lord? And he said unto them, Wheresoever the body is, thither will the eagles be gathered together.

MATTHEW 24:37–41

37 But as the days of Noe were, so shall also the coming of the Son of man be.

38 For as in the days that were before the flood they were eating and drinking, marrying and giving in marriage, until the day that Noe entered into the ark,

39 And knew not until the flood came, and took them all away; so shall also the coming of the Son of man be.

40 Then shall two be in the field; the one shall be taken, and the other left.

41 Two women shall be grinding at the mill; the one shall be taken, and the other left.

MATTHEW 10:39

39 He that findeth his life shall lose it: and he that loseth his life for my sake shall find it.

MATTHEW 24:40

40 Then shall two be in the field; the one shall be taken, and the other left.

MATTHEW 24:28

28 For wheresoever the carcase is, there will the eagles be gathered together.

A PARABLE ABOUT AND UNJUST JUDGE AND AN UNRELENTING WIDOW

LUKE 18:1–8

1 And he spake a parable unto them to this end, that men ought always to pray, and not to faint;

2 Saying, There was in a city a judge, which feared not God, neither regarded man:

3 And there was a widow in that city; and she came unto him, saying, Avenge me of mine adversary.

4 And he would not for a while: but afterward he said within himself, Though I fear not God, nor regard man;

5 Yet because this widow troubleth me, I will avenge her, lest by her continual coming she weary me.

6 And the Lord said, Hear what the unjust judge saith.

7 And shall not God avenge his own elect, which cry day and night unto him, though he bear long with them?

8 I tell you that he will avenge them speedily. Nevertheless when the Son of man cometh, shall he find faith on the earth?

A PARABLE ABOUT A PHARISEE AND A TAX COLLECTOR

LUKE 18:9–14

9 And he spake this parable unto certain which trusted in themselves that they were righteous, and despised others:

10 Two men went up into the temple to pray; the one a Pharisee, and the other a publican.

Saint Radegund Curing Demolenus, a Tax Collector, in His Dreams, 11th century, Artist Unknown

11 The Pharisee stood and prayed thus with himself, God, I thank thee, that I am not as other men are, extortioners, unjust, adulterers, or even as this publican.

12 I fast twice in the week, I give tithes of all that I possess.

13 And the publican, standing afar off, would not lift up so much as his eyes unto heaven, but smote upon his breast, saying, God be merciful to me a sinner.

14 I tell you, this man went down to his house justified rather than the other: for every one that exalteth himself shall be abased; and he that humbleth himself shall be exalted.

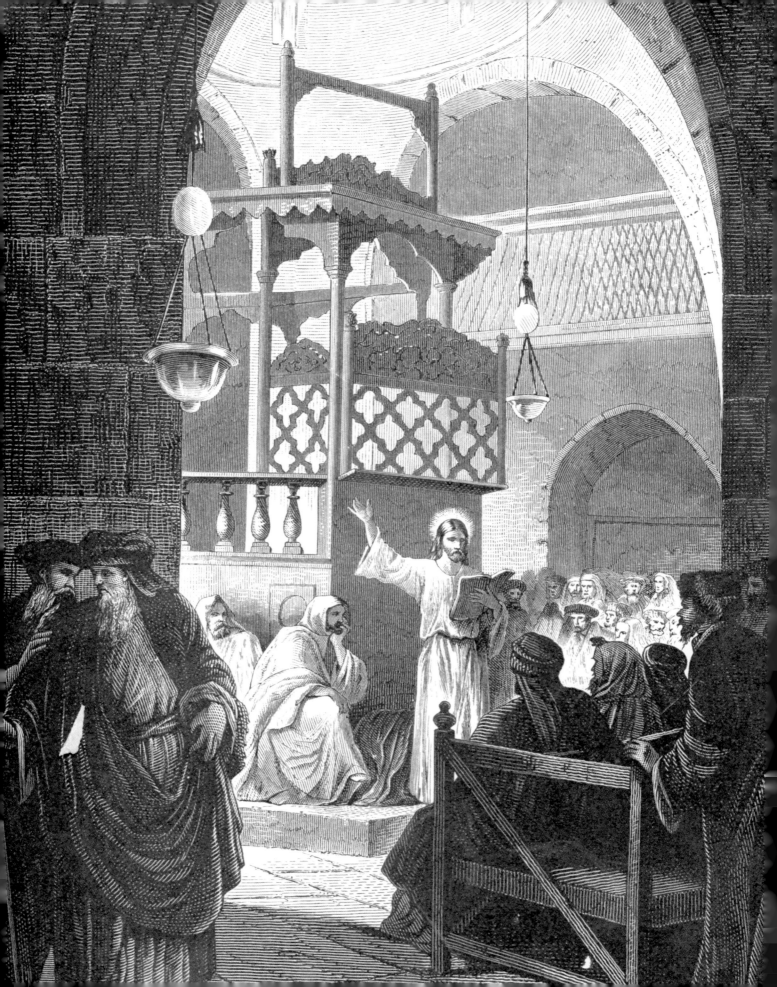

Jesus Visits Jerusalem

Jesus Visits Jerusalem

View of Jerusalem from Valley of Jehoshaphat, 1825, by Count Auguste de Forbin, 1777–1841

FOR THE THIRD TIME IN JOHN'S STORY, Jesus visits Jerusalem to celebrate Sukkoth (Tabernacles), a feast that each fall remembers and relives Israel's journey through the desert. The name *Sukkah* comes from the temporary shelters in which the celebrants eat their meals during its eight days. The feast recalls God's daily providence (the water from the rock, the pillar of cloud, and the fire that led them) and praying for the rain that will bring future harvests. These twin themes of water and light provide the backdrop for Jesus' teaching. John's Jesus says "I am the light of the world" and speaks of the "rivers of living water" (the Spirit) that will flow forth from him when he is "glorified."

JESUS DECIDES TO GO SECRETLY TO THE FEAST

JOHN 7:1–13

1 After these things Jesus walked in Galilee: for he would not walk in Jewry, because the Jews sought to kill him.

2 Now the Jews' feast of tabernacles was at hand.

3 His brethren therefore said unto him, Depart hence, and go into Judaea, that thy disciples also may see the works that thou doest.

4 For there is no man that doeth any thing in secret, and he himself seeketh to be known openly. If thou do these things, shew thyself to the world.

5 For neither did his brethren believe in him.

6 Then Jesus said unto them, My time is not yet come but your time is always ready.

7 The world cannot hate you; but me it hateth, because I testify of it, that the works thereof are evil.

8 Go ye up unto this feast: I go not up yet unto this feast; for my time is not yet full come.

9 When he had said these words unto them, he abode still in Galilee.

10 But when his brethren were gone up, then went he also up unto the feast, not openly, but as it were in secret.

11 Then the Jews sought him at the feast, and said, Where is he?

12 And there was much murmuring among the people concerning him: for some said, He is a good man: others said, Nay; but he deceiveth the people.

13 Howbeit no man spake openly of him for fear of the Jews.

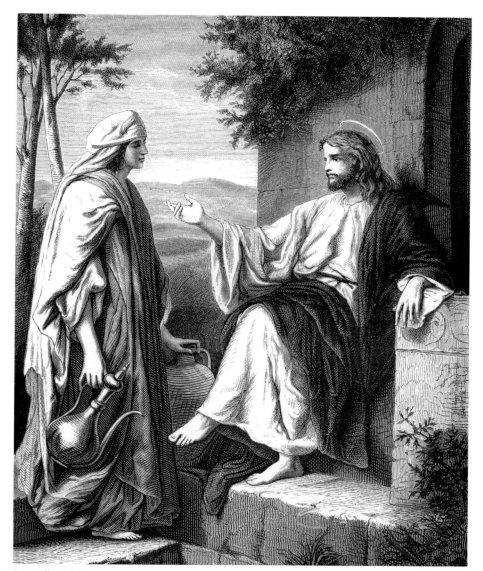

Jesus Talks with the Samaritan Woman, by Alexander Bida, 1813-1895

In the last day, that great day of the feast, Jesus stood and cried, saying, If any man thirst, let him come unto me, and drink.

He that believeth on me, as the scripture hath said, out of his belly shall flow rivers of living water.

—JOHN 7:37–38

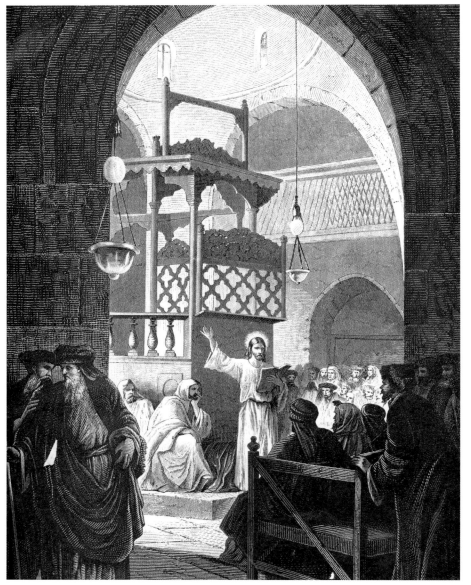

Jesus Preaching in the Synagogue, by Alexander Bida, 1813-1895

JESUS TEACHES IN THE TEMPLE

JOHN 7:14–39

14 Now about the midst of the feast Jesus went up into the temple, and taught.

15 And the Jews marvelled, saying, How knoweth this man letters, having never learned?

16 Jesus answered them, and said, My doctrine is not mine, but his that sent me.

17 If any man will do his will, he shall know of the doctrine, whether it be of God, or whether I speak of myself.

18 He that speaketh of himself seeketh his own glory: but he that seeketh his glory that sent him, the same is true, and no unrighteousness is in him.

19 Did not Moses give you the law, and yet none of you keepeth the law? Why go ye about to kill me?

20 The people answered and said, Thou hast a devil: who goeth about to kill thee?

21 Jesus answered and said unto them, I have done one work, and ye all marvel.

22 Moses therefore gave unto you circumcision; (not because it is of Moses, but of the fathers;) and ye on the sabbath day circumcise a man.

23 If a man on the sabbath day receive circumcision, that the law of Moses should not be broken; are ye angry at me, because I have made a man every whit whole on the sabbath day?

24 Judge not according to the appearance, but judge righteous judgment.

25 Then said some of them of Jerusalem, Is not this he, whom they seek to kill?

26 But, lo, he speaketh boldly, and they say nothing unto him. Do the rulers know indeed that this is the very Christ?

27 Howbeit we know this man whence he is: but when Christ cometh, no man knoweth whence he is.

28 Then cried Jesus in the temple as he taught, saying, Ye both know me, and ye know whence I am: and I am not come of myself, but he that sent me is true, whom ye know not.

29 But I know him: for I am from him, and he hath sent me.

30 Then they sought to take him: but no man laid hands on him, because his hour was not yet come.

31 And many of the people believed on him, and said, When Christ cometh, will he do more miracles than these which this man hath done?

32 The Pharisees heard that the people murmured such things concerning him; and the Pharisees and the chief priests sent officers to take him.

33 Then said Jesus unto them, Yet a little while am I with you, and then I go unto him that sent me.

34 Ye shall seek me, and shall not find me: and where I am, thither ye cannot come.

35 Then said the Jews among themselves, Whither will he go, that we shall not find him? will he go unto the dispersed among the Gentiles, and teach the Gentiles?

36 What manner of saying is this that he said, Ye shall seek me, and shall not find me: and where I am, thither ye cannot come?

37 In the last day, that great day of the feast, Jesus stood and cried, saying, If any man thirst, let him come unto me, and drink.

38 He that believeth on me, as the scripture hath said, out of his belly shall flow rivers of living water.

39 (But this spake he of the Spirit, which they that believe on him should receive: for the Holy Ghost was not yet given; because that Jesus was not yet glorified.)

And they which heard it, being convicted by their own conscience, went out one by one, beginning at the eldest, even unto the last: and Jesus was left alone, and the woman standing in the midst.

—JOHN 8:9

JESUS' TEACHING CAUSES DIVISION AMONG THE PEOPLE

JOHN 7:40–52

40 Many of the people therefore, when they heard this saying, said, Of a truth this is the Prophet.

41 Others said, This is the Christ. But some said, Shall Christ come out of Galilee?

42 Hath not the scripture said, That Christ cometh of the seed of David, and out of the town of Bethlehem, where David was?

43 So there was a division among the people because of him.

44 And some of them would have taken him; but no man laid hands on him.

45 Then came the officers to the chief priests and Pharisees; and they said unto them, Why have ye not brought him?

46 The officers answered, Never man spake like this man.

47 Then answered them the Pharisees, Are ye also deceived?

48 Have any of the rulers or of the Pharisees believed on him?

49 But this people who knoweth not the law are cursed.

50 Nicodemus saith unto them, (he that came to Jesus by night, being one of them,)

51 Doth our law judge any man, before it hear him, and know what he doeth?

52 They answered and said unto him, Art thou also of Galilee? Search, and look: for out of Galilee ariseth no prophet.

A WOMAN CAUGHT IN ADULTERY

Into the middle of a brewing controversy about Jesus' authority to teach, comes a woman, dragged before him by a group of scribes and Pharisees, caught in the act of adultery. Those who bring her want a judgment from Jesus as to whether or not she should be stoned to death as the commandment in Deuteronomy 22:21 prescribes. Magnificent as the story is in describing Jesus' balance of judgment and mercy, it does not appear in the oldest manuscripts of John's gospel— and it appears in some manuscripts as part of Luke's story, where Jesus is teaching in the Temple in the days before his Passion. Jerome's *Latin Vulgate* included it, as does King James' version used here. The Church has long considered it inspired Scripture. Very possibly it was an ancient story that came to be added into manuscripts later, to make sure it would not be lost. What was Jesus writing on the ground? Among the suggestions is Psalm 130:3–4: "If thou, LORD, shouldest mark iniquities, O LORD, who shall stand? But there is forgiveness with thee, that thou mayest be feared."

JOHN 8:1–8:11

1 Jesus went unto the mount of Olives.

2 And early in the morning he came again into the temple, and all the people came unto him; and he sat down, and taught them.

3 And the scribes and Pharisees brought unto him a woman taken in adultery; and when they had set her in the midst,

4 They say unto him, Master, this woman was taken in adultery, in the very act.

5 Now Moses in the law commanded us, that such should be stoned: but what sayest thou?

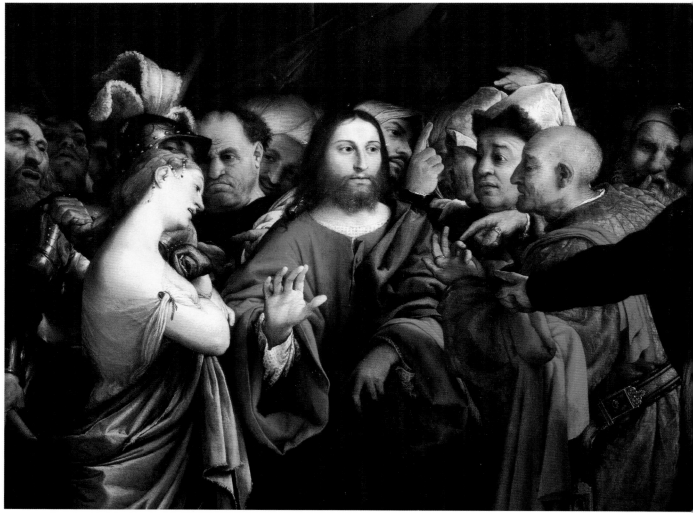

Christ and the Adulterous Woman, by Lorenzo Lotto, 1480-1556

6 This they said, tempting him, that they might have to accuse him. But Jesus stooped down, and with his finger wrote on the ground, as though he heard them not.

7 So when they continued asking him, he lifted up himself, and said unto them, He that is without sin among you, let him first cast a stone at her.

8 And again he stooped down, and wrote on the ground.

9 And they which heard it, being convicted by their own conscience, went out one by one, beginning at the eldest, even unto the last: and Jesus was left alone, and the woman standing in the midst.

10 When Jesus had lifted up himself, and saw none but the woman, he said unto her, Woman, where are those thine accusers? hath no man condemned thee?

11 She said, No man, Lord. And Jesus said unto her, Neither do I condemn thee: go, and sin no more.

"I AM THE LIGHT OF THE WORLD"

JOHN 8:12–20

12 Then spake Jesus again unto them, saying, I am the light of the world: he that followeth me shall not walk in darkness, but shall have the light of life.

13 The Pharisees therefore said unto him, Thou bearest record of thyself; thy record is not true.

14 Jesus answered and said unto them, Though I bear record of myself, yet my record is true: for I know whence I came, and whither I go; but ye cannot tell whence I come, and whither I go.

15 Ye judge after the flesh; I judge no man.

16 And yet if I judge, my judgment is true: for I am not alone, but I and the Father that sent me.

17 It is also written in your law, that the testimony of two men is true.

18 I am one that bear witness of myself, and the Father that sent me beareth witness of me.

19 Then said they unto him, Where is thy Father? Jesus answered, Ye neither know me, nor my Father: if ye had known me, ye should have known my Father also.

20 These words spake Jesus in the treasury, as he taught in the temple: and no man laid hands on him; for his hour was not yet come.

CONTROVERSY WITH THE JUDEANS

JOHN 8:21–29

21 Then said Jesus again unto them, I go my way, and ye shall seek me, and shall die in your sins: whither I go, ye cannot come.

22 Then said the Jews, Will he kill himself? because he saith, Whither I go, ye cannot come.

23 And he said unto them, Ye are from beneath; I am from above: ye are of this world; I am not of this world.

24 I said therefore unto you, that ye shall die in your sins: for if ye believe not that I am he, ye shall die in your sins.

25 Then said they unto him, Who art thou? And Jesus saith unto them, Even the same that I said unto you from the beginning.

26 I have many things to say and to judge of you: but he that sent me is true; and I speak to the world those things which I have heard of him.

27 They understood not that he spake to them of the Father.

28 Then said Jesus unto them, When ye have lifted up the Son of man, then shall ye know that I am he, and that I do nothing of myself; but as my Father hath taught me, I speak these things.

29 And he that sent me is with me: the Father hath not left me alone; for I do always those things that please him.

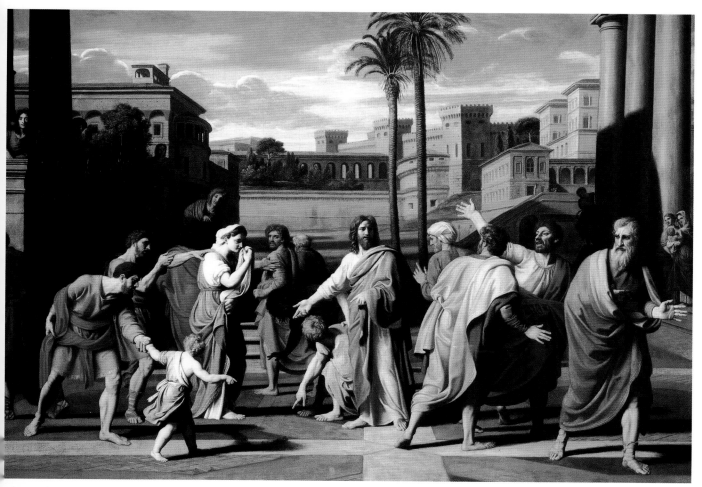

Christ and the Adulterous Woman, 1682, by Nicolas Colombel, 1646–1717

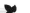

"THE TRUTH SHALL MAKE YOU FREE"

As mentioned earlier, many of the places where John uses the term "the Jews," seem to refer to those who opposed Jesus' teaching. Here Jesus clearly speaks "to those Jews which believed on him." The opposition heats up to the point where "the Jews" pick up stones to hurl at him. This passage seems to be inserted as an aside to the many Jews in John's community who came to believe in Jesus. In the story of the man born blind that follows, mention is made of those who confessed Jesus as Messiah (Christ) being put out of the synagogue. Many of John's community had likely been through that experience. Here Jesus speaks directly to them (and, therefore, to the reader) that the truth will make them free. His concept of truth is not ideological, but relational. Truth is not merely something one lives by—truth is someone we live with.

JOHN 8:30–36

30 As he spake these words, many believed on him.

31 Then said Jesus to those Jews which believed on him, If ye continue in my word, then are ye my disciples indeed;

32 And ye shall know the truth, and the truth shall make you free.

33 They answered him, We be Abraham's seed, and were never in bondage to any man: how sayest thou, Ye shall be made free?

34 Jesus answered them, Verily, verily, I say unto you, Whosoever committeth sin is the servant of sin.

35 And the servant abideth not in the house for ever: but the Son abideth ever.

36 If the Son therefore shall make you free, ye shall be free indeed.

THE CONTROVERSY HEATS UP

JOHN 8:37–47

37 I know that ye are Abraham's seed; but ye seek to kill me, because my word hath no place in you.

38 I speak that which I have seen with my Father: and ye do that which ye have seen with your father.

39 They answered and said unto him, Abraham is our father. Jesus saith unto them, If ye were Abraham's children, ye would do the works of Abraham.

40 But now ye seek to kill me, a man that hath told you the truth, which I have heard of God: this did not Abraham.

41 Ye do the deeds of your father. Then said they to him, We be not born of fornication; we have one Father, even God.

42 Jesus said unto them, If God were your Father, ye would love me: for I proceeded forth and came from God; neither came I of myself, but he sent me.

43 Why do ye not understand my speech? even because ye cannot hear my word.

44 Ye are of your father the devil, and the lusts of your father ye will do. He was a murderer from the beginning, and abode not in the truth, because there is no truth in him. When he speaketh a lie, he speaketh of his own: for he is a liar, and the father of it.

45 And because I tell you the truth, ye believe me not.

46 Which of you convinceth me of sin? And if I say the truth, why do ye not believe me?

47 He that is of God heareth God's words: ye therefore hear them not, because ye are not of God.

"BEFORE ABRAHAM WAS, I AM"

JOHN 8:48–59

48 Then answered the Jews, and said unto him, Say we not well that thou art a Samaritan, and hast a devil?

49 Jesus answered, I have not a devil; but I honour my Father, and ye do dishonour me.

50 And I seek not mine own glory: there is one that seeketh and judgeth.

51 Verily, verily, I say unto you, If a man keep my saying, he shall never see death.

52 Then said the Jews unto him, Now we know that thou hast a devil. Abraham is dead, and the prophets; and thou sayest, If a man keep my saying, he shall never taste of death.

53 Art thou greater than our father Abraham, which is dead? and the prophets are dead: whom makest thou thyself?

54 Jesus answered, If I honour myself, my honour is nothing: it is my Father that honoureth me; of whom ye say, that he is your God:

55 Yet ye have not known him; but I know him: and if I should say, I know him not, I shall be a liar like unto you: but I know him, and keep his saying.

56 Your father Abraham rejoiced to see my day: and he saw it, and was glad.

57 Then said the Jews unto him, Thou art not yet fifty years old, and hast thou seen Abraham?

58 Jesus said unto them, Verily, verily, I say unto you, Before Abraham was, I am.

59 Then took they up stones to cast at him: but Jesus hid himself, and went out of the temple, going through the midst of them, and so passed by.

JESUS HEALS A MAN BORN BLIND DESPITE THE SABBATH

Earlier, Mark's Jesus healed a blind man in Bethsaida, using spittle on the man's eyes. In this elaborately developed account, Jesus again uses spittle, making a paste with mud, anointing the man's eyes, and telling him to wash in the Pool of Siloam (from which the ritual water was drawn each day of the feast). At Jesus' word he does, and he comes back seeing. For this man Jesus becomes the water of life, the light that shines into his darkness and overcomes it. (The washing, the anointing, and the lighting of a candle all were from the Christian baptismal liturgy.) In John's artistic orchestration the man's "enlightenment" continues through the chapter, as he is repeatedly questioned about what happened to him. In the process, through repeated contacts with Jesus, the man grows in faith and boldness until he questions his questioners—and they drive him out. The man thus becomes a model of every believer's faith journey. People are "judged" by their reactions to Jesus—either as blind, or as seeing.

The Man Blind from His Birth, by Alexander Bida, 1813-1895

JOHN 9:1–41

1 And as Jesus passed by, he saw a man which was blind from his birth.

2 And his disciples asked him, saying, Master, who did sin, this man, or his parents, that he was born blind?

3 Jesus answered, Neither hath this man sinned, nor his parents: but that the works of God should be made manifest in him.

4 I must work the works of him that sent me, while it is day: the night cometh, when no man can work.

5 As long as I am in the world, I am the light of the world.

6 When he had thus spoken, he spat on the ground, and made clay of the spittle, and he anointed the eyes of the blind man with the clay,

7 And said unto him, Go, wash in the pool of Siloam, (which is by interpretation, Sent.) He went his way therefore, and washed, and came seeing.

8 The neighbours therefore, and they which before had seen him that he was blind, said, Is not this he that sat and begged?

9 Some said, This is he: others said, He is like him: but he said, I am he.

10 Therefore said they unto him, How were thine eyes opened?

I must work the works of him that sent me, while it is day: the night cometh, when no man can work.

—JOHN 9:4

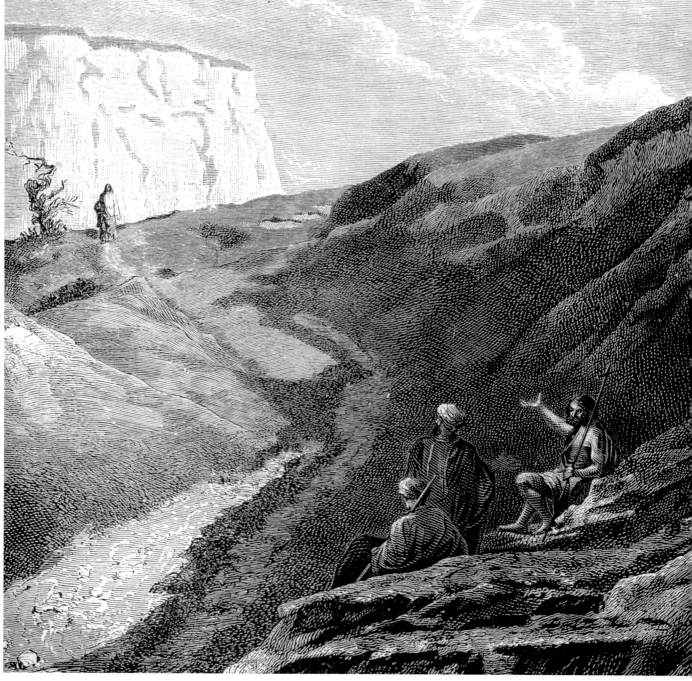

"Behold the Lamb of God," by Alexander Bida, 1813-1895

11 He answered and said, A man that is called Jesus made clay, and anointed mine eyes, and said unto me, Go to the pool of Siloam, and wash: and I went and washed, and I received sight.

12 Then said they unto him, Where is he? He said, I know not.

13 They brought to the Pharisees him that aforetime was blind.

14 And it was the sabbath day when Jesus made the clay, and opened his eyes.

15 Then again the Pharisees also asked him how he had received his sight. He said unto them, He put clay upon mine eyes, and I washed, and do see.

16 Therefore said some of the Pharisees, This man is not of God, because he keepeth not the sabbath day. Others said, How can a man that is a sinner do such miracles? And there was a division among them.

17 They say unto the blind man again, What sayest thou of him, that he hath opened thine eyes? He said, He is a prophet.

18 But the Jews did not believe concerning him, that he had been blind, and received his sight, until they called the parents of him that had received his sight.

19 And they asked them, saying, Is this your son, who ye say was born blind? how then doth he now see?

20 His parents answered them and said, We know that this is our son, and that he was born blind:

21 But by what means he now seeth, we know not; or who hath opened his eyes, we know not: he is of age; ask him: he shall speak for himself.

22 These words spake his parents, because they feared the Jews: for the Jews had agreed already, that if any man did confess that he was Christ, he should be put out of the synagogue.

23 Therefore said his parents, He is of age; ask him.

24 Then again called they the man that was blind, and said unto him, Give God the praise: we know that this man is a sinner.

25 He answered and said, Whether he be a sinner or no, I know not: one thing I know, that, whereas I was blind, now I see.

26 Then said they to him again, What did he to thee? how opened he thine eyes?

27 He answered them, I have told you already, and ye did not hear: wherefore would ye hear it again? will ye also be his disciples?

28 Then they reviled him, and said, Thou art his disciple; but we are Moses' disciples.

29 We know that God spake unto Moses: as for this fellow, we know not from whence he is.

30 The man answered and said unto them, Why herein is a marvellous thing, that ye know not from whence he is, and yet he hath opened mine eyes.

31 Now we know that God heareth not sinners: but if any man be a worshipper of God, and doeth his will, him he heareth.

32 Since the world began was it not heard that any man opened the eyes of one that was born blind.

33 If this man were not of God, he could do nothing.

34 They answered and said unto him, Thou wast altogether born in sins, and dost thou teach us? And they cast him out.

35 Jesus heard that they had cast him out; and when he had found him, he said unto him, Dost thou believe on the Son of God?

36 He answered and said, Who is he, Lord, that I might believe on him?

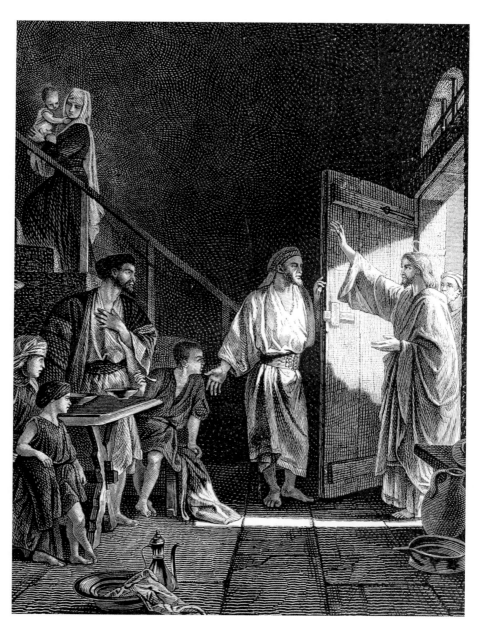

"Peace Be to this House," by ALEXANDER BIDA, 1813-1895

37 And Jesus said unto him, Thou hast both seen him, and it is he that talketh with thee.

38 And he said, Lord, I believe. And he worshipped him.

39 And Jesus said, For judgment I am come into this world, that they which see not might see; and that they which see might be made blind.

40 And some of the Pharisees which were with him heard these words, and said unto him, Are we blind also?

41 Jesus said unto them, If ye were blind, ye should have no sin: but now ye say, We see; therefore your sin remaineth.

And other sheep I have, which are not of this fold: them also I must bring, and they shall hear my voice; and there shall be one fold, and one shepherd.

Therefore doth my Father love me, because I lay down my life, that I might take it again.

—JOHN 10:16–17

"I AM THE GOOD SHEPHERD"

In this extended metaphor, Jesus compares himself to other "shepherds" before him, for whom shepherding was merely a "job," but Jesus, the good shepherd "lays down his life for the sheep." John's "I am . . ." sayings serve the same purpose as the parables of the synoptic gospels—they give Jesus a vivid, down-to-earth picture to frame his teaching. Here he speaks about "laying down" his life and "taking it again," predicting his death and resurrection.

JOHN 10:1–21

1 Verily, verily, I say unto you, He that entereth not by the door into the sheepfold, but climbeth up some other way, the same is a thief and a robber.

2 But he that entereth in by the door is the shepherd of the sheep.

3 To him the porter openeth; and the sheep hear his voice: and he calleth his own sheep by name, and leadeth them out.

4 And when he putteth forth his own sheep, he goeth before them, and the sheep follow him: for they know his voice.

5 And a stranger will they not follow, but will flee from him: for they know not the voice of strangers.

6 This parable spake Jesus unto them: but they understood not what things they were which he spake unto them.

7 Then said Jesus unto them again, Verily, verily, I say unto you, I am the door of the sheep.

8 All that ever came before me are thieves and robbers: but the sheep did not hear them.

9 I am the door: by me if any man enter in, he shall be saved, and shall go in and out, and find pasture.

10 The thief cometh not, but for to steal, and to kill, and to destroy: I am come that they might have life, and that they might have it more abundantly.

11 I am the good shepherd: the good shepherd giveth his life for the sheep.

12 But he that is an hireling, and not the shepherd, whose own the sheep are not, seeth the wolf coming, and leaveth the sheep, and fleeth: and the wolf catcheth them, and scattereth the sheep.

13 The hireling fleeth, because he is an hireling, and careth not for the sheep.

14 I am the good shepherd, and know my sheep, and am known of mine.

15 As the Father knoweth me, even so know I the Father: and I lay down my life for the sheep.

16 And other sheep I have, which are not of this fold: them also I must bring, and they shall hear my voice; and there shall be one fold, and one shepherd.

17 Therefore doth my Father love me, because I lay down my life, that I might take it again.

18 No man taketh it from me, but I lay it down of myself. I have power to lay it down, and I have power to take it again. This commandment have I received of my Father.

19 There was a division therefore again among the Jews for these sayings.

20 And many of them said, He hath a devil, and is mad; why hear ye him?

21 Others said, These are not the words of him that hath a devil. Can a devil open the eyes of the blind?

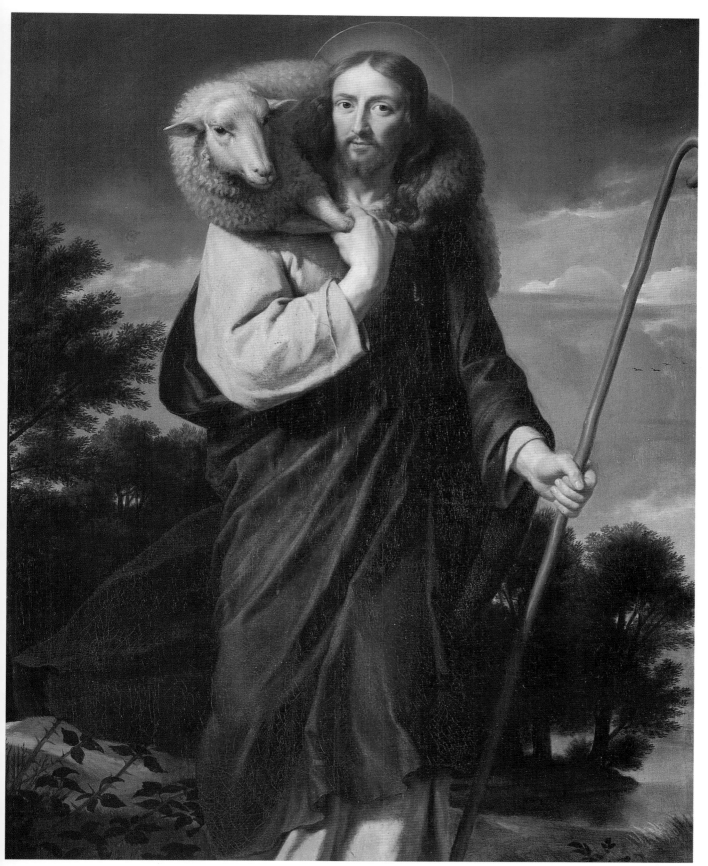

The Good Shepherd, by Philippe de Champaigne, 1602-1674

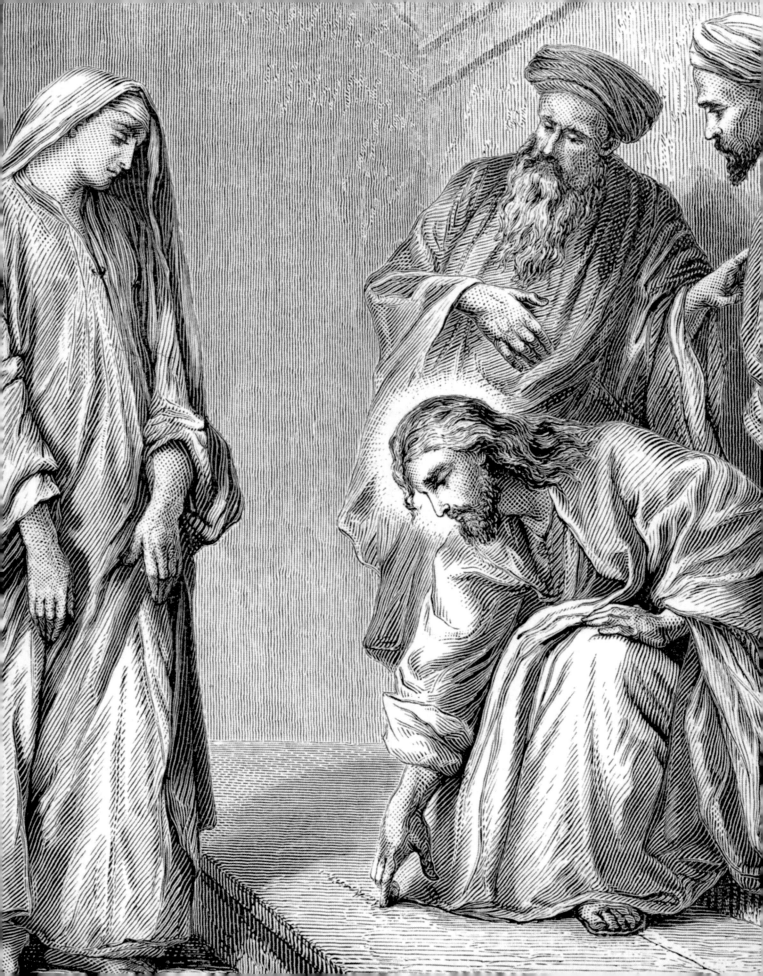

LIFE of JESUS

Jesus' Ministry in Judea

Jesus' Ministry in Judea

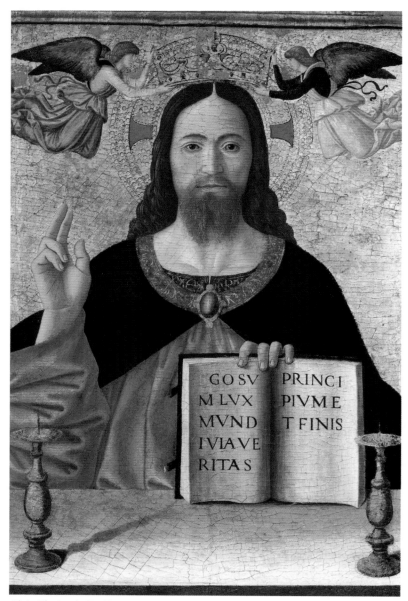

Christ Blessing the World, by Melozzo da Forli, 1438–1494

AS JESUS AND HIS DISCIPLES DREW NEAR TO JERUSALEM, the gospel writers record those "last words" of Jesus that he wants his followers to remember. In the next teachings, the common theme is that the commitments and sacrifices of being a disciple are so all-encompassing as to be impossible. The disciples begin to gather this in Jesus' teachings about marriage and divorce. As Jesus blesses the children, he makes the point about receiving the kingdom as a child, that is, as one who is completely dependent on another for everything. The kingdom is not something achieved by human performance, it is received as a gift.

TEACHINGS ABOUT DIVORCE AND MARRIAGE

MATTHEW 19:1–12

1 And it came to pass, that when Jesus had finished these sayings, he departed from Galilee, and came into the coasts of Judaea beyond Jordan;

2 And great multitudes followed him; and he healed them there.

3 The Pharisees also came unto him, tempting him, and saying unto him, Is it lawful for a man to put away his wife for every cause?

4 And he answered and said unto them, Have ye not read, that he which made them at the beginning made them male and female,

5 And said, For this cause shall a man leave father and mother, and shall cleave to his wife: and they twain shall be one flesh?

6 Wherefore they are no more twain, but one flesh. What therefore God hath joined together, let not man put asunder.

7 They say unto him, Why did Moses then command to give a writing of divorcement, and to put her away?

8 He saith unto them, Moses because of the hardness of your hearts suffered you to put away your wives: but from the beginning it was not so.

9 And I say unto you, Whosoever shall put away his wife, except it be for fornication, and shall marry another, committeth adultery: and whoso marrieth her which is put away doth commit adultery.

10 His disciples say unto him, If the case of the man be so with his wife, it is not good to marry.

11 But he said unto them, All men cannot receive this saying, save they to whom it is given.

The Woman Taken in Adultery, by Alexander Bida, 1813–1895

12 For there are some eunuchs, which were so born from their mother's womb: and there are some eunuchs, which were made eunuchs of men: and there be eunuchs, which have made themselves eunuchs for the kingdom of heaven's sake. He that is able to receive it, let him receive it.

MARK 10:1–12

1 And he arose from thence, and cometh into the coasts of Judaea by the farther side of Jordan: and the people resort unto him again; and, as he was wont, he taught them again.

2 And the Pharisees came to him, and asked him, Is it lawful for a man to put away his wife? tempting him.

3 And he answered and said unto them, What did Moses command you?

4 And they said, Moses suffered to write a bill of divorcement, and to put her away.

5 And Jesus answered and said unto them, For the hardness of your heart he wrote you this precept.

6 But from the beginning of the creation God made them male and female.

7 For this cause shall a man leave his father and mother, and cleave to his wife;

8 And they twain shall be one flesh: so then they are no more twain, but one flesh.

9 What therefore God hath joined together, let not man put asunder.

10 And in the house his disciples asked him again of the same matter.

11 And he saith unto them, Whosoever shall put away his wife, and marry another, committeth adultery against her.

12 And if a woman shall put away her husband, and be married to another, she committeth adultery.

LUKE 16:18

18 Whosoever putteth away his wife, and marrieth another, committeth adultery: and whosoever marrieth her that is put away from her husband committeth adultery.

JESUS AND THE CHILDREN

MATTHEW 19:13–15

13 Then were there brought unto him little children, that he should put his hands on them, and pray: and the disciples rebuked them.

14 But Jesus said, Suffer little children, and forbid them not, to come unto me: for of such is the kingdom of heaven.

15 And he laid his hands on them, and departed thence.

MARK 10:13–16

13 And they brought young children to him, that he should touch them: and his disciples rebuked those that brought them.

14 But when Jesus saw it, he was much displeased, and said unto them, Suffer the little children to come unto me, and forbid them not: for of such is the kingdom of God.

15 Verily I say unto you, Whosoever shall not receive the kingdom of God as a little child, he shall not enter therein.

16 And he took them up in his arms, put his hands upon them, and blessed them.

LUKE 18:15–17

15 And they brought unto him also infants, that he would touch them: but when his disciples saw it, they rebuked them.

16 But Jesus called them unto him, and said, Suffer little children to come unto me, and forbid them not: for of such is the kingdom of God.

Jesus and the Child, by Alexander Bida, 1813–1895

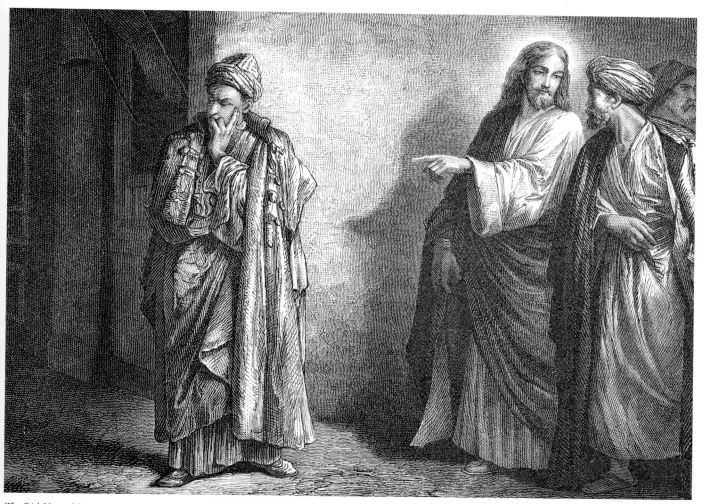

The Rich Young Man, by Alexander Bida, 1813–1895

17 Verily I say unto you, Whosoever shall not receive the kingdom of God as a little child shall in no wise enter therein.

A RICH YOUNG MAN COMES TO JESUS

MATTHEW 19:16–30

16 And, behold, one came and said unto him, Good Master, what good thing shall I do, that I may have eternal life?

17 And he said unto him, Why callest thou me good? there is none good but one, that is, God: but if thou wilt enter into life, keep the commandments.

18 He saith unto him, Which? Jesus said, Thou shalt do no murder, Thou shalt not commit adultery, Thou shalt not steal, Thou shalt not bear false witness,

19 Honour thy father and thy mother: and, Thou shalt love thy neighbour as thyself.

20 The young man saith unto him, All these things have I kept from my youth up: what lack I yet?

21 Jesus said unto him, If thou wilt be perfect, go and sell that thou hast, and give to the poor, and thou shalt have treasure in heaven: and come and follow me.

22 But when the young man heard that saying, he went away sorrowful: for he had great possessions.

23 Then said Jesus unto his disciples, Verily I say unto you, That a rich man shall hardly enter into the kingdom of heaven.

24 And again I say unto you, It is easier for a camel to go through the eye of a needle, than for a rich man to enter into the kingdom of God.

25 When his disciples heard it, they were exceedingly amazed, saying, Who then can be saved?

26 But Jesus beheld them, and said unto them, With men this is impossible; but with God all things are possible.

27 Then answered Peter and said unto him, Behold, we have forsaken all, and followed thee; what shall we have therefore?

28 And Jesus said unto them, Verily I say unto you, That ye which have followed me, in the regeneration when the Son of man shall sit in the throne of his glory, ye also shall sit upon twelve thrones, judging the twelve tribes of Israel.

29 And every one that hath forsaken houses, or brethren, or sisters, or father, or mother, or wife, or children, or lands, for my name's sake, shall receive an hundredfold, and shall inherit everlasting life.

30 But many that are first shall be last; and the last shall be first.

MARK 10:17–31

17 And when he was gone forth into the way, there came one running, and kneeled to him, and asked him, Good Master, what shall I do that I may inherit eternal life?

18 And Jesus said unto him, Why callest thou me good? there is none good but one, that is, God.

19 Thou knowest the commandments, Do not commit adultery, Do not kill, Do not steal, Do not bear false witness, Defraud not, Honour thy father and mother.

20 And he answered and said unto him, Master, all these have I observed from my youth.

And Jesus looking upon them saith, With men it is impossible, but not with God: for with God all things are possible.

—MARK 10:27

21 Then Jesus beholding him loved him, and said unto him, One thing thou lackest: go thy way, sell whatsoever thou hast, and give to the poor, and thou shalt have treasure in heaven: and come, take up the cross, and follow me.

22 And he was sad at that saying, and went away grieved: for he had great possessions.

23 And Jesus looked round about, and saith unto his disciples, How hardly shall they that have riches enter into the kingdom of God!

24 And the disciples were astonished at his words. But Jesus answereth again, and saith unto them, Children, how hard is it for them that trust in riches to enter into the kingdom of God!

25 It is easier for a camel to go through the eye of a needle, than for a rich man to enter into the kingdom of God.

26 And they were astonished out of measure, saying among themselves, Who then can be saved?

27 And Jesus looking upon them saith, With men it is impossible, but not with God: for with God all things are possible.

28 Then Peter began to say unto him, Lo, we have left all, and have followed thee.

29 And Jesus answered and said, Verily I say unto you, There is no man that hath left house, or brethren, or sisters, or father, or mother, or wife, or children, or lands, for my sake, and the gospel's,

30 But he shall receive an hundredfold now in this time, houses, and brethren, and sisters, and mothers, and children, and lands, with persecutions; and in the world to come eternal life.

31 But many that are first shall be last; and the last first.

LUKE 18:18–30

18 And a certain ruler asked him, saying, Good Master, what shall I do to inherit eternal life?

19 And Jesus said unto him, Why callest thou me good? none is good, save one, that is, God.

20 Thou knowest the commandments, Do not commit adultery, Do not kill, Do not steal, Do not bear false witness, Honour thy father and thy mother.

21 And he said, All these have I kept from my youth up.

22 Now when Jesus heard these things, he said unto him, Yet lackest thou one thing: sell all that thou hast, and distribute unto the poor, and thou shalt have treasure in heaven: and come, follow me.

23 And when he heard this, he was very sorrowful: for he was very rich.

24 And when Jesus saw that he was very sorrowful, he said, How hardly shall they that have riches enter into the kingdom of God!

25 For it is easier for a camel to go through a needle's eye, than for a rich man to enter into the kingdom of God.

26 And they that heard it said, Who then can be saved?

27 And he said, The things which are impossible with men are possible with God.

28 Then Peter said, Lo, we have left all, and followed thee.

29 And he said unto them, Verily I say unto you, There is no man that hath left house, or parents, or brethren, or wife, or children, for the kingdom of God's sake,

30 Who shall not receive manifold more in this present time, and in the world to come life everlasting.

A PARABLE ABOUT LABORERS IN A VINEYARD

MATTHEW 20:1–16

1 For the kingdom of heaven is like unto a man that is an householder, which went out early in the morning to hire labourers into his vineyard.

2 And when he had agreed with the labourers for a penny a day, he sent them into his vineyard.

3 And he went out about the third hour, and saw others standing idle in the marketplace,

4 And said unto them; Go ye also into the vineyard, and whatsoever is right I will give you. And they went their way.

5 Again he went out about the sixth and ninth hour, and did likewise.

6 And about the eleventh hour he went out, and found others standing idle, and saith unto them, Why stand ye here all the day idle?

7 They say unto him, Because no man hath hired us. He saith unto them, Go ye also into the vineyard; and whatsoever is right, that shall ye receive.

8 So when even was come, the lord of the vineyard saith unto his steward, Call the labourers, and give them their hire, beginning from the last unto the first.

9 And when they came that were hired about the eleventh hour, they received every man a penny.

10 But when the first came, they supposed that they should have received more; and they likewise received every man a penny.

11 And when they had received it, they murmured against the goodman of the house,

12 Saying, These last have wrought but one hour, and thou hast made them equal unto us, which have borne the burden and heat of the day.

13 But he answered one of them, and said, Friend, I do thee no wrong: didst not thou agree with me for a penny?

14 Take that thine is, and go thy way: I will give unto this last, even as unto thee.

15 Is it not lawful for me to do what I will with mine own? Is thine eye evil, because I am good?

16 So the last shall be first, and the first last: for many be called, but few chosen.

MARK 10:31

31 But many that are first shall be last; and the last first.

LUKE 13:30

30 And, behold, there are last which shall be first, and there are first which shall be last.

Cultivating the Vines, from the Parable of the Workers in the Vineyard, c. 1160, Mosan (Art of the Meuse Valley)

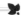 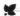

Wine Press in Oriental Vineyard, Artist Unknown

JESUS AT THE FEAST OF DEDICATION (HANUKAH) IN JERUSALEM

With this section John's Jesus completes the section of his Book of Signs, where Jesus replaces the major festivals of the Jewish liturgical cycle. It is the Feast of Dedication, where the altar of the Temple, desecrated by Antiochus IV the Syrian ruler, was rededicated and the Temple restored by the Maccabees in 164 B.C. Jesus, standing in the Temple, describes himself as the one "whom the Father hath sanctified and sent into the world." Those who hear him once again take up stones to destroy him for blaspheming, bringing dishonor on God's holy name by claiming himself to be God. With this same charge, Jesus will be handed over by the High Priest and the Council to be put to death.

JOHN 10:22–42

22 And it was at Jerusalem the feast of the dedication, and it was winter.

23 And Jesus walked in the temple in Solomon's porch.

24 Then came the Jews round about him, and said unto him, How long dost thou make us to doubt? If thou be the Christ, tell us plainly.

25 Jesus answered them, I told you, and ye believed not: the works that I do in my Father's name, they bear witness of me.

26 But ye believe not, because ye are not of my sheep, as I said unto you.

27 My sheep hear my voice, and I know them, and they follow me:

28 And I give unto them eternal life; and they shall never perish, neither shall any man pluck them out of my hand.

29 My Father, which gave them me, is greater than all; and no man is able to pluck them out of my Father's hand.

30 I and my Father are one.

31 Then the Jews took up stones again to stone him.

32 Jesus answered them, Many good works have I shewed you from my Father; for which of those works do ye stone me?

33 The Jews answered him, saying, For a good work we stone thee not; but for blasphemy; and because that thou, being a man, makest thyself God.

34 Jesus answered them, Is it not written in your law, I said, Ye are gods?

35 If he called them gods, unto whom the word of God came, and the scripture cannot be broken;

36 Say ye of him, whom the Father hath sanctified, and sent into the world, Thou blasphemest; because I said, I am the Son of God?

37 If I do not the works of my Father, believe me not.

38 But if I do, though ye believe not me, believe the works: that ye may know, and believe, that the Father is in me, and I in him.

39 Therefore they sought again to take him: but he escaped out of their hand,

40 And went away again beyond Jordan into the place where John at first baptized; and there he abode.

41 And many resorted unto him, and said, John did no miracle: but all things that John spake of this man were true.

42 And many believed on him there.

Jesus answered them, Is it not written in your law, I said, Ye are gods?

If he called them gods, unto whom the word of God came, and the scripture cannot be broken

—JOHN 10:34–35

JESUS RAISES LAZARUS TO LIFE

The seventh and last of Jesus' "signs" (as recorded by John) takes place in Bethany, just outside of Jerusalem. Jesus gets word from his friends Martha and her sister Mary that their brother Lazarus is sick. Jesus comments, "This sickness is not unto death, but for the glory of God, that the Son of God might be glorified thereby." Thomas, the realist among Jesus' disciples, picks up what Jesus means by "being glorified," as after two days Jesus wants to go to Jerusalem to "wake Lazarus from sleep." Thomas responds: "Let us also go, that we may die with him." Indeed, in John's dramatic presentation of events, all the themes of the gospel come together through this sign—light and darkness, life and death. Jesus' words in Chapter 5 come to be fulfilled: "The hour is coming, and now is, when the dead shall hear the voice of the Son of God; and they that hear shall live." But as Jesus calls Lazarus to life, he brings on himself the judgment of death—for the chief priests and Pharisees take counsel, and Caiphas the High Priest in their midst declares: "It is expedient that one man should die for the people, and that the whole nation perish not." The story is powerfully related as the ultimate showdown between life and death. "I am the resurrection and the life," Jesus says. And Martha believes, even as she knows the reality of the grave: "Lord, by this time he stinketh …" But Jesus has the last word here: "Lazarus, come forth!" And the first word: "Loose him and let him go."

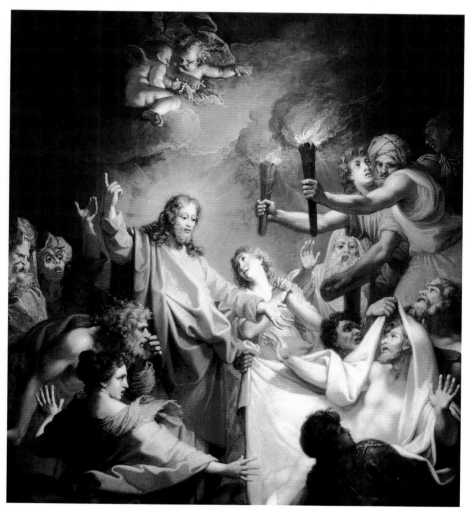

The Resurrection of Lazarus, by Jean-Baptiste Corneille, 1646–95

JOHN 11:1–44

1 Now a certain man was sick, named Lazarus, of Bethany, the town of Mary and her sister Martha.

2 (It was that Mary which anointed the Lord with ointment, and wiped his feet with her hair, whose brother Lazarus was sick.)

3 Therefore his sisters sent unto him, saying, Lord, behold, he whom thou lovest is sick.

4 When Jesus heard that, he said, This sickness is not unto death, but for the glory of God, that the Son of God might be glorified thereby.

5 Now Jesus loved Martha, and her sister, and Lazarus.

6 When he had heard therefore that he was sick, he abode two days still in the same place where he was.

7 Then after that saith he to his disciples, Let us go into Judaea again.

8 His disciples say unto him, Master, the Jews of late sought to stone thee; and goest thou thither again?

9 Jesus answered, Are there not twelve hours in the day? If any man walk in the day, he stumbleth not, because he seeth the light of this world.

10 But if a man walk in the night, he stumbleth, because there is no light in him.

11 These things said he: and after that he saith unto them, Our friend Lazarus sleepeth; but I go, that I may awake him out of sleep.

12 Then said his disciples, Lord, if he sleep, he shall do well.

13 Howbeit Jesus spake of his death: but they thought that he had spoken of taking of rest in sleep.

14 Then said Jesus unto them plainly, Lazarus is dead.

15 And I am glad for your sakes that I was not there, to the intent ye may believe; nevertheless let us go unto him.

16 Then said Thomas, which is called Didymus, unto his fellow disciples, Let us also go, that we may die with him.

17 Then when Jesus came, he found that he had lain in the grave four days already.

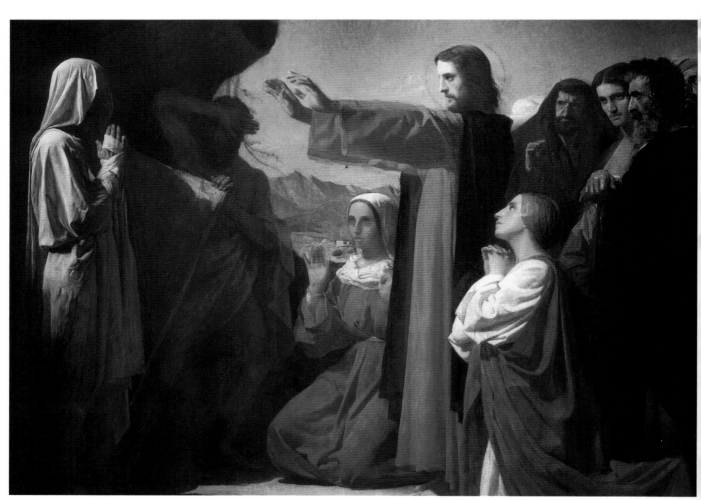

The Resurrection of Lazarus, by Leon Bonnat, 1833–1922

18 Now Bethany was nigh unto Jerusalem, about fifteen furlongs off:

19 And many of the Jews came to Martha and Mary, to comfort them concerning their brother.

20 Then Martha, as soon as she heard that Jesus was coming, went and met him: but Mary sat still in the house.

21 Then said Martha unto Jesus, Lord, if thou hadst been here, my brother had not died.

22 But I know, that even now, whatsoever thou wilt ask of God, God will give it thee.

23 Jesus saith unto her, Thy brother shall rise again.

24 Martha saith unto him, I know that he shall rise again in the resurrection at the last day.

25 Jesus said unto her, I am the resurrection, and the life: he that believeth in me, though he were dead, yet shall he live:

26 And whosoever liveth and believeth in me shall never die. Believest thou this?

27 She saith unto him, Yea, Lord: I believe that thou art the Christ, the Son of God, which should come into the world.

28 And when she had so said, she went her way, and called Mary her sister secretly, saying, The Master is come, and calleth for thee.

29 As soon as she heard that, she arose quickly, and came unto him.

30 Now Jesus was not yet come into the town, but was in that place where Martha met him.

31 The Jews then which were with her in the house, and comforted her, when they saw Mary, that she rose up hastily and went out, followed her, saying, She goeth unto the grave to weep there.

Lazarus Raised from the Dead, by Alexander Bida, 1813–1895

32 Then when Mary was come where Jesus was, and saw him, she fell down at his feet, saying unto him, Lord, if thou hadst been here, my brother had not died.

33 When Jesus therefore saw her weeping, and the Jews also weeping which came with her, he groaned in the spirit, and was troubled,

34 And said, Where have ye laid him? They said unto him, Lord, come and see.

35 Jesus wept.

36 Then said the Jews, Behold how he loved him!

37 And some of them said, Could not this man, which opened the eyes of the blind, have caused that even this man should not have died?

38 Jesus therefore again groaning in himself cometh to the grave. It was a cave, and a stone lay upon it.

39 Jesus said, Take ye away the stone. Martha, the sister of him that was dead, saith unto him, Lord, by this time he stinketh: for he hath been dead four days.

40 Jesus saith unto her, Said I not unto thee, that, if thou wouldest believe, thou shouldest see the glory of God?

41 Then they took away the stone from the place where the dead was laid. And Jesus lifted up his eyes, and said, Father, I thank thee that thou hast heard me.

42 And I knew that thou hearest me always: but because of the people which stand by I said it, that they may believe that thou hast sent me.

43 And when he thus had spoken, he cried with a loud voice, Lazarus, come forth.

44 And he that was dead came forth, bound hand and foot with graveclothes: and his face was bound about with a napkin. Jesus saith unto them, Loose him, and let him go.

And he saith unto them, Ye shall drink indeed of my cup, and be baptized with the baptism that I am baptized with: but to sit on my right hand, and on my left, is not mine to give, but it shall be given to them for whom it is prepared of my Father.

—MATTHEW 20:23

THE CHIEF PRIESTS AND PHARISEES TAKE COUNSEL

JOHN 11:45–53

45 Then many of the Jews which came to Mary, and had seen the things which Jesus did, believed on him.

46 But some of them went their ways to the Pharisees, and told them what things Jesus had done.

47 Then gathered the chief priests and the Pharisees a council, and said, What do we? for this man doeth many miracles.

48 If we let him thus alone, all men will believe on him: and the Romans shall come and take away both our place and nation.

49 And one of them, named Caiaphas, being the high priest that same year, said unto them, Ye know nothing at all,

50 Nor consider that it is expedient for us, that one man should die for the people, and that the whole nation perish not.

51 And this spake he not of himself: but being high priest that year, he prophesied that Jesus should die for that nation;

52 And not for that nation only, but that also he should gather together in one the children of God that were scattered abroad.

53 Then from that day forth they took counsel together for to put him to death.

THE PASSOVER DRAWS NEAR

JOHN 11:54–57

54 Jesus therefore walked no more openly among the Jews; but went thence unto a country near to the wilderness, into a city called Ephraim, and there continued with his disciples.

55 And the Jews' passover was nigh at hand: and many went out of the country up to Jerusalem before the passover, to purify themselves.

56 Then sought they for Jesus, and spake among themselves, as they stood in the temple, What think ye, that he will not come to the feast?

57 Now both the chief priests and the Pharisees had given a commandment, that, if any man knew where he were, he should shew it, that they might take him.

JESUS FORETELLS HIS PASSION A THIRD TIME

MATTHEW 20:17–19

17 And Jesus going up to Jerusalem took the twelve disciples apart in the way, and said unto them,

18 Behold, we go up to Jerusalem; and the Son of man shall be betrayed unto the chief priests and unto the scribes, and they shall condemn him to death,

19 And shall deliver him to the Gentiles to mock, and to scourge, and to crucify him: and the third day he shall rise again.

MARK 10:32–34

32 And they were in the way going up to Jerusalem; and Jesus went before them: and they were amazed; and as they followed, they were afraid. And he took again the twelve, and began to tell them what things should happen unto him,

33 Saying, Behold, we go up to Jerusalem; and the Son of man shall be delivered unto the chief priests, and unto the scribes; and they shall condemn him to death, and shall deliver him to the Gentiles:

34 And they shall mock him, and shall scourge him, and shall spit upon him, and shall kill him: and the third day he shall rise again.

LUKE 18:31–34

31 Then he took unto him the twelve, and said unto them, Behold, we go up to Jerusalem, and all things that are written by the prophets concerning the Son of man shall be accomplished.

32 For he shall be delivered unto the Gentiles, and shall be mocked, and spitefully entreated, and spitted on:

33 And they shall scourge him, and put him to death: and the third day he shall rise again.

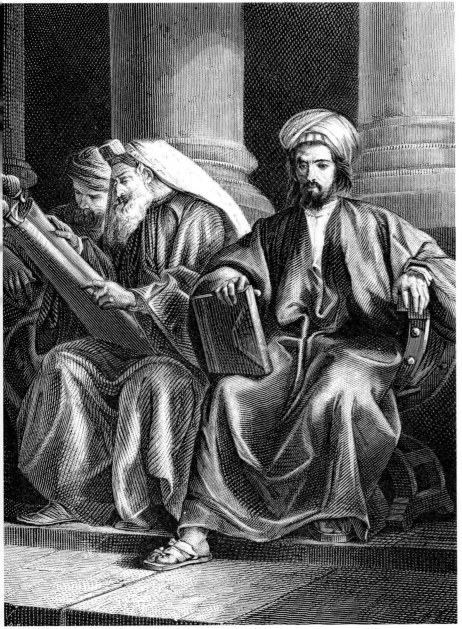

The Scribes and Pharisees sit in Moses' Seat, by Alexander Bida, 1813–1895

with? They say unto him, We are able.

23 And he saith unto them, Ye shall drink indeed of my cup, and be baptized with the baptism that I am baptized with: but to sit on my right hand, and on my left, is not mine to give, but it shall be given to them for whom it is prepared of my Father.

24 And when the ten heard it, they were moved with indignation against the two brethren.

25 But Jesus called them unto him, and said, Ye know that the princes of the Gentiles exercise dominion over them, and they that are great exercise authority upon them.

26 But it shall not be so among you: but whosoever will be great among you, let him be your minister;

27 And whosoever will be chief among you, let him be your servant:

28 Even as the Son of man came not to be ministered unto, but to minister, and to give his life a ransom for many.

MARK 10:35–45

35 And James and John, the sons of Zebedee, come unto him, saying, Master, we would that thou shouldest do for us whatsoever we shall desire.

36 And he said unto them, What would ye that I should do for you?

37 They said unto him, Grant unto us that we may sit, one on thy right hand, and the other on thy left hand, in thy glory.

38 But Jesus said unto them, Ye know not what ye ask: can ye drink of the cup that I drink of? and be baptized with the baptism that I am baptized with?

39 And they said unto him, We can. And Jesus said unto them, Ye shall indeed drink of the cup that I drink of; and with the baptism that I am baptized withal shall ye be baptized:

34 And they understood none of these things: and this saying was hid from them, neither knew they the things which were spoken.

JAMES AND JOHN ASK A FAVOR OF JESUS

MATTHEW 20:20–28

20 Then came to him the mother of Zebedee's children with her sons, worshipping him, and desiring a certain thing of him.

21 And he said unto her, What wilt thou? She saith unto him, Grant that these my two sons may sit, the one on thy right hand, and the other on the left, in thy kingdom.

22 But Jesus answered and said, Ye know not what ye ask. Are ye able to drink of the cup that I shall drink of, and to be baptized with the baptism that I am baptized

40 But to sit on my right hand and on my left hand is not mine to give; but it shall be given to them for whom it is prepared.

41 And when the ten heard it, they began to be much displeased with James and John.

42 But Jesus called them to him, and saith unto them, Ye know that they which are accounted to rule over the Gentiles exercise lordship over them; and their great ones exercise authority upon them.

43 But so shall it not be among you: but whosoever will be great among you, shall be your minister:

44 And whosoever of you will be the chiefest, shall be servant of all.

45 For even the Son of man came not to be ministered unto, but to minister, and to give his life a ransom for many.

But Jesus called them to him, and saith unto them, Ye know that they which are accounted to rule over the Gentiles exercise lordship over them; and their great ones exercise authority upon them.

—MARK 10:42

JESUS HEALS THE BLIND MAN BARTIMAEUS

MATTHEW 20:29–34

29 And as they departed from Jericho, a great multitude followed him.

30 And, behold, two blind men sitting by the way side, when they heard that Jesus passed by, cried out, saying, Have mercy on us, O Lord, thou Son of David.

31 And the multitude rebuked them, because they should hold their peace: but they cried the more, saying, Have mercy on us, O Lord, thou Son of David.

32 And Jesus stood still, and called them, and said, What will ye that I shall do unto you?

33 They say unto him, Lord, that our eyes may be opened.

34 So Jesus had compassion on them, and touched their eyes: and immediately their eyes received sight, and they followed him.

MARK 10:46–52

46 And they came to Jericho: and as he went out of Jericho with his disciples and a great number of people, blind Bartimaeus, the son of Timaeus, sat by the highway side begging.

47 And when he heard that it was Jesus of Nazareth, he began to cry out, and say, Jesus, thou Son of David, have mercy on me.

48 And many charged him that he should hold his peace: but he cried the more a great deal, Thou Son of David, have mercy on me.

49 And Jesus stood still, and commanded him to be called. And they call the blind man, saying unto him, Be of good comfort, rise; he calleth thee.

50 And he, casting away his garment, rose, and came to Jesus.

51 And Jesus answered and said unto him, What wilt thou that I should do unto thee? The blind man said unto him, Lord, that I might receive my sight.

52 And Jesus said unto him, Go thy way; thy faith hath made thee whole. And immediately he received his sight, and followed Jesus in the way.

LUKE 18:35–43

35 And it came to pass, that as he was come nigh unto Jericho, a certain blind man sat by the way side begging:

36 And hearing the multitude pass by, he asked what it meant.

37 And they told him, that Jesus of Nazareth passeth by.

38 And he cried, saying, Jesus, thou Son of David, have mercy on me.

39 And they which went before rebuked him, that he should hold his peace: but he cried so much the more, Thou Son of David, have mercy on me.

40 And Jesus stood, and commanded him to be brought unto him and when he was come near, he asked him,

41 Saying, What wilt thou that I shall do unto thee? And he said, Lord, that I may receive my sight.

42 And Jesus said unto him, Receive thy sight: thy faith hath saved thee.

43 And immediately he received his sight, and followed him, glorifying God: and all the people, when they saw it, gave praise unto God.

ZACCHAEUS CLIMBS A TREE TO SEE JESUS

MATTHEW 18:11

11 For the Son of man is come to save that which was lost.

LUKE 19:1–10

1 And Jesus entered and passed through Jericho.

2 And, behold, there was a man named Zacchaeus, which was the chief among the publicans, and he was rich.

3 And he sought to see Jesus who he was; and could not for the press, because he was little of stature.

4 And he ran before, and climbed up into a sycomore tree to see him: for he was to pass that way.

5 And when Jesus came to the place, he looked up, and saw him, and said unto him, Zacchaeus, make haste, and come down; for to day I must abide at thy house.

6 And he made haste, and came down, and received him joyfully.

7 And when they saw it, they all murmured, saying, That he was gone to be guest with a man that is a sinner.

8 And Zacchaeus stood, and said unto the Lord; Behold, Lord, the half of my goods I give to the poor; and if I have taken any thing from any man by false accusation, I restore him fourfold.

9 And Jesus said unto him, This day is salvation come to this house, forsomuch as he also is a son of Abraham.

10 For the Son of man is come to seek and to save that which was lost.

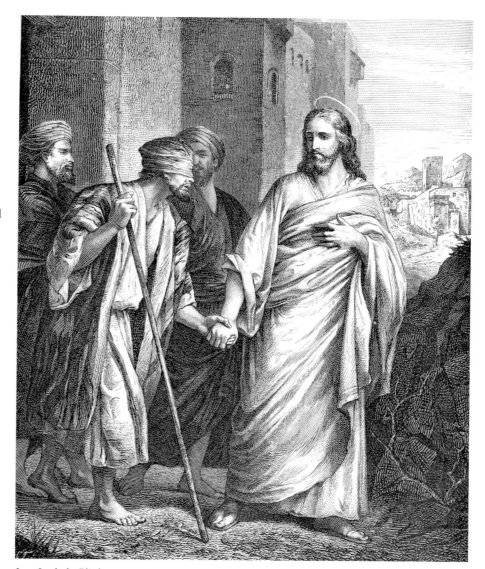

Jesus Leads the Blind, by Alexander Bida, 1813–1895

And he ran before, and climbed up into a sycomore tree to see him: for he was to pass that way.

And when Jesus came to the place, he looked up, and saw him, and said unto him, Zacchaeus, make haste, and come down;
for to day I must abide at thy house.

—LUKE 19:4–5

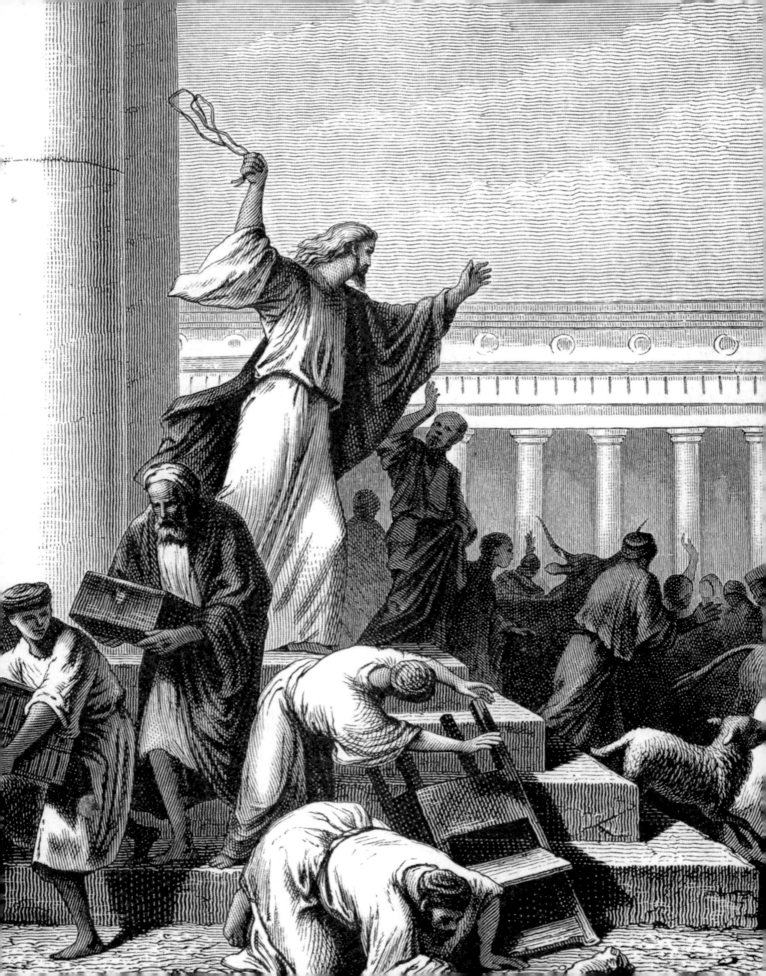

LIFE of JESUS

Jesus Enters Jerusalem

Jesus Enters Jerusalem

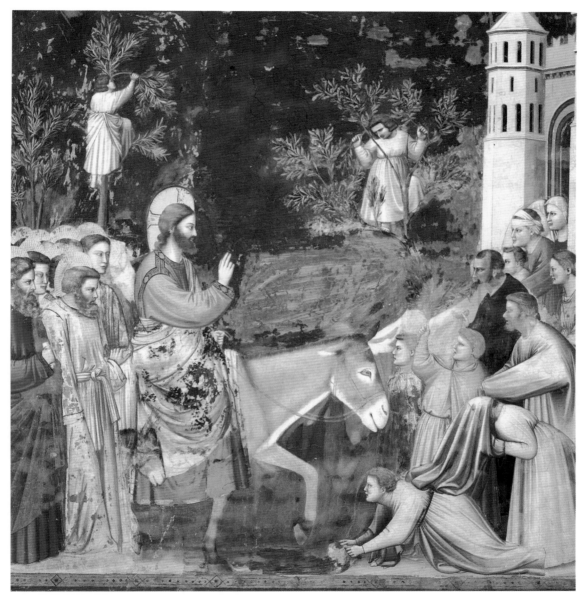

Triumphal Entry into Jerusalem, by Giotto Di Bondone, 1276–1337

PASSOVER, THE FEAST OF DELIVERANCE, marks a new beginning for God's people in Egypt. Slaves of a cruel ruler, they are set free by the LORD's hand. With signs and wonders they are brought to a new land—the land promised generations before to their ancestors. Like Moses and Joshua before him, Jesus understands his mission as the agent of God's deliverance. He takes the fulfillment of the prophets' words as God's master plan for his people's redemption.

JESUS ENTERS JERUSALEM

MATTHEW 21:1–9

1 And when they drew nigh unto Jerusalem, and were come to Bethphage, unto the mount of Olives, then sent Jesus two disciples,

2 Saying unto them, Go into the village over against you, and straightway ye shall find an ass tied, and a colt with her: loose them, and bring them unto me.

3 And if any man say ought unto you, ye shall say, The Lord hath need of them; and straightway he will send them.

4 All this was done, that it might be fulfilled which was spoken by the prophet, saying,

5 Tell ye the daughter of Sion, Behold, thy King cometh unto thee, meek, and sitting upon an ass, and a colt the foal of an ass.

6 And the disciples went, and did as Jesus commanded them,

7 And brought the ass, and the colt, and put on them their clothes, and they set him thereon.

8 And a very great multitude spread their garments in the way; others cut down branches from the trees, and strawed them in the way.

9 And the multitudes that went before, and that followed, cried, saying, Hosanna to the Son of David: Blessed is he that cometh in the name of the Lord; Hosanna in the highest.

MARK 11:1–10

1 And when they came nigh to Jerusalem, unto Bethphage and Bethany, at the mount of Olives, he sendeth forth two of his disciples,

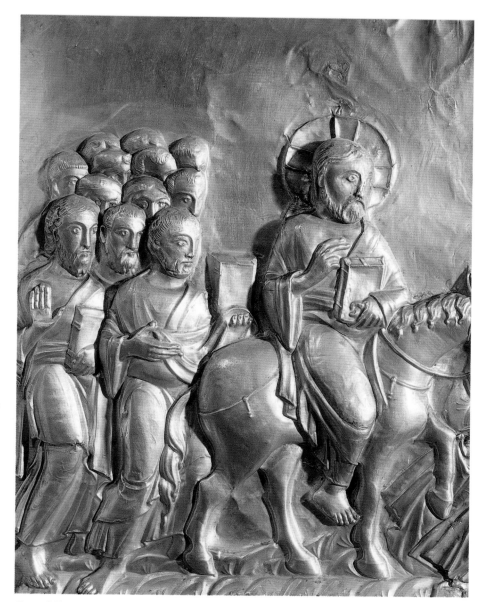

Entry of Christ into Jerusalem, 1020, from the Pala d'Oro altar piece

And the multitudes that went before, and that followed, cried, saying, Hosanna to the Son of David: Blessed is he that cometh in the name of the Lord; Hosanna in the highest.

—MATTHEW 21:9

2 And saith unto them, Go your way into the village over against you: and as soon as ye be entered into it, ye shall find a colt tied, whereon never man sat; loose him, and bring him.

3 And if any man say unto you, Why do ye this? say ye that the Lord hath need of him; and straightway he will send him hither.

4 And they went their way, and found the colt tied by the door without in a place where two ways met; and they loose him.

5 And certain of them that stood there said unto them, What do ye, loosing the colt?

6 And they said unto them even as Jesus had commanded: and they let them go.

7 And they brought the colt to Jesus, and cast their garments on him; and he sat upon him.

8 And many spread their garments in the way: and others cut down branches off the trees, and strawed them in the way.

9 And they that went before, and they that followed, cried, saying, Hosanna; Blessed is he that cometh in the name of the Lord:

10 Blessed be the kingdom of our father David, that cometh in the name of the Lord: Hosanna in the highest.

LUKE 19:28–40

28 And when he had thus spoken, he went before, ascending up to Jerusalem.

29 And it came to pass, when he was come nigh to Bethphage and Bethany, at the mount called the mount of Olives, he sent two of his disciples,

30 Saying, Go ye into the village over against you; in the which at your entering ye shall find a colt tied, whereon yet never man sat: loose him, and bring him hither.

31 And if any man ask you, Why do ye loose him? thus shall ye say unto him, Because the Lord hath need of him.

32 And they that were sent went their way, and found even as he had said unto them.

33 And as they were loosing the colt, the owners thereof said unto them, Why loose ye the colt?

34 And they said, The Lord hath need of him.

35 And they brought him to Jesus: and they cast their garments upon the colt, and they set Jesus thereon.

36 And as he went, they spread their clothes in the way.

37 And when he was come nigh, even now at the descent of the mount of Olives, the whole multitude of the disciples began to rejoice and praise God with a loud voice for all the mighty works that they had seen;

38 Saying, Blessed be the King that cometh in the name of the Lord: peace in heaven, and glory in the highest.

39 And some of the Pharisees from among the multitude said unto him, Master, rebuke thy disciples.

40 And he answered and said unto them, I tell you that, if these should hold their peace, the stones would immediately cry out.

JOHN 12:12–19

12 On the next day much people that were come to the feast, when they heard that Jesus was coming to Jerusalem,

13 Took branches of palm trees, and went forth to meet him, and cried, Hosanna: Blessed is the King of Israel that cometh in the name of the Lord.

14 And Jesus, when he had found a young ass, sat thereon; as it is written,

15 Fear not, daughter of Sion: behold, thy King cometh, sitting on an ass's colt.

16 These things understood not his disciples at the first: but when Jesus was glorified, then remembered they that these things were written of him, and that they had done these things unto him.

17 The people therefore that was with him when he called Lazarus out of his grave, and raised him from the dead, bare record.

18 For this cause the people also met him, for that they heard that he had done this miracle.

19 The Pharisees therefore said among themselves, Perceive ye how ye prevail nothing? behold, the world is gone after him.

LUKE 19:41–44

41 And when he was come near, he beheld the city, and wept over it,

42 Saying, If thou hadst known, even thou, at least in this thy day, the things which belong unto thy peace! but now they are hid from thine eyes.

43 For the days shall come upon thee, that thine enemies shall cast a trench about thee, and compass thee round, and keep thee in on every side,

And many spread their garments in the way: and others cut down branches off the trees, and strawed them in the way.

—MARK 11:8

44 And shall lay thee even with the ground, and thy children within thee; and they shall not leave in thee one stone upon another; because thou knewest not the time of thy visitation.

JESUS DRIVES THE BUYERS AND SELLERS FROM THE TEMPLE COURTS

For Mark and Matthew, this is the first time Jesus visits Jerusalem and the Temple. An architectural masterpiece rebuilt by Herod the Great, the Temple reflected the daylight sun so well it was difficult to look at its brightness. But what Jesus sees inside—moneychangers and sellers of sacrificial animals—moves him to immediate action, and he casts them all out. Jesus' word of rebuke is drawn from God's words in Isaiah 56:7: "Mine house shall be called an house of prayer for all people," and Jeremiah 7:11: "Is this house, which is called by my name, become a den of robbers?…Behold, even I have seen it, saith the LORD." John, who puts this episode at the beginning of Jesus' ministry, adds another quote from Psalm 69:9: "The zeal of thy house has eaten me up." John also places here Jesus' prophecy of his resurrection: "Destroy this temple and in three days I will raise it up." The portrayal brings to mind the words of the prophet Malachi (3:1–3), cited earlier in connection with John the Baptist: "Behold I send my messenger, and he shall prepare my way for me: and the Lord, whom ye seek, shall suddenly come into his temple…and he shall purify the sons of Levi…that they may offer unto the LORD an offering in righteousness."

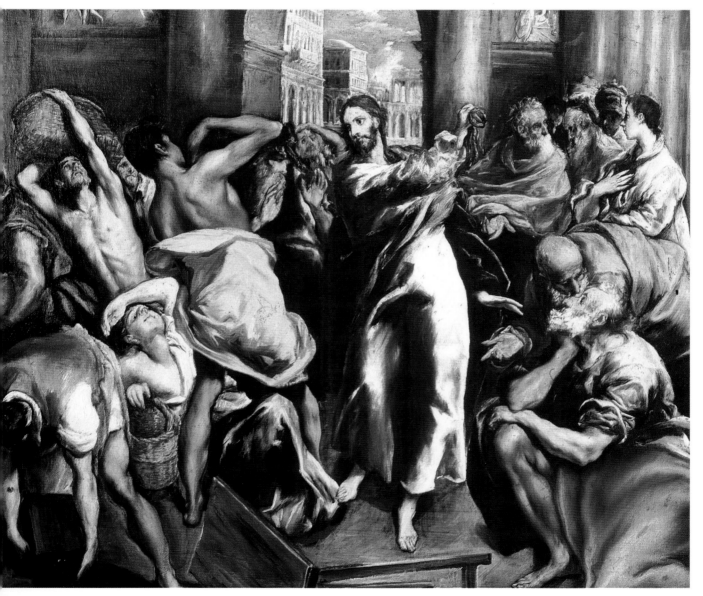

Expulsion of Traders from Temple, 1600, by El Greco, 1540–1614

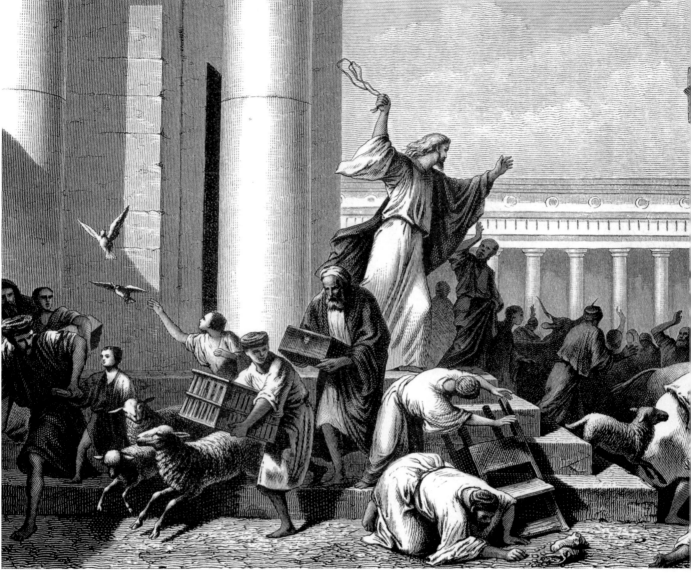

Jesus Drives the Money-Changers from the Temple, by Alexander Bida, 1813–1895

MATTHEW 21:10–17

10 And when he was come into Jerusalem, all the city was moved, saying, Who is this?

11 And the multitude said, This is Jesus the prophet of Nazareth of Galilee.

12 And Jesus went into the temple of God, and cast out all them that sold and bought in the temple, and over-threw the tables of the moneychang-ers, and the seats of them that sold doves,

13 And said unto them, It is written, My house shall be called the house of prayer; but ye have made it a den of thieves.

14 And the blind and the lame came to him in the temple; and he healed them.

15 And when the chief priests and scribes saw the wonderful things that he did, and the children crying in the temple, and saying, Hosanna to the Son of David; they were sore displeased,

16 And said unto him, Hearest thou

what these say? And Jesus saith unto them, Yea; have ye never read, Out of the mouth of babes and sucklings thou hast perfected praise?

17 And he left them, and went out of the city into Bethany; and he lodged there.

MARK 11:11

11 And Jesus entered into Jerusalem, and into the temple: and when he had looked round about upon all things, and now the eventide was come, he went out unto Bethany with the twelve.

LUKE 19:45–46

45 And he went into the temple, and began to cast out them that sold therein, and them that bought;

46 Saying unto them, It is written, My house is the house of prayer: but ye have made it a den of thieves.

JOHN 2:13–17

13 And the Jews' passover was at hand, and Jesus went up to Jerusalem,

14 And found in the temple those that sold oxen and sheep and doves, and the changers of money sitting:

15 And when he had made a scourge of small cords, he drove them all out of the temple, and the sheep, and the oxen; and poured out the changers' money, and overthrew the tables;

16 And said unto them that sold doves, Take these things hence; make not my Father's house an house of merchandise.

17 And his disciples remembered that it was written, The zeal of thine house hath eaten me up.

MARK 11:15–17

15 And they come to Jerusalem: and Jesus went into the temple, and began to cast out them that sold and bought in the temple, and overthrew the tables of the moneychangers, and the seats of them that sold doves;

16 And would not suffer that any man should carry any vessel through the temple.

17 And he taught, saying unto them, Is it not written, My house shall be called of all nations the house of prayer? but ye have made it a den of thieves.

LUKE 19:39–40

39 And some of the Pharisees from among the multitude said unto him, Master, rebuke thy disciples.

40 And he answered and said unto them, I tell you that, if these should hold their peace, the stones would immediately cry out.

LUKE 21:37

37 And in the day time he was teaching in the temple; and at night he went out, and abode in the mount that is called the mount of Olives.

JESUS AND THE UNPRODUCTIVE FIG TREE

MATTHEW 21:18–22

18 Now in the morning as he returned into the city, he hungered.

19 And when he saw a fig tree in the way, he came to it, and found nothing thereon, but leaves only, and said unto it, Let no fruit grow on thee henceforward for ever. And presently the fig tree withered away.

20 And when the disciples saw it, they marvelled, saying, How soon is the fig tree withered away!

21 Jesus answered and said unto them, Verily I say unto you, If ye have

faith, and doubt not, ye shall not only do this which is done to the fig tree, but also if ye shall say unto this mountain, Be thou removed, and be thou cast into the sea; it shall be done.

22 And all things, whatsoever ye shall ask in prayer, believing, ye shall receive.

MARK 11:12–14

12 And on the morrow, when they were come from Bethany, he was hungry:

13 And seeing a fig tree afar off having leaves, he came, if haply he might find any thing thereon: and when he came to it, he found nothing but leaves; for the time of figs was not yet.

14 And Jesus answered and said unto it, No man eat fruit of thee hereafter for ever. And his disciples heard it.

LUKE 19:6–9

6 And he made haste, and came down, and received him joyfully.

7 And when they saw it, they all murmured, saying, That he was gone to be guest with a man that is a sinner.

And said unto them that sold doves, Take these things hence; make not my Father's house an house of merchandise.

And his disciples remembered that it was written, The zeal of thine house hath eaten me up.

—JOHN 2:16–17

Jesus Drives the Money-Changers out of the Temple, 1521, by Lucas Cranach, the Elder, 1472–1553

26 But if ye do not forgive, neither will your Father which is in heaven forgive your trespasses.

BY WHOSE AUTHORITY ARE YOU DOING THESE THINGS?

MATTHEW 21:23–27

23 And when he was come into the temple, the chief priests and the elders of the people came unto him as he was teaching, and said, By what authority doest thou these things? and who gave thee this authority?

24 And Jesus answered and said unto them, I also will ask you one thing, which if ye tell me, I in like wise will tell you by what authority I do these things.

25 The baptism of John, whence was it? from heaven, or of men? And they reasoned with themselves, saying, If we shall say, From heaven; he will say unto us, Why did ye not then believe him?

26 But if we shall say, Of men; we fear the people; for all hold John as a prophet.

27 And they answered Jesus, and said, We cannot tell. And he said unto them, Neither tell I you by what authority I do these things.

MARK 11:27–33

27 And they come again to Jerusalem: and as he was walking in the temple, there come to him the chief priests, and the scribes, and the elders,

28 And say unto him, By what authority doest thou these things? and who gave thee this authority to do these things?

29 And Jesus answered and said unto them, I will also ask of you one question, and answer me, and I will tell you by what authority I do these things.

8 And Zacchaeus stood, and said unto the Lord; Behold, Lord, the half of my goods I give to the poor; and if I have taken any thing from any man by false accusation, I restore him fourfold.

9 And Jesus said unto him, This day is salvation come to this house, forsomuch as he also is a son of Abraham.

MARK 11:20–26

20 And in the morning, as they passed by, they saw the fig tree dried up from the roots.

21 And Peter calling to remembrance saith unto him, Master, behold, the fig tree which thou cursedst is withered away.

22 And Jesus answering saith unto them, Have faith in God.

23 For verily I say unto you, That whosoever shall say unto this mountain, Be thou removed, and be thou cast into the sea; and shall not doubt in his heart, but shall believe that those things which he saith shall come to pass; he shall have whatsoever he saith.

24 Therefore I say unto you, What things soever ye desire, when ye pray, believe that ye receive them, and ye shall have them.

25 And when ye stand praying, forgive, if ye have ought against any: that your Father also which is in heaven may forgive you your trespasses.

30 The baptism of John, was it from heaven, or of men? answer me.

31 And they reasoned with themselves, saying, If we shall say, From heaven; he will say, Why then did ye not believe him?

32 But if we shall say, Of men; they feared the people: for all men counted John, that he was a prophet indeed.

33 And they answered and said unto Jesus, We cannot tell. And Jesus answering saith unto them, Neither do I tell you by what authority I do these things.

LUKE 20:1–8

1 And it came to pass, that on one of those days, as he taught the people in the temple, and preached the gospel, the chief priests and the scribes came upon him with the elders,

2 And spake unto him, saying, Tell us, by what authority doest thou these things? or who is he that gave thee this authority?

3 And he answered and said unto them, I will also ask you one thing; and answer me:

4 The baptism of John, was it from heaven, or of men?

5 And they reasoned with themselves, saying, If we shall say, From heaven; he will say, Why then believed ye him not?

6 But and if we say, Of men; all the people will stone us: for they be persuaded that John was a prophet.

7 And they answered, that they could not tell whence it was.

8 And Jesus said unto them, Neither tell I you by what authority I do these things.

JOHN 2:18–22

18 Then answered the Jews and said unto him, What sign shewest thou

unto us, seeing that thou doest these things?

19 Jesus answered and said unto them, Destroy this temple, and in three days I will raise it up.

20 Then said the Jews, Forty and six years was this temple in building, and wilt thou rear it up in three days?

21 But he spake of the temple of his body.

22 When therefore he was risen from the dead, his disciples remembered that he had said this unto them; and they believed the scripture, and the word which Jesus had said.

A PARABLE ABOUT TWO SONS

MATTHEW 21:28–32

28 But what think ye? A certain man had two sons; and he came to the first, and said, Son, go work to day in my vineyard.

29 He answered and said, I will not: but afterward he repented, and went.

30 And he came to the second, and said likewise. And he answered and said, I go, sir: and went not.

31 Whether of them twain did the will of his father? They say unto him, The first. Jesus saith unto them, Verily I say unto you, That the publicans and the harlots go into the kingdom of God before you.

32 For John came unto you in the way of righteousness, and ye believed him not: but the publicans and the harlots believed him and ye, when ye had seen it, repented not afterward, that ye might believe him.

LUKE 7:29–30

29 And all the people that heard him, and the publicans, justified God,

being baptized with the baptism of John.

30 But the Pharisees and lawyers rejected the counsel of God against themselves, being not baptized of him.

A PARABLE ABOUT A VINEYARD'S WICKED TENANTS

Earlier in Mark's story (Mark 4:3–9), the Sower (Jesus) sows seeds abundantly in every place; some grow, and some do not. This parable picks up the prophetic imagery of God's people as a vineyard or a fig tree, from which God looks for fruit and finds none. Here the parable is modeled to portray the way the tenants of the vineyard (the leaders of God's people) have failed to pass along the fruits to which the owner of the vineyard is entitled. The "beloved son" is thrown out of the vineyard and killed by the rebellious tenants— but God will have the last word. Once again the Hallel of the Passover Seder is quoted in connection with the story of Jesus: "The stone which the builders rejected has become the head of the corner: this is the LORD's doing, and it is marvelous in our eyes" (Psalm 118:22–23).

MATTHEW 21:33–46

33 Hear another parable: There was a certain householder, which planted a vineyard, and hedged it round about, and digged a winepress in it, and built a tower, and let it out to husbandmen, and went into a far country:

34 And when the time of the fruit drew near, he sent his servants to the husbandmen, that they might receive the fruits of it.

35 And the husbandmen took his servants, and beat one, and killed another, and stoned another.

36 Again, he sent other servants more than the first: and they did unto them likewise.

soever it shall fall, it will grind him to powder.

45 And when the chief priests and Pharisees had heard his parables, they perceived that he spake of them.

46 But when they sought to lay hands on him, they feared the multitude, because they took him for a prophet.

MARK 12:1–12

1 And he began to speak unto them by parables. A certain man planted a vineyard, and set an hedge about it, and digged a place for the winefat, and built a tower, and let it out to husbandmen, and went into a far country.

2 And at the season he sent to the husbandmen a servant, that he might receive from the husbandmen of the fruit of the vineyard.

3 And they caught him, and beat him, and sent him away empty.

4 And again he sent unto them another servant; and at him they cast stones, and wounded him in the head, and sent him away shamefully handled.

5 And again he sent another; and him they killed, and many others; beating some, and killing some.

6 Having yet therefore one son, his well-beloved, he sent him also last unto them, saying, They will reverence my son.

7 But those husbandmen said among themselves, This is the heir; come, let us kill him, and the inheritance shall be ours.

8 And they took him, and killed him, and cast him out of the vineyard.

9 What shall therefore the lord of the vineyard do? he will come and destroy the husbandmen, and will give the vineyard unto others.

Return of the Prodigal Son, by Alexander Bida, 1813–1895

37 But last of all he sent unto them his son, saying, They will reverence my son.

38 But when the husbandmen saw the son, they said among themselves, This is the heir; come, let us kill him, and let us seize on his inheritance.

39 And they caught him, and cast him out of the vineyard, and slew him.

40 When the lord therefore of the vineyard cometh, what will he do unto those husbandmen?

41 They say unto him, He will miserably destroy those wicked men, and will let out his vineyard unto other husbandmen, which shall render him the fruits in their seasons.

42 Jesus saith unto them, Did ye never read in the scriptures, The stone which the builders rejected, the same is become the head of the corner: this is the Lord's doing, and it is marvellous in our eyes?

43 Therefore say I unto you, The kingdom of God shall be taken from you, and given to a nation bringing forth the fruits thereof.

44 And whosoever shall fall on this stone shall be broken: but on whom-

10 And have ye not read this scripture; The stone which the builders rejected is become the head of the corner:

11 This was the Lord's doing, and it is marvellous in our eyes?

12 And they sought to lay hold on him, but feared the people: for they knew that he had spoken the parable against them and they left him, and went their way.

LUKE 20:9–19

9 Then began he to speak to the people this parable; A certain man planted a vineyard, and let it forth to husbandmen, and went into a far country for a long time.

10 And at the season he sent a servant to the husbandmen, that they should give him of the fruit of the vineyard: but the husbandmen beat him, and sent him away empty.

11 And again he sent another servant: and they beat him also, and entreated him shamefully, and sent him away empty.

12 And again he sent a third: and they wounded him also, and cast him out.

13 Then said the lord of the vineyard, What shall I do? I will send my beloved son: it may be they will reverence him when they see him.

14 But when the husbandmen saw him, they reasoned among themselves, saying, This is the heir: come, let us kill him, that the inheritance may be ours.

15 So they cast him out of the vineyard, and killed him. What therefore shall the lord of the vineyard do unto them?

16 He shall come and destroy these husbandmen, and shall give the vineyard to others. And when they heard it, they said, God forbid.

17 And he beheld them, and said, What is this then that is written, The stone which the builders rejected, the same is become the head of the corner?

And he saith unto them, Whose is this image and superscription?

They say unto him, Caesar's. Then saith he unto them, Render therefore unto Caesar the things which are Caesar's; and unto God the things that are God's.

—MATTHEW 22:20–21

18 Whosoever shall fall upon that stone shall be broken; but on whomsoever it shall fall, it will grind him to powder.

19 And the chief priests and the scribes the same hour sought to lay hands on him; and they feared the people: for they perceived that he had spoken this parable against them.

A PARABLE ABOUT A GREAT (MARRIAGE) FEAST

MATTHEW 22:1–14

1 And Jesus answered and spake unto them again by parables, and said,

2 The kingdom of heaven is like unto a certain king, which made a marriage for his son,

3 And sent forth his servants to call them that were bidden to the wedding: and they would not come.

4 Again, he sent forth other servants, saying, Tell them which are bidden, Behold, I have prepared my dinner: my oxen and my fatlings are killed, and all things are ready: come unto the marriage.

5 But they made light of it, and went their ways, one to his farm, another to his merchandise:

6 And the remnant took his servants, and entreated them spitefully, and slew them.

7 But when the king heard thereof, he was wroth: and he sent forth his armies, and destroyed those murderers, and burned up their city.

8 Then saith he to his servants, The wedding is ready, but they which were bidden were not worthy.

9 Go ye therefore into the highways, and as many as ye shall find, bid to the marriage.

10 So those servants went out into the highways, and gathered together all as many as they found, both bad and good: and the wedding was furnished with guests.

11 And when the king came in to see the guests, he saw there a man which had not on a wedding garment:

12 And he saith unto him, Friend, how camest thou in hither not having a wedding garment? And he was speechless.

13 Then said the king to the servants, Bind him hand and foot, and take him away, and cast him into outer darkness; there shall be weeping and gnashing of teeth.

14 For many are called, but few are chosen.

LUKE 14:15–24

15 And when one of them that sat at meat with him heard these things, he said unto him, Blessed is he that shall eat bread in the kingdom of God.

16 Then said he unto him, A certain man made a great supper, and bade many:

17 And sent his servant at supper time to say to them that were bidden, Come; for all things are now ready.

18 And they all with one consent began to make excuse. The first said unto him, I have bought a piece of ground, and I must needs go and see it: I pray thee have me excused.

19 And another said, I have bought five yoke of oxen, and I go to prove them: I pray thee have me excused.

20 And another said, I have married a wife, and therefore I cannot come.

21 So that servant came, and shewed his lord these things. Then the master of the house being angry said to his servant, Go out quickly into the streets and lanes of the city, and bring in hither the poor, and the maimed, and the halt, and the blind.

22 And the servant said, Lord, it is done as thou hast commanded, and yet there is room.

23 And the lord said unto the servant, Go out into the highways and hedges, and compel them to come in, that my house may be filled.

24 For I say unto you, That none of those men which were bidden shall taste of my supper.

JESUS QUESTIONED ABOUT PAYING TRIBUTE TO THE EMPEROR

One after another, Jesus' opponents try to trap him into making a statement that can be used in their case against him. First in line are the Pharisees and the Herodians, who ask him about paying taxes to the Emperor. If he says, "Yes," he loses face before those who believe that God is their only legitimate ruler (and the Roman coinage, unlike Jewish coins, contains a "graven image" of the emperor on it). If he says, "No," then he speaks treason against the occupying Romans. Next in line are the Sadducees, who, unlike the Pharisees, do not believe in a resurrection after death. In an earlier story about the greatest commandment, Mark has a scribe asking the question sincerely, while Matthew has a lawyer from the Pharisees (in Luke, he is simply a lawyer) ask the question. The outcome is the same: after this no one else dares to ask him any questions. Now Jesus asks a "teaser" question about the Messiah (Christ) of God: How can he be David's son, if David (in Psalm 110:1) says, "The LORD said to my Lord, Sit thou on my right hand, till I make thy enemies my footstool?" If David calls him Lord, how can he be his son? The question goes before the reader, to ponder as the story moves to its dramatic climax.

MATTHEW 22:15–22

15 Then went the Pharisees, and took counsel how they might entangle him in his talk.

16 And they sent out unto him their disciples with the Herodians, saying, Master, we know that thou art true, and teachest the way of God in truth, neither carest thou for any man: for thou regardest not the person of men.

17 Tell us therefore, What thinkest thou? Is it lawful to give tribute unto Caesar, or not?

18 But Jesus perceived their wickedness, and said, Why tempt ye me, ye hypocrites?

19 Shew me the tribute money. And they brought unto him a penny.

20 And he saith unto them, Whose is this image and superscription?

21 They say unto him, Caesar's. Then saith he unto them, Render therefore unto Caesar the things which are Caesar's; and unto God the things that are God's.

22 When they had heard these words, they marvelled, and left him, and went their way.

MARK 12:13–17

13 And they send unto him certain of the Pharisees and of the Herodians, to catch him in his words.

14 And when they were come, they say unto him, Master, we know that thou art true, and carest for no man: for thou regardest not the person of men, but teachest the way of God in truth: Is it lawful to give tribute to Caesar, or not?

15 Shall we give, or shall we not give? But he, knowing their hypocrisy, said unto them, Why tempt ye me? bring me a penny, that I may see it.

16 And they brought it. And he saith unto them, Whose is this image and superscription? And they said unto him, Caesar's.

17 And Jesus answering said unto them, Render to Caesar the things that are Caesar's, and to God the things that are God's. And they marvelled at him.

LUKE 20:20–26

20 And they watched him, and sent forth spies, which should feign themselves just men, that they might take hold of his words, that so they might deliver him unto the power and authority of the governor.

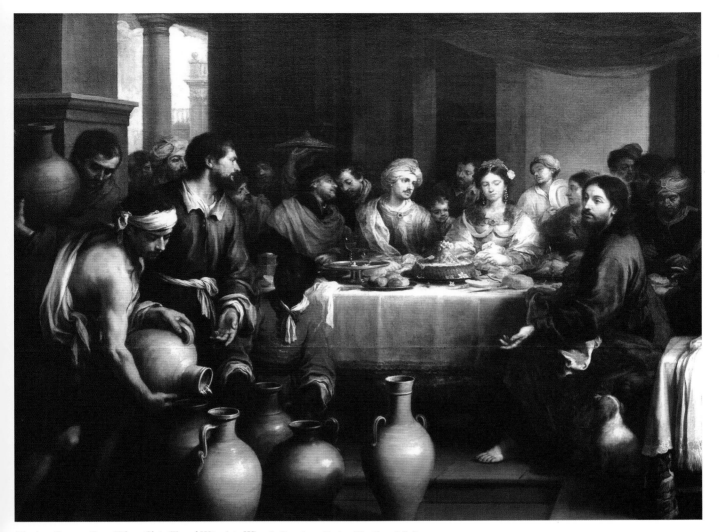

Marriage Feast at Cana, Where Christ Turned Water into Wine, by Bartolome Esteban Murillo, 1618–82

21 And they asked him, saying, Master, we know that thou sayest and teachest rightly, neither acceptest thou the person of any, but teachest the way of God truly:

22 Is it lawful for us to give tribute unto Caesar, or no?

23 But he perceived their craftiness, and said unto them, Why tempt ye me?

24 Shew me a penny. Whose image and superscription hath it? They answered and said, Caesar's.

25 And he said unto them, Render therefore unto Caesar the things which be Caesar's, and unto God the things which be God's.

26 And they could not take hold of his words before the people: and they marvelled at his answer, and held their peace.

JESUS QUESTIONED ABOUT THE RESURRECTION

MATTHEW 22:23–33

23 The same day came to him the Sadducees, which say that there is no resurrection, and asked him,

24 Saying, Master, Moses said, If a man die, having no children, his brother shall marry his wife, and raise up seed unto his brother.

25 Now there were with us seven brethren: and the first, when he had married a wife, deceased, and, having no issue, left his wife unto his brother:

26 Likewise the second also, and the third, unto the seventh.

27 And last of all the woman died also.

28 Therefore in the resurrection whose wife shall she be of the seven? for they all had her.

29 Jesus answered and said unto them, Ye do err, not knowing the scriptures, nor the power of God.

30 For in the resurrection they neither marry, nor are given in marriage, but are as the angels of God in heaven.

31 But as touching the resurrection of the dead, have ye not read that which was spoken unto you by God, saying,

32 I am the God of Abraham, and the God of Isaac, and the God of Jacob? God is not the God of the dead, but of the living.

33 And when the multitude heard this, they were astonished at his doctrine.

MARK 12:18–27

18 Then come unto him the Sadducees, which say there is no resurrection; and they asked him, saying,

19 Master, Moses wrote unto us, If a man's brother die, and leave his wife behind him, and leave no children, that his brother should take his wife, and raise up seed unto his brother.

20 Now there were seven brethren: and the first took a wife, and dying left no seed.

21 And the second took her, and died, neither left he any seed: and the third likewise.

22 And the seven had her, and left no seed: last of all the woman died also.

23 In the resurrection therefore, when they shall rise, whose wife shall she be of them? for the seven had her to wife.

24 And Jesus answering said unto them, Do ye not therefore err, because ye know not the scriptures, neither the power of God?

25 For when they shall rise from the dead, they neither marry, nor are given in marriage; but are as the angels which are in heaven.

26 And as touching the dead, that they rise: have ye not read in the book of Moses, how in the bush God spake unto him, saying, I am the God of Abraham, and the God of Isaac, and the God of Jacob?

27 He is not the God of the dead, but the God of the living: ye therefore do greatly err.

LUKE 20:27–40

27 Then came to him certain of the Sadducees, which deny that there is any resurrection; and they asked him,

28 Saying, Master, Moses wrote unto us, If any man's brother die, having a wife, and he die without children, that his brother should take his wife, and raise up seed unto his brother.

29 There were therefore seven brethren: and the first took a wife, and died without children.

30 And the second took her to wife, and he died childless.

31 And the third took her; and in like manner the seven also: and they left no children, and died.

32 Last of all the woman died also.

33 Therefore in the resurrection whose wife of them is she? for seven had her to wife.

34 And Jesus answering said unto them, The children of this world marry, and are given in marriage:

35 But they which shall be accounted worthy to obtain that world, and the resurrection from the dead, neither marry, nor are given in marriage:

36 Neither can they die any more: for they are equal unto the angels; and are the children of God, being the children of the resurrection.

37 Now that the dead are raised, even Moses shewed at the bush, when he calleth the Lord the God of Abraham, and the God of Isaac, and the God of Jacob.

38 For he is not a God of the dead, but of the living: for all live unto him.

39 Then certain of the scribes answering said, Master, thou hast well said.

40 And after that they durst not ask him any question at all.

WHICH IS THE GREATEST COMMANDMENT?

MATTHEW 22:34–40

34 But when the Pharisees had heard that he had put the Sadducees to silence, they were gathered together.

35 Then one of them, which was a lawyer, asked him a question, tempting him, and saying,

36 Master, which is the great commandment in the law?

37 Jesus said unto him, Thou shalt love the Lord thy God with all thy heart, and with all thy soul, and with all thy mind.

38 This is the first and great commandment.

39 And the second is like unto it, Thou shalt love thy neighbour as thyself.

40 On these two commandments hang all the law and the prophets.

MARK 12:28–34

28 And one of the scribes came, and having heard them reasoning together, and perceiving that he had answered them well, asked him, Which is the first commandment of all?

29 And Jesus answered him, The first of all the commandments is, Hear, O Israel; The Lord our God is one Lord:

30 And thou shalt love the Lord thy God with all thy heart, and with all thy soul, and with all thy mind, and with all thy strength: this is the first commandment.

31 And the second is like, namely this, Thou shalt love thy neighbour as thyself. There is none other commandment greater than these.

32 And the scribe said unto him, Well, Master, thou hast said the truth: for there is one God; and there is none other but he:

33 And to love him with all the heart, and with all the understanding, and with all the soul, and with all the strength, and to love his neighbour as himself, is more than all whole burnt offerings and sacrifices.

34 And when Jesus saw that he answered discreetly, he said unto him, Thou art not far from the kingdom of God. And no man after that durst ask him any question.

LUKE 10:25–28

25 And, behold, a certain lawyer stood up, and tempted him, saying, Master, what shall I do to inherit eternal life?

26 He said unto him, What is written in the law? how readest thou?

27 And he answering said, Thou shalt love the Lord thy God with all thy heart, and with all thy soul, and with all thy strength, and with all thy mind; and thy neighbour as thyself.

28 And he said unto him, Thou hast answered right: this do, and thou shalt live.

THE MESSIAH: IS HE DAVID'S SON OR DAVID'S LORD?

MATTHEW 22:41–46

41 While the Pharisees were gathered together, Jesus asked them,

42 Saying, What think ye of Christ? whose son is he? They say unto him, The Son of David.

43 He saith unto them, How then doth David in spirit call him Lord, saying,

44 The LORD said unto my Lord, Sit thou on my right hand, till I make thine enemies thy footstool?

45 If David then call him Lord, how is he his son?

46 And no man was able to answer him a word, neither durst any man from that day forth ask him any more questions.

MARK 12:35–37

35 And Jesus answered and said, while he taught in the temple, How say the scribes that Christ is the Son of David?

36 For David himself said by the Holy Ghost, The Lord said to my Lord, Sit thou on my right hand, till I make thine enemies thy footstool.

37 David therefore himself calleth him Lord; and whence is he then his son? And the common people heard him gladly.

LUKE 20:41–44

41 And he said unto them, How say they that Christ is David's son?

42 And David himself saith in the book of Psalms, The LORD said unto my Lord, Sit thou on my right hand,

43 Till I make thine enemies thy footstool.

44 David therefore calleth him Lord, how is he then his son?

MARK 12:34

34 And when Jesus saw that he answered discreetly, he said unto him, Thou art not far from the kingdom of God. And no man after that durst ask him any question.

LUKE 20:40

40 And after that they durst not ask him any question at all.

"WOE TO YOU, SCRIBES AND PHARISEES!"

MATTHEW 23:1–36

1 Then spake Jesus to the multitude, and to his disciples,

2 Saying, The scribes and the Pharisees sit in Moses' seat:

3 All therefore whatsoever they bid you observe, that observe and do; but do not ye after their works: for they say, and do not.

4 For they bind heavy burdens and grievous to be borne, and lay them on men's shoulders; but they themselves will not move them with one of their fingers.

5 But all their works they do for to be seen of men: they make broad their phylacteries, and enlarge the borders of their garments,

6 And love the uppermost rooms at feasts, and the chief seats in the synagogues,

7 And greetings in the markets, and to be called of men, Rabbi, Rabbi.

8 But be not ye called Rabbi: for one is your Master, even Christ; and all ye are brethren.

9 And call no man your father upon the earth: for one is your Father, which is in heaven.

10 Neither be ye called masters: for one is your Master, even Christ.

11 But he that is greatest among you shall be your servant.

12 And whosoever shall exalt himself shall be abased; and he that shall humble himself shall be exalted.

13 But woe unto you, scribes and Pharisees, hypocrites! for ye shut up the kingdom of heaven against men: for ye neither go in yourselves, neither suffer ye them that are entering to go in.

14 Woe unto you, scribes and Pharisees, hypocrites! for ye devour widows' houses, and for a pretence make long prayer: therefore ye shall receive the greater damnation.

15 Woe unto you, scribes and Pharisees, hypocrites! for ye compass sea and land to make one proselyte, and when he is made, ye make him twofold more the child of hell than yourselves.

16 Woe unto you, ye blind guides, which say, Whosoever shall swear by the temple, it is nothing; but whosoever shall swear by the gold of the temple, he is a debtor!

17 Ye fools and blind: for whether is greater, the gold, or the temple that sanctifieth the gold?

18 And, Whosoever shall swear by the altar, it is nothing; but whosoever sweareth by the gift that is upon it, he is guilty.

19 Ye fools and blind: for whether is greater, the gift, or the altar that sanctifieth the gift?

20 Whoso therefore shall swear by the altar, sweareth by it, and by all things thereon.

21 And whoso shall swear by the temple, sweareth by it, and by him that dwelleth therein.

22 And he that shall swear by heaven, sweareth by the throne of God, and by him that sitteth thereon.

23 Woe unto you, scribes and Pharisees, hypocrites! for ye pay tithe of mint and anise and cummin, and have omitted the weightier matters of the law, judgment, mercy, and faith: these ought ye to have done, and not to leave the other undone.

24 Ye blind guides, which strain at a gnat, and swallow a camel.

25 Woe unto you, scribes and Pharisees, hypocrites! for ye make clean the outside of the cup and of the platter, but within they are full of extortion and excess.

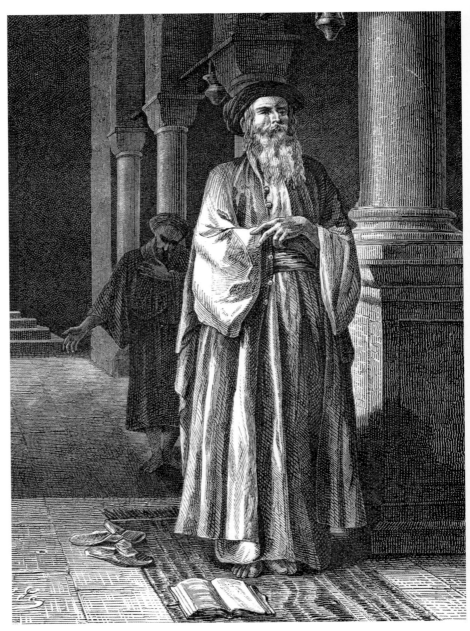

The Pharisee and the Publican, by Alexander Bida, 1813–1895

26 Thou blind Pharisee, cleanse first that which is within the cup and platter, that the outside of them may be clean also.

27 Woe unto you, scribes and Pharisees, hypocrites! for ye are like unto whited sepulchres, which indeed appear beautiful outward, but are within full of dead men's bones, and of all uncleanness.

28 Even so ye also outwardly appear righteous unto men, but within ye are full of hypocrisy and iniquity.

29 Woe unto you, scribes and Pharisees, hypocrites! because ye build the tombs of the prophets, and garnish the sepulchres of the righteous,

30 And say, If we had been in the days of our fathers, we would not have been partakers with them in the blood of the prophets.

31 Wherefore ye be witnesses unto yourselves, that ye are the children of them which killed the prophets.

32 Fill ye up then the measure of your fathers.

33 Ye serpents, ye generation of vipers, how can ye escape the damnation of hell?

34 Wherefore, behold, I send unto you prophets, and wise men, and scribes: and some of them ye shall kill and crucify; and some of them shall ye scourge in your synagogues, and persecute them from city to city:

35 That upon you may come all the righteous blood shed upon the earth, from the blood of righteous Abel unto the blood of Zacharias son of Barachias, whom ye slew between the temple and the altar.

36 Verily I say unto you, All these things shall come upon this generation.

MARK 12:37–40

37 David therefore himself calleth him Lord; and whence is he then his son? And the common people heard him gladly.

38 And he said unto them in his doctrine, Beware of the scribes, which love to go in long clothing, and love salutations in the marketplaces,

39 And the chief seats in the synagogues, and the uppermost rooms at feasts:

40 Which devour widows' houses, and for a pretence make long prayers: these shall receive greater damnation.

LUKE 20:45–47

45 Then in the audience of all the people he said unto his disciples,

46 Beware of the scribes, which desire to walk in long robes, and love greetings in the markets, and the highest seats in the synagogues, and the chief rooms at feasts;

47 Which devour widows' houses, and for a shew make long prayers: the same shall receive greater damnation.

LUKE 11:46, 52

46 And he said, Woe unto you also, ye lawyers! for ye lade men with burdens grievous to be borne, and ye yourselves touch not the burdens with one of your fingers.

52 Woe unto you, lawyers! for ye have taken away the key of knowledge: ye entered not in yourselves, and them that were entering in ye hindered.

JESUS LAMENTS OVER JERUSALEM

MATTHEW 23:37–39

37 O Jerusalem, Jerusalem, thou that killest the prophets, and stonest them which are sent unto thee, how often would I have gathered thy children together, even as a hen gathereth her chickens under her wings, and ye would not!

38 Behold, your house is left unto you desolate.

39 For I say unto you, Ye shall not see me henceforth, till ye shall say, Blessed is he that cometh in the name of the Lord.

LUKE 13:34–35

34 O Jerusalem, Jerusalem, which killest the prophets, and stonest them that are sent unto thee; how often would I have gathered thy children together, as a hen doth gather her brood under her wings, and ye would not!

35 Behold, your house is left unto you desolate: and verily I say unto you, Ye shall not see me, until the time come when ye shall say, Blessed is he that cometh in the name of the Lord.

A WIDOW'S OFFERING

When Mark wants to enlighten the reader about the major turning points in the drama of Jesus' ministry, he includes an account of someone's eyes or ears being opened. The story of the widow's offering comes as a refreshing break in the intensity of Jesus' woes to the scribes and Pharisees. A poor woman puts her offering, two copper coins, into the Temple treasury. But as Jesus points out, she gives more than all the rest: she gives herself—her whole living. She serves as a sublime parallel to Jesus, who will offer his life "as a ransom for many."

MARK 12:41–44

41 And Jesus sat over against the treasury, and beheld how the people cast money into the treasury: and many that were rich cast in much.

42 And there came a certain poor widow, and she threw in two mites, which make a farthing.

43 And he called unto him his disciples, and saith unto them, Verily I say unto you, That this poor widow hath cast more in, than all they which have cast into the treasury:

44 For all they did cast in of their abundance; but she of her want did cast in all that she had, even all her living.

LUKE 21:1–4

1 And he looked up, and saw the rich men casting their gifts into the treasury.

2 And he saw also a certain poor widow casting in thither two mites.

3 And he said, Of a truth I say unto you, that this poor widow hath cast in more than they all:

4 For all these have of their abundance cast in unto the offerings of God: but she of her penury hath cast in all the living that she had.

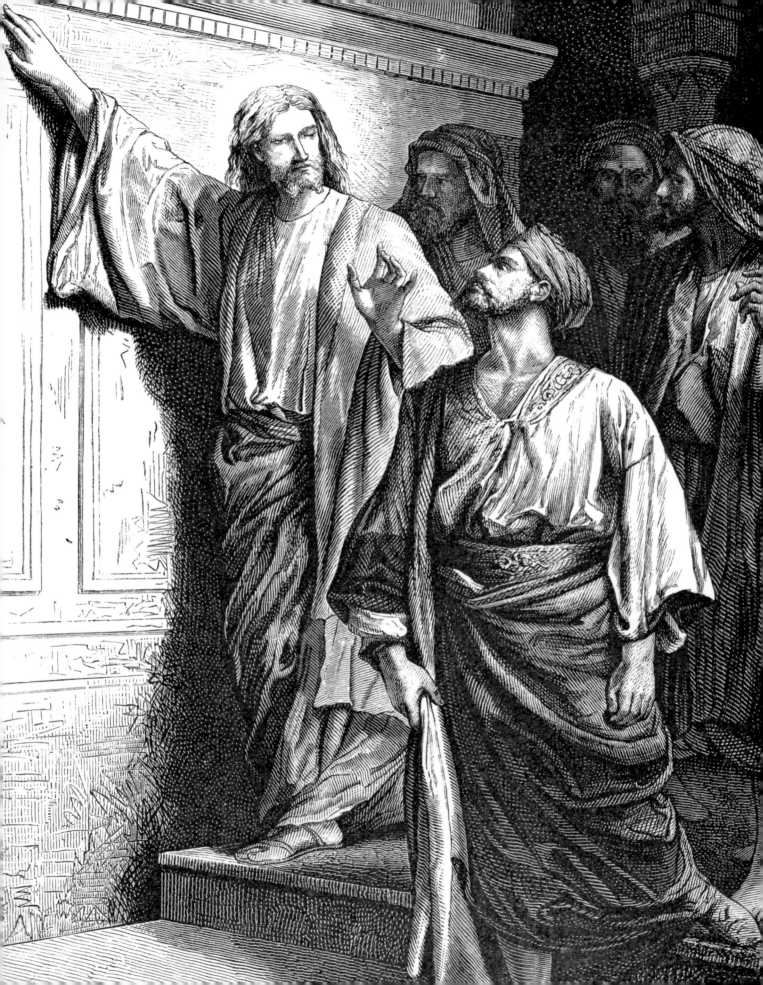

LIFE of JESUS

Jesus Prophesies and Teaches

Jesus Prophesies and Teaches

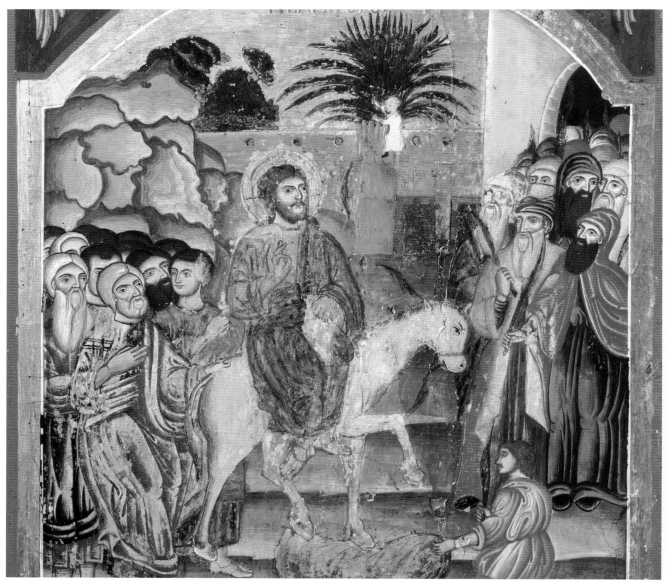

Jesus Christ Entering Jerusalem, late 17th century, Artist Unknown

JESUS ENTERS JERUSALEM from the Mount of Olives, humble, and riding on a donkey, as Zechariah portrays. But Zechariah, chapter 14, beginning at verse 2 also says, "Then shall the LORD go forth, and fight against those nations, as when he fought in the day of battle. And his feet shall stand on the Mount of Olives…and the LORD shall be king over all the earth; in that day there will be one LORD, and his name one." The prophesy Jesus makes about the Temple and its destruction is made from the Mount of Olives, Zechariah's location for the start of the end-time struggle of God against God's enemies that will usher in God's ultimate triumph.

JESUS PREDICTS THE DESTRUCTION OF THE TEMPLE

In Mark, Luke, and Matthew, Jesus begins his teaching about the last things with his prediction of the destruction of the Temple—an event that came to pass in 70 A.D. when the rebellion of the Jewish zealots (with probably some Christian Jews among them) was finally crushed: the city and the Temple were completely destroyed. Matthew's fifth and last "great sermon" or teaching section begins here and continues through the next chapter with three vivid parables about the way it will be when the Lord returns to settle accounts. The imagery that pervades this section resembles the Biblical Book of Daniel and the New Testament's Revelation (or Apocalypse)—a pictorial description that seems almost like a message in code about the final battle between good and evil, where things will get worse before they get better, but good will ultimately conquer, and God's children will all be safe and accounted for. Jesus' objective here is to warn his disciples to expect that they will be persecuted, and since no one knows exactly when these things will take place, disciples must always be alert, watching for the Lord's return.

Jesus Foretells the Destruction of the Temple, by Alexander Bida, 1813–1895

MATTHEW 24:1–8

1 And Jesus went out, and departed from the temple: and his disciples came to him for to shew him the buildings of the temple.

2 And Jesus said unto them, See ye not all these things? verily I say unto you, There shall not be left here one stone upon another, that shall not be thrown down.

3 And as he sat upon the mount of Olives, the disciples came unto him privately, saying, Tell us, when shall these things be? and what shall be the sign of thy coming, and of the end of the world?

For nation shall rise against nation, and kingdom against kingdom: and there shall be earthquakes in divers places, and there shall be famines and troubles: these are the beginnings of sorrows.

—MARK 13:8

4 And Jesus answered and said unto them, Take heed that no man deceive you.

5 For many shall come in my name, saying, I am Christ; and shall deceive many.

6 And ye shall hear of wars and rumours of wars: see that ye be not troubled: for all these things must come to pass, but the end is not yet.

7 For nation shall rise against nation, and kingdom against kingdom: and there shall be famines, and pestilences, and earthquakes, in divers places.

8 All these are the beginning of sorrows.

MARK 13:1–8

1 And as he went out of the temple, one of his disciples saith unto him, Master, see what manner of stones and what buildings are here!

2 And Jesus answering said unto him, Seest thou these great buildings? there shall not be left one stone upon another, that shall not be thrown down.

3 And as he sat upon the mount of Olives over against the temple, Peter and James and John and Andrew asked him privately,

4 Tell us, when shall these things be? and what shall be the sign when all these things shall be fulfilled?

5 And Jesus answering them began to say, Take heed lest any man deceive you:

6 For many shall come in my name, saying, I am Christ; and shall deceive many.

7 And when ye shall hear of wars and rumours of wars, be ye not troubled: for such things must needs be; but the end shall not be yet.

8 For nation shall rise against nation, and kingdom against kingdom: and there shall be earthquakes in divers

Christ Tempted by the Devil, 16th century, Artist Unknown

places, and there shall be famines and troubles: these are the beginnings of sorrows.

LUKE 21:5–11

5 And as some spake of the temple, how it was adorned with goodly stones and gifts, he said,

6 As for these things which ye behold, the days will come, in the which there shall not be left one stone upon another, that shall not be thrown down.

7 And they asked him, saying, Master, but when shall these things be? and what sign will there be when these things shall come to pass?

And this gospel of the kingdom shall be preached in all the world for a witness unto all nations; and then shall the end come.

—MATTHEW 24:14

8 And he said, Take heed that ye be not deceived: for many shall come in my name, saying, I am Christ; and the time draweth near: go ye not therefore after them.

9 But when ye shall hear of wars and commotions, be not terrified: for these things must first come to pass; but the end is not by and by.

10 Then said he unto them, Nation shall rise against nation, and kingdom against kingdom:

11 And great earthquakes shall be in divers places, and famines, and pestilences; and fearful sights and great signs shall there be from heaven.

"YOU WILL BE PERSECUTED BECAUSE OF ME"

MATTHEW 24:9–14

9 Then shall they deliver you up to be afflicted, and shall kill you: and ye shall be hated of all nations for my name's sake.

10 And then shall many be offended, and shall betray one another, and shall hate one another.

11 And many false prophets shall rise, and shall deceive many.

12 And because iniquity shall abound, the love of many shall wax cold.

13 But he that shall endure unto the end, the same shall be saved.

14 And this gospel of the kingdom shall be preached in all the world for a witness unto all nations; and then shall the end come.

MARK 13:9–13

9 But take heed to yourselves: for they shall deliver you up to councils; and in the synagogues ye shall be beaten: and ye shall be brought before rulers and kings for my sake, for a testimony against them.

10 And the gospel must first be published among all nations.

11 But when they shall lead you, and deliver you up, take no thought beforehand what ye shall speak, neither do ye premeditate: but whatsoever shall be given you in that hour, that speak ye: for it is not ye that speak, but the Holy Ghost.

12 Now the brother shall betray the brother to death, and the father the son; and children shall rise up against their parents, and shall cause them to be put to death.

13 And ye shall be hated of all men for my name's sake: but he that shall endure unto the end, the same shall be saved.

LUKE 21:12–19

12 But before all these, they shall lay their hands on you, and persecute you, delivering you up to the synagogues, and into prisons, being brought before kings and rulers for my name's sake.

13 And it shall turn to you for a testimony.

14 Settle it therefore in your hearts, not to meditate before what ye shall answer:

15 For I will give you a mouth and wisdom, which all your adversaries shall not be able to gainsay nor resist.

16 And ye shall be betrayed both by parents, and brethren, and kinsfolks, and friends; and some of you shall they cause to be put to death.

17 And ye shall be hated of all men for my name's sake.

18 But there shall not an hair of your head perish.

19 In your patience possess ye your souls.

JERUSALEM'S GREAT TRIBULATION

MATTHEW 24:15–28

15 When ye therefore shall see the abomination of desolation, spoken of by Daniel the prophet, stand in the holy place, (whoso readeth, let him understand:)

16 Then let them which be in Judaea flee into the mountains:

17 Let him which is on the housetop not come down to take any thing out of his house:

But when they shall lead you, and deliver you up, take no thought beforehand what ye shall speak, neither do ye premeditate: but whatsoever shall be given you in that hour, that speak ye: for it is not ye that speak, but the Holy Ghost.

—MARK 13:11

For as the lightning, that lighteneth out of the one part under heaven, shineth unto the other part under heaven; so shall also the Son of man be in his day.

—LUKE 17:24

18 Neither let him which is in the field return back to take his clothes.

19 And woe unto them that are with child, and to them that give suck in those days!

20 But pray ye that your flight be not in the winter, neither on the sabbath day:

21 For then shall be great tribulation, such as was not since the beginning of the world to this time, no, nor ever shall be.

22 And except those days should be shortened, there should no flesh be saved: but for the elect's sake those days shall be shortened.

23 Then if any man shall say unto you, Lo, here is Christ, or there; believe it not.

24 For there shall arise false Christs, and false prophets, and shall shew great signs and wonders; insomuch that, if it were possible, they shall deceive the very elect.

25 Behold, I have told you before.

26 Wherefore if they shall say unto you, Behold, he is in the desert; go not forth: behold, he is in the secret chambers; believe it not.

27 For as the lightning cometh out of the east, and shineth even unto the west; so shall also the coming of the Son of man be.

28 For wheresoever the carcase is, there will the eagles be gathered together.

MARK 13:14–23

14 But when ye shall see the abomination of desolation, spoken of by Daniel the prophet, standing where it ought not, (let him that readeth understand,) then let them that be in Judaea flee to the mountains:

15 And let him that is on the housetop not go down into the house, neither enter therein, to take any thing out of his house:

16 And let him that is in the field not turn back again for to take up his garment.

17 But woe to them that are with child, and to them that give suck in those days!

18 And pray ye that your flight be not in the winter.

19 For in those days shall be affliction, such as was not from the beginning of the creation which God created unto this time, neither shall be.

20 And except that the Lord had shortened those days, no flesh should be saved: but for the elect's sake, whom he hath chosen, he hath shortened the days.

21 And then if any man shall say to you, Lo, here is Christ; or, lo, he is there; believe him not:

22 For false Christs and false prophets shall rise, and shall shew signs and wonders, to seduce, if it were possible, even the elect.

23 But take ye heed: behold, I have foretold you all things.

LUKE 21:20–24

20 And when ye shall see Jerusalem compassed with armies, then know that the desolation thereof is nigh.

21 Then let them which are in Judaea flee to the mountains; and let them which are in the midst of it depart out; and let not them that are in the countries enter thereinto.

22 For these be the days of vengeance, that all things which are written may be fulfilled.

23 But woe unto them that are with child, and to them that give suck, in those days! for there shall be great distress in the land, and wrath upon this people.

24 And they shall fall by the edge of the sword, and shall be led away captive into all nations: and Jerusalem shall be trodden down of the Gentiles, until the times of the Gentiles be fulfilled.

LUKE 17:23–24, 37

23 And they shall say to you, See here; or, see there: go not after them, nor follow them.

24 For as the lightning, that lighteneth out of the one part under heaven, shineth unto the other part under heaven; so shall also the Son of man be in his day.

37 And they answered and said unto him, Where, Lord? And he said unto them, Wheresoever the body is, thither will the eagles be gathered together.

THE COMING OF THE SON OF MAN

MATTHEW 24:29–31

29 Immediately after the tribulation of those days shall the sun be darkened, and the moon shall not give her light, and the stars shall fall from heaven, and the powers of the heavens shall be shaken:

30 And then shall appear the sign of the Son of man in heaven: and then shall all the tribes of the earth mourn, and they shall see the Son of man coming in the clouds of heaven with power and great glory.

31 And he shall send his angels with a great sound of a trumpet, and they shall gather together his elect from the four winds, from one end of heaven to the other.

MARK 13:24–27

24 But in those days, after that tribulation, the sun shall be darkened, and the moon shall not give her light,

25 And the stars of heaven shall fall, and the powers that are in heaven shall be shaken.

26 And then shall they see the Son of man coming in the clouds with great power and glory.

27 And then shall he send his angels, and shall gather together his elect from the four winds, from the uttermost part of the earth to the uttermost part of heaven.

LUKE 21:25–28

25 And there shall be signs in the sun, and in the moon, and in the stars; and upon the earth distress of nations, with perplexity; the sea and the waves roaring;

26 Men's hearts failing them for fear, and for looking after those things which are coming on the earth: for the powers of heaven shall be shaken.

27 And then shall they see the Son of man coming in a cloud with power and great glory.

28 And when these things begin to come to pass, then look up, and lift up your heads; for your redemption draweth nigh.

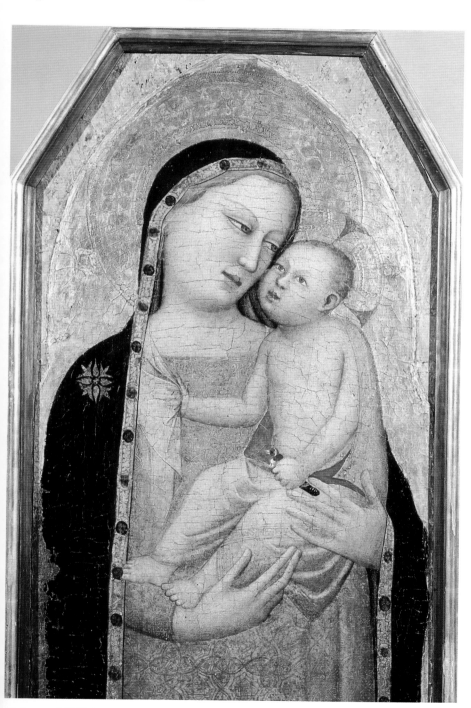

Madonna and Child, by Bernardo Daddi, 14th century

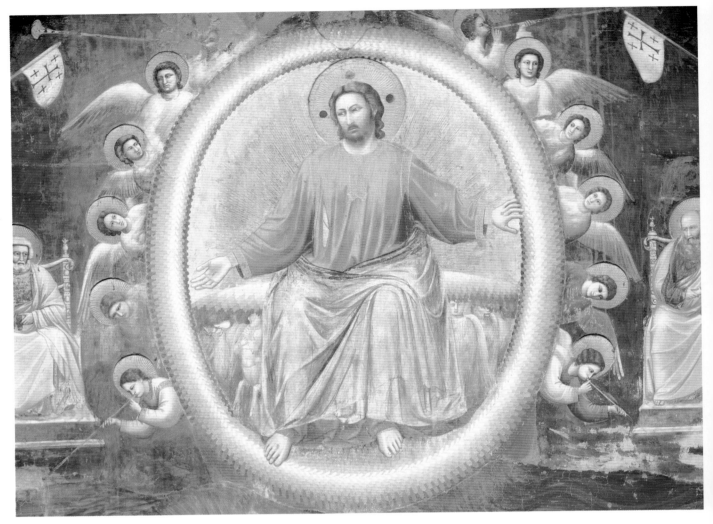

Last Judgement, Giotto Di Bondone, 1276–1337

WHEN WILL THIS TAKE PLACE?

MATTHEW 24:32–36

32 Now learn a parable of the fig tree; When his branch is yet tender, and putteth forth leaves, ye know that summer is nigh:

33 So likewise ye, when ye shall see all these things, know that it is near, even at the doors.

34 Verily I say unto you, This generation shall not pass, till all these things be fulfilled.

35 Heaven and earth shall pass away, but my words shall not pass away.

36 But of that day and hour knoweth no man, no, not the angels of heaven, but my Father only.

MARK 13:28–32

28 Now learn a parable of the fig tree; When her branch is yet tender, and putteth forth leaves, ye know that summer is near:

29 So ye in like manner, when ye shall see these things come to pass, know that it is nigh, even at the doors.

30 Verily I say unto you, that this generation shall not pass, till all these things be done.

31 Heaven and earth shall pass away: but my words shall not pass away.

32 But of that day and that hour knoweth no man, no, not the angels which are in heaven, neither the Son, but the Father.

LUKE 21:29–33

29 And he spake to them a parable; Behold the fig tree, and all the trees;

30 When they now shoot forth, ye see and know of your own selves that summer is now nigh at hand.

31 So likewise ye, when ye see these things come to pass, know ye that the kingdom of God is nigh at hand.

32 Verily I say unto you, This generation shall not pass away, till all be fulfilled.

33 Heaven and earth shall pass away: but my words shall not pass away.

TAKE HEED! KEEP WATCH!

MATTHEW 24:37–51

37 But as the days of Noe were, so shall also the coming of the Son of man be.

38 For as in the days that were before the flood they were eating and drinking, marrying and giving in marriage, until the day that Noe entered into the ark,

39 And knew not until the flood came, and took them all away; so shall also the coming of the Son of man be.

40 Then shall two be in the field; the one shall be taken, and the other left.

41 Two women shall be grinding at the mill; the one shall be taken, and the other left.

42 Watch therefore: for ye know not what hour your Lord doth come.

43 But know this, that if the goodman of the house had known in what watch the thief would come, he would have watched, and would not have suffered his house to be broken up.

44 Therefore be ye also ready: for in such an hour as ye think not the Son of man cometh.

45 Who then is a faithful and wise servant, whom his lord hath made ruler over his household, to give them meat in due season?

46 Blessed is that servant, whom his lord when he cometh shall find so doing.

47 Verily I say unto you, That he shall make him ruler over all his goods.

48 But and if that evil servant shall say in his heart, My lord delayeth his coming;

49 And shall begin to smite his fellowservants, and to eat and drink with the drunken;

50 The lord of that servant shall come in a day when he looketh not for him, and in an hour that he is not aware of,

51 And shall cut him asunder, and appoint him his portion with the hypocrites: there shall be weeping and gnashing of teeth.

MARK 13:33–37

33 Take ye heed, watch and pray: for ye know not when the time is.

34 For the Son of man is as a man taking a far journey, who left his house, and gave authority to his servants, and to every man his work, and commanded the porter to watch.

35 Watch ye therefore: for ye know not when the master of the house cometh, at even, or at midnight, or at the cockcrowing, or in the morning:

36 Lest coming suddenly he find you sleeping.

37 And what I say unto you I say unto all, Watch.

LUKE 21:34–38

34 And take heed to yourselves, lest at any time your hearts be overcharged with surfeiting, and drunkenness, and cares of this life, and so that day come upon you unawares.

35 For as a snare shall it come on all them that dwell on the face of the whole earth.

36 Watch ye therefore, and pray always, that ye may be accounted worthy to escape all these things that shall come to pass, and to stand before the Son of man.

37 And in the day time he was teaching in the temple; and at night he went out, and abode in the mount that is called the mount of Olives.

38 And all the people came early in the morning to him in the temple, for to hear him.

LUKE 17:26–36

26 And as it was in the days of Noe, so shall it be also in the days of the Son of man.

27 They did eat, they drank, they married wives, they were given in marriage, until the day that Noe entered into the ark, and the flood came, and destroyed them all.

28 Likewise also as it was in the days of Lot; they did eat, they drank, they bought, they sold, they planted, they builded;

29 But the same day that Lot went out of Sodom it rained fire and brimstone from heaven, and destroyed them all.

30 Even thus shall it be in the day when the Son of man is revealed.

31 In that day, he which shall be upon the housetop, and his stuff in the house, let him not come down to take it away: and he that is in the field, let him likewise not return back.

Watch ye therefore: for ye know not when the master of the house cometh, at even, or at midnight, or at the cockcrowing, or in the morning.

—MARK

13:35

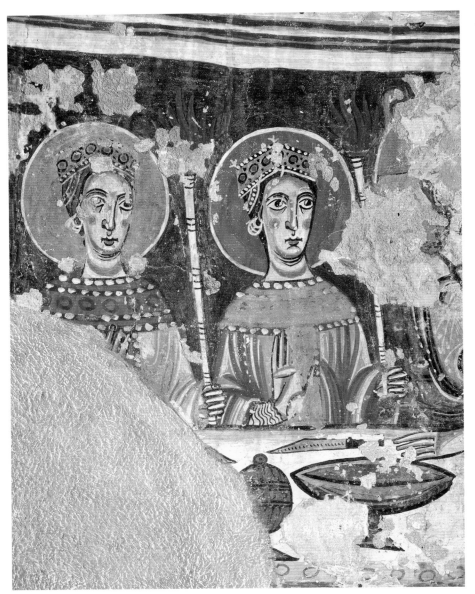

Wise Virgins, 11th century, by Romanesque Artist

42 And the Lord said, Who then is that faithful and wise steward, whom his lord shall make ruler over his household, to give them their portion of meat in due season?

43 Blessed is that servant, whom his lord when he cometh shall find so doing.

44 Of a truth I say unto you, that he will make him ruler over all that he hath.

45 But and if that servant say in his heart, My lord delayeth his coming; and shall begin to beat the menservants and maidens, and to eat and drink, and to be drunken;

46 The lord of that servant will come in a day when he looketh not for him, and at an hour when he is not aware, and will cut him in sunder, and will appoint him his portion with the unbelievers.

A PARABLE ABOUT WISE AND FOOLISH MAIDENS

The three parables that follow in Matthew paint in pictures Jesus' teaching about the end of time. Jesus, being master teacher that he is, wants to make sure his disciples pass through the final examination. In these parables he gives them the questions that will be asked on the day of the final test. The moral of the first parable comes from Matthew 24:44: "Therefore be ye also ready; for in such an hour as ye think not the son of man cometh." In the second parable, Jesus reminds his disciples that decisive, responsible action, not fearful laziness, is the way to "enter into the joy of your master." The third parable portrays the final judgment as a shepherd king separating the sheep from the goats. Interestingly, the righteous and the cursed are the ones who ask the questions in this final exam: "Lord, when saw we thee hungered, thirsty, a stranger, sick, in prison and came to thee?" And the king will answer

32 Remember Lot's wife.

33 Whosoever shall seek to save his life shall lose it; and whosoever shall lose his life shall preserve it.

34 I tell you, in that night there shall be two men in one bed; the one shall be taken, and the other shall be left.

35 Two women shall be grinding together; the one shall be taken, and the other left.

36 Two men shall be in the field; the one shall be taken, and the other left.

LUKE 12:39–46

39 And this know, that if the goodman of the house had known what hour the thief would come, he would have watched, and not have suffered his house to be broken through.

40 Be ye therefore ready also: for the Son of man cometh at an hour when ye think not.

41 Then Peter said unto him, Lord, speakest thou this parable unto us, or even to all?

them, "Inasmuch as ye have done it unto one of the least of these…ye have done it unto me." Neither the righteous or the cursed realize what they were or were not doing to the king—yet the ones who naturally act mercifully toward the "little ones" who are dear to the Lord's heart are blessed. As the beatitude puts it: "Blessed are the merciful, for they shall obtain mercy."

MATTHEW 25:1–13

1 Then shall the kingdom of heaven be likened unto ten virgins, which took their lamps, and went forth to meet the bridegroom.

2 And five of them were wise, and five were foolish.

3 They that were foolish took their lamps, and took no oil with them:

4 But the wise took oil in their vessels with their lamps.

5 While the bridegroom tarried, they all slumbered and slept.

6 And at midnight there was a cry made, Behold, the bridegroom cometh; go ye out to meet him.

7 Then all those virgins arose, and trimmed their lamps.

8 And the foolish said unto the wise, Give us of your oil; for our lamps are gone out.

9 But the wise answered, saying, Not so; lest there be not enough for us and you: but go ye rather to them that sell, and buy for yourselves.

10 And while they went to buy, the bridegroom came; and they that were ready went in with him to the marriage: and the door was shut.

11 Afterward came also the other virgins, saying, Lord, Lord, open to us.

12 But he answered and said, Verily I say unto you, I know you not.

13 Watch therefore, for ye know neither the day nor the hour wherein the Son of man cometh.

LUKE 12:35–38

35 Let your loins be girded about, and your lights burning;

36 And ye yourselves like unto men that wait for their lord, when he will return from the wedding; that when he cometh and knocketh, they may open unto him immediately.

37 Blessed are those servants, whom the lord when he cometh shall find watching: verily I say unto you, that he shall gird himself, and make them to sit down to meat, and will come forth and serve them.

38 And if he shall come in the second watch, or come in the third watch, and find them so, blessed are those servants.

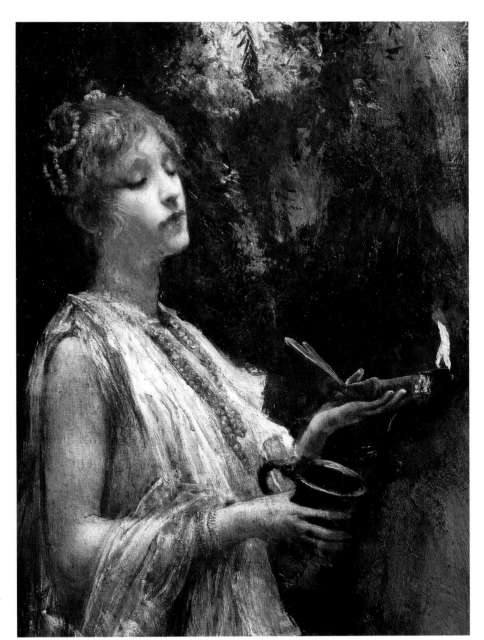

Parable of Wise and Foolish Virgins, by Giulio Aristide Sartorio, 1860–1932

For I say unto you, That unto every one which hath shall be given; and from him that hath not, even that he hath shall be taken away from him.

—LUKE 19:26

LUKE 13:25–28

25 When once the master of the house is risen up, and hath shut to the door, and ye begin to stand without, and to knock at the door, saying, Lord, Lord, open unto us; and he shall answer and say unto you, I know you not whence ye are:

26 Then shall ye begin to say, We have eaten and drunk in thy presence, and thou hast taught in our streets.

27 But he shall say, I tell you, I know you not whence ye are; depart from me, all ye workers of iniquity.

28 There shall be weeping and gnashing of teeth, when ye shall see Abraham, and Isaac, and Jacob, and all the prophets, in the kingdom of God, and you yourselves thrust out.

A PARABLE ABOUT MANAGING THE MASTER'S PROPERTY

MATTHEW 25: 14–30

14 For the kingdom of heaven is as a man travelling into a far country, who called his own servants, and delivered unto them his goods.

15 And unto one he gave five talents, to another two, and to another one; to every man according to his several ability; and straightway took his journey.

16 Then he that had received the five talents went and traded with the same, and made them other five talents.

17 And likewise he that had received two, he also gained other two.

18 But he that had received one went and digged in the earth, and hid his lord's money.

19 After a long time the lord of those servants cometh, and reckoneth with them.

20 And so he that had received five talents came and brought other five talents, saying, Lord, thou deliveredst unto me five talents: behold, I have gained beside them five talents more.

21 His lord said unto him, Well done, thou good and faithful servant: thou hast been faithful over a few things, I will make thee ruler over many things: enter thou into the joy of thy lord.

22 He also that had received two talents came and said, Lord, thou deliveredst unto me two talents: behold, I have gained two other talents beside them.

23 His lord said unto him, Well done, good and faithful servant; thou hast been faithful over a few things, I will make thee ruler over many things: enter thou into the joy of thy lord.

24 Then he which had received the one talent came and said, Lord, I knew thee that thou art an hard man, reaping where thou hast not sown, and gathering where thou hast not strawed:

25 And I was afraid, and went and hid thy talent in the earth: lo, there thou hast that is thine.

26 His lord answered and said unto him, Thou wicked and slothful servant, thou knewest that I reap where I sowed not, and gather where I have not strawed:

27 Thou oughtest therefore to have put my money to the exchangers, and then at my coming I should have received mine own with usury.

28 Take therefore the talent from him, and give it unto him which hath ten talents.

29 For unto every one that hath shall be given, and he shall have abundance: but from him that hath not shall be taken away even that which he hath.

30 And cast ye the unprofitable servant into outer darkness: there shall be weeping and gnashing of teeth.

LUKE 19:11–27

11 And as they heard these things, he added and spake a parable, because he was nigh to Jerusalem, and because they thought that the kingdom of God should immediately appear.

12 He said therefore, A certain nobleman went into a far country to receive for himself a kingdom, and to return.

13 And he called his ten servants, and delivered them ten pounds, and said unto them, Occupy till I come.

14 But his citizens hated him, and sent a message after him, saying, We will not have this man to reign over us.

15 And it came to pass, that when he was returned, having received the kingdom, then he commanded these servants to be called unto him, to whom he had given the money, that he might know how much every man had gained by trading.

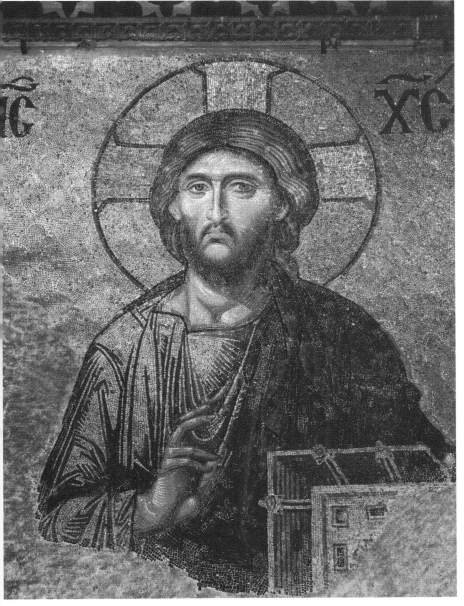

Head of Christ, 12th century, Artist Unknown

23 Wherefore then gavest not thou my money into the bank, that at my coming I might have required mine own with usury?

24 And he said unto them that stood by, Take from him the pound, and give it to him that hath ten pounds.

25 (And they said unto him, Lord, he hath ten pounds.)

26 For I say unto you, That unto every one which hath shall be given; and from him that hath not, even that he hath shall be taken away from him.

27 But those mine enemies, which would not that I should reign over them, bring hither, and slay them before me.

A PARABLE ABOUT THE LAST JUDGMENT

MATTHEW 25:31–46

31 When the Son of man shall come in his glory, and all the holy angels with him, then shall he sit upon the throne of his glory:

32 And before him shall be gathered all nations: and he shall separate them one from another, as a shepherd divideth his sheep from the goats:

33 And he shall set the sheep on his right hand, but the goats on the left.

34 Then shall the King say unto them on his right hand, Come, ye blessed of my Father, inherit the kingdom prepared for you from the foundation of the world:

35 For I was an hungred, and ye gave me meat: I was thirsty, and ye gave me drink: I was a stranger, and ye took me in:

36 Naked, and ye clothed me: I was sick, and ye visited me: I was in prison, and ye came unto me.

16 Then came the first, saying, Lord, thy pound hath gained ten pounds.

17 And he said unto him, Well, thou good servant: because thou hast been faithful in a very little, have thou authority over ten cities.

18 And the second came, saying, Lord, thy pound hath gained five pounds.

19 And he said likewise to him, Be thou also over five cities.

20 And another came, saying, Lord,

behold, here is thy pound, which I have kept laid up in a napkin:

21 For I feared thee, because thou art an austere man: thou takest up that thou layedst not down, and reapest that thou didst not sow.

22 And he saith unto him, Out of thine own mouth will I judge thee, thou wicked servant. Thou knewest that I was an austere man, taking up that I laid not down, and reaping that I did not sow:

Or when saw we thee sick, or in prison, and came unto thee?

—MATTHEW 25:39

37 Then shall the righteous answer him, saying, Lord, when saw we thee an hungred, and fed thee? or thirsty, and gave thee drink?

38 When saw we thee a stranger, and took thee in? or naked, and clothed thee?

39 Or when saw we thee sick, or in prison, and came unto thee?

40 And the King shall answer and say unto them, Verily I say unto you, Inasmuch as ye have done it unto one of the least of these my brethren, ye have done it unto me.

41 Then shall he say also unto them on the left hand, Depart from me, ye cursed, into everlasting fire, prepared for the devil and his angels:

42 For I was an hungred, and ye gave me no meat: I was thirsty, and ye gave me no drink:

43 I was a stranger, and ye took me not in: naked, and ye clothed me not: sick, and in prison, and ye visited me not.

44 Then shall they also answer him, saying, Lord, when saw we thee an hungred, or athirst, or a stranger, or naked, or sick, or in prison, and did not minister unto thee?

45 Then shall he answer them, saying, Verily I say unto you, Inasmuch as ye did it not to one of the least of these, ye did it not to me.

46 And these shall go away into everlasting punishment: but the righteous into life eternal.

JOHN 5:29

29 And shall come forth; they that have done good, unto the resurrection of life; and they that have done evil, unto the resurrection of damnation.

THE GREEKS SEEK JESUS AND HE SPEAKS ABOUT HIS DEATH

John's story of Jesus falls into two parts: the Book of Signs, where the focus is on Jesus, and the Book of Glory, which focuses on his disciples, who have seen his glory revealed in the signs and come to believe in him (John 2:11). The "Greeks" who come looking to see Jesus are the sign that the "hour" has come for Jesus to be lifted up—for this hour he has come into the world. Jesus, seeking to teach his

The Last Supper, Illuminated Capital Letter N, 1526, Artist Unknown

disciples, uses the image of a seed planted in the earth. Unless it is planted, buried in the ground, it produces no fruit—but, when it is planted it produces abundantly. This passage is John's way of predicting Jesus' passion, death, and resurrection, as Mark, Matthew, and Luke have him doing at Caesarea Philippi (Mark 8:27–9:1, and parallels). For John, the passion becomes the ultimate revelation of God's saving presence—the glory of God. In John's version of the Transfiguration (Mark 9:2–9 and parallels), Jesus prays: "Father, glorify thy name." A voice from heaven responds: "I have both glorified it [through Jesus' ministry], and will glorify it again [as Jesus now is lifted up]." Jesus sums up the fruits God will bring out of this hour: "Now is the judgment of this world; now shall the prince of this world be cast out. And I, if I be lifted up from the earth, will draw all men unto me."

JOHN 12:20–36

20 And there were certain Greeks among them that came up to worship at the feast:

21 The same came therefore to Philip, which was of Bethsaida of Galilee, and desired him, saying, Sir, we would see Jesus.

22 Philip cometh and telleth Andrew: and again Andrew and Philip tell Jesus.

23 And Jesus answered them, saying, The hour is come, that the Son of man should be glorified.

24 Verily, verily, I say unto you, Except a corn of wheat fall into the ground and die, it abideth alone: but if it die, it bringeth forth much fruit.

25 He that loveth his life shall lose it; and he that hateth his life in this world shall keep it unto life eternal.

26 If any man serve me, let him follow me; and where I am, there shall also my servant be: if any man serve me, him will my Father honour.

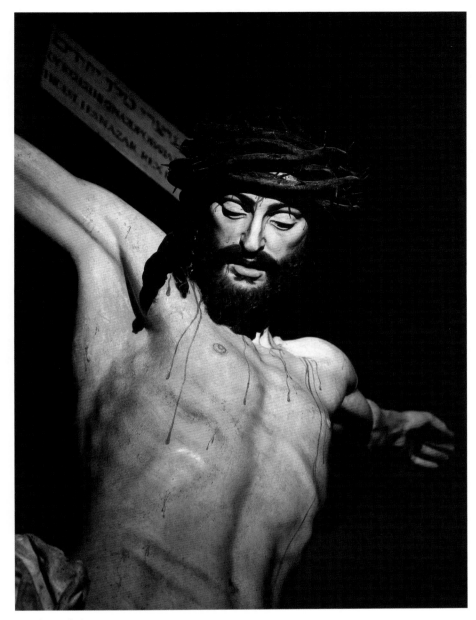

Crucifixion of Christ, by Juan Martinez Montanez, 1568–1649

27 Now is my soul troubled; and what shall I say? Father, save me from this hour: but for this cause came I unto this hour.

28 Father, glorify thy name. Then came there a voice from heaven, saying, I have both glorified it, and will glorify it again.

29 The people therefore, that stood by, and heard it, said that it thundered: others said, An angel spake to him.

30 Jesus answered and said, This voice came not because of me, but for your sakes.

31 Now is the judgment of this world: now shall the prince of this world be cast out.

32 And I, if I be lifted up from the earth, will draw all men unto me.

33 This he said, signifying what death he should die.

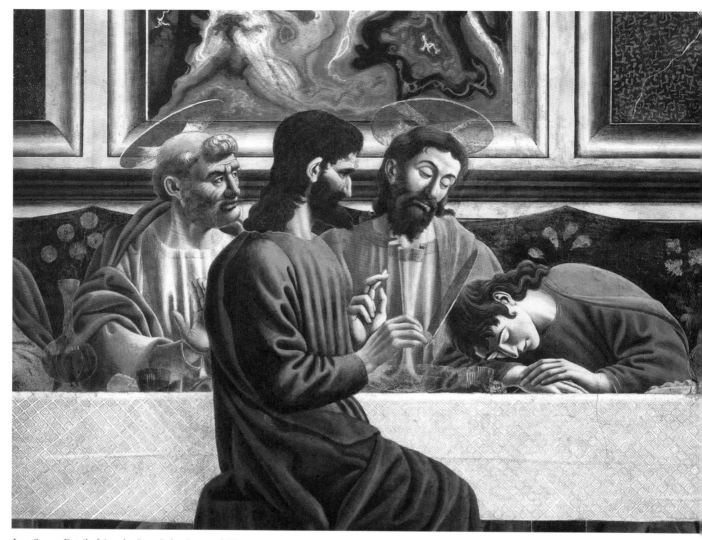

Last Supper Detail of Apostles Peter, Judas, Jesus, and John, c.1444–50, by Andrea del Castagno, 1421–57

34 The people answered him, We have heard out of the law that Christ abideth for ever: and how sayest thou, The Son of man must be lifted up? who is this Son of man?

35 Then Jesus said unto them, Yet a little while is the light with you. Walk while ye have the light, lest darkness come upon you: for he that walketh in darkness knoweth not whither he goeth.

36 While ye have light, believe in the light, that ye may be the children of light. These things spake Jesus, and departed, and did hide himself from them.

THE UNBELIEF OF THE PEOPLE

MATTHEW 13:10–17

10 And the disciples came, and said unto him, Why speakest thou unto them in parables?

11 He answered and said unto them, Because it is given unto you to know the mysteries of the kingdom of heaven, but to them it is not given.

12 For whosoever hath, to him shall be given, and he shall have more abundance: but whosoever hath not, from him shall be taken away even that he hath.

13 Therefore speak I to them in parables: because they seeing see not; and hearing they hear not, neither do they understand.

14 And in them is fulfilled the prophecy of Esaias, which saith, By hearing ye shall hear, and shall not understand; and seeing ye shall see, and shall not perceive:

15 For this people's heart is waxed gross, and their ears are dull of hearing, and their eyes they have closed; lest at any time they should see with their eyes, and hear with their ears, and should understand with their heart, and should be converted, and I should heal them.

16 But blessed are your eyes, for they see: and your ears, for they hear.

17 For verily I say unto you, That many prophets and righteous men have desired to see those things which ye see, and have not seen them; and to hear those things which ye hear, and have not heard them.

MARK 4:10–12

10 And when he was alone, they that were about him with the twelve asked of him the parable.

11 And he said unto them, Unto you it is given to know the mystery of the kingdom of God: but unto them that are without, all these things are done in parables:

12 That seeing they may see, and not perceive; and hearing they may hear, and not understand; lest at any time they should be converted, and their sins should be forgiven them.

LUKE 8:9–10

9 And his disciples asked him, saying, What might this parable be?

10 And he said, Unto you it is given to know the mysteries of the kingdom of God: but to others in parables; that seeing they might not see, and hearing they might not understand.

JOHN 12:37–43

37 But though he had done so many miracles before them, yet they believed not on him:

38 That the saying of Esaias the prophet might be fulfilled, which he spake, Lord, who hath believed our report? and to whom hath the arm of the Lord been revealed?

39 Therefore they could not believe, because that Esaias said again,

40 He hath blinded their eyes, and hardened their heart; that they should not see with their eyes, nor understand with their heart, and be converted, and I should heal them.

41 These things said Esaias, when he saw his glory, and spake of him.

42 Nevertheless among the chief rulers also many believed on him; but because of the Pharisees they did not confess him, lest they should be put out of the synagogue:

43 For they loved the praise of men more than the praise of God.

MARK 8:17–18

17 And when Jesus knew it, he saith unto them, Why reason ye, because ye have no bread? perceive ye not yet, neither understand? have ye your heart yet hardened?

18 Having eyes, see ye not? and having ears, hear ye not? and do ye not remember?

JUDGMENT BY THE WORD OF GOD

JOHN 12:44–50

44 Jesus cried and said, He that believeth on me, believeth not on me, but on him that sent me.

45 And he that seeth me seeth him that sent me.

46 I am come a light into the world, that whosoever believeth on me should not abide in darkness.

47 And if any man hear my words, and believe not, I judge him not: for I came not to judge the world, but to save the world.

48 He that rejecteth me, and receiveth not my words, hath one that judgeth him: the word that I have spoken, the same shall judge him in the last day.

49 For I have not spoken of myself; but the Father which sent me, he gave me a commandment, what I should say, and what I should speak.

50 And I know that his commandment is life everlasting: whatsoever I speak therefore, even as the Father said unto me, so I speak.

Then Jesus said unto them, Yet a little while is the light with you. Walk while ye have the light, lest darkness come upon you: for he that walketh in darkness knoweth not whither he goeth.

—JOHN 12:35

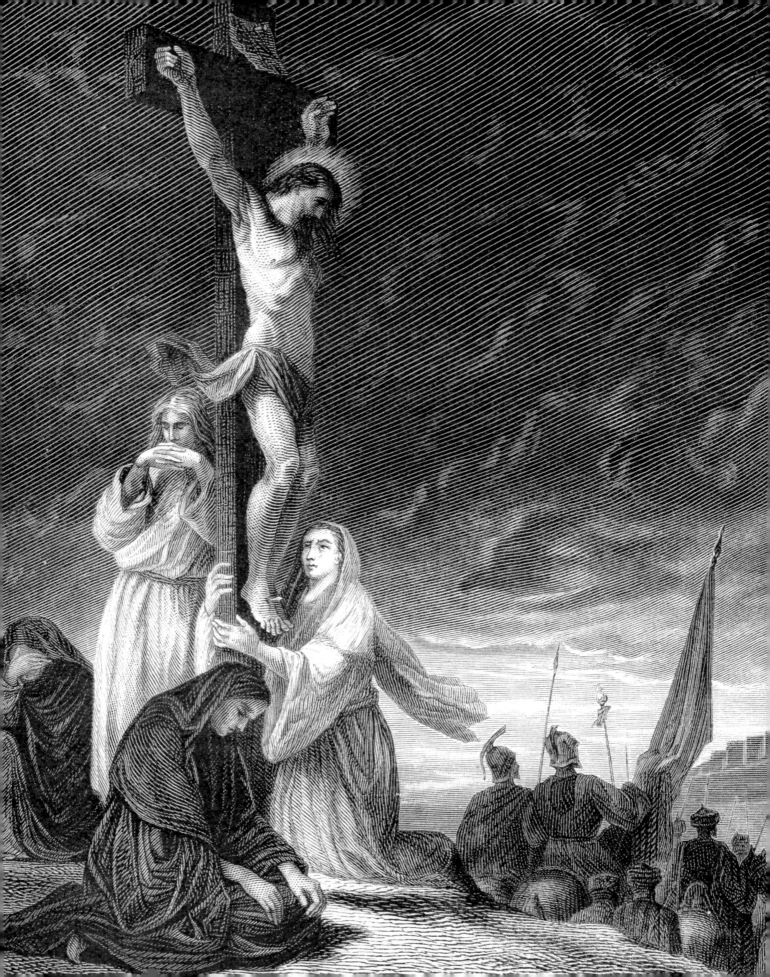

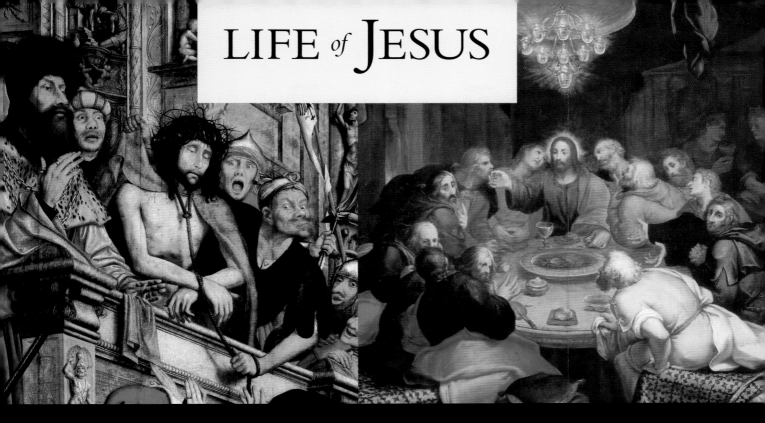

LIFE *of* JESUS

The Passion and Death of Jesus

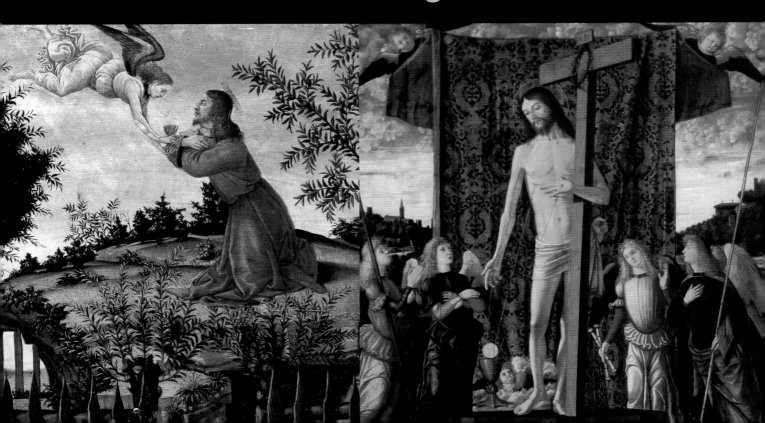

The Passion and Death of Jesus

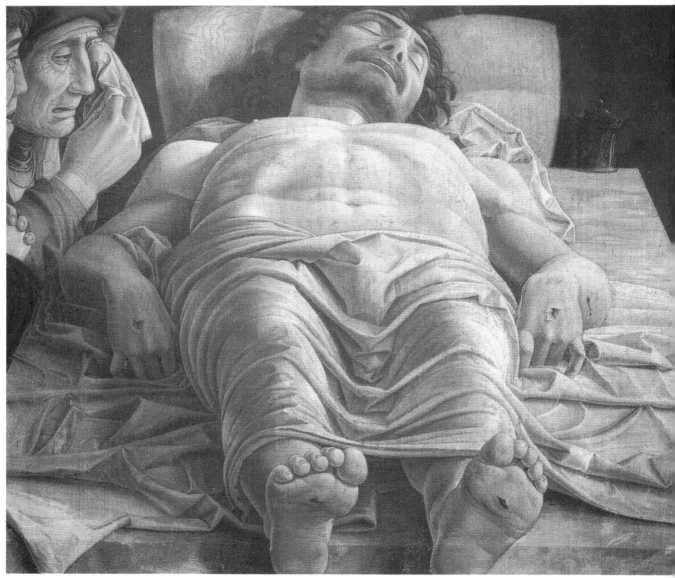

The Dead Christ, by Andrea Mantegna, 1431–1506

THE PASSION ACCOUNTS IN THE FOUR GOSPELS ARE THE HEART, the power, and the glory of Jesus' ongoing story. The evangelists report the "good news" about Jesus' teaching and acts of power from vantage points that reflect the struggles and challenges of different faith communities. The good news is more like the Haggadah used by the head of a Jewish household to "tell the story" of God's deliverance in the Exodus from Egypt. The purpose of both is to involve the reader in the story, and to see God's mighty acts as the source of the hope, comfort, and mission for God's people.

THE PLOT AGAINST JESUS

Here in the celebration of Passover, Jesus' story comes together, even as it appears to be coming apart. Just as in the first Passover, God has the last—and most powerful—word. The Passion story begins "behind the scenes," in a way that asks, "Why do the heathen rage, and the people imagine a vain thing? The kings of the earth…and the rulers take counsel together against the LORD and against his anointed…" (Psalm 2:1-2)

MATTHEW 26:1–5

1 And it came to pass, when Jesus had finished all these sayings, he said unto his disciples,

2 Ye know that after two days is the feast of the passover, and the Son of man is betrayed to be crucified.

3 Then assembled together the chief priests, and the scribes, and the elders of the people, unto the palace of the high priest, who was called Caiaphas,

4 And consulted that they might take Jesus by subtilty, and kill him.

5 But they said, Not on the feast day, lest there be an uproar among the people.

MARK 14:1–2

1 After two days was the feast of the passover, and of unleavened bread: and the chief priests and the scribes sought how they might take him by craft, and put him to death.

2 But they said, Not on the feast day, lest there be an uproar of the people.

LUKE 22:1–2

1 Now the feast of unleavened bread drew nigh, which is called the Passover.

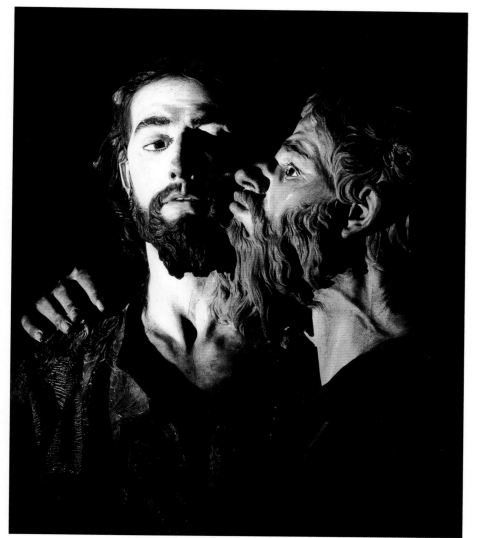

Spanish Betrayal of Christ, by Francisco Zarcillo, 1707–1783

After two days was the feast of the passover, and of unleavened bread: and the chief priests and the scribes sought how they might take him by craft, and put him to death.

But they said, Not on the feast day, lest there be an uproar of the people.

—MARK 14:1–2

2 And the chief priests and scribes sought how they might kill him; for they feared the people.

JOHN 11:47–53

47 Then gathered the chief priests and the Pharisees a council, and said, What do we? for this man doeth many miracles.

48 If we let him thus alone, all men will believe on him: and the Romans shall come and take away both our place and nation.

49 And one of them, named Caiaphas, being the high priest that same year, said unto them, Ye know nothing at all,

50 Nor consider that it is expedient for us, that one man should die for the people, and that the whole nation perish not.

51 And this spake he not of himself: but being high priest that year, he prophesied that Jesus should die for that nation;

52 And not for that nation only, but that also he should gather together in one the children of God that were scattered abroad.

53 Then from that day forth they took counsel together for to put him to death.

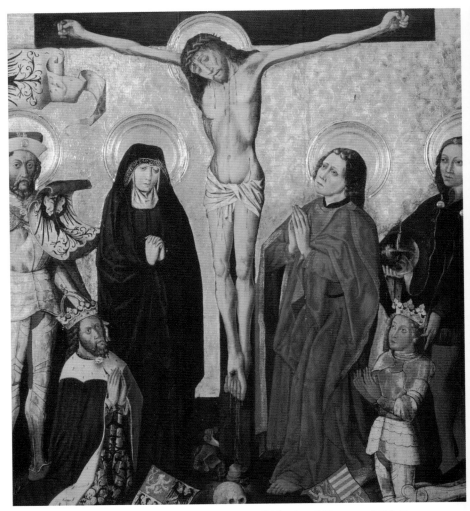

Crucifixion of Jesus Christ with Charles IV 1316–78, King of Bohemia and Hungary and Holy Roman Emperor, 1455–57, Artist Unknown

JESUS' ANOINTING IN BETHANY

MATTHEW 26:6–13

6 Now when Jesus was in Bethany, in the house of Simon the leper,

7 There came unto him a woman having an alabaster box of very precious ointment, and poured it on his head, as he sat at meat.

8 But when his disciples saw it, they had indignation, saying, To what purpose is this waste?

9 For this ointment might have been sold for much, and given to the poor.

10 When Jesus understood it, he said unto them, Why trouble ye the woman? for she hath wrought a good work upon me.

11 For ye have the poor always with you; but me ye have not always.

12 For in that she hath poured this ointment on my body, she did it for my burial.

13 Verily I say unto you, Wheresoever this gospel shall be preached in the whole world, there shall also this, that this woman hath done, be told for a memorial of her.

There came unto him a woman having an alabaster box of very precious ointment, and poured it on his head, as he sat at meat.

—MATTHEW 26:7

MARK 14:3–9

3 And being in Bethany in the house of Simon the leper, as he sat at meat, there came a woman having an alabaster box of ointment of spikenard very precious; and she brake the box, and poured it on his head.

4 And there were some that had indignation within themselves, and said, Why was this waste of the ointment made?

5 For it might have been sold for more than three hundred pence, and have been given to the poor. And they murmured against her.

6 And Jesus said, Let her alone; why trouble ye her? she hath wrought a good work on me.

7 For ye have the poor with you always, and whensoever ye will ye may do them good: but me ye have not always.

8 She hath done what she could: she is come aforehand to anoint my body to the burying.

9 Verily I say unto you, Wheresoever this gospel shall be preached throughout the whole world, this also that she hath done shall be spoken of for a memorial of her.

LUKE 7:36–50

36 And one of the Pharisees desired him that he would eat with him. And he went into the Pharisee's house, and sat down to meat.

37 And, behold, a woman in the city, which was a sinner, when she knew that Jesus sat at meat in the Pharisee's house, brought an alabaster box of ointment,

38 And stood at his feet behind him weeping, and began to wash his feet with tears, and did wipe them with the hairs of her head, and kissed his feet, and anointed them with the ointment.

39 Now when the Pharisee which had bidden him saw it, he spake within himself, saying, This man, if he were a prophet, would have known who and what manner of woman this is that toucheth him: for she is a sinner.

40 And Jesus answering said unto him, Simon, I have somewhat to say unto thee. And he saith, Master, say on.

41 There was a certain creditor which had two debtors: the one owed five hundred pence, and the other fifty.

42 And when they had nothing to pay, he frankly forgave them both. Tell me therefore, which of them will love him most?

43 Simon answered and said, I suppose that he, to whom he forgave most. And he said unto him, Thou hast rightly judged.

44 And he turned to the woman, and said unto Simon, Seest thou this woman? I entered into thine house, thou gavest me no water for my feet: but she hath washed my feet with tears, and wiped them with the hairs of her head.

45 Thou gavest me no kiss: but this woman since the time I came in hath not ceased to kiss my feet.

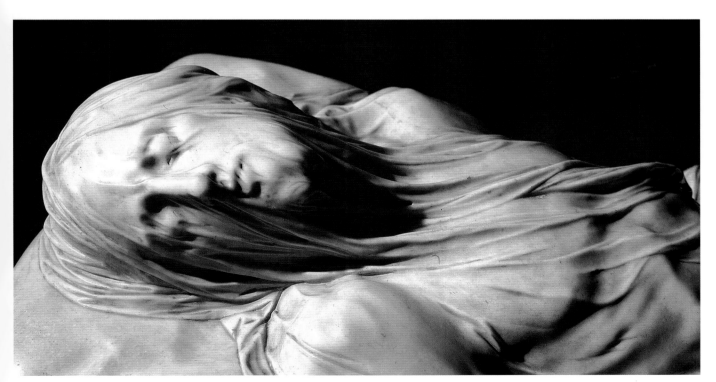

Veiled Christ, 1753, by Giuseppe Sanmartino, 1720–93

46 My head with oil thou didst not anoint: but this woman hath anointed my feet with ointment.

47 Wherefore I say unto thee, Her sins, which are many, are forgiven; for she loved much: but to whom little is forgiven, the same loveth little.

48 And he said unto her, Thy sins are forgiven.

49 And they that sat at meat with him began to say within themselves, Who is this that forgiveth sins also?

50 And he said to the woman, Thy faith hath saved thee; go in peace.

JOHN 12:1–8

1 Then Jesus six days before the passover came to Bethany, where Lazarus was which had been dead, whom he raised from the dead.

2 There they made him a supper; and Martha served: but Lazarus was one of them that sat at the table with him.

3 Then took Mary a pound of ointment of spikenard, very costly, and anointed the feet of Jesus, and wiped his feet with her hair: and the house was filled with the odour of the ointment.

And when they heard it, they were glad, and promised to give him money. And he sought how he might conveniently betray him.

—MARK 14:11

4 Then saith one of his disciples, Judas Iscariot, Simon's son, which should betray him,

5 Why was not this ointment sold for three hundred pence, and given to the poor?

6 This he said, not that he cared for the poor; but because he was a thief, and had the bag, and bare what was put therein.

7 Then said Jesus, Let her alone: against the day of my burying hath she kept this.

8 For the poor always ye have with you; but me ye have not always.

JUDAS AGREES TO BETRAY JESUS

MATTHEW 26:14–16

14 Then one of the twelve, called Judas Iscariot, went unto the chief priests,

15 And said unto them, What will ye give me, and I will deliver him unto you? And they covenanted with him for thirty pieces of silver.

16 And from that time he sought opportunity to betray him.

MARK 14:10–11

10 And Judas Iscariot, one of the twelve, went unto the chief priests, to betray him unto them.

11 And when they heard it, they were glad, and promised to give him money. And he sought how he might conveniently betray him.

LUKE 22: 3–6

3 Then entered Satan into Judas surnamed Iscariot, being of the number of the twelve.

4 And he went his way, and communed with the chief priests and captains, how he might betray him unto them.

5 And they were glad, and covenanted to give him money.

6 And he promised, and sought opportunity to betray him unto them in the absence of the multitude.

JOHN 13:2

2 And supper being ended, the devil having now put into the heart of Judas Iscariot, Simon's son, to betray him;

JESUS' DISCIPLES PREPARE FOR THE PASSOVER MEAL

Jesus' instructions to his disciples about where to prepare the Passover meal—like the instructions he gives for procuring the donkey (and its colt) for his entrance into Jerusalem—reveal Jesus' foreknowledge of where and how these events will play out. His words at the table during the Last Supper further illustrate this. Matthew, the most clearly Jewish of the four gospels, develops the roots of the Last Supper in the Passover Seder. Matthew emphasizes the blood—a prominent theme in the Exodus and covenant accounts in the Hebrew Bible. Luke mentions two cups: one at the beginning of his account, one "after supper," as in the Seder. Mark and Matthew mention the singing of a hymn at the conclusion: the Hallel, already mentioned. And yet, Matthew and Luke—presenting the good news to a largely non-Jewish audience—both following Mark, leave out the main course of the Seder: the Lamb. In a different way, John's version of the Last Supper makes that point as Jesus is lifted up on the cross at the very time the lambs for the Passover were being offered up in the Temple. John does not narrate the institution of the Lord's Supper on the night before Jesus', death but, uses the image of foot-washing to represent the self-abasing service of Jesus in the events to come. In unique ways, all four gospels clearly

present Jesus as the "lamb of God," as John the Baptist describes him in John 1, "that taketh away the sin of the world."

MATTHEW 26:17–20

17 Now the first day of the feast of unleavened bread the disciples came to Jesus, saying unto him, Where wilt thou that we prepare for thee to eat the passover?

18 And he said, Go into the city to such a man, and say unto him, The Master saith, My time is at hand; I will keep the passover at thy house with my disciples.

19 And the disciples did as Jesus had appointed them; and they made ready the passover.

20 Now when the even was come, he sat down with the twelve.

MARK 14:12–17

12 And the first day of unleavened bread, when they killed the passover, his disciples said unto him, Where wilt thou that we go and prepare that thou mayest eat the passover?

13 And he sendeth forth two of his disciples, and saith unto them, Go ye into the city, and there shall meet you a man bearing a pitcher of water: follow him.

14 And wheresoever he shall go in, say ye to the goodman of the house, The Master saith, Where is the guestchamber, where I shall eat the passover with my disciples?

15 And he will shew you a large upper room furnished and prepared: there make ready for us.

16 And his disciples went forth, and came into the city, and found as he had said unto them: and they made ready the passover.

17 And in the evening he cometh with the twelve.

LUKE 22:7–14

7 Then came the day of unleavened bread, when the passover must be killed.

8 And he sent Peter and John, saying, Go and prepare us the passover, that we may eat.

9 And they said unto him, Where wilt thou that we prepare?

10 And he said unto them, Behold, when ye are entered into the city, there shall a man meet you, bearing a pitcher of water; follow him into the house where he entereth in.

11 And ye shall say unto the goodman of the house, The Master saith unto thee, Where is the guestchamber, where I shall eat the passover with my disciples?

12 And he shall shew you a large upper room furnished: there make ready.

13 And they went, and found as he had said unto them: and they made ready the passover.

14 And when the hour was come, he sat down, and the twelve apostles with him.

JOHN 13:1

1 Now before the feast of the passover, when Jesus knew that his hour was come that he should depart out of this world unto the Father, having loved his own which were in the world, he loved them unto the end.

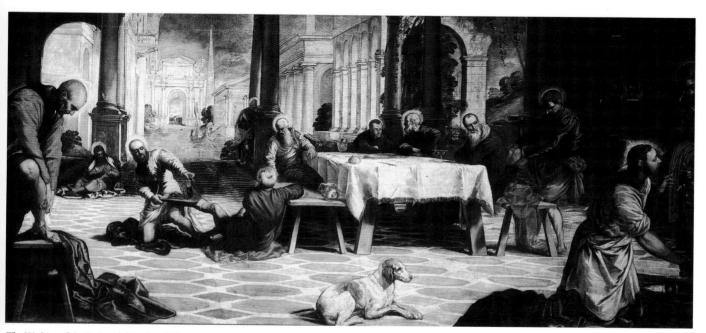

The Washing of the Feet with Blessing of Host, c.1547, by Jacopo Robusti Tintoretto, 1518–94

JUDAS FORETELLS HIS BETRAYAL

MATTHEW 26:20–25

20 Now when the even was come, he sat down with the twelve.

21 And as they did eat, he said, Verily I say unto you, that one of you shall betray me.

22 And they were exceeding sorrowful, and began every one of them to say unto him, Lord, is it I?

23 And he answered and said, He that dippeth his hand with me in the dish, the same shall betray me.

24 The Son of man goeth as it is written of him: but woe unto that man by whom the Son of man is betrayed! it had been good for that man if he had not been born.

25 Then Judas, which betrayed him, answered and said, Master, is it I? He said unto him, Thou hast said.

MARK 14:18–21

18 And as they sat and did eat, Jesus said, Verily I say unto you, One of you which eateth with me shall betray me.

19 And they began to be sorrowful, and to say unto him one by one, Is it I? and another said, Is it I?

20 And he answered and said unto them, It is one of the twelve, that dippeth with me in the dish.

21 The Son of man indeed goeth, as it is written of him: but woe to that man by whom the Son of man is betrayed! good were it for that man if he had never been born.

LUKE 22:21–23

21 But, behold, the hand of him that betrayeth me is with me on the table.

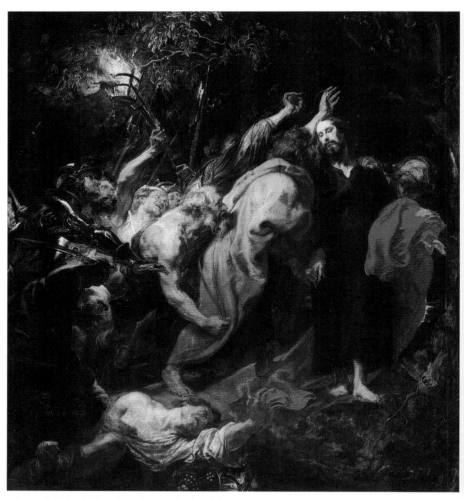

Seizure of Christ: Soldiers Arrest Jesus in Garden of Gethsemane, by Anthony Van Dyck, 1599–1641

22 And truly the Son of man goeth, as it was determined: but woe unto that man by whom he is betrayed!

23 And they began to inquire among themselves, which of them it was that should do this thing.

JOHN 13:21–30

21 When Jesus had thus said, he was troubled in spirit, and testified, and said, Verily, verily, I say unto you, that one of you shall betray me.

22 Then the disciples looked one on another, doubting of whom he spake.

23 Now there was leaning on Jesus' bosom one of his disciples, whom Jesus loved.

24 Simon Peter therefore beckoned to him, that he should ask who it should be of whom he spake.

25 He then lying on Jesus' breast saith unto him, Lord, who is it?

26 Jesus answered, He it is, to whom I shall give a sop, when I have dipped it. And when he had dipped the sop, he gave it to Judas Iscariot, the son of Simon.

27 And after the sop Satan entered into him. Then said Jesus unto him, That thou doest, do quickly.

28 Now no man at the table knew for what intent he spake this unto him.

29 For some of them thought, because Judas had the bag, that Jesus had said unto him, Buy those things that we have need of against the feast; or, that he should give something to the poor.

30 He then having received the sop went immediately out: and it was night.

JESUS INSTITUTES THE LORD'S SUPPER

MATTHEW 26:26–29

26 And as they were eating, Jesus took bread, and blessed it, and brake it, and gave it to the disciples, and said, Take, eat; this is my body.

27 And he took the cup, and gave thanks, and gave it to them, saying, Drink ye all of it;

28 For this is my blood of the new testament, which is shed for many for the remission of sins.

29 But I say unto you, I will not drink henceforth of this fruit of the vine, until that day when I drink it new with you in my Father's kingdom.

❦❦❦❦❦❦❦❦

And as they were eating, Jesus took bread, and blessed it, and brake it, and gave it to the disciples, and said, Take, eat; this is my body.

—MATTHEW 26:26

❦❦❦❦❦❦❦❦

MARK 14:22–25

22 And as they did eat, Jesus took bread, and blessed, and brake it, and gave to them, and said, Take, eat: this is my body.

23 And he took the cup, and when he had given thanks, he gave it to them: and they all drank of it.

24 And he said unto them, This is my blood of the new testament, which is shed for many.

25 Verily I say unto you, I will drink no more of the fruit of the vine, until that day that I drink it new in the kingdom of God.

LUKE 22:15–20

15 And he said unto them, With desire I have desired to eat this passover with you before I suffer:

16 For I say unto you, I will not any more eat thereof, until it be fulfilled in the kingdom of God.

17 And he took the cup, and gave thanks, and said, Take this, and divide it among yourselves:

18 For I say unto you, I will not drink of the fruit of the vine, until the kingdom of God shall come.

19 And he took bread, and gave thanks, and brake it, and gave unto them, saying, This is my body which is given for you: this do in remembrance of me.

20 Likewise also the cup after supper, saying, This cup is the new testament in my blood, which is shed for you.

JOHN 6:51–59

51 I am the living bread which came down from heaven: if any man eat of this bread, he shall live for ever: and the bread that I will give is my flesh, which I will give for the life of the world.

52 The Jews therefore strove among themselves, saying, How can this man give us his flesh to eat?

53 Then Jesus said unto them, Verily, verily, I say unto you, Except ye eat the flesh of the Son of man, and drink his blood, ye have no life in you.

54 Whoso eateth my flesh, and drinketh my blood, hath eternal life; and I will raise him up at the last day.

55 For my flesh is meat indeed, and my blood is drink indeed.

56 He that eateth my flesh, and drinketh my blood, dwelleth in me, and I in him.

57 As the living Father hath sent me, and I live by the Father: so he that eateth me, even he shall live by me.

58 This is that bread which came down from heaven: not as your fathers did eat manna, and are dead: he that eateth of this bread shall live for ever.

59 These things said he in the synagogue, as he taught in Capernaum.

JESUS WASHES THE DISCIPLES' FEET

JOHN 13:1–20

1 Now before the feast of the passover, when Jesus knew that his hour was come that he should depart out of this world unto the Father, having loved his own which were in the world, he loved them unto the end.

2 And supper being ended, the devil having now put into the heart of Judas Iscariot, Simon's son, to betray him;

3 Jesus knowing that the Father had given all things into his hands, and that he was come from God, and went to God;

4 He riseth from supper, and laid aside his garments; and took a towel, and girded himself.

5 After that he poureth water into a bason, and began to wash the disciples' feet, and to wipe them with the towel wherewith he was girded.

6 Then cometh he to Simon Peter: and Peter saith unto him, Lord, dost thou wash my feet?

7 Jesus answered and said unto him, What I do thou knowest not now; but thou shalt know hereafter.

8 Peter saith unto him, Thou shalt never wash my feet. Jesus answered him, If I wash thee not, thou hast no part with me.

9 Simon Peter saith unto him, Lord, not my feet only, but also my hands and my head.

10 Jesus saith to him, He that is washed needeth not save to wash his feet, but is clean every whit: and ye are clean, but not all.

11 For he knew who should betray him; therefore said he, Ye are not all clean.

12 So after he had washed their feet, and had taken his garments, and was set down again, he said unto them, Know ye what I have done to you?

13 Ye call me Master and Lord: and ye say well; for so I am.

14 If I then, your Lord and Master, have washed your feet; ye also ought to wash one another's feet.

15 For I have given you an example, that ye should do as I have done to you.

16 Verily, verily, I say unto you, The servant is not greater than his lord; neither he that is sent greater than he that sent him.

17 If ye know these things, happy are ye if ye do them.

18 I speak not of you all: I know whom I have chosen: but that the scripture may be fulfilled, He that eateth bread with me hath lifted up his heel against me.

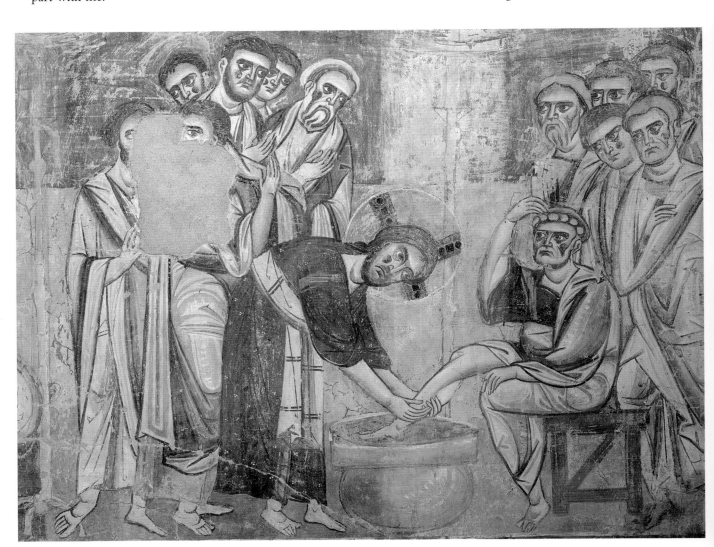

Jesus Washing Feet, 1072, Artist Unknown

19 Now I tell you before it come, that, when it is come to pass, ye may believe that I am he.

20 Verily, verily, I say unto you, He that receiveth whomsoever I send receiveth me; and he that receiveth me receiveth him that sent me.

JESUS PREPARES HIS DISCIPLES FOR THE COMING EVENTS

MATTHEW 20:24–28

24 And when the ten heard it, they were moved with indignation against the two brethren.

25 But Jesus called them unto him, and said, Ye know that the princes of the Gentiles exercise dominion over them, and they that are great exercise authority upon them.

26 But it shall not be so among you: but whosoever will be great among you, let him be your minister;

27 And whosoever will be chief among you, let him be your servant:

28 Even as the Son of man came not to be ministered unto, but to minister, and to give his life a ransom for many.

MARK 10:41–45

41 And when the ten heard it, they began to be much displeased with James and John.

42 But Jesus called them to him, and saith unto them, Ye know that they which are accounted to rule over the Gentiles exercise lordship over them; and their great ones exercise authority upon them.

43 But so shall it not be among you: but whosoever will be great among you, shall be your minister:

44 And whosoever of you will be the chiefest, shall be servant of all.

45 For even the Son of man came not to be ministered unto, but to minister, and to give his life a ransom for many.

LUKE 22:24–30

24 And there was also a strife among them, which of them should be accounted the greatest.

25 And he said unto them, The kings of the Gentiles exercise lordship over them; and they that exercise authority upon them are called benefactors.

26 But ye shall not be so: but he that is greatest among you, let him be as the younger; and he that is chief, as he that doth serve.

27 For whether is greater, he that sitteth at meat, or he that serveth? is not he that sitteth at meat? but I am among you as he that serveth.

28 Ye are they which have continued with me in my temptations.

29 And I appoint unto you a kingdom, as my Father hath appointed unto me;

30 That ye may eat and drink at my table in my kingdom, and sit on thrones judging the twelve tribes of Israel.

JOHN 13:4–5

4 He riseth from supper, and laid aside his garments; and took a towel, and girded himself.

5 After that he poureth water into a bason, and began to wash the disciples' feet, and to wipe them with the towel wherewith he was girded.

MATTHEW 19:28

28 And Jesus said unto them, Verily I say unto you, That ye which have followed me, in the regeneration when the Son of man shall sit in the throne of his glory, ye also shall sit upon twelve thrones, judging the twelve tribes of Israel.

JOHN 13:12–17

12 So after he had washed their feet, and had taken his garments, and was set down again, he said unto them, Know ye what I have done to you?

13 Ye call me Master and Lord: and ye say well; for so I am.

14 If I then, your Lord and Master, have washed your feet; ye also ought to wash one another's feet.

15 For I have given you an example, that ye should do as I have done to you.

16 Verily, verily, I say unto you, The servant is not greater than his lord; neither he that is sent greater than he that sent him.

17 If ye know these things, happy are ye if ye do them.

JOHN 13:31–35

31 Therefore, when he was gone out, Jesus said, Now is the Son of man glorified, and God is glorified in him.

32 If God be glorified in him, God shall also glorify him in himself, and shall straightway glorify him.

33 Little children, yet a little while I am with you. Ye shall seek me: and as I said unto the Jews, Whither I go, ye cannot come; so now I say to you.

34 A new commandment I give unto you, That ye love one another; as I have loved you, that ye also love one another.

35 By this shall all men know that ye are my disciples, if ye have love one to another.

JESUS FAREWELL DISCOURSE (ACCORDING TO JOHN)

John's account of the Last Supper, while it includes many Passover features (the dipping of the morsel, the beloved disciple's reclining on Jesus' breast, for example), is not the Passover Seder, because, in John's reckoning, Jesus is crucified on the Day of Preparation. The feast itself does not begin until sundown on Friday. John, therefore, does not include the "words of institution" (of the Christian Holy Communion. John's Jesus does, however, make a statement which many take as John's equivalent of the "words"—in the "bread of life" dialogue that follows the feeding of the 5,000: "Whoso eateth my flesh, and drinketh my blood, hath eternal life…dwelleth in me and I in him." (John 6:54, 56). The "new commandment" of love that features into the foot-washing is embellished and restated in Jesus' lengthy farewell discourse. His discourse is similar to that of Jacob and Moses (in Genesis 49 and Deuteronomy 32 and 33, respectively). Jesus recalls to his disciples what he has taught and they have seen, he points ahead to what is to come, and he blesses those he leaves behind. Unique to Jesus' farewell is his promise of "another comforter (besides himself), "that he may abide with you, even the spirit of truth…" (John 14:16-17). Jesus seems almost to be speaking and praying with one foot on earth and one foot in heaven, already showing signs of "being lifted up."

JOHN 14:1–16

1 Let not your heart be troubled: ye believe in God, believe also in me.

2 In my Father's house are many mansions: if it were not so, I would have told you. I go to prepare a place for you.

3 And if I go and prepare a place for you, I will come again, and receive you unto myself; that where I am, there ye may be also.

4 And whither I go ye know, and the way ye know.

5 Thomas saith unto him, Lord, we know not whither thou goest; and how can we know the way?

6 Jesus saith unto him, I am the way, the truth, and the life: no man cometh unto the Father, but by me.

7 If ye had known me, ye should have known my Father also: and from henceforth ye know him, and have seen him.

8 Philip saith unto him, Lord, shew us the Father, and it sufficeth us.

9 Jesus saith unto him, Have I been so long time with you, and yet hast thou not known me, Philip? he that hath seen me hath seen the Father; and how sayest thou then, Shew us the Father?

10 Believest thou not that I am in the Father, and the Father in me? the words that I speak unto you I speak not of myself: but the Father that dwelleth in me, he doeth the works.

11 Believe me that I am in the Father, and the Father in me: or else believe me for the very works' sake.

12 Verily, verily, I say unto you, He that believeth on me, the works that I do shall he do also; and greater works than these shall he do; because I go unto my Father.

13 And whatsoever ye shall ask in my name, that will I do, that the Father may be glorified in the Son.

14 If ye shall ask any thing in my name, I will do it.

15 If ye love me, keep my commandments.

16 And I will pray the Father, and he shall give you another Comforter, that he may abide with you for ever;

JOHN 14: 17–31

17 Even the Spirit of truth; whom the world cannot receive, because it seeth him not, neither knoweth him: but ye know him; for he dwelleth with you, and shall be in you.

18 I will not leave you comfortless: I will come to you.

19 Yet a little while, and the world seeth me no more; but ye see me: because I live, ye shall live also.

20 At that day ye shall know that I am in my Father, and ye in me, and I in you.

21 He that hath my commandments, and keepeth them, he it is that loveth me: and he that loveth me shall be loved of my Father, and I will love him, and will manifest myself to him.

22 Judas saith unto him, not Iscariot, Lord, how is it that thou wilt manifest thyself unto us, and not unto the world?

23 Jesus answered and said unto him, If a man love me, he will keep my words: and my Father will love him, and we will come unto him, and make our abode with him.

24 He that loveth me not keepeth not my sayings: and the word which ye hear is not mine, but the Father's which sent me.

25 These things have I spoken unto you, being yet present with you.

26 But the Comforter, which is the Holy Ghost, whom the Father will send in my name, he shall teach you all things, and bring all things to your remembrance, whatsoever I have said unto you.

27 Peace I leave with you, my peace I give unto you: not as the world giveth, give I unto you. Let not your heart be troubled, neither let it be afraid.

28 Ye have heard how I said unto you, I go away, and come again unto you. If ye loved me, ye would rejoice, because I said, I go unto the Father: for my Father is greater than I.

29 And now I have told you before it come to pass, that, when it is come to pass, ye might believe.

30 Hereafter I will not talk much with you: for the prince of this world cometh, and hath nothing in me.

31 But that the world may know that I love the Father; and as the Father gave me commandment, even so I do. Arise, let us go hence.

JOHN 15:1–27

1 I am the true vine, and my Father is the husbandman.

2 Every branch in me that beareth not fruit he taketh away: and every branch that beareth fruit, he purgeth it, that it may bring forth more fruit.

3 Now ye are clean through the word which I have spoken unto you.

4 Abide in me, and I in you. As the branch cannot bear fruit of itself, except it abide in the vine; no more can ye, except ye abide in me.

5 I am the vine, ye are the branches: He that abideth in me, and I in him, the same bringeth forth much fruit: for without me ye can do nothing.

6 If a man abide not in me, he is cast forth as a branch, and is withered; and men gather them, and cast them into the fire, and they are burned.

7 Ye abide in me, and my words abide in you, ye shall ask what ye will, and it shall be done unto you.

8 Herein is my Father glorified, that ye bear much fruit; so shall ye be my disciples.

9 As the Father hath loved me, so have I loved you: continue ye in my love.

10 If ye keep my commandments, ye shall abide in my love; even as I have kept my Father's commandments, and abide in his love.

11 These things have I spoken unto you, that my joy might remain in you, and that your joy might be full.

12 This is my commandment, That ye love one another, as I have loved you.

13 Greater love hath no man than this, that a man lay down his life for his friends.

14 Ye are my friends, if ye do whatsoever I command you.

15 Henceforth I call you not servants; for the servant knoweth not what his lord doeth: but I have called you friends; for all things that I have heard of my Father I have made known unto you.

16 Ye have not chosen me, but I have chosen you, and ordained you, that ye should go and bring forth fruit, and that your fruit should remain: that whatsoever ye shall ask of the Father in my name, he may give it you.

17 These things I command you, that ye love one another.

18 If the world hate you, ye know that it hated me before it hated you.

19 If ye were of the world, the world would love his own: but because ye are not of the world, but I have chosen you out of the world, therefore the world hateth you.

20 Remember the word that I said unto you, The servant is not greater than his lord. If they have persecuted me, they will also persecute you; if they have kept my saying, they will keep yours also.

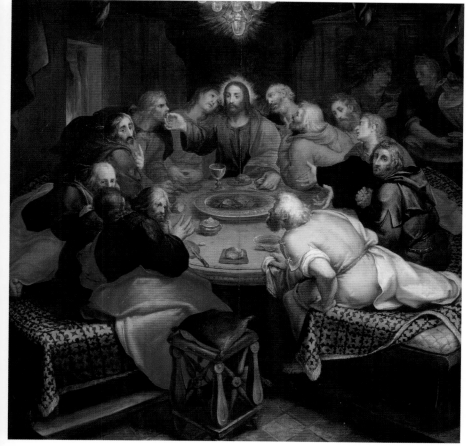

Last Supper, by Otto van Veen, 1556–1629

21 But all these things will they do unto you for my name's sake, because they know not him that sent me.

22 If I had not come and spoken unto them, they had not had sin: but now they have no cloak for their sin.

23 He that hateth me hateth my Father also.

24 If I had not done among them the works which none other man did, they had not had sin: but now have they both seen and hated both me and my Father.

25 But this cometh to pass, that the word might be fulfilled that is written in their law; They hated me without a cause.

26 But when the Comforter is come, whom I will send unto you from the Father, even the Spirit of truth, which proceedeth from the Father, he shall testify of me:

27 And ye also shall bear witness, because ye have been with me from the beginning.

JOHN 16:1–33

1 These things have I spoken unto you, that ye should not be offended.

2 They shall put you out of the synagogues: yea, the time cometh, that whosoever killeth you will think that he doeth God service.

3 And these things will they do unto you, because they have not known the Father, nor me.

4 But these things have I told you, that when the time shall come, ye may remember that I told you of them. And these things I said not unto you at the beginning, because I was with you.

5 But now I go my way to him that sent me; and none of you asketh me, Whither goest thou?

6 But because I have said these things unto you, sorrow hath filled your heart.

7 Nevertheless I tell you the truth; It is expedient for you that I go away: for if I go not away, the Comforter will not come unto you; but if I depart, I will send him unto you.

8 And when he is come, he will reprove the world of sin, and of righteousness, and of judgment:

9 Of sin, because they believe not on me;

10 Of righteousness, because I go to my Father, and ye see me no more;

11 Of judgment, because the prince of this world is judged.

12 I have yet many things to say unto you, but ye cannot bear them now.

13 Howbeit when he, the Spirit of truth, is come, he will guide you into all truth: for he shall not speak of himself; but whatsoever he shall hear, that shall he speak: and he will shew you things to come.

14 He shall glorify me: for he shall receive of mine, and shall shew it unto you.

15 All things that the Father hath are mine: therefore said I, that he shall take of mine, and shall shew it unto you.

16 A little while, and ye shall not see me: and again, a little while, and ye shall see me, because I go to the Father.

17 Then said some of his disciples among themselves, What is this that he saith unto us, A little while, and ye shall not see me: and again, a little while, and ye shall see me: and, Because I go to the Father?

18 They said therefore, What is this that he saith, A little while? we cannot tell what he saith.

19 Now Jesus knew that they were desirous to ask him, and said unto them, Do ye enquire among yourselves of that I said, A little while, and ye shall not see me:

and again, a little while, and ye shall see me?

20 Verily, verily, I say unto you, That ye shall weep and lament, but the world shall rejoice: and ye shall be sorrowful, but your sorrow shall be turned into joy.

21 A woman when she is in travail hath sorrow, because her hour is come: but as soon as she is delivered of the child, she remembereth no more the anguish, for joy that a man is born into the world.

22 And ye now therefore have sorrow: but I will see you again, and your heart shall rejoice, and your joy no man taketh from you.

23 And in that day ye shall ask me nothing. Verily, verily, I say unto you, Whatsoever ye shall ask the Father in my name, he will give it you.

24 Hitherto have ye asked nothing in my name: ask, and ye shall receive, that your joy may be full.

25 These things have I spoken unto you in proverbs: but the time cometh, when I shall no more speak unto you in proverbs, but I shall shew you plainly of the Father.

26 At that day ye shall ask in my name: and I say not unto you, that I will pray the Father for you:

27 For the Father himself loveth you, because ye have loved me, and have believed that I came out from God.

28 I came forth from the Father, and am come into the world: again, I leave the world, and go to the Father.

29 His disciples said unto him, Lo, now speakest thou plainly, and speakest no proverb.

30 Now are we sure that thou knowest all things, and needest not that any man should ask thee: by this we believe that thou camest forth from God.

31 Jesus answered them, Do ye now believe?

32 Behold, the hour cometh, yea, is now come, that ye shall be scattered, every man to his own, and shall leave me alone: and yet I am not alone, because the Father is with me.

33 These things I have spoken unto you, that in me ye might have peace. In the world ye shall have tribulation: but be of good cheer; I have overcome the world.

JESUS PRAYS FOR HIS DISCIPLES

Those who read carefully Jesus' so-called "High Priestly Prayer" can detect in it the echoes of the Lord's Prayer (Matthew 6:7–15 and Luke 11:1–4), the "Our Father," as well as the Prayer of Thanksgiving or Eucharistic Prayer of the Christian liturgy. Like the blessings of the patriarchs' farewells, Jesus offers up his life and work, commending himself, "his own," and "them also which shall believe on me through their word" to the Father's care and protection. He prays for them all to "be one, even as thou, Father, art in me and I in thee"—and for them to "be with me where I am." For these, like Jesus himself, are "not of the world," though they are "in the world."

JOHN 17:1–26

1 These words spake Jesus, and lifted up his eyes to heaven, and said, Father, the hour is come; glorify thy Son, that thy Son also may glorify thee:

2 As thou hast given him power over all flesh, that he should give eternal life to as many as thou hast given him.

3 And this is life eternal, that they might know thee the only true God, and Jesus Christ, whom thou hast sent.

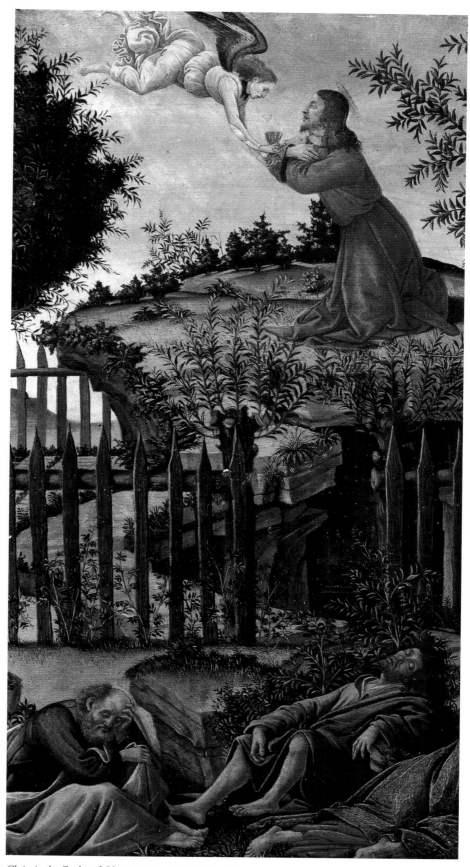

Christ in the Garden of Olives, by Filipepi Sandro Botticelli, 1445–1510

4 I have glorified thee on the earth: I have finished the work which thou gavest me to do.

5 And now, O Father, glorify thou me with thine own self with the glory which I had with thee before the world was.

6 I have manifested thy name unto the men which thou gavest me out of the world: thine they were, and thou gavest them me; and they have kept thy word.

7 Now they have known that all things whatsoever thou hast given me are of thee.

8 For I have given unto them the words which thou gavest me; and they have received them, and have known surely that I came out from thee, and they have believed that thou didst send me.

9 I pray for them: I pray not for the world, but for them which thou hast given me; for they are thine.

10 And all mine are thine, and thine are mine; and I am glorified in them.

11 And now I am no more in the world, but these are in the world, and I come to thee. Holy Father, keep through thine own name those whom thou hast given me, that they may be one, as we are.

12 While I was with them in the world, I kept them in thy name: those that thou gavest me I have kept, and none of them is lost, but the son of perdition; that the scripture might be fulfilled.

13 And now come I to thee; and these things I speak in the world, that they might have my joy fulfilled in themselves.

14 I have given them thy word; and the world hath hated them, because they are not of the world, even as I am not of the world.

15 I pray not that thou shouldest take them out of the world, but that thou shouldest keep them from the evil.

16 They are not of the world, even as I am not of the world.

17 Sanctify them through thy truth: thy word is truth.

18 As thou hast sent me into the world, even so have I also sent them into the world.

19 And for their sakes I sanctify myself, that they also might be sanctified through the truth.

20 Neither pray I for these alone, but for them also which shall believe on me through their word;

21 That they all may be one; as thou, Father, art in me, and I in thee, that they also may be one in us: that the world may believe that thou hast sent me.

22 And the glory which thou gavest me I have given them; that they may be one, even as we are one:

23 I in them, and thou in me, that they may be made perfect in one; and that the world may know that thou hast sent me, and hast loved them, as thou hast loved me.

24 Father, I will that they also, whom thou hast given me, be with me where I am; that they may behold my glory, which thou hast given me: for thou lovedst me before the foundation of the world.

25 O righteous Father, the world hath not known thee: but I have known thee, and these have known that thou hast sent me.

26 And I have declared unto them thy name, and will declare it: that the love wherewith thou hast loved me may be in them, and I in them.

JESUS DEPARTS FOR THE MOUNT OF OLIVES

MATTHEW 26:30–35

30 And when they had sung an hymn, they went out into the mount of Olives.

31 Then saith Jesus unto them, All ye shall be offended because of me this night: for it is written, I will smite the shepherd, and the sheep of the flock shall be scattered abroad.

32 But after I am risen again, I will go before you into Galilee.

33 Peter answered and said unto him, Though all men shall be offended because of thee, yet will I never be offended.

34 Jesus said unto him, Verily I say unto thee, That this night, before the cock crow, thou shalt deny me thrice.

35 Peter said unto him, Though I should die with thee, yet will I not deny thee. Likewise also said all the disciples.

MARK 14:26–31

26 And when they had sung an hymn, they went out into the mount of Olives.

27 And Jesus saith unto them, All ye shall be offended because of me this night: for it is written, I will smite the shepherd, and the sheep shall be scattered.

28 But after that I am risen, I will go before you into Galilee.

29 But Peter said unto him, Although all shall be offended, yet will not I.

30 And Jesus saith unto him, Verily I say unto thee, That this day, even in this night, before the cock crow twice, thou shalt deny me thrice.

31 But he spake the more vehemently, If I should die with thee, I will not deny thee in any wise. Likewise also said they all.

LUKE 22:31–38

31 And the Lord said, Simon, Simon, behold, Satan hath desired to have you, that he may sift you as wheat:

32 But I have prayed for thee, that thy faith fail not: and when thou art converted, strengthen thy brethren.

33 And he said unto him, Lord, I am ready to go with thee, both into prison, and to death.

34 And he said, I tell thee, Peter, the cock shall not crow this day, before that thou shalt thrice deny that thou knowest me.

35 And he said unto them, When I sent you without purse, and scrip, and shoes, lacked ye any thing? And they said, Nothing.

36 Then said he unto them, But now, he that hath a purse, let him take it, and likewise his scrip: and he that hath no sword, let him sell his garment, and buy one.

37 For I say unto you, that this that is written must yet be accomplished in me, And he was reckoned among the transgressors: for the things concerning me have an end.

38 And they said, Lord, behold, here are two swords. And he said unto them, It is enough.

JOHN 13:36–38

36 Simon Peter said unto him, Lord, whither goest thou? Jesus answered him, Whither I go, thou canst not follow me now; but thou shalt follow me afterwards.

37 Peter said unto him, Lord, why cannot I follow thee now? I will lay down my life for thy sake.

38 Jesus answered him, Wilt thou lay down thy life for my sake? Verily, verily, I say unto thee, The cock shall not crow, till thou hast denied me thrice.

THE GARDEN OF GETHSEMANE

As Jesus and his disciples leave the upper room, they head once again for the Mount of Olives. On the way Jesus warns them ahead of time that they will "all be offended because of me this night," even as Zechariah 13:7 predicted: "Awake, O sword, against my shepherd . . . saith the LORD of hosts: smite the shepherd and the sheep shall be scattered; and I will turn mine hand upon the little ones." Then Jesus adds his own prophecy to the scenario: "But after that I am risen, I will go before you into Galilee." Then Jesus, whose "soul is exceeding sorrowful," taking Peter, James, and John with him, reveals his true humanity as he prays: "all things are possible unto thee; take away this cup from me." All who look death in the face can know that Jesus, too, has been to— and through—that place, and on to the place where in earnest he can pray with us, in the words he taught: "O my Father, if this cup may not pass away…except I drink it, thy will be done." His disciples sleep, while Jesus "looked for comforters and found none" (Psalm 69:20). Judas comes, as planned, betraying Jesus with a kiss. The crowd lays hands on Jesus, Peter takes his sword and "turning his hand on the little ones" slices off the ear of the High Priest's slave (Luke's Jesus, always the reconciler, heals it). Why the swords? In Isaiah 53, the Suffering Servant "was numbered among the transgressors" (verse 12). And, as predicted, all the disciples forsook him and fled. Mark alone tells of a young man, dressed only in a linen cloth, who, when they seize him, runs away naked. Could this be Mark? Or "every disciple"—a symbol of others yet to join the story?

MATTHEW 26:36–46

36 Then cometh Jesus with them unto a place called Gethsemane, and saith unto the disciples, Sit ye here, while I go and pray yonder.

37 And he took with him Peter and the two sons of Zebedee, and began to be sorrowful and very heavy.

38 Then saith he unto them, My soul is exceeding sorrowful, even unto death: tarry ye here, and watch with me.

39 And he went a little further, and fell on his face, and prayed, saying, O my Father, if it be possible, let this cup pass from me: nevertheless not as I will, but as thou wilt.

40 And he cometh unto the disciples, and findeth them asleep, and saith unto Peter, What, could ye not watch with me one hour?

41 Watch and pray, that ye enter not into temptation: the spirit indeed is willing, but the flesh is weak.

42 He went away again the second time, and prayed, saying, O my Father, if this cup may not pass away from me, except I drink it, thy will be done.

43 And he came and found them asleep again: for their eyes were heavy.

44 And he left them, and went away again, and prayed the third time, saying the same words.

45 Then cometh he to his disciples, and saith unto them, Sleep on now, and take your rest: behold, the hour is at hand, and the Son of man is betrayed into the hands of sinners.

46 Rise, let us be going: behold, he is at hand that doth betray me.

MARK 14:32–42

32 And they came to a place which was named Gethsemane: and he saith to his disciples, Sit ye here, while I shall pray.

33 And he taketh with him Peter and James and John, and began to be sore amazed, and to be very heavy;

34 And saith unto them, My soul is exceeding sorrowful unto death: tarry ye here, and watch.

35 And he went forward a little, and fell on the ground, and prayed that, if it were possible, the hour might pass from him.

36 And he said, Abba, Father, all things are possible unto thee; take away this cup from me: nevertheless not what I will, but what thou wilt.

37 And he cometh, and findeth them sleeping, and saith unto Peter, Simon, sleepest thou? couldest not thou watch one hour?

38 Watch ye and pray, lest ye enter into temptation. The spirit truly is ready, but the flesh is weak.

39 And again he went away, and prayed, and spake the same words.

40 And when he returned, he found them asleep again, (for their eyes were heavy,) neither wist they what to answer him.

41 And he cometh the third time, and saith unto them, Sleep on now, and take your rest: it is enough, the hour is come; behold, the Son of man is betrayed into the hands of sinners.

42 Rise up, let us go; lo, he that betrayeth me is at hand.

LUKE 22:39–46

39 And he came out, and went, as he was wont, to the mount of Olives; and his disciples also followed him.

40 And when he was at the place, he said unto them, Pray that ye enter not into temptation.

41 And he was withdrawn from them about a stone's cast, and kneeled down, and prayed,

42 Saying, Father, if thou be willing, remove this cup from me: nevertheless not my will, but thine, be done.

43 And there appeared an angel unto him from heaven, strengthening him.

44 And being in an agony he prayed more earnestly: and his sweat was as it were great drops of blood falling down to the ground.

45 And when he rose up from prayer, and was come to his disciples, he found them sleeping for sorrow,

46 And said unto them, Why sleep ye? rise and pray, lest ye enter into temptation.

JOHN 18:1

1 When Jesus had spoken these words, he went forth with his disciples over the brook Cedron, where was a garden, into the which he entered, and his disciples.

JESUS IS TAKEN INTO CUSTODY

MATTHEW 26:47–56

47 And while he yet spake, lo, Judas, one of the twelve, came, and with him a great multitude with swords and staves, from the chief priests and elders of the people.

48 Now he that betrayed him gave them a sign, saying, Whomsoever I shall kiss, that same is he: hold him fast.

49 And forthwith he came to Jesus, and said, Hail, master; and kissed him.

50 And Jesus said unto him, Friend, wherefore art thou come? Then came they, and laid hands on Jesus, and took him.

51 And, behold, one of them which were with Jesus stretched out his hand, and drew his sword, and struck a servant of the high priest's, and smote off his ear.

52 Then said Jesus unto him, Put up again thy sword into his place: for all they that take the sword shall perish with the sword.

53 Thinkest thou that I cannot now pray to my Father, and he shall

presently give me more than twelve legions of angels?

54 But how then shall the scriptures be fulfilled, that thus it must be?

55 In that same hour said Jesus to the multitudes, Are ye come out as against a thief with swords and staves for to take me? I sat daily with you teaching in the temple, and ye laid no hold on me.

56 But all this was done, that the scriptures of the prophets might be fulfilled. Then all the disciples forsook him, and fled.

MARK 14:43–52

43 And immediately, while he yet spake, cometh Judas, one of the twelve, and with him a great multitude with swords and staves, from the chief priests and the scribes and the elders.

44 And he that betrayed him had given them a token, saying, Whomsoever I shall kiss, that same is he; take him, and lead him away safely.

45 And as soon as he was come, he goeth straightway to him, and saith, Master, master; and kissed him.

46 And they laid their hands on him, and took him.

47 And one of them that stood by drew a sword, and smote a servant of the high priest, and cut off his ear.

48 And Jesus answered and said unto them, Are ye come out, as against a thief, with swords and with staves to take me?

49 I was daily with you in the temple teaching, and ye took me not: but the scriptures must be fulfilled.

50 And they all forsook him, and fled.

51 And there followed him a certain young man, having a linen cloth cast about his naked body; and the young men laid hold on him:

52 And he left the linen cloth, and fled from them naked.

47 And while he yet spake, behold a multitude, and he that was called Judas, one of the twelve, went before them, and drew near unto Jesus to kiss him.

48 But Jesus said unto him, Judas, betrayest thou the Son of man with a kiss?

49 When they which were about him saw what would follow, they said unto him, Lord, shall we smite with the sword?

50 And one of them smote the servant of the high priest, and cut off his right ear.

51 And Jesus answered and said, Suffer ye thus far. And he touched his ear, and healed him.

52 Then Jesus said unto the chief priests, and captains of the temple, and the elders, which were come to him, Be ye come out, as against a thief, with swords and staves?

53 When I was daily with you in the temple, ye stretched forth no hands against me: but this is your hour, and the power of darkness.

JOHN 18:2–12

2 And Judas also, which betrayed him, knew the place: for Jesus ofttimes resorted thither with his disciples.

3 Judas then, having received a band of men and officers from the chief priests and Pharisees, cometh thither with lanterns and torches and weapons.

4 Jesus therefore, knowing all things that should come upon him, went forth, and said unto them, Whom seek ye?

5 They answered him, Jesus of Nazareth. Jesus saith unto them, I am he. And Judas also, which betrayed him, stood with them.

6 As soon then as he had said unto them, I am he, they went backward, and fell to the ground.

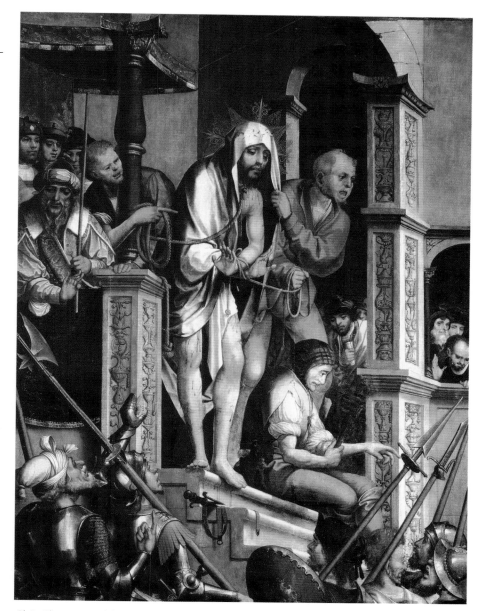

Christ Shown to People by Pontius Pilate, c. 1522, by Christovao Figueiredo

7 Then asked he them again, Whom seek ye? And they said, Jesus of Nazareth.

8 Jesus answered, I have told you that I am he: if therefore ye seek me, let these go their way:

9 That the saying might be fulfilled, which he spake, Of them which thou gavest me have I lost none.

10 Then Simon Peter having a sword drew it, and smote the high priest's servant, and cut off his right ear. The servant's name was Malchus.

11 Then said Jesus unto Peter, Put up thy sword into the sheath: the cup which my Father hath given me, shall I not drink it?

12 Then the band and the captain and officers of the Jews took Jesus, and bound him,

JESUS APPEARS BEFORE THE COUNCIL

Woven together for dramatic effect are the stories of Jesus and Peter— Jesus inside the High Priest's courtyard, and Peter outside by the fire. Jesus, the accused, hears many allegations against him, yet says nothing, fulfilling another word (Isaiah 53:7): "He was oppressed, and he was afflicted, yet he opened not his mouth." But when the High Priest asks him directly, "Art thou the Christ, the Son of the Blessed?" Mark's Jesus says "I am," and then goes on to quote Daniel 7:13: "…and ye shall see the Son of man sitting on the right hand of power and coming on the clouds of heaven." The High Priest had no trouble in understanding Jesus. "I Am" is the name God gave Moses at the burning bush (Exodus 3:14). For a man to say that is blasphemy, the ultimate evil, punishable by being stoned to death (Leviticus 24:16). But if the Son of God were to say it, it would be the truth. The High Priest and the Council take it as blasphemy, and condemn him to death. Both Matthew and Luke soften Jesus' answer to "Thou hast said" and "Ye say that I am."

MATTHEW 26:57–68

57 And they that had laid hold on Jesus led him away to Caiaphas the high priest, where the scribes and the elders were assembled.

58 But Peter followed him afar off unto the high priest's palace, and went in, and sat with the servants, to see the end.

59 Now the chief priests, and elders, and all the council, sought false witness against Jesus, to put him to death;

60 But found none: yea, though many false witnesses came, yet found they none. At the last came two false witnesses,

61 And said, This fellow said, I am able to destroy the temple of God, and to build it in three days.

62 And the high priest arose, and said unto him, Answerest thou nothing? what is it which these witness against thee?

63 But Jesus held his peace. And the high priest answered and said unto him, I adjure thee by the living God, that thou tell us whether thou be the Christ, the Son of God.

64 Jesus saith unto him, Thou hast said: nevertheless I say unto you, Hereafter shall ye see the Son of man sitting on the right hand of power, and coming in the clouds of heaven.

65 Then the high priest rent his clothes, saying, He hath spoken blasphemy; what further need have we of witnesses? behold, now ye have heard his blasphemy.

66 What think ye? They answered and said, He is guilty of death.

67 Then did they spit in his face, and buffeted him; and others smote him with the palms of their hands,

68 Saying, Prophesy unto us, thou Christ, Who is he that smote thee?

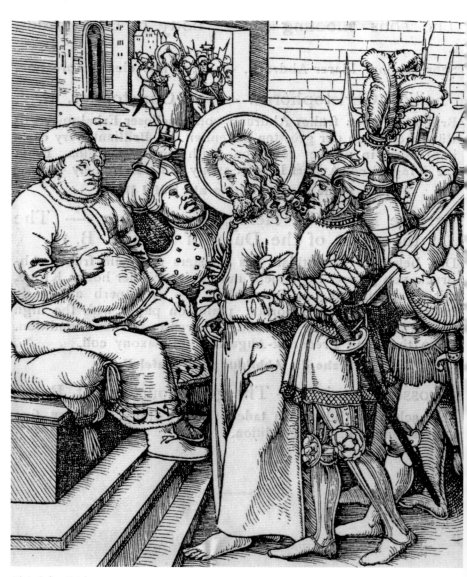

Christ before Caiphas, by Hans Wechtlin, c.1480–1526

MARK 14:53–65

53 And they led Jesus away to the high priest: and with him were assembled all the chief priests and the elders and the scribes.

54 And Peter followed him afar off, even into the palace of the high priest: and he sat with the servants, and warmed himself at the fire.

55 And the chief priests and all the council sought for witness against Jesus to put him to death; and found none.

56 For many bare false witness against him, but their witness agreed not together.

57 And there arose certain, and bare false witness against him, saying,

58 We heard him say, I will destroy this temple that is made with hands, and within three days I will build another made without hands.

59 But neither so did their witness agree together.

60 And the high priest stood up in the midst, and asked Jesus, saying, Answerest thou nothing? what is it which these witness against thee?

61 But he held his peace, and answered nothing. Again the high priest asked him, and said unto him, Art thou the Christ, the Son of the Blessed?

62 And Jesus said, I am: and ye shall see the Son of man sitting on the right hand of power, and coming in the clouds of heaven.

63 Then the high priest rent his clothes, and saith, What need we any further witnesses?

64 Ye have heard the blasphemy: what think ye? And they all condemned him to be guilty of death.

65 And some began to spit on him, and to cover his face, and to buffet him, and to say unto him, Prophesy: and the servants did strike him with the palms of their hands.

LUKE 22:54–71

54 Then took they him, and led him, and brought him into the high priest's house. And Peter followed afar off.

55 And when they had kindled a fire in the midst of the hall, and were set down together, Peter sat down among them.

56 But a certain maid beheld him as he sat by the fire, and earnestly looked upon him, and said, This man was also with him.

57 And he denied him, saying, Woman, I know him not.

58 And after a little while another saw him, and said, Thou art also of them. And Peter said, Man, I am not.

59 And about the space of one hour after another confidently affirmed, saying, Of a truth this fellow also was with him: for he is a Galilaean.

60 And Peter said, Man, I know not what thou sayest. And immediately, while he yet spake, the cock crew.

61 And the Lord turned, and looked upon Peter. And Peter remembered the word of the Lord, how he had said unto him, Before the cock crow, thou shalt deny me thrice.

62 And Peter went out, and wept bitterly.

63 And the men that held Jesus mocked him, and smote him.

64 And when they had blindfolded him, they struck him on the face, and asked him, saying, Prophesy, who is it that smote thee?

65 And many other things blasphemously spake they against him.

66 And as soon as it was day, the elders of the people and the chief priests and the scribes came together, and led him into their council, saying,

67 Art thou the Christ? tell us. And he said unto them, If I tell you, ye will not believe:

68 And if I also ask you, ye will not answer me, nor let me go.

69 Hereafter shall the Son of man sit on the right hand of the power of God.

70 Then said they all, Art thou then the Son of God? And he said unto them, Ye say that I am.

71 And they said, What need we any further witness? for we ourselves have heard of his own mouth.

JOHN 18:13–24

13 And led him away to Annas first; for he was father in law to Caiaphas, which was the high priest that same year.

14 Now Caiaphas was he, which gave counsel to the Jews, that it was expedient that one man should die for the people.

15 And Simon Peter followed Jesus, and so did another disciple: that disciple was known unto the high priest, and went in with Jesus into the palace of the high priest.

16 But Peter stood at the door without. Then went out that other disciple, which was known unto the high priest, and spake unto her that kept the door, and brought in Peter.

17 Then saith the damsel that kept the door unto Peter, Art not thou also one of this man's disciples? He saith, I am not.

18 And the servants and officers stood there, who had made a fire of coals; for it was cold: and they warmed themselves: and Peter stood with them, and warmed himself.

19 The high priest then asked Jesus of his disciples, and of his doctrine.

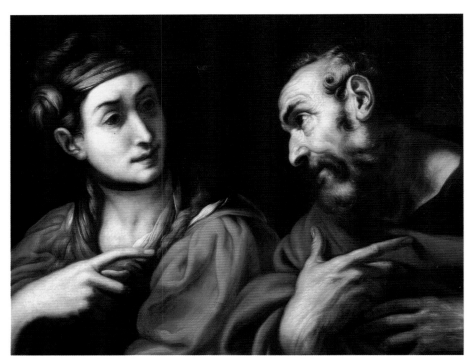

Betrayal by Saint Peter, by Daniele Crispi, 1597–1630

20 Jesus answered him, I spake openly to the world; I ever taught in the synagogue, and in the temple, whither the Jews always resort; and in secret have I said nothing.

21 Why askest thou me? ask them which heard me, what I have said unto them: behold, they know what I said.

22 And when he had thus spoken, one of the officers which stood by struck Jesus with the palm of his hand, saying, Answerest thou the high priest so?

23 Jesus answered him, If I have spoken evil, bear witness of the evil: but if well, why smitest thou me?

24 Now Annas had sent him bound unto Caiaphas the high priest.

PETER DENIES JESUS

Jesus makes the good confession, while Peter "falls away," just as Jesus foresees. In Mark and Matthew, Peter invokes a curse on himself, swearing to God he does not know Jesus. Luke's Jesus makes a personal aside to him at the Last Supper, telling him that Satan wants to "sift (him) as wheat." Jesus prays for his faith not to fall—and gives him a task to do after his fall (and rising): "And when thou art converted, strengthen thy brethren." (Luke 22:32) Luke tells us, after his third denial and the cock-crow, "The Lord looked upon Peter. And Peter remembered the word of the Lord . . . Jesus intends for Peter to remember both of his words, the before and the after.

MATTHEW 26:69–75

69 Now Peter sat without in the palace: and a damsel came unto him, saying, Thou also wast with Jesus of Galilee.

70 But he denied before them all, saying, I know not what thou sayest.

71 And when he was gone out into the porch, another maid saw him, and said unto them that were there, This fellow was also with Jesus of Nazareth.

72 And again he denied with an oath, I do not know the man.

73 And after a while came unto him they that stood by, and said to Peter, Surely thou also art one of them; for thy speech bewrayeth thee.

74 Then began he to curse and to swear, saying, I know not the man. And immediately the cock crew.

75 And Peter remembered the word of Jesus, which said unto him, Before the cock crow, thou shalt deny me thrice. And he went out, and wept bitterly.

MARK 14:66–72

66 And as Peter was beneath in the palace, there cometh one of the maids of the high priest:

67 And when she saw Peter warming himself, she looked upon him, and said, And thou also wast with Jesus of Nazareth.

68 But he denied, saying, I know not, neither understand I what thou sayest. And he went out into the porch; and the cock crew.

69 And a maid saw him again, and began to say to them that stood by, This is one of them.

70 And he denied it again. And a little after, they that stood by said again to Peter, Surely thou art one of them: for thou art a Galilaean, and thy speech agreeth thereto.

71 But he began to curse and to swear, saying, I know not this man of whom ye speak.

72 And the second time the cock crew. And Peter called to mind the word that Jesus said unto him, Before the cock crow twice, thou shalt deny me thrice. And when he thought thereon, he wept.

56 But a certain maid beheld him as he sat by the fire, and earnestly looked upon him, and said, This man was also with him.

57 And he denied him, saying, Woman, I know him not.

58 And after a little while another saw him, and said, Thou art also of them. And Peter said, Man, I am not.

59 And about the space of one hour after another confidently affirmed, saying, Of a truth this fellow also was with him: for he is a Galilaean.

60 And Peter said, Man, I know not what thou sayest. And immediately, while he yet spake, the cock crew.

61 And the Lord turned, and looked upon Peter. And Peter remembered the word of the Lord, how he had said unto him, Before the cock crow, thou shalt deny me thrice.

62 And Peter went out, and wept bitterly.

JOHN 18:25–27

25 And Simon Peter stood and warmed himself. They said therefore unto him, Art not thou also one of his disciples? He denied it, and said, I am not.

❧❧❧❧❧❧❧❧❧

And Jesus stood before the governor: and the governor asked him, saying, Art thou the King of the Jews? And Jesus said unto him, Thou sayest.

—MATTHEW 27:11

❧❧❧❧❧❧❧❧❧

26 One of the servants of the high priest, being his kinsman whose ear Peter cut off, saith, Did not I see thee in the garden with him?

27 Peter then denied again: and immediately the cock crew.

JESUS IS HANDED OVER TO PONTIUS PILATE

Since Judea, unlike Galilee, was under the direct control of a Roman governor, appointed by the emperor, the High Priest and the Council or Sanhedrin did not have the authority to execute those found guilty of capital offenses under Jewish law. So Jesus had to be handed over to Pontius Pilate, the Roman governor from 26-36 A.D., to be put to death. All the gospels have Jesus questioned by Pilate, who, finding no grounds for crucifying him, wants to have him scourged and then released. Pilate offers to release a condemned prisoner, as a gesture of amnesty honoring the feast. The crowd is given the choice of Jesus or Barabbas (Aramaic for "son of the Father"), an insurrectionist and murderer. The crowd chooses Barabbas, shouting for Jesus to be crucified. Pilate accedes to their demands and hands Jesus over. Luke, who knows the Roman justice system, modifies Mark along those lines, three times declaring Jesus innocent. In Matthew, a gospel written by a Jesus-believing Jew for a Jewish audience, Pilate washes his hands before "all the people," stating that he is innocent of his blood, to which they respond: "His blood be on us and on our children." Regretfully, the misreading of this verse has led to persecution of Jews over many centuries. If one recalls Jesus' words at the Last Supper, "This is my blood, of the new testament…shed for many for the remission of sins"—and that "all the people" means the entire covenant people (including Matthew's community)—it becomes clear that the people's acceptance of his blood, though spoken in deri-

sion, sounds like the covenant ceremony in Exodus 24:8. Judas goes to the priests to return the silver and confess his sin in betraying "innocent blood." The priests refuse to hear his confession, and tell him to "see to it yourself." See to it he does—by hanging himself as Jesus is himself hanging on the cross. In John, it almost seems that it is Pilate who is on trial. The people themselves judge as they respond to Pilate's question, "Shall I crucify your king?" They reply, "We have no king but Caesar."

MATTHEW 27:1–2, 11–14

1 When the morning was come, all the chief priests and elders of the people took counsel against Jesus to put him to death:

2 And when they had bound him, they led him away, and delivered him to Pontius Pilate the governor.

11 And Jesus stood before the governor: and the governor asked him, saying, Art thou the King of the Jews? And Jesus said unto him, Thou sayest.

12 And when he was accused of the chief priests and elders, he answered nothing.

13 Then said Pilate unto him, Hearest thou not how many things they witness against thee?

14 And he answered him to never a word; insomuch that the governor marvelled greatly.

MARK 15:1–5

1 And straightway in the morning the chief priests held a consultation with the elders and scribes and the whole council, and bound Jesus, and carried him away, and delivered him to Pilate.

2 And Pilate asked him, Art thou the King of the Jews? And he answering said unto him, Thou sayest it.

3 And the chief priests accused him of many things: but he answered nothing.

4 And Pilate asked him again, saying, Answerest thou nothing? behold how many things they witness against thee.

5 But Jesus yet answered nothing; so that Pilate marvelled.

LUKE 23:1–5

1 And the whole multitude of them arose, and led him unto Pilate.

2 And they began to accuse him, saying, We found this fellow perverting the nation, and forbidding to give tribute to Caesar, saying that he himself is Christ a King.

3 And Pilate asked him, saying, Art thou the King of the Jews? And he answered him and said, Thou sayest it.

4 Then said Pilate to the chief priests and to the people, I find no fault in this man.

5 And they were the more fierce, saying, He stirreth up the people, teaching throughout all Jewry, beginning from Galilee to this place.

JOHN 18:28–38

28 Then led they Jesus from Caiaphas unto the hall of judgment: and it was early; and they themselves went not into the judgment hall, lest they should be defiled; but that they might eat the passover.

29 Pilate then went out unto them, and said, What accusation bring ye against this man?

30 They answered and said unto him, If he were not a malefactor, we would not have delivered him up unto thee.

31 Then said Pilate unto them, Take ye him, and judge him according to your law. The Jews therefore said unto him, It is not lawful for us to put any man to death:

32 That the saying of Jesus might be fulfilled, which he spake, signifying what death he should die.

33 Then Pilate entered into the judgment hall again, and called Jesus, and said unto him, Art thou the King of the Jews?

34 Jesus answered him, Sayest thou this thing of thyself, or did others tell it thee of me?

35 Pilate answered, Am I a Jew? Thine own nation and the chief priests have delivered thee unto me: what hast thou done?

36 Jesus answered, My kingdom is not of this world: if my kingdom were of this world, then would my servants fight, that I should not be delivered to the Jews: but now is my kingdom not from hence.

37 Pilate therefore said unto him, Art thou a king then? Jesus answered, Thou sayest that I am a king. To this end was I born, and for this cause came I into the world, that I should bear witness unto the truth. Every one that is of the truth heareth my voice.

38 Pilate saith unto him, What is truth? And when he had said this, he went out again unto the Jews, and saith unto them, I find in him no fault at all.

JESUS APPEARS BEFORE HEROD

Only Luke has Pilate handing Jesus over to Herod Antipas (in Jerusalem for Passover), when he discovers Jesus is from Galilee, Herod's territory. Luke, when he relates the story of John the Baptist's death in chapter 9:7–9, mentions that Herod sought to see Jesus. Now he gets his chance. And, once again, Luke's Jesus, as the master reconciler, restores the relationship between Pilate and Herod, who had before been at enmity with each other.

LUKE 23:6–12

6 When Pilate heard of Galilee, he asked whether the man were a Galilaean.

7 And as soon as he knew that he belonged unto Herod's jurisdiction, he sent him to Herod, who himself also was at Jerusalem at that time.

8 And when Herod saw Jesus, he was exceeding glad: for he was desirous to see him of a long season, because he had heard many things of him; and he hoped to have seen some miracle done by him.

9 Then he questioned with him in many words; but he answered him nothing.

10 And the chief priests and scribes stood and vehemently accused him.

11 And Herod with his men of war set him at nought, and mocked him, and arrayed him in a gorgeous robe, and sent him again to Pilate.

12 And the same day Pilate and Herod were made friends together: for before they were at enmity between themselves.

JESUS OR BARABBAS?

MATTHEW 27:15–23

15 Now at that feast the governor was wont to release unto the people a prisoner, whom they would.

16 And they had then a notable prisoner, called Barabbas.

17 Therefore when they were gathered together, Pilate said unto them, Whom will ye that I release unto you? Barabbas, or Jesus which is called Christ?

18 For he knew that for envy they had delivered him.

19 When he was set down on the judgment seat, his wife sent unto him, saying, Have thou nothing to do with that just man: for I have suffered many things this day in a dream because of him.

20 But the chief priests and elders persuaded the multitude that they should ask Barabbas, and destroy Jesus.

21 The governor answered and said unto them, Whether of the twain will ye that I release unto you? They said, Barabbas.

22 Pilate saith unto them, What shall I do then with Jesus which is called Christ? They all say unto him, Let him be crucified.

23 And the governor said, Why, what evil hath he done? But they cried out the more, saying, Let him be crucified.

MARK 15:6–14

6 Now at that feast he released unto them one prisoner, whomsoever they desired.

7 And there was one named Barabbas, which lay bound with them that had made insurrection with him, who had committed murder in the insurrection.

8 And the multitude crying aloud began to desire him to do as he had ever done unto them.

9 But Pilate answered them, saying, Will ye that I release unto you the King of the Jews?

10 For he knew that the chief priests had delivered him for envy.

11 But the chief priests moved the people, that he should rather release Barabbas unto them.

12 And Pilate answered and said again unto them, What will ye then that I shall do unto him whom ye call the King of the Jews?

13 And they cried out again, Crucify him.

14 Then Pilate said unto them, Why, what evil hath he done? And they cried out the more exceedingly, Crucify him.

LUKE 23:17–23

17 (For of necessity he must release one unto them at the feast.)

18 And they cried out all at once, saying, Away with this man, and release unto us Barabbas:

19 (Who for a certain sedition made in the city, and for murder, was cast into prison.)

20 Pilate therefore, willing to release Jesus, spake again to them.

21 But they cried, saying, Crucify him, crucify him.

22 And he said unto them the third time, Why, what evil hath he done? I have found no cause of death in him: I will therefore chastise him, and let him go.

23 And they were instant with loud voices, requiring that he might be crucified. And the voices of them and of the chief priests prevailed.

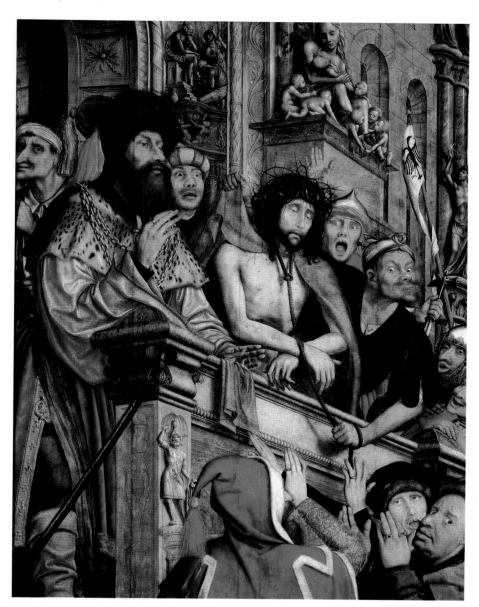

Christ Shown to the People by Pontius Pilate, 1518-20, by Quentin Massys, 1464/5–1530

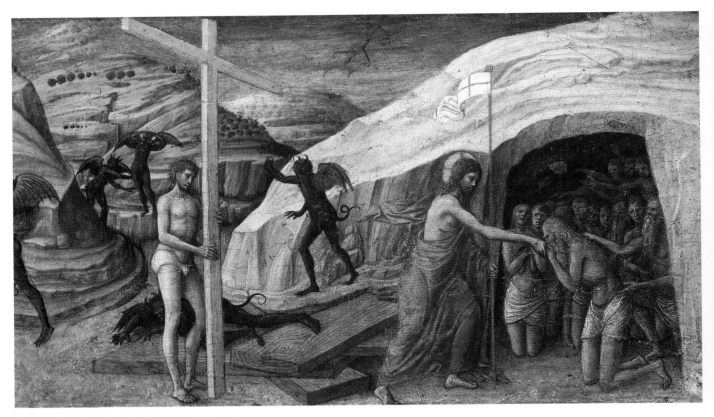

Descent of Jesus Christ into Limbo, by Jacopo Bellini, 1400–70

JOHN 18:39–40

39 But ye have a custom, that I should release unto you one at the passover: will ye therefore that I release unto you the King of the Jews?

40 Then cried they all again, saying, Not this man, but Barabbas. Now Barabbas was a robber.

BEHOLD THE MAN!

MATTHEW 27:28–31

28 And they stripped him, and put on him a scarlet robe.

29 And when they had platted a crown of thorns, they put it upon his head, and a reed in his right hand: and they bowed the knee before him, and mocked him, saying, Hail, King of the Jews!

30 And they spit upon him, and took the reed, and smote him on the head.

31 And after that they had mocked him, they took the robe off from him, and put his own raiment on him, and led him away to crucify him.

MARK 15:17–20

17 And they clothed him with purple, and platted a crown of thorns, and put it about his head,

18 And began to salute him, Hail, King of the Jews!

19 And they smote him on the head with a reed, and did spit upon him, and bowing their knees worshipped him.

20 And when they had mocked him, they took off the purple from him, and put his own clothes on him, and led him out to crucify him.

JOHN 19:1–15

1 Then Pilate therefore took Jesus, and scourged him.

2 And the soldiers platted a crown of thorns, and put it on his head, and they put on him a purple robe,

3 And said, Hail, King of the Jews! and they smote him with their hands.

4 Pilate therefore went forth again, and saith unto them, Behold, I bring him forth to you, that ye may know that I find no fault in him.

5 Then came Jesus forth, wearing the crown of thorns, and the purple robe. And Pilate saith unto them, Behold the man!

6 When the chief priests therefore and officers saw him, they cried out, saying, Crucify him, crucify him. Pilate saith unto them, Take ye him, and crucify him: for I find no fault in him.

7 The Jews answered him, We have a law, and by our law he ought to die, because he made himself the Son of God.

8 When Pilate therefore heard that saying, he was the more afraid;

9 And went again into the judgment hall, and saith unto Jesus, Whence art thou? But Jesus gave him no answer.

10 Then saith Pilate unto him, Speakest thou not unto me? knowest thou not that I have power to crucify thee, and have power to release thee?

11 Jesus answered, Thou couldest have no power at all against me, except it were given thee from above: therefore he that delivered me unto thee hath the greater sin.

12 And from thenceforth Pilate sought to release him: but the Jews cried out, saying, If thou let this man go, thou art not Caesar's friend: whosoever maketh himself a king speaketh against Caesar.

13 When Pilate therefore heard that saying, he brought Jesus forth, and sat down in the judgment seat in a place that is called the Pavement, but in the Hebrew, Gabbatha.

14 And it was the preparation of the passover, and about the sixth hour: and he saith unto the Jews, Behold your King!

15 But they cried out, Away with him, away with him, crucify him. Pilate saith unto them, Shall I crucify your King? The chief priest answered, We have no king but Caesar.

JESUS IS HANDED OVER TO BE CRUCIFIED

Ever since the story of Jesus' passion began to be told and retold, people have looked for ways to connect the rapid progression of events of Passover week from the shouts of "Hosanna!" to the shouts of "Crucify him!" One of those, mentioned above, is Isaiah 53, the song of the servant of the Lord who suffers for the sins of the nations. Another is Psalm 22, an innocent sufferer's prayer for deliverance. Jesus himself prays it on the cross: "My God, my God, why hast thou forsaken me?" Details from that psalm abound in the gospel accounts, among them "All who see me laugh me to scorn," and "they parted my garments among them, and cast lots upon my vesture." Yet another connecting device is the Greek word Mark uses in every scene of the Passion, from the treachery of Judas' betrayal to Pilate's "delivering" Jesus to the soldiers to be crucified. The same word is translated "betray," when Judas does it, "deliver" when the chief priests and the governor do it. John's Jesus does it. After his victorious "It is finished!," he "gives up the ghost," i.e. hands over the spirit. Passover, as noted earlier, is a feast of deliverance. There is another word in Hebrew for that kind of delivering. It occurs in Psalm 22:21: "Save me from the lion's mouth"—it is the root of Jesus' name, itself a confession of faith: "The LORD saves, delivers."

MATTHEW 27:24–31

24 When Pilate saw that he could prevail nothing, but that rather a tumult was made, he took water, and washed his hands before the multitude, saying, I am innocent of the blood of this just person: see ye to it.

25 Then answered all the people, and said, His blood be on us, and on our children.

26 Then released he Barabbas unto them: and when he had scourged Jesus, he delivered him to be crucified.

27 Then the soldiers of the governor took Jesus into the common hall, and gathered unto him the whole band of soldiers.

28 And they stripped him, and put on him a scarlet robe.

29 And when they had platted a crown of thorns, they put it upon his head, and a reed in his right hand: and they bowed the knee before him, and mocked him, saying, Hail, King of the Jews!

30 And they spit upon him, and took the reed, and smote him on the head.

31 And after that they had mocked him, they took the robe off from him, and put his own raiment on him, and led him away to crucify him.

MARK 15:15–20

15 And so Pilate, willing to content the people, released Barabbas unto them, and delivered Jesus, when he had scourged him, to be crucified.

16 And the soldiers led him away into the hall, called Praetorium; and they call together the whole band.

17 And they clothed him with purple, and platted a crown of thorns, and put it about his head,

18 And began to salute him, Hail, King of the Jews!

Then came Jesus forth, wearing the crown of thorns, and the purple robe. And Pilate saith unto them, Behold the man!

—JOHN 19:5

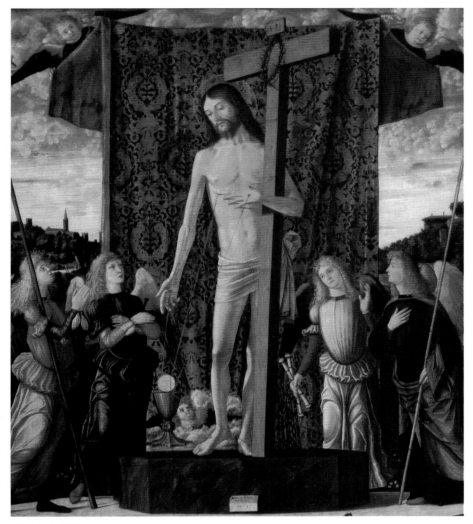

The Blood of Christ, by Vittore Carpaccio, 1465–1525

THE WAY TO GOLGOTHA

MATTHEW 27:31–32

31 And after that they had mocked him, they took the robe off from him, and put his own raiment on him, and led him away to crucify him.

32 And as they came out, they found a man of Cyrene, Simon by name: him they compelled to bear his cross.

MARK 15:20–21

20 And when they had mocked him, they took off the purple from him, and put his own clothes on him, and led him out to crucify him.

21 And they compel one Simon a Cyrenian, who passed by, coming out of the country, the father of Alexander and Rufus, to bear his cross.

LUKE 23:26–32

26 And as they led him away, they laid hold upon one Simon, a Cyrenian, coming out of the country, and on him they laid the cross, that he might bear it after Jesus.

27 And there followed him a great company of people, and of women, which also bewailed and lamented him.

28 But Jesus turning unto them said, Daughters of Jerusalem, weep not for me, but weep for yourselves, and for your children.

29 For, behold, the days are coming, in the which they shall say, Blessed are the barren, and the wombs that never bare, and the paps which never gave suck.

30 Then shall they begin to say to the mountains, Fall on us; and to the hills, Cover us.

31 For if they do these things in a green tree, what shall be done in the dry?

19 And they smote him on the head with a reed, and did spit upon him, and bowing their knees worshipped him.

20 And when they had mocked him, they took off the purple from him, and put his own clothes on him, and led him out to crucify him.

LUKE 23:24–25

24 And Pilate gave sentence that it should be as they required.

25 And he released unto them him that for sedition and murder was cast into prison, whom they had desired; but he delivered Jesus to their will.

JOHN 19:16

16 Then delivered he him therefore unto them to be crucified. And they took Jesus, and led him away.

JOHN 19:2–3

2 And the soldiers platted a crown of thorns, and put it on his head, and they put on him a purple robe,

3 And said, Hail, King of the Jews! and they smote him with their hands.

32 And there were also two other, malefactors, led with him to be put to death.

JOHN 19:16–17

16 Then delivered he him therefore unto them to be crucified. And they took Jesus, and led him away.

17 And he bearing his cross went forth into a place called the place of a skull, which is called in the Hebrew Golgotha:

THE CRUCIFIXION

Luke's temptation story concludes: "And when the devil had ended all the temptation, he departed from him for a season" (Luke 4:11). Now he returns. All the gospels portray the passion as a showdown between Jesus and the power of evil. Even John, whose seven "signs" include no exorcisms, notes that at the Last Supper, after Judas ate the morsel Jesus gave him, "Satan entered into him…" (John 13:27) Luke's report of the soldiers' mockery, "If you are the Son of God…", begins with the same words the devil uses in his temptations. Crucifixion itself had a sign value—it portrayed graphically the fate of those who would counter the rule of law or usurp the power of the empire. While Jesus' kingdom is "not of this world" (John 18:35), the sign above Jesus' head on the cross (in Hebrew, Greek, and Latin, John notes) declares for all the world to see: "Jesus of Nazareth, the King of the Jews." Since death by crucifixion could take days, soldiers frequently beat the condemned nearly to death, thus speeding up the process. The "wine mingled with gall"—also a reminder of Psalm 69:21—served as a sedative. Nevertheless, soldiers constantly exposed to death at the hands of rebels and scorn from the occupied people likely found enjoyment in burlesquing the elevation of Jesus to his "throne," decked with a crown of thorns. Mark, Matthew, and Luke all note the darkness at noonday ("the sixth hour"). All the gospels note the sign above Jesus' head on the cross. All note the presence of the women at the foot of the cross, who watch Jesus die, witness his burial…and come to be the first witnesses to the empty tomb.

MATTHEW 27:33–37

33 And when they were come unto a place called Golgotha, that is to say, a place of a skull,

34 They gave him vinegar to drink mingled with gall: and when he had tasted thereof, he would not drink.

35 And they crucified him, and parted his garments, casting lots: that it might be fulfilled which was spoken by the prophet, They parted my garments among them, and upon my vesture did they cast lots.

36 And sitting down they watched him there;

37 And set up over his head his accusation written, THIS IS JESUS THE KING OF THE JEWS.

MARK 15:22–26

22 And they bring him unto the place Golgotha, which is, being interpreted, The place of a skull.

23 And they gave him to drink wine mingled with myrrh: but he received it not.

24 And when they had crucified him, they parted his garments, casting lots upon them, what every man should take.

25 And it was the third hour, and they crucified him.

26 And the superscription of his accusation was written over, THE KING OF THE JEWS.

LUKE 23:33–34

33 And when they were come to the place, which is called Calvary, there they crucified him, and the malefactors, one on the right hand, and the other on the left.

34 Then said Jesus, Father, forgive them; for they know not what they do. And they parted his raiment, and cast lots.

JOHN 19:17–27

17 And he bearing his cross went forth into a place called the place of a skull, which is called in the Hebrew Golgotha:

18 Where they crucified him, and two other with him, on either side one, and Jesus in the midst.

19 And Pilate wrote a title, and put it on the cross. And the writing was, JESUS OF NAZARETH THE KING OF THE JEWS.

20 This title then read many of the Jews: for the place where Jesus was crucified was nigh to the city: and it was written in Hebrew, and Greek, and Latin.

21 Then said the chief priests of the Jews to Pilate, Write not, The King of the Jews; but that he said, I am King of the Jews.

22 Pilate answered, What I have written I have written.

23 Then the soldiers, when they had crucified Jesus, took his garments, and made four parts, to every soldier a part; and also his coat: now the coat was without seam, woven from the top throughout.

24 They said therefore among themselves, Let us not rend it, but cast lots for it, whose it shall be: that the scripture might be fulfilled, which saith, They parted my raiment among them, and for my vesture they did cast lots. These things therefore the soldiers did.

25 Now there stood by the cross of Jesus his mother, and his mother's sister, Mary the wife of Cleophas, and Mary Magdalene.

26 When Jesus therefore saw his mother, and the disciple standing by, whom he loved, he saith unto his mother, Woman, behold thy son!

27 Then saith he to the disciple, Behold thy mother! And from that hour that disciple took her unto his own home.

JESUS IS MOCKED ON THE CROSS

MATTHEW 27:38–43

38 Then were there two thieves crucified with him, one on the right hand, and another on the left.

39 And they that passed by reviled him, wagging their heads,

40 And saying, Thou that destroyest the temple, and buildest it in three days, save thyself. If thou be the Son of God, come down from the cross.

41 Likewise also the chief priests mocking him, with the scribes and elders, said,

42 He saved others; himself he cannot save. If he be the King of Israel, let him now come down from the cross, and we will believe him.

43 He trusted in God; let him deliver him now, if he will have him: for he said, I am the Son of God.

MARK 15:27–32

27 And with him they crucify two thieves; the one on his right hand, and the other on his left.

28 And the scripture was fulfilled, which saith, And he was numbered with the transgressors.

29 And they that passed by railed on him, wagging their heads, and saying, Ah, thou that destroyest the temple, and buildest it in three days,

30 Save thyself, and come down from the cross.

31 Likewise also the chief priests mocking said among themselves with the scribes, He saved others; himself he cannot save.

32 Let Christ the King of Israel descend now from the cross, that we may see and believe. And they that were crucified with him reviled him.

LUKE 23:35–38

35 And the people stood beholding. And the rulers also with them derided him, saying, He saved others; let him save himself, if he be Christ, the chosen of God.

36 And the soldiers also mocked him, coming to him, and offering him vinegar,

37 And saying, If thou be the king of the Jews, save thyself.

38 And a superscription also was written over him in letters of Greek, and Latin, and Hebrew, THIS IS THE KING OF THE JEWS.

THE TWO THIEVES

MATTHEW 27:44

44 The thieves also, which were crucified with him, cast the same in his teeth.

MARK 15:32

32 Let Christ the King of Israel descend now from the cross, that we may see and believe. And they that were crucified with him reviled him.

LUKE 23:39–43

39 And one of the malefactors which were hanged railed on him, saying, If thou be Christ, save thyself and us.

40 But the other answering rebuked him, saying, Dost not thou fear God, seeing thou art in the same condemnation?

41 And we indeed justly; for we receive the due reward of our deeds: but this man hath done nothing amiss.

42 And he said unto Jesus, Lord, remember me when thou comest into thy kingdom.

43 And Jesus said unto him, Verily I say unto thee, To day shalt thou be with me in paradise.

THE DEATH OF JESUS

All the gospels share many details. Yet in the way they note Jesus' last words, each one uniquely expresses the meaning of Jesus' death for the future of humankind. In Mark and Matthew, Jesus prays Psalm 22, expressing the absence in death of what has been the source of power in his life—Jesus' intimacy with his Father. Jesus cries out with a loud voice: "My God, my God, why hast thou forsaken me?" Bystanders mistake it for Jesus' crying for Elijah, thought to be the deliverer of the innocent. In Jesus' exorcisms a loud cry frequently signifies the departure of the demon from the one it inhabits. The rending of the Temple curtain at his death proclaims open access to the presence of God. Matthew alone notes the splitting of rocks, the opening of the tombs—a sign of the end time and the resurrection of Israel's saints. Now the secret of Jesus' real identity is out in the open. A Roman centurion declares it: "Truly this man was the Son of God!" Luke's portrayal of Jesus as the reconciler and man of prayer emerges clearly as he prays for all (Jews and Gentiles alike) who put him on the cross: "Father, forgive them, for they know not what they do." To the thief, crucified with him, who asks, "Lord, remember me," Jesus promises, "today shalt thou be with me in paradise." To God he offers himself, praying the words of Psalm 31:5: "Father, into thy hands I commend my spirit." John, for whom Jesus' lifting up becomes occasion for the outpouring of the

spirit, the act by which Jesus draws all to himself, emphasizes the glory of the cross. His words indicate the birthing of a new community in the bringing together of his mother and the beloved disciple: "Woman, behold thy son. Son, behold your mother." Jesus, reigning from the cross, having fulfilled all the scriptures—except one—declares, "I thirst." He receives vinegar to drink, as per Psalm 69:21. Jesus' last words proclaim all has been accomplished: "It is finished!" No one takes his life from him—he lays it down himself: bowing his head, he "hands over" or "passes along" the spirit. Among those drawn to him as he is lifted up are Joseph of Arimathea and Nicodemus, prominent members of the Sanhedrin who give Jesus a king's burial, with a hundred pounds of spices. Even now he fulfills the mission of the Lord's servant: "And he made his grave with the wicked, and with a rich man in his death." (Isaiah 53:9)

MATTHEW 27:45–54

45 Now from the sixth hour there was darkness over all the land unto the ninth hour.

46 And about the ninth hour Jesus cried with a loud voice, saying, Eli, Eli, lama sabachthani? that is to say, My God, my God, why hast thou forsaken me?

47 Some of them that stood there, when they heard that, said, This man calleth for Elias.

48 And straightway one of them ran, and took a spunge, and filled it with vinegar, and put it on a reed, and gave him to drink.

49 The rest said, Let be, let us see whether Elias will come to save him.

50 Jesus, when he had cried again with a loud voice, yielded up the ghost.

51 And, behold, the veil of the temple was rent in twain from the top to the bottom; and the earth did quake, and the rocks rent;

52 And the graves were opened; and many bodies of the saints which slept arose,

53 And came out of the graves after his resurrection, and went into the holy city, and appeared unto many.

54 Now when the centurion, and they that were with him, watching Jesus, saw the earthquake, and those things that were done, they feared greatly, saying, Truly this was the Son of God.

MARK 15:33–39

33 And when the sixth hour was come, there was darkness over the whole land until the ninth hour.

34 And at the ninth hour Jesus cried with a loud voice, saying, Eloi, Eloi, lama sabachthani? which is, being interpreted, My God, my God, why hast thou forsaken me?

35 And some of them that stood by, when they heard it, said, Behold, he calleth Elias.

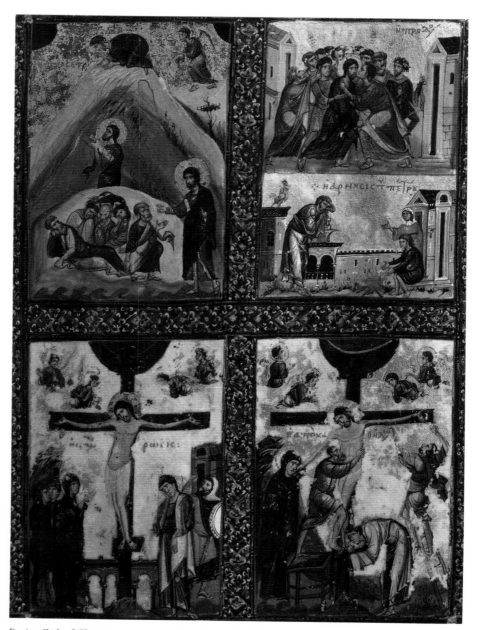

Passion Cycle of Christ: Agony in garden, Kiss of Judas, Crucifixion, 11th century, Artist Unknown

36 And one ran and filled a spunge full of vinegar, and put it on a reed, and gave him to drink, saying, Let alone; let us see whether Elias will come to take him down.

37 And Jesus cried with a loud voice, and gave up the ghost.

38 And the veil of the temple was rent in twain from the top to the bottom.

39 And when the centurion, which stood over against him, saw that he so cried out, and gave up the ghost, he said, Truly this man was the Son of God.

LUKE 23:44–48

44 And it was about the sixth hour, and there was a darkness over all the earth until the ninth hour.

45 And the sun was darkened, and the veil of the temple was rent in the midst.

46 And when Jesus had cried with a loud voice, he said, Father, into thy hands I commend my spirit: and having said thus, he gave up the ghost.

47 Now when the centurion saw what was done, he glorified God, saying, Certainly this was a righteous man.

48 And all the people that came together to that sight, beholding the things which were done, smote their breasts, and returned.

JOHN 19:28–30

28 After this, Jesus knowing that all things were now accomplished, that the scripture might be fulfilled, saith, I thirst.

29 Now there was set a vessel full of vinegar: and they filled a spunge with vinegar, and put it upon hyssop, and put it to his mouth.

30 When Jesus therefore had received the vinegar, he said, It is finished: and he bowed his head, and gave up the ghost.

WITNESSES OF THE CRUCIFIXION

MATTHEW 27:55–56

55 And many women were there beholding afar off, which followed Jesus from Galilee, ministering unto him:

56 Among which was Mary Magdalene, and Mary the mother of James and Joses, and the mother of Zebedee's children.

MARK 15:40–41

40 There were also women looking on afar off: among whom was Mary Magdalene, and Mary the mother of James the less and of Joses, and Salome;

41 (Who also, when he was in Galilee, followed him, and ministered unto him;) and many other women which came up with him unto Jerusalem.

LUKE 23:49

49 And all his acquaintance, and the women that followed him from Galilee, stood afar off, beholding these things.

JOHN 19:24–27

24 They said therefore among themselves, Let us not rend it, but cast lots for it, whose it shall be: that the scripture might be fulfilled, which saith, They parted my raiment among them, and for my vesture they did cast lots. These things therefore the soldiers did.

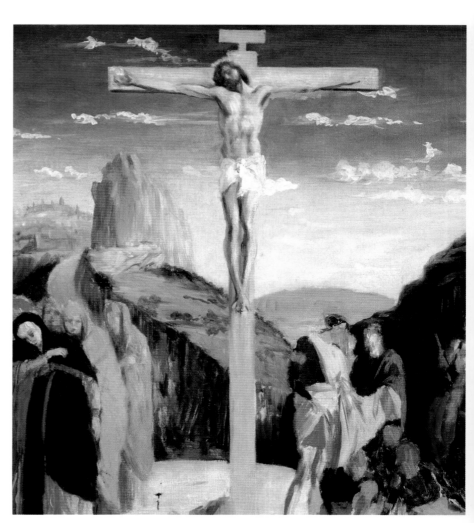

Calvary, c.1864, by Edgar Degas, 1834-1917

25 Now there stood by the cross of Jesus his mother, and his mother's sister, Mary the wife of Cleophas, and Mary Magdalene.

26 When Jesus therefore saw his mother, and the disciple standing by, whom he loved, he saith unto his mother, Woman, behold thy son!

27 Then saith he to the disciple, Behold thy mother! And from that hour that disciple took her unto his own home.

JESUS' SIDE PIERCED

JOHN 19:31–37

31 The Jews therefore, because it was the preparation, that the bodies should not remain upon the cross on the sabbath day, (for that sabbath day was an high day,) besought Pilate that their legs might be broken, and that they might be taken away.

32 Then came the soldiers, and brake the legs of the first, and of the other which was crucified with him.

33 But when they came to Jesus, and saw that he was dead already, they brake not his legs:

34 But one of the soldiers with a spear pierced his side, and forthwith came there out blood and water.

35 And he that saw it bare record, and his record is true: and he knoweth that he saith true, that ye might believe.

36 For these things were done, that the scripture should be fulfilled, A bone of him shall not be broken.

37 And again another scripture saith, They shall look on him whom they pierced.

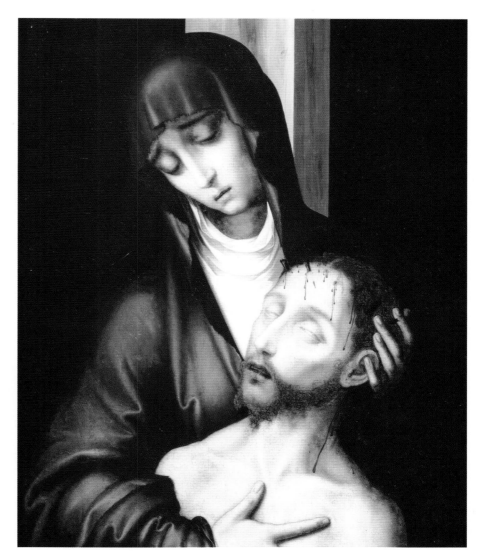

Dead Christ in Mary's Arms, by Luis de Morales, c.1509–1586

Then took they the body of Jesus, and wound it in linen clothes with the spices, as the manner of the Jews is to bury.

Now in the place where he was crucified there was a garden; and in the garden a new sepulchre, wherein was never man yet laid.

—JOHN 19:40–41

THE BURIAL OF JESUS

MATTHEW 27:57–61

57 When the even was come, there came a rich man of Arimathaea, named Joseph, who also himself was Jesus' disciple:

58 He went to Pilate, and begged the body of Jesus. Then Pilate commanded the body to be delivered.

59 And when Joseph had taken the body, he wrapped it in a clean linen cloth,

60 And laid it in his own new tomb, which he had hewn out in the rock: and he rolled a great stone to the door of the sepulchre, and departed.

61 And there was Mary Magdalene, and the other Mary, sitting over against the sepulchre.

MARK 15:42–47

42 And now when the even was come, because it was the preparation, that is, the day before the sabbath,

43 Joseph of Arimathaea, and honourable counseller, which also waited for the kingdom of God, came, and went in boldly unto Pilate, and craved the body of Jesus.

44 And Pilate marvelled if he were already dead: and calling unto him the centurion, he asked him whether he had been any while dead.

45 And when he knew it of the centurion, he gave the body to Joseph.

46 And he bought fine linen, and took him down, and wrapped him in the linen, and laid him in a sepulchre which was hewn out of a rock, and rolled a stone unto the door of the sepulchre.

47 And Mary Magdalene and Mary the mother of Joses beheld where he was laid.

LUKE 23:50–56

50 And, behold, there was a man named Joseph, a counseller; and he was a good man, and a just:

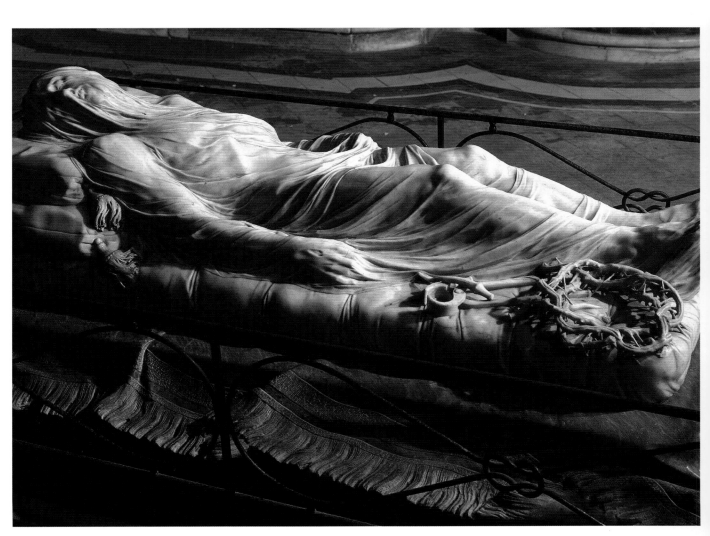

Veiled Christ, 1753, by Giuseppe Sammartino, 1720–1793

51 (The same had not consented to the counsel and deed of them;) he was of Arimathaea, a city of the Jews: who also himself waited for the kingdom of God.

52 This man went unto Pilate, and begged the body of Jesus.

53 And he took it down, and wrapped it in linen, and laid it in a sepulchre that was hewn in stone, wherein never man before was laid.

54 And that day was the preparation, and the sabbath drew on.

55 And the women also, which came with him from Galilee, followed after, and beheld the sepulchre, and how his body was laid.

56 And they returned, and prepared spices and ointments; and rested the sabbath day according to the commandment.

JOHN 19:38–42

38 And after this Joseph of Arimathaea, being a disciple of Jesus, but secretly for fear of the Jews, besought Pilate that he might take away the body of Jesus: and Pilate gave him leave. He came therefore, and took the body of Jesus.

39 And there came also Nicodemus, which at the first came to Jesus by night, and brought a mixture of myrrh and aloes, about an hundred pound weight.

40 Then took they the body of Jesus, and wound it in linen clothes with the spices, as the manner of the Jews is to bury.

41 Now in the place where he was crucified there was a garden; and in the garden a new sepulchre, wherein was never man yet laid.

42 There laid they Jesus therefore because of the Jews' preparation day; for the sepulchre was nigh at hand.

A GUARD IS PLACED AT THE TOMB

MATTHEW 27:62–66

62 Now the next day, that followed the day of the preparation, the chief priests and Pharisees came together unto Pilate,

63 Saying, Sir, we remember that that deceiver said, while he was yet alive, After three days I will rise again.

64 Command therefore that the sepulchre be made sure until the third day, lest his disciples come by night, and steal him away, and say unto the people, He is risen from the dead: so the last error shall be worse than the first.

65 Pilate said unto them, Ye have a watch: go your way, make it as sure as ye can.

66 So they went, and made the sepulchre sure, sealing the stone, and setting a watch.

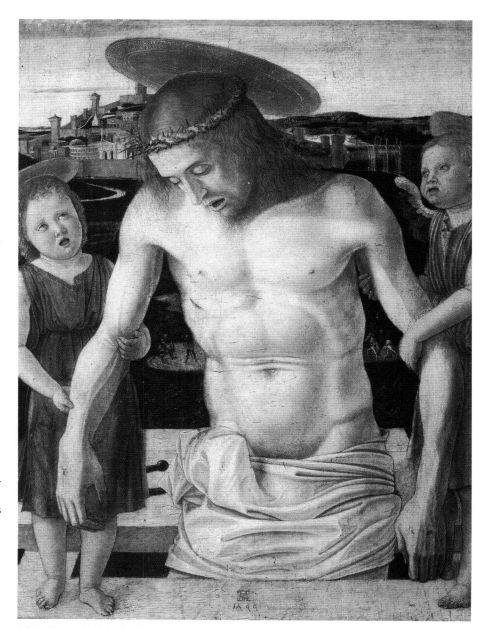

Christ Supported by Two Angels, by Giovanni Bellini, 1430–1516

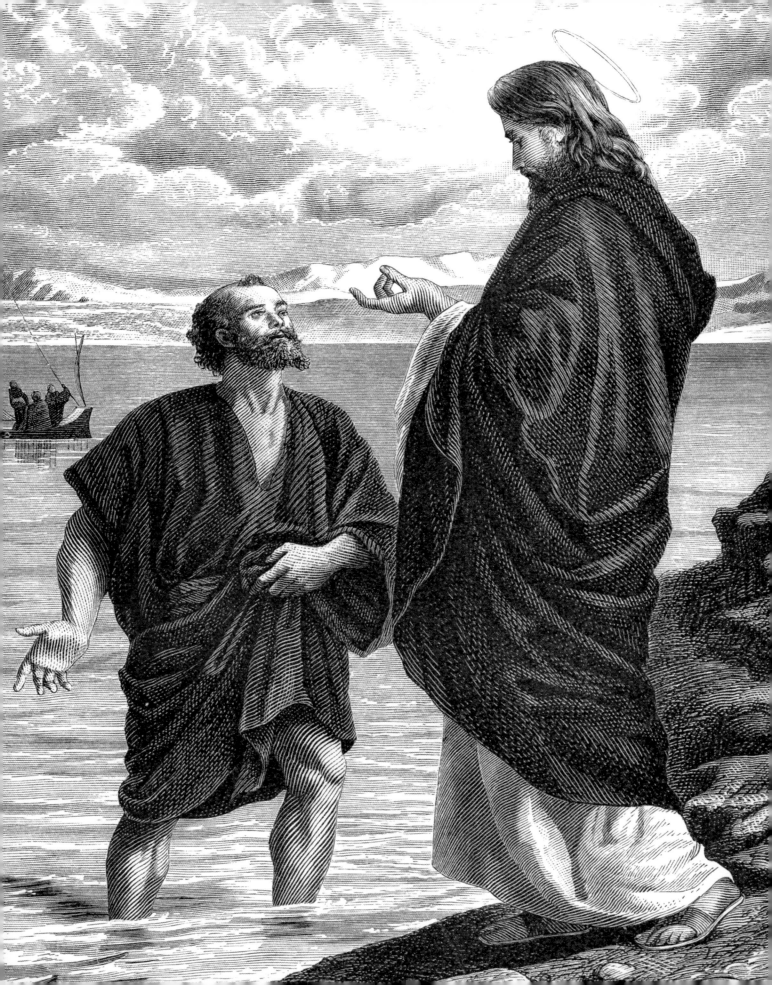

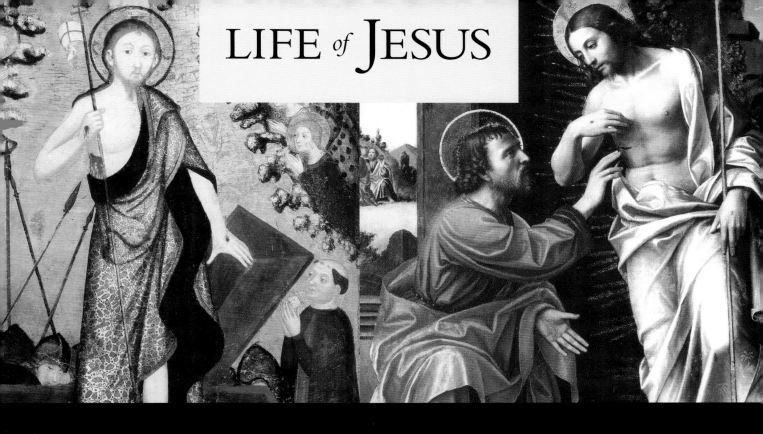

LIFE of JESUS

The Risen One

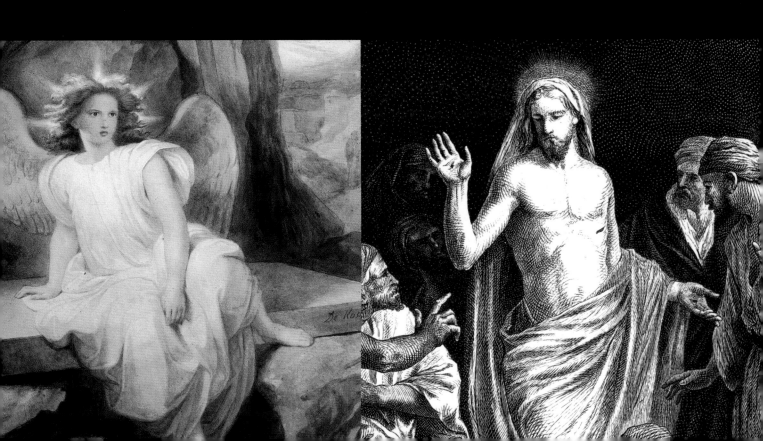

The Risen One

Holy Sepulchre with Resurrection of Christ, by Jaime Serra, 1358–89

THE MOST POWERFUL ASPECT OF JESUS' STORY is that it does not end at the tomb. A huge stone seals the tomb's entrance and a guard has been placed there by those who have heard Jesus say he would be killed, and, on the third day, be raised. From its first telling, the story of Jesus has centered on these two crucial events. The gospels include two kinds of witnesses: reports of the empty tomb and of Jesus' appearances. The empty tomb stories illustrate that the risen one is the same Jesus who was buried. The appearances attest to Jesus being recognized by those who had followed him before his death.

THE EMPTY TOMB

In all the gospels, the first people to deliver the news of the empty tomb are the women who followed Jesus from Galilee, were present at the cross, and watched his burial. The earliest written testimony to the risen Lord is passed along by Paul, as it had been told to him (within five years of the resurrection): "For I delivered unto you first of all that which I also received, how that Christ died for our sins according to the scriptures; and that he was buried, and that he rose again the third day according to the scriptures: And that he was seen of Cephas [Peter], then of the twelve: After that he was seen of above five hundred brethren at once; of whom the greater part remain unto the present, but some are fallen asleep. After that, he was seen of James; then of all the apostles. And last of all he was seen of me also." (1 Corinthians 15:3–8) Interestingly, all the witnesses in Paul's early testimony are men. Luke suggests a reason for that: "And they [the women] remembered his [Jesus'] words, And returned from the sepulchre, and told all these things unto the eleven, and to all the rest. …And their words seemed to them [the disciples] as idle tales, and they believed them not." (Luke 24:8–11). Even more interesting is the story Mark tells, of which the oldest, most reliable manuscripts do not contain verses 9–20. Some suggest that those ancient manuscripts are missing their final pages. Several other "endings" have been found on a few manuscripts, in place of verses 9–20. If the report of the risen Lord's going on to Galilee was never told to any man, then how did Mark or anyone else hear about it? Perhaps Mark intended the story to leave the reader hanging—so that it would not be just another "happy ending" story, but a story to challenge and engage those who follow Jesus. In Matthew's expansion of Mark, the women meet Jesus, who greets them, and "they came and held him by the feet, and worshipped him." Jesus could be "held," i.e. he was not a spirit. In

Luke's account of Jesus' appearance to the disciples in Jerusalem, he eats a piece of broiled fish, to make the same point.

MATTHEW 28:1–8

1 In the end of the sabbath, as it began to dawn toward the first day of the week, came Mary Magdalene and the other Mary to see the sepulchre.

2 And, behold, there was a great earthquake: for the angel of the Lord descended from heaven, and came and rolled back the stone from the door, and sat upon it.

3 His countenance was like lightning, and his raiment white as snow:

4 And for fear of him the keepers did shake, and became as dead men.

5 And the angel answered and said unto the women, Fear not ye: for I know that ye seek Jesus, which was crucified.

6 He is not here: for he is risen, as he said. Come, see the place where the Lord lay.

7 And go quickly, and tell his disciples that he is risen from the dead; and, behold, he goeth before you into Galilee; there shall ye see him: lo, I have told you.

8 And they departed quickly from the sepulchre with fear and great joy; and did run to bring his disciples word.

MARK 16:1–8

1 And when the sabbath was past, Mary Magdalene, and Mary the mother of James, and Salome, had bought sweet spices, that they might come and anoint him.

2 And very early in the morning the first day of the week, they came unto the sepulchre at the rising of the sun.

3 And they said among themselves, Who shall roll us away the stone from the door of the sepulchre?

4 And when they looked, they saw that the stone was rolled away: for it was very great.

5 And entering into the sepulchre, they saw a young man sitting on the right side, clothed in a long white garment; and they were affrighted.

6 And he saith unto them, Be not affrighted: Ye seek Jesus of Nazareth, which was crucified: he is risen; he is not here: behold the place where they laid him.

7 But go your way, tell his disciples and Peter that he goeth before you into Galilee: there shall ye see him, as he said unto you.

8 And they went out quickly, and fled from the sepulchre; for they trembled and were amazed: neither said they any thing to any man; for they were afraid.

LUKE 24:1–12

1 Now upon the first day of the week, very early in the morning, they came unto the sepulchre, bringing the spices which they had prepared, and certain others with them.

2 And they found the stone rolled away from the sepulchre.

3 And they entered in, and found not the body of the Lord Jesus.

4 And it came to pass, as they were much perplexed thereabout, behold, two men stood by them in shining garments:

5 And as they were afraid, and bowed down their faces to the earth, they said unto them, Why seek ye the living among the dead?

6 He is not here, but is risen: remember how he spake unto you when he was yet in Galilee,

7 Saying, The Son of man must be delivered into the hands of sinful men, and be crucified, and the third day rise again.

8 And they remembered his words,

9 And returned from the sepulchre, and told all these things unto the eleven, and to all the rest.

10 It was Mary Magdalene, and Joanna, and Mary the mother of James, and other women that were with them, which told these things unto the apostles.

11 And their words seemed to them as idle tales, and they believed them not.

12 Then arose Peter, and ran unto the sepulchre; and stooping down, he beheld the linen clothes laid by themselves, and departed, wondering in himself at that which was come to pass.

JOHN 20:1–13

1 The first day of the week cometh Mary Magdalene early, when it was yet dark, unto the sepulchre, and seeth the stone taken away from the sepulchre.

2 Then she runneth, and cometh to Simon Peter, and to the other disciple, whom Jesus loved, and saith unto them, They have taken away the Lord out of the sepulchre, and we know not where they have laid him.

3 Peter therefore went forth, and that other disciple, and came to the sepulchre.

4 So they ran both together: and the other disciple did outrun Peter, and came first to the sepulchre.

5 And he stooping down, and looking in, saw the linen clothes lying; yet went he not in.

6 Then cometh Simon Peter following him, and went into the sepulchre, and seeth the linen clothes lie,

The Angel at Christ's Tomb with Three Marys in Distance, by Casimiro Brugnone de Rossi, 1818–76

7 And the napkin, that was about his head, not lying with the linen clothes, but wrapped together in a place by itself.

8 Then went in also that other disciple, which came first to the sepulchre, and he saw, and believed.

9 For as yet they knew not the scripture, that he must rise again from the dead.

10 Then the disciples went away again unto their own home.

11 But Mary stood without at the sepulchre weeping: and as she wept, she stooped down, and looked into the sepulchre,

12 And seeth two angels in white sitting, the one at the head, and the other at the feet, where the body of Jesus had lain.

13 And they say unto her, Woman, why weepest thou? She saith unto them, Because they have taken away my Lord, and I know not where they have laid him.

JESUS APPEARS TO THE WOMEN

MATTHEW 28:9–10

9 And as they went to tell his disciples, behold, Jesus met them, saying, All hail. And they came and held him by the feet, and worshipped him.

10 Then said Jesus unto them, Be not afraid: go tell my brethren that they go into Galilee, and there shall they see me.

MARK 16:9–11

9 Now when Jesus was risen early the first day of the week, he appeared first to Mary Magdalene, out of whom he had cast seven devils.

10 And she went and told them that had been with him, as they mourned and wept.

11 And they, when they had heard that he was alive, and had been seen of her, believed not.

LUKE 24:10–11

10 It was Mary Magdalene, and Joanna, and Mary the mother of James, and other women that were with them, which told these things unto the apostles.

11 And their words seemed to them as idle tales, and they believed them not.

JOHN 20:14–18

14 And when she had thus said, she turned herself back, and saw Jesus standing, and knew not that it was Jesus.

15 Jesus saith unto her, Woman, why weepest thou? whom seekest thou? She, supposing him to be the gardener, saith unto him, Sir, if thou have borne him hence, tell me where thou hast laid him, and I will take him away.

And they found the stone rolled away from the sepulchre.

And they entered in, and found not the body of the Lord Jesus.

And it came to pass, as they were much perplexed thereabout, behold, two men stood by them in shining garments.

—LUKE 24:2–4

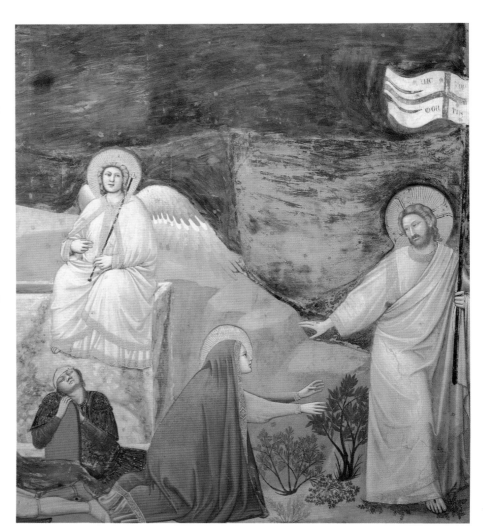

The Risen Jesus Appears to Mary Magdalene, by Giotto Di Bondone, 1276–1337

14 And if this come to the governor's ears, we will persuade him, and secure you.

15 So they took the money, and did as they were taught: and this saying is commonly reported among the Jews until this day.

JESUS APPEARS TO TWO ON THE ROAD TO EMMAUS

The empty tomb stories give the hearer a sense of continuity—that the Jesus who was buried and the risen Lord are the same. Yet the risen Lord was also different. Witness Luke's account of the two men on the road to Emmaus, sometime later in the afternoon of Easter day. Meeting a traveler, they relate the women's story about Jesus vanishing from the tomb, the angel's appearance and the disciples' incredulous reaction to their report. This story is a masterpiece of dramatic irony—the reader knows who their companion is, but the men cannot recognize him. This stranger can spell out in detail, with support from the law, the prophets, and the psalms, why the things that happened to Jesus were "necessary"—part of God's plan. Still they do not pick it up. And what about those of us who read these stories nearly two millennia after the first Easter day? "If this is the way it is, then who can be saved?" Jesus' answer then is his answer now: "With man it is impossible, but not for God. For all things are possible with God." The "presence" that made their hearts burn on the road, has the same power today. "They recognized him in the breaking of the bread," as can we— at the table that turned out not to be the last supper at all!

MARK 16:9–11

9 Now when Jesus was risen early the first day of the week, he appeared first to Mary Magdalene, out of whom he had cast seven devils.

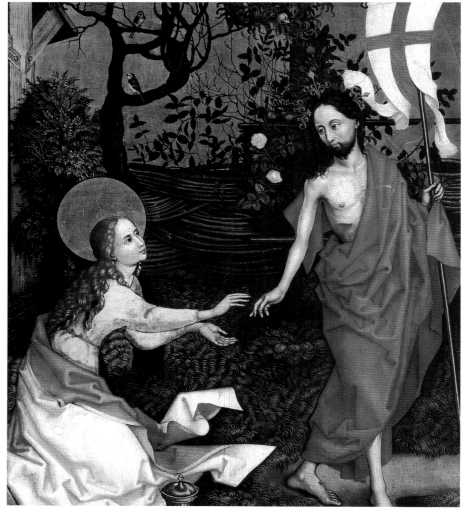

Risen Christ Appears to Mary Magdalene, 1470–80, by Martin Schongauer, c.1430–91

16 Jesus saith unto her, Mary. She turned herself, and saith unto him, Rabboni; which is to say, Master.

17 Jesus saith unto her, Touch me not; for I am not yet ascended to my Father: but go to my brethren, and say unto them, I ascend unto my Father, and your Father; and to my God, and your God.

18 Mary Magdalene came and told the disciples that she had seen the Lord, and that he had spoken these things unto her.

THE REPORT OF THE GUARD

MATTHEW 28:11–15

11 Now when they were going, behold, some of the watch came into the city, and shewed unto the chief priests all the things that were done.

12 And when they were assembled with the elders, and had taken counsel, they gave large money unto the soldiers,

13 Saying, Say ye, His disciples came by night, and stole him away while we slept.

10 And she went and told them that had been with him, as they mourned and wept.

11 And they, when they had heard that he was alive, and had been seen of her, believed not.

LUKE 24:13–35

13 And, behold, two of them went that same day to a village called Emmaus, which was from Jerusalem about threescore furlongs.

14 And they talked together of all these things which had happened.

15 And it came to pass, that, while they communed together and reasoned, Jesus himself drew near, and went with them.

16 But their eyes were holden that they should not know him.

17 And he said unto them, What manner of communications are these that ye have one to another, as ye walk, and are sad?

18 And the one of them, whose name was Cleopas, answering said unto him, Art thou only a stranger in Jerusalem, and hast not known the things which are come to pass therein these days?

19 And he said unto them, What things? And they said unto him, Concerning Jesus of Nazareth, which was a prophet mighty in deed and word before God and all the people:

20 And how the chief priests and our rulers delivered him to be condemned to death, and have crucified him.

21 But we trusted that it had been he which should have redeemed Israel: and beside all this, to day is the third day since these things were done.

22 Yea, and certain women also of our company made us astonished, which were early at the sepulchre;

23 And when they found not his body, they came, saying, that they had also seen a vision of angels, which said that he was alive.

24 And certain of them which were with us went to the sepulchre, and found it even so as the women had said: but him they saw not.

25 Then he said unto them, O fools, and slow of heart to believe all that the prophets have spoken:

26 Ought not Christ to have suffered these things, and to enter into his glory?

27 And beginning at Moses and all the prophets, he expounded unto them in all the scriptures the things concerning himself.

28 And they drew nigh unto the village, whither they went: and he made as though he would have gone further.

29 But they constrained him, saying, Abide with us: for it is toward evening, and the day is far spent. And he went in to tarry with them.

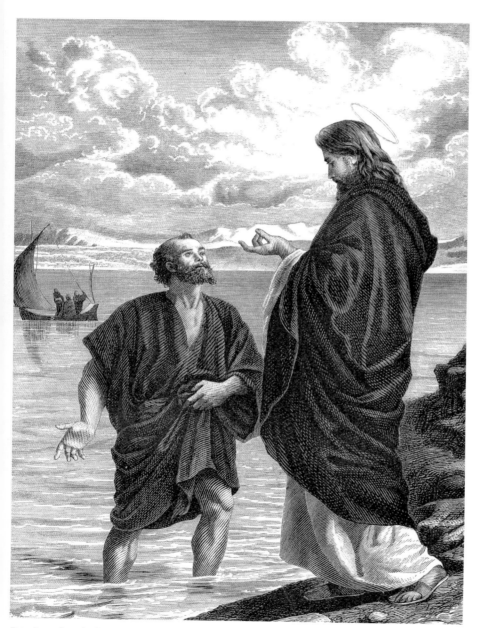

Peter Leaps from the Boat to Meet Jesus, by Alexander Bida, 1813–1895

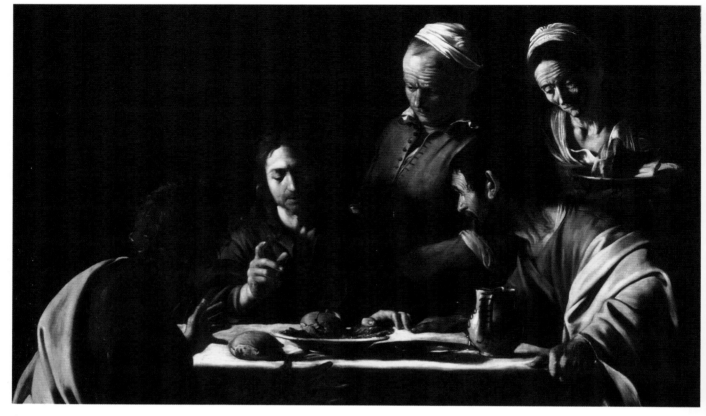

Supper at Emmaus, 1606, by Michelangelo Merisi da Caravaggio, 1571–1610

30 And it came to pass, as he sat at meat with them, he took bread, and blessed it, and brake, and gave to them.

31 And their eyes were opened, and they knew him; and he vanished out of their sight.

32 And they said one to another, Did not our heart burn within us, while he talked with us by the way, and while he opened to us the scriptures?

33 And they rose up the same hour, and returned to Jerusalem, and found the eleven gathered together, and them that were with them,

34 Saying, The Lord is risen indeed, and hath appeared to Simon.

35 And they told what things were done in the way, and how he was known of them in breaking of bread.

JESUS APPEARS TO THE DISCIPLES (WITHOUT THOMAS)

MARK 16:14

14 Afterward he appeared unto the eleven as they sat at meat, and upbraided them with their unbelief and hardness of heart, because they believed not them which had seen him after he was risen.

LUKE 24:36–43

36 And as they thus spake, Jesus himself stood in the midst of them, and saith unto them, Peace be unto you.

37 But they were terrified and affrighted, and supposed that they had seen a spirit.

38 And he said unto them, Why are ye troubled? and why do thoughts arise in your hearts?

39 Behold my hands and my feet, that it is I myself: handle me, and see; for a spirit hath not flesh and bones, as ye see me have.

40 And when he had thus spoken, he shewed them his hands and his feet.

41 And while they yet believed not for joy, and wondered, he said unto them, Have ye here any meat?

42 And they gave him a piece of a broiled fish, and of an honeycomb.

43 And he took it, and did eat before them.

JOHN 20:19–23

19 Then the same day at evening, being the first day of the week, when the doors were shut where the disciples were assembled for fear of the Jews, came Jesus and stood in the midst, and saith unto them, Peace be unto you.

20 And when he had so said, he shewed unto them his hands and his side. Then were the disciples glad, when they saw the Lord.

21 Then said Jesus to them again, Peace be unto you: as my Father hath sent me, even so send I you.

22 And when he had said this, he breathed on them, and saith unto them, Receive ye the Holy Ghost:

23 Whose soever sins ye remit, they are remitted unto them; and whose soever sins ye retain, they are retained.

JESUS APPEARS AGAIN TO THE DISCIPLES WITH THOMAS

JOHN 20:24–29

24 But Thomas, one of the twelve, called Didymus, was not with them when Jesus came.

25 The other disciples therefore said unto him, We have seen the Lord. But he said unto them, Except I shall see in his hands the print of the nails, and put my finger into the print of the nails, and thrust my hand into his side, I will not believe.

26 And after eight days again his disciples were within, and Thomas with them: then came Jesus, the doors being shut, and stood in the midst, and said, Peace be unto you.

27 Then saith he to Thomas, reach hither thy finger, and behold my hands; and reach hither thy hand, and thrust it into my side: and be not faithless, but believing.

28 And Thomas answered and said unto him, My Lord and my God.

29 Jesus saith unto him, Thomas, because thou hast seen me, thou hast believed: blessed are they that have not seen, and yet have believed.

JESUS APPEARS ON A MOUNTAIN IN GALILEE: THE GREAT COMMISSION

MATTHEW 28:16–20

16 Then the eleven disciples went away into Galilee, into a mountain where Jesus had appointed them.

17 And when they saw him, they worshipped him: but some doubted.

18 And Jesus came and spake unto them, saying, All power is given unto me in heaven and in earth.

19 Go ye therefore, and teach all nations, baptizing them in the name of the Father, and of the Son, and of the Holy Ghost:

20 Teaching them to observe all things whatsoever I have commanded you: and, lo, I am with you always, even unto the end of the world. Amen.

MARK 16:14–18

14 Afterward he appeared unto the eleven as they sat at meat, and upbraided them with their unbelief and hardness of heart, because they believed not them which had seen him after he was risen.

15 And he said unto them, Go ye into all the world, and preach the gospel to every creature.

16 He that believeth and is baptized shall be saved; but he that believeth not shall be damned.

17 And these signs shall follow them that believe; In my name shall they cast out devils; they shall speak with new tongues;

18 They shall take up serpents; and if they drink any deadly thing, it shall not hurt them; they shall lay hands on the sick, and they shall recover.

And he said unto them, Why are ye troubled? and why do thoughts arise in your hearts?

Behold my hands and my feet, that it is I myself: handle me, and see; for a spirit hath not flesh and bones, as ye see me have.

And when he had thus spoken, he shewed them his hands and his feet.

—LUKE 24:38–40

JOHN 14:23

23 Jesus answered and said unto him, If a man love me, he will keep my words: and my Father will love him, and we will come unto him, and make our abode with him.

JESUS APPEARS ON THE SEA OF TIBERIAS

JOHN 21:1–14

1 After these things Jesus shewed himself again to the disciples at the sea of Tiberias; and on this wise shewed he himself.

2 There were together Simon Peter, and Thomas called Didymus, and Nathanael of Cana in Galilee, and the sons of Zebedee, and two other of his disciples.

3 Simon Peter saith unto them, I go a fishing. They say unto him, We also go with thee. They went forth, and entered into a ship immediately; and that night they caught nothing.

4 But when the morning was now come, Jesus stood on the shore: but the disciples knew not that it was Jesus.

5 Then Jesus saith unto them, Children, have ye any meat? They answered him, No.

6 And he said unto them, Cast the net on the right side of the ship, and ye shall find. They cast therefore, and now they were not able to draw it for the multitude of fishes.

7 Therefore that disciple whom Jesus loved saith unto Peter, It is the Lord. Now when Simon Peter heard that it was the Lord, he girt his fisher's coat unto him, (for he was naked,) and did cast himself into the sea.

8 And the other disciples came in a little ship; (for they were not far from land, but as it were two hundred cubits,) dragging the net with fishes.

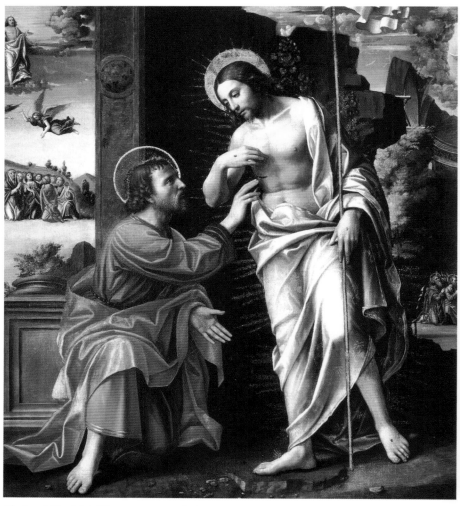

The Incredulity of Saint Thomas, 1st century, Paolo Morando, 1486–1522

9 As soon then as they were come to land, they saw a fire of coals there, and fish laid thereon, and bread.

10 Jesus saith unto them, Bring of the fish which ye have now caught.

11 Simon Peter went up, and drew the net to land full of great fishes, and hundred and fifty and three: and for all there were so many, yet was not the net broken.

12 Jesus saith unto them, Come and dine. And none of the disciples durst ask him, Who art thou? knowing that it was the Lord.

13 Jesus then cometh, and taketh bread, and giveth them, and fish likewise.

14 This is now the third time that Jesus shewed himself to his disciples, after that he was risen from the dead.

This third appearance of the risen Lord greatly resembles Luke's account of Simon Peter's call to discipleship (pages 66–67 above). In both, Jesus prefigures the ultimate success of the gospel with an incredible catch of fish. Duly awed by a power bigger than this world, Luke's Peter confesses himself to be a "sinful man." John's Peter puts on his clothes ("for he was naked") before he swims ashore to meet the Lord. Were there two "miraculous catches," or do both evangelists relate the same event, one at the beginning, the other at the end of Jesus' earthly ministry? This much

we can say for certain: all who heard the gospel knew two things about Peter—that he who three times had denied his Lord came to be a rock (in Greek, petra) through whom the Lord would build his church. His before-and-after story became a prototype for many, who would come to find new life in the light of Jesus' resurrection.

LUKE 5:1–11

1 *And it came to pass, that, as the people pressed upon him to hear the word of God, he stood by the lake of Gennesaret,*

2 *And saw two ships standing by the lake: but the fishermen were gone out of them, and were washing their nets.*

3 *And he entered into one of the ships, which was Simon's, and prayed him that he would thrust out a little from the land. And he sat down, and taught the people out of the ship.*

4 *Now when he had left speaking, he said unto Simon, Launch out into the deep, and let down your nets for a draught.*

5 *And Simon answering said unto him, Master, we have toiled all the night, and have taken nothing: nevertheless at thy word I will let down the net.*

6 *And when they had this done, they inclosed a great multitude of fishes: and their net brake.*

7 *And they beckoned unto their partners, which were in the other ship, that they should come and help them. And they came, and filled both the ships, so that they began to sink.*

8 *When Simon Peter saw it, he fell down at Jesus' knees, saying, Depart from me; for I am a sinful man, O Lord.*

9 *For he was astonished, and all that were with him, at the draught of the fishes which they had taken:*

10 *And so was also James, and John, the sons of Zebedee, which were partners with Simon. And Jesus said unto Simon, Fear not; from henceforth thou shalt catch men.*

11 *And when they had brought their ships to land, they forsook all, and followed him.*

JESUS INSTRUCTS HIS DISCIPLES AND ASCENDS INTO HEAVEN

At the conclusion of Luke's "orderly declaration" (*Luke* 1:1), Jesus instructs his disciples about all the things in the Law, the prophets, and the psalms that needed to be fulfilled: "Thus it is written, and thus it behoved Christ to suffer and to rise from the dead on the third day; and that repentance and the remission of sins should be preached in his name to all nations, beginning at Jerusalem" (*Luke* 24:46–47). Jesus continues, inviting us as readers to become part of the story: "And ye are witnesses to these things." For Luke, Jesus' blessing and ascension into heaven are not the end. Volume two, the Acts of the Apostles, begins in Jerusalem and continues "to the uttermost part of the earth" (Acts 1:8). Matthew's Jesus sends his disciples to all the nations with a promise—a promise fulfilled in the birth of Emmanuel ("God with us"). "And lo, I am with you always, even unto the end of the world." What about all those "endings" of Mark's story? They were most likely not from Mark's hand. Yet, the Church accepts their authority as

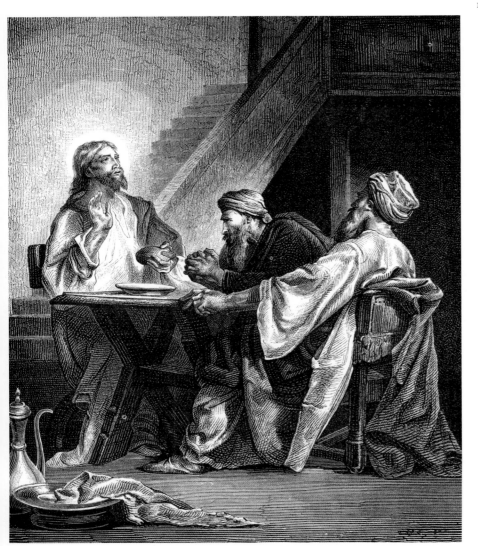

The Disciples at Emmaus, by Alexander Bida, 1813–1895

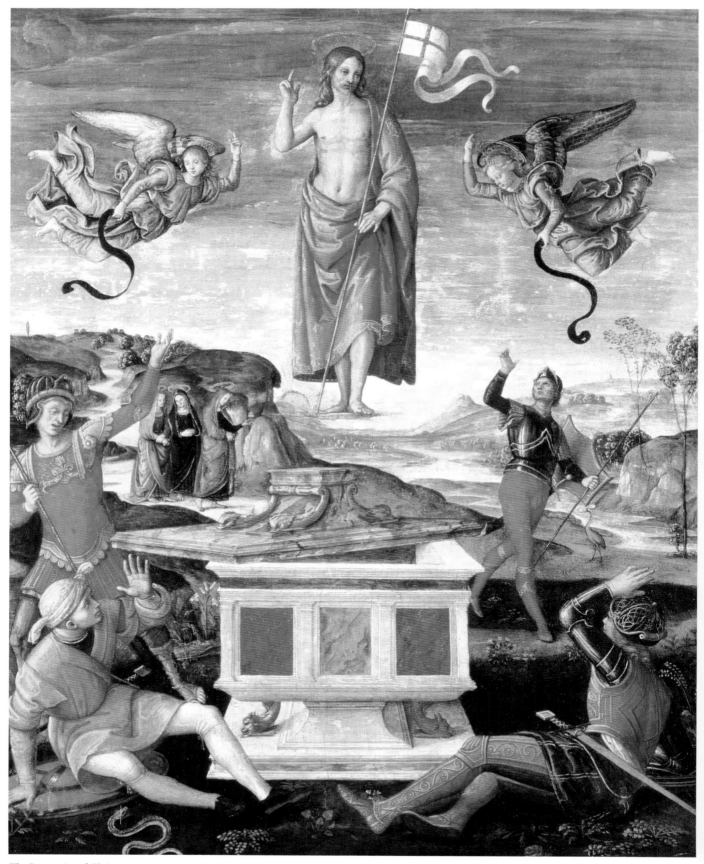

The Resurrection of Christ, c.1502, by Raphael, 1483-1520

inspired scripture, all the same. Inspired also are the stories we write. For their inspiration is what Luke's Jesus calls "the promise of my Father" and John's Jesus calls "the spirit." John's story has two conclusions, as the reader will notice below. The later one leaves plenty of space for more books, more stories, yet to be written, "… if they should be written every one, I suppose that even the world itself could not contain the books that should be written" (John 21:25).

MARK 16:15, 19

15 And he said unto them, Go ye into all the world, and preach the gospel to every creature.

19 So then after the Lord had spoken unto them, he was received up into heaven, and sat on the right hand of God.

LUKE 24:44–53

44 And he said unto them, These are the words which I spake unto you, while I was yet with you, that all things must be fulfilled, which were written in the law of Moses, and in the prophets, and in the psalms, concerning me.

45 Then opened he their understanding, that they might understand the scriptures,

46 And said unto them, Thus it is written, and thus it behoved Christ to suffer, and to rise from the dead the third day:

47 And that repentance and remission of sins should be preached in his name among all nations, beginning at Jerusalem.

48 And ye are witnesses of these things.

49 And, behold, I send the promise of my Father upon you: but tarry ye in the city of Jerusalem, until ye be endued with power from on high.

50 And he led them out as far as to Bethany, and he lifted up his hands, and blessed them.

51 And it came to pass, while he blessed them, he was parted from them, and carried up into heaven.

52 And they worshipped him, and returned to Jerusalem with great joy:

53 And were continually in the temple, praising and blessing God. Amen.

THE CONCLUSION OF JOHN'S STORY

JOHN 20:30–31

30 And many other signs truly did Jesus in the presence of his disciples, which are not written in this book:

31 But these are written, that ye might believe that Jesus is the Christ, the Son of God; and that believing ye might have life through his name.

AN APPENDIX TO JOHN'S STORY: PETER AND THE BELOVED DISCIPLE

JOHN 21:15–25

15 So when they had dined, Jesus saith to Simon Peter, Simon, son of Jonas, lovest thou me more than these? He saith unto him, Yea, Lord; thou knowest that I love thee. He saith unto him, Feed my lambs.

16 He saith to him again the second time, Simon, son of Jonas, lovest thou me? He saith unto him, Yea, Lord; thou knowest that I love thee. He saith unto him, Feed my sheep.

17 He saith unto him the third time, Simon, son of Jonas, lovest thou me? Peter was grieved because he said unto him the third time, Lovest thou me? And he said unto him, Lord, thou knowest all things; thou knowest that I love thee. Jesus saith unto him, Feed my sheep.

18 Verily, verily, I say unto thee, When thou wast young, thou girdedst thyself, and walkedst whither thou wouldest: but when thou shalt be old, thou shalt stretch forth thy hands, and another shall gird thee, and carry thee whither thou wouldest not.

19 This spake he, signifying by what death he should glorify God. And when he had spoken this, he saith unto him, Follow me.

20 Then Peter, turning about, seeth the disciple whom Jesus loved following; which also leaned on his breast at supper, and said, Lord, which is he that betrayeth thee?

21 Peter seeing him saith to Jesus, Lord, and what shall this man do?

22 Jesus saith unto him, If I will that he tarry till I come, what is that to thee? follow thou me.

23 Then went this saying abroad among the brethren, that that disciple should not die: yet Jesus said not unto him, He shall not die; but, If I will that he tarry till I come, what is that to thee?

24 This is the disciple which testifieth of these things, and wrote these things: and we know that his testimony is true.

25 And there are also many other things which Jesus did, the which, if they should be written every one, I suppose that even the world itself could not contain the books that should be written. Amen.